European Art of the
Eighteenth Century

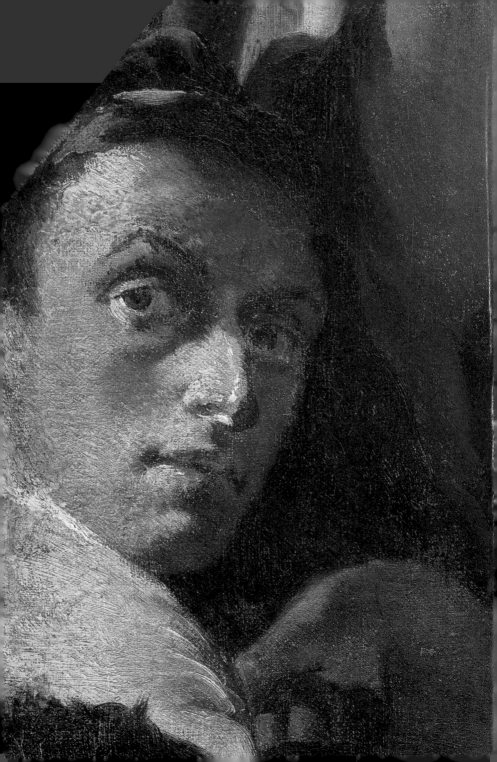

Daniela Tarabra

European Art of the
Eighteenth Century

Translated by Rosanna M. Giammanco Frongia

The J. Paul Getty Museum
Los Angeles

OC ᴄ 2 '08 709.033
 T17e

edition © 2006 Mondadori Electa S.p.A., Milan
.ghts reserved. www.electaweb.it

~ries Editor: Stefano Zuffi
Original Graphic Coordinator: Dario Tagliabue
Original Graphic Designer: Anna Piccarreta
Original Layout: Paola Forini
Original Editorial Coordinator: Virginia Ponciroli
Original Editor: Carla Ferrucci
Original Photographic Researchers: Daniela Tarabra, Daniela Teggi
Original Technicolor Coordinator: Andrea Panozzo
Original Quality Control: Giancarlo Berti

English translation © 2008 J. Paul Getty Trust

First published in the United States of America in 2008 by
The J. Paul Getty Museum

Getty Publications
1200 Getty Center Drive, Suite 500
Los Angeles, California 90049-1682
www.getty.edu

Gregory M. Britton, *Publisher*
Mark Greenberg, *Editor in Chief*

Ann Lucke, *Managing Editor*
Mollie Holtman, *Editor*
Sharon R. Herson, *Copy Editor*
Pamela Heath, *Production Coordinator*
Michael Shaw, *Typesetter*
Translation, copyediting, and typesetting coordinated by LibriSource Inc.

Library of Congress Cataloging-in-Publication Data

Tarabra, Daniela.
 [Settecento. English]
 European art of the eighteenth century / Daniela Tarabra;
 translated by Rosanna M. Giammanco Frongia.
 p. cm. — (Art through the centuries)
 Includes index.
 ISBN 978-0-89236-921-8 (pbk.)
 1. Art, European—18th century. 2. Art, Baroque. 3. Neoclassicism (Art).
 I. J. Paul Getty Museum. II. Title. III. Title: European art of the 18th century.
 N6756.T3713 2008
 709.03'3—dc22
 2008001954

Printed in Hong Kong

Page 2: Giambattista Tiepolo, *Self-Portrait,* detail from *The Triumph of Marius,* 1729. New York, Metropolitan Museum of Art.

Contents

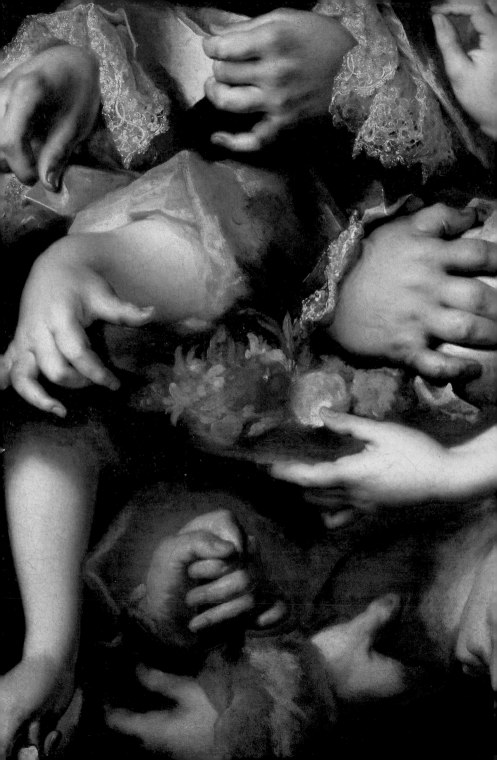

KEY WORDS

Rococo

Fêtes Galantes

Royal Manufactories

Porcelain

Cabinetmaking

Chinoiserie

Stucco

Quadratura

Theater

Churriguerismo

Regency

Chippendale

Parks and Gardens

The Grand Tour

Vedutismo

Capriccio

Ruins

Archaeological Discoveries

The Picturesque

The Sublime

The Enlightenment

Encyclopédie

Academies and Nudes

Salon

Satire and Caricature

Neoclassicism

The French Revolution

Architectural Utopia

A taste in art that animated the first half of the 18th century, characterized by elegant, delicate decorations and a masterly use of stucco, intaglio, mirrors, silks, and brocades.

Rococo

Notes of interest
In addition to impressive stucco decoration on walls and ceilings, the rooms were also enriched with coverings of *boiserie*, or ornately carved wood panels, and precious fabrics, such as silk and brocade; also typical were rooms lined with richly framed mirrors. Even the furniture followed this trend, with slender, elongated legs forming a gentle S-curve.

The term "Rococo" was coined at the end of the 18th century to denote the dominant artistic taste of the first part of the century. It is probably derived from *rocaille*, a French word indicating a type of decoration that was used especially in gardens to imitate natural rock formations for small grottoes, hidden ravines, pavilions, and fountains, often encrusted with shells and pebbles. Somewhat successful throughout Europe, this ornamental genre was especially prominent in the France of Louis XV where it originated. It soon spread to all areas of décor and furnishings as a permutation of that taste for movement, opulence, and optical illusion that had triumphed in the Baroque style. Rococo was intended to evoke playfulness, grace, and imagination; for this reason, it was especially successful in interior decoration, where precious materials and colors were combined with mirrors, intricately patterned stuccoes, and woodwork to produce ever-changing compositions. Each room or space was considered a world unto itself, where the designer could unleash his creative talent without considering the overall unity of the building. Rococo was a natural response to a renewed aristocratic lifestyle based on the refinement and agility of the senses, love of frivolity, and courtly games and pastimes. Less solemn than the Baroque, the Rococo suggests, under its fanciful elegance, the birth of a new, warm intimacy: in this period, *boudoirs*, dainty drawing rooms with alcoves, first appeared, alongside the vast reception rooms.

▼ Juste-Aurèle Meissonnier, Drawing for table centerpiece and two silver terrines, 1735. Paris, Bibliothèque Nationale.

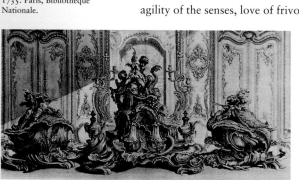

It is interesting to see how this elaborate 17th-century stucco decoration foreshadows the graceful and elegant style so typical of the 18th.

The Palermo artist Serpotta (1656–1732) raised the tradition of Sicilian stucco work to the level of art. This elaborate decoration of leaf tendrils and human figures winding around the columns of the altar of Saint Dionysius interprets the theme with typical rocaille delicacy.

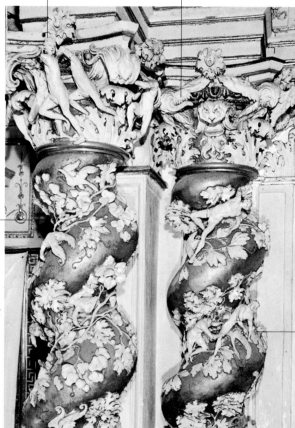

The white stucco figures depict the Mysteries of the Rosary and episodes of the Passion of Christ. They are applied to the Bernini-inspired gilded spiral columns with minute details and a nimble narrative smoothness.

Long neglected in the history of art, Serpotta is one of the preeminent figures in the transition from 17th- to 18th-century sculpture: the stucco relief work is nested with elegant and refined imagination into the spirals of these gigantic Solomonic columns.

▲ Giacomo Serpotta, Gilded Altar Columns (detail), 1684. Palermo, Chiesa del Carmine.

The Cuvilliés salon in Amalienburg is a Rococo jewel, a refined play of mother-of-pearl, mirrors, and delicate pastel decorations that seem to dissolve the architectural structure.

The idyllic, elegant interior decoration evokes nature by re-creating an arbor with vine shoots, trees, and birds.

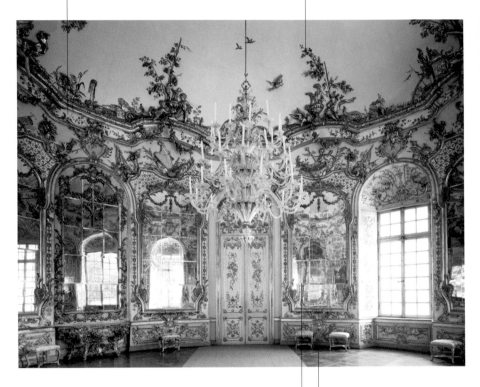

Cuvilliés was the leading Bavarian artist of the Rococo. He created a truly enchanting salon: delicate colors and metallic stucco tracings cover the walls and the ceiling and multiply endlessly in the huge crystal mirrors that expand space to the infinite.

Located in Nymphenburg Park, near Munich, Amalienburg was designed as a hunting pavilion, in plan a plain rectangle with a central rotunda that projects forward.

▲ François de Cuvilliés, Mirror Salon, 1734–39. Munich, Amalienburg.

The Rococo style reached its zenith in the central years of Louis XV's reign (1715–70). An expression of petit goût—the "modern style" as defined by the art literature of the time—the Rococo style was applied primarily to interior decoration, from boiserie to furniture and tapestries.

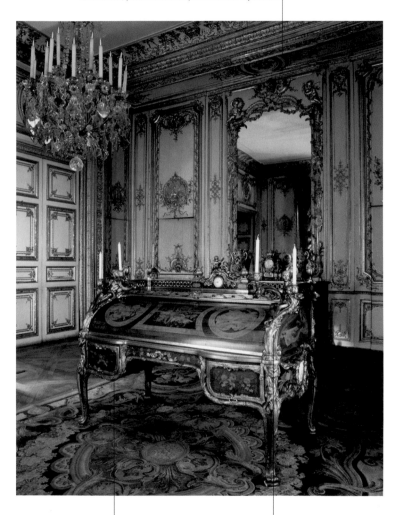

▲ François Oeben and Jean-Henri Riesener, Rolltop Desk, 1760–69. Chateau de Versailles.

This desk is in the king's writing room in the royal quarters. Its wavy, irregular lines recall the rocaille shapes that originally evoked the contours of seashells.

Delicate arabesques of slender, rhythmical floral inlays decorate this desk, which was begun by the cabinetmaker Oeben and completed by Riesener. Together with the room's decoration, it is a highly refined example of Louis XV style.

In the luminous sky, putti fly about and frolic with iridescent, two-tone silk drapery, which almost forms a canopy over the pale, languid goddess.

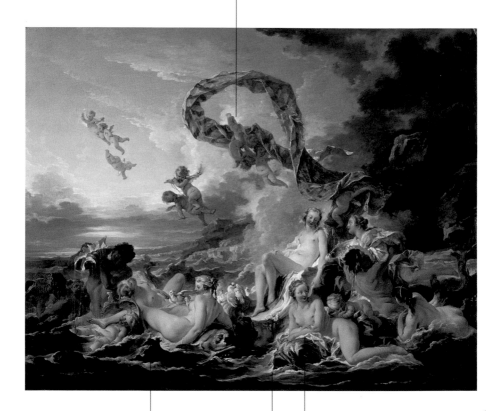

Boucher plays with the radiant, velvety transparency of the naked flesh and the luminous refraction of the waves and silks that envelop the nymphs, creating a provocative, ingenuous female type that is sensual and elegant, in an airy, limpid universe.

In this mythological scene, the artist displays his unequaled skill: light and joy spread throughout a composition marked by richly blended colors and refined tones.

Magnificent, soft female figures stretch out on the rocks lapped by the waves, with the same placid sensuality of aristocratic ladies lying in the intimacy of their boudoir.

▲ François Boucher, *The Triumph of Venus*, 1740. Stockholm, Nationalmuseum.

The erotic nature of this scene is somewhat
disguised by the masterly chromatic handling
that creates a dreamy ambience, recalling the
idealized landscapes of Watteau.

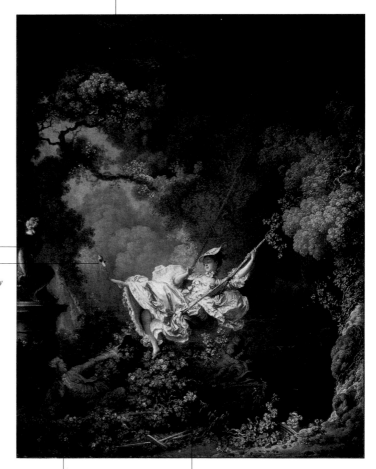

The statue of a putto
on a sculpted pedestal
gazes at the scene,
seemingly amused: his
gesture, urging silence,
underlines the furtive
nature of the liaison.

The woman sees her
lover and mischievously
drops her dainty shoe,
which her secret
admirer will retrieve.

The delighted lover casts
naughty glances under
the woman's full, billowy
skirts. In the Rococo
garden, spaces become
more secluded, and the
decorative elements more
lighthearted.

Commissioned in 1766 by Baron
de Saint-Julien, treasurer of the
French Church, this painting
depicts a traditional love triangle:
hidden in the flowering bushes,
the lover stealthily eyes the
woman who plays on the swing
pushed by her husband.

▲ Jean-Honoré Fragonard,
The Swing, 1766. London,
Wallace Collection.

A painting genre that had its best interpreter in Watteau, who painted aristocrats courting amid games and concerts in a bucolic, rarefied atmosphere.

Fêtes Galantes

Related entries
Meissen, Paris, Sèvres
Boucher, Fragonard,
Kändler, Watteau

Notes of interest
Watteau's *fêtes galantes*
were so successful that
some of his paintings, or
scenes from them—such
as *The Scale of Love*—
were copied for ceramic
decorations until they
became decorative clichés.

▼ Donato Creti, *Dance
of the Nymphs*, ca. 1725.
Rome, Museo Nazionale
di Palazzo Venezia.

One of the artists who best embodies the Rococo spirit is the Frenchman Jean-Antoine Watteau, who, starting in 1710, began to paint what is known as "gallant" or amorous themes. He soon distinguished himself in this new genre, which freed itself from the traditional majestic, austere quality of classicizing academic art in favor of levity, grace, and elegance—distinctive Rococo traits—and in 1717 was admitted to the Royal Academy precisely as a "painter of *fêtes galantes.*" Louis XIV had promoted the values of honor and glory in order to confer on his kingdom a sense of sacredness and absolute nobility; but the new century demanded a relaxed attitude, diversion, and following the pleasures of the senses. The new protagonist is love in its most playful, scheming guise. Thus, French social life and its pastimes, theater actors and artists included, became the focus of Watteau's *fêtes galantes*, in which all is idealized and suffused in a rosy twilight. The artist painted happy lovers or small groups of friends, usually outdoors in blooming gardens, busy amusing themselves or being entertained with music. Often actors still in costume mingle with aristocrats, and all are caught conversing, dancing, listening to music, or exchanging pleasantries under tall trees that function as a backdrop. Watteau's scenes are outdoor parties steeped in the atmosphere of a pastoral novel, with its blend of eroticism and bucolic spirit that suggests the intimate, elegant, frivolous—and sometimes unexpectedly melancholy—universe that marked the aristocratic pastimes of that era. Watteau does not hint at any narrative plot in his paintings, thus stressing the ambiguity of gestures and feelings that link the characters in a manifold approach to love, be it acceptance or refusal and desertion.

*This canvas belongs to the "amorous
conversations" genre set against a
background of luxuriant nature, in an
atmosphere steeped in iridescent light.*

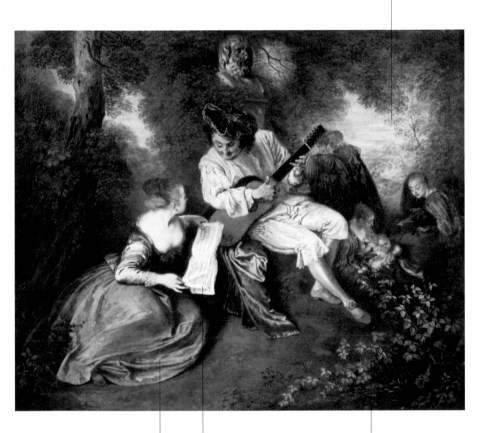

*In the foreground, the main group
is set on a receding diagonal; behind
the man's shoulder, a perspective
view of a sculpted herm is covered
by garden shrubs. The themes of
music and love are so intertwined
as to become inseparable.*

*According to a common interpretation,
the main couple are performing varia-
tions on a stanza, a musical exercise
that required close coordination
between the singer and the musician,
with amorous implications.*

*In the middle ground,
three young people, a
crying baby, and a
couple moving off
into the distance seem
to bear no relation to
the principal scene.*

▲ Jean-Antoine Watteau, *The
Scale of Love*, 1715–18. London,
National Gallery.

Fêtes Galantes

Pater (1695–1736), a refined interpreter of the lifestyle that was becoming popular in France in the wake of Rococo, describes a new society of courtly customs, parties, and music. This work, however, projects a certain melancholy, as if the artist realized the inexorable passing of time and the fleeting nature of life's pleasures.

In the background on the left, groups of young men and women chat amiably, sitting on the grass or strolling in the expansive natural scenery, blending like a gentle arabesque into the landscape.

This fête galante *portrays groups of ladies and gentlemen evoked in a soft, nostalgic atmosphere, painted with quick, supple strokes of delicate but sparkling colors that combine a warm Rubenesque chromaticism with Venetian iridescence.*

▲ Jean-Baptiste Pater, *Amorous Conversation*, ca. 1728. London, formerly Sotheby's.

A painter of fêtes galantes, Pater was the favorite student of Watteau, from whom he borrowed style and themes. He was a brilliant colorist, a talented draftsman, and a portraitist sought after by the French aristocracy, but for commercial reasons he often repeated his successful compositions. One of the largest repositories of Pater works is the Wallace Collection in London.

A typical example of a garden that evokes a theatrical space or, rather, a stage set inspired by real gardens: the placement of trees and branches has been carefully studied to create a backdrop effect and direct the gaze from the couple in the foreground to the distant background on the left.

The couple in the foreground marks a portion of the diagonal that starts from the top right corner, continues to the young woman who casts a curious, sidelong glance at the courting couple, moves along the billowing dress of the central female figure, and ends with the girl who plays happily with a dog.

The sentimental, Arcadian tone of this composition is not a celebration of sensual spontaneity, but instead, as always happens in the paintings of the master Watteau, an absorbed awareness of the fragile nature of pleasure and love.

Fêtes Galantes

Rendered with hazy, diaphanous strokes, the garden evokes a dreamy atmosphere, typical of the country feasts and dances beloved by the aristocracy.

A setting with a trellis that ends in a sculpted, gushing fountain forms the backdrop for several couples in the composition.

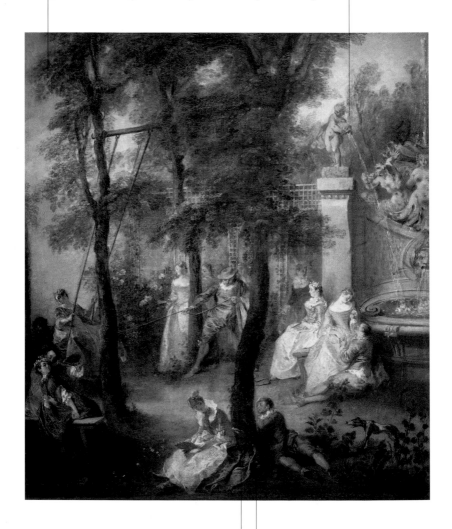

▲ Nicolas Lancret, *The Swing*, ca. 1735. Madrid, Museo Thyssen-Bornemisza.

The lovers' meetings, typical of Rococo culture, take place in intimate garden corners or in secluded, secret groves.

The three trees add depth to the scene and also act as the focal points around which the artist built the composition: the girl on the swing, the man pulling the rope, and a couple courting.

The manufacture of objects using traditional artisanal methods, with great importance given to craftsmanship, was directly supervised by the royal courts.

Royal Manufactories

In 18th-century Europe, several factories opened for the production of decorative objects of remarkably high quality, from porcelain to textiles and the cutting of semiprecious stones. A taste for these objets d'art grew also as a result of archaeological discoveries of pottery and vases. Their beauty so enchanted collectors and antiquarians that they illustrated them in drawings, many of which were then used as models by master ceramists. In Europe, porcelain, first manufactured in Meissen, Saxony, became fashionable and was used for tea, coffee, or chocolate sets. European courts competed to establish their own factories in which they could create ever more precious and rare pieces. In quick succession after Meissen, royal manufactories were founded in Vincennes-Sèvres in France, and Capodimonte in Italy, to mention just two of the principal ones. In 1743, Charles of Bourbon, king of Naples and Sicily, founded the Real Fabbrica di Capodimonte near Naples, which introduced a great variety of artifacts, from tea sets, vases, and figurines, to walking-stick pommels and snuffboxes. In 1759, the king moved to Madrid and transferred the factory to that city. Ferdinand IV, heir to the throne of Naples, established a new one there in 1771 (the Fabbrica Reale Ferdinandea), which a few years later specialized in archaeologically inspired patterns and designs. The prospect of enhancing their political prestige induced even the House of Savoy to support the establishment of highly specialized factories that produced porcelain, textiles, silverware, and furniture.

▼ Beauvais Manufactory, after a cartoon by François Boucher, *Bacchus and Ariadne*, a tapestry in the series *The Loves of the Gods*, 1750–52. Rome, Palazzo del Quirinale.

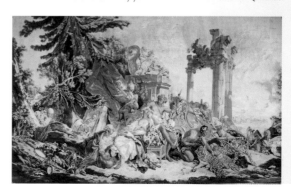

Perhaps designed as a private drawing room for Queen Maria Amalia, this room, created under the direction of Giuseppe Gricci, is the highest expression of the art of the Royal Manufactory of Capodimonte.

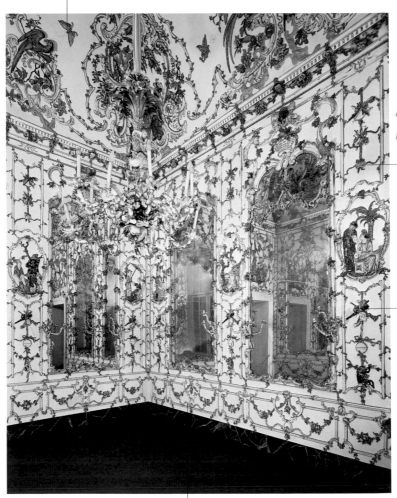

The scrolls tied with ribbons and bows are inscribed with ancient Chinese characters, in all probability faithfully copied from authentic Chinese prints.

The room is lined with porcelain tiles set onto a wood backing and decorated with festoons, musical trophies, scrolls, and scenes in the chinoiserie style inspired by Boucher's French models.

▲ Royal Manufactory of Capodimonte, Porcelain Drawing-room from the Portici Palace, 1757–59. Naples, Museo di Capodimonte.

This room was dismantled in the royal palace in Portici and reassembled in the palace at Capodimonte. The factory was founded by Charles of Bourbon in 1743; after he became king of Spain in 1759, he moved it to the Buen Retiro Palace in Madrid, where it was in continuous production from 1760 to 1808.

For decades, porcelain was the exclusive property of the European courts, which decided on forms and decorations according to current taste and fashions.

Porcelain

From the 16th century on, numerous unsuccessful attempts were made in Europe to duplicate the Chinese hard-paste process for making porcelain. This precious material, imported into Europe by the English East India Company and the product of a complex, highly secret formula and process, had conquered courts and palaces, becoming almost a fetish. European establishments such as the French factory in Rouen had been producing for years a soft-paste material that resembled the original, though it lacked the hardness and fine transparency of true porcelain. On January 15, 1708, the German alchemist Johann F. Böttger, then in the service of Augustus the Strong, elector of Saxony, succeeded in nearly reproducing the secret formula: he combined Kolditz kaolin—a clay that becomes white when fired—and calcinated alabaster, then fired the compound for twelve hours at an extremely high temperature, about 2500° F. The result was very similar to Chinese porcelain in both hardness and transparency. In 1710, the Royal Porcelain Manufactory was inaugurated in Meissen, Germany; three years later it officially introduced its wares at the Leipzig fair. Meissen produced splendid artifacts with Chinese-style decorations, in line with the contemporary craze for *chinoiseries*. Other subjects were views of port cities, battle scenes, and floral compositions. The formula, called *arcanum*, was sold secretly to the Vienna Manufactory in 1719 and from there, through many adventures, reached France and the rest of Europe. Thus several factories were born, all closely supervised by the royal courts, which tightly regulated their commerce. The growing taste for hot beverages such as tea, coffee, and chocolate further spurred production.

Related entries
Meissen, Munich, Vienna, Sèvres, Madrid, Naples

Kändler

Notes of interest
The Sèvres Royal Manufactory stood out from the competition for the beauty of the solid-color backgrounds and the gold-leaf work: these were royal proprietary techniques. Also famous are their precious, unmistakable backgrounds, such as royal blue, Pompadour pink, yellow, and intense green.

▼ Franz Anton Bustelli, *Captain and Leda*, 1759–60. Hamburg, Museum für Kunst und Gewerbe.

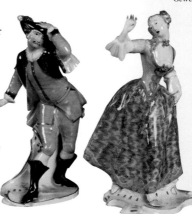

21

The art of elegant wood furniture reached extraordinary heights thanks to the talent and ingeniousness of master cabinet makers throughout Europe and the precious materials used.

Cabinetmaking

Notes of interest
Chinese lacquer was in high demand everywhere and heavily imitated, especially in Holland and England; it was also used in Venice with highly pleasing and original results characterized by novel, polychrome lacquered motifs on multihued backgrounds.

▼ Giuseppe Maggiolini, Chest, with the central panel marquetry after a drawing by Andrea Appiani, 1780–85. Milan, Castello Sforzesco.

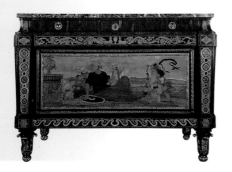

The cabinetmaking art reached its splendor in the 18th century when craftsmen created true masterpieces in wood for the European courts and the aristocracy. By the middle of the century the artists had acquired such fame that they began to sign their work. Refined furniture had been produced actively in France since the 17th century, thanks to the Royal Furniture Manufactory for the Crown, founded in 1667, and the work of the exceptionally talented André-Charles Boulle (1642–1732), the "dovetailing" inlay master who had become Louis XIV's personal cabinetmaker. To precious wood panels Boulle applied the most varied materials, such as copper, tin, silver, horn, ivory, tortoiseshell, and mother-of-pearl, creating veneers in garland patterns or pastoral scenes finished with surprising chiaroscuro effects. From France, this art spread throughout Europe. As a result of overseas colonial expansion, new precious woods such as rosewood, mahogany, and even ebony became more readily available, which in turn spurred the centuries-old marquetry technique, enriching it with a wider range of natural colors and combinations. The application of lacquer also grew in importance in homage to the *chinoiserie* taste, as did *radicatura*, adding veneers of olive or walnut root-wood to furniture in whole or part. Cabinetmakers in the 18th century, inspired by Oriental suggestions and the fashion for Chinese decorations, created new inlay and decorative patterns. Among the best European craftsmen were, in addition to Boulle, Charles Cressent, Van der Cruse, Thomas Chippendale, Pietro Piffetti, Giuseppe Maria Bonzanigo, and Giuseppe Maggiolini.

Brustolon created a number of furniture pieces for the San Vio Palace owned by the Venier family, now housed at Ca' Rezzonico. One such piece is this vase-stand, a masterpiece that is both sculpture and furniture.

Born in Belluno and active in the Veneto region, the sculptor Andrea Brustolon (1660–1732) became famous for the marquetry of his wood furniture. His technical virtuosity surpasses craft work and is one of the highest expressions of the Venetian Rococo.

Brustolon's exuberant imagination has created an object where the Bernini-inspired plasticity of the figures blends perfectly in the naturalistic frame.

At the bottom of the stand, Hercules, having defeated Cerberus and the Hydra, supports a shelf with two personified rivers holding two Chinese vases. In the center, three chained Moors hold the largest vase. The contrasts among the almost metallic luster of the ebony Moors, the brownish red of the boxwood, the other woods, and the porcelain emphasize the connection, still part of the Baroque inheritance, between the pairing of finished and unfinished, natural spontaneity and artificial elegance of the piece.

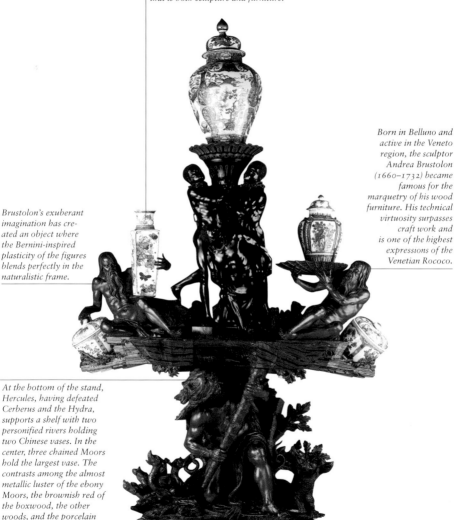

▲ Andrea Brustolon, Vase-Stand in the Form of Hercules, 1700–1720. Venice, Ca' Rezzonico.

Cabinetmaking

Master cabinetmakers such as Luigi Prinotto and Giuseppe Maria Bonzanigo made Turin a European center of exquisite furniture production. Here, precious inlaid wood was combined with mother-of-pearl, bronze, semiprecious stones, tortoiseshell, bone, and ivory.

This piece of furniture amazed the Savoy court, and is still admired today by visitors to the royal palace as one of the highest expressions of the European settecento.

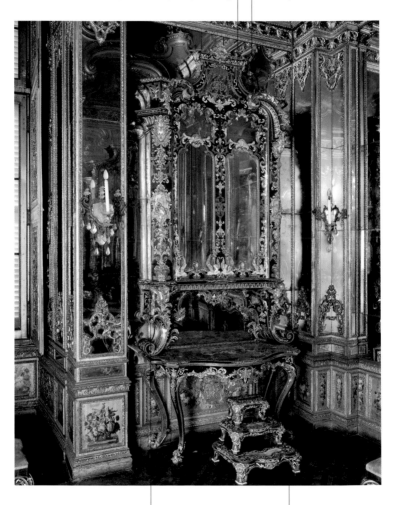

▲ Pietro Piffetti and Francesco Ladatte, Furniture ensemble, 1732. Turin, Palazzo Reale.

Starting from the bottom, the decoration begins with the winged female faces inserted in leaf scrolls and continues above in the medallions of putti representing the four seasons.

This exceptional work of art combines Piffetti's cabinetry with ornate bronze work by Ladatte; it follows the elegant lines of the early settecento, still dominated by Filippo Juvarra.

Although opposed by the advocates of classicism, chinoiserie *affected all areas of furnishings and ornamentation, from porcelain to furniture, from jewelry to tapestries and precious fabrics.*

Chinoiserie

Oriental-type decoration was already popular in the 1600s, but in the following century it became a veritable fashion: everyone in Europe wanted *chinoiseries*. And it was faraway, mysterious Cathay that filled the demand for new interior and garden décor and ornamental motifs. Patrons displayed a thirst for exoticism, rather than a genuine scholarly interest in Chinese art and architecture. As original forms were adapted to both formal and decorative Western taste, China began to manufacture objects targeted exclusively for the European market, such as porcelain sets and furniture. For the Western architect, the Orient represented liberation from classical standards: he could design with unbridled imagination, away from codified aesthetic principles. In the garden, the fashion for bizarre pagoda-roofed pavilions took hold: the first such is the 17th-century Trianon de Porcelaine in Versailles. The European nobility welcomed this frivolous, exotic fashion and enriched the interiors of their palaces with porcelain, silks, and large painted fans, lacquered furniture, and screens made of fabric or decorated wood. In England, the rage for *chinoiserie* inspired exterior decorations as well as porcelains and lacquered furniture. In 1753, a Chinese-style bridge was built over the Thames, and London became a flourishing market not just for imported artifacts but also for excellent imitations, especially lacquered furniture and objets d'art produced by highly skilled craftsmen.

Related entries
Saint Petersburg, Berlin-Potsdam, Dresden, Meissen, Munich, Vienna, Paris, Sèvres, Venice, Rome, Naples, London

Boucher, Kändler, Giandomenico Tiepolo

Notes of interest
A splendid example of ceramic wall décor in the *chinoiserie* style is Giuseppe Gricci's porcelain lounge created in mid-century for Maria Amalia of Saxony in the royal palace of Portici, now housed in the Museo di Capodimonte (see p. 20).

◀ Jean-Baptiste Pater, *The Chinese Hunt*, ca. 1730. Paris, private collection.

Chinoiserie

This Chinese pagoda is an example of the trend toward Oriental architectural models that prevailed in the European courts. Other examples include the Tea Pavilion in the park of Sanssouci, Potsdam.

England looked to Eastern models to replace French- and Italian-inspired geometric garden designs. Thus tea-houses, pagodas, and miniature bridges were added to the Neoclassical or Gothic-style structures of the landscaped gardens.

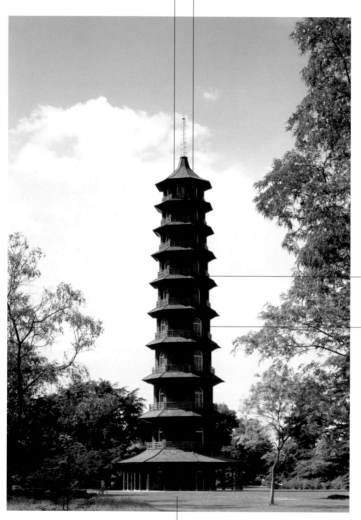

In this context, the Kew Gardens pagoda succeeds by transgression and boldness, translating into architecture the precepts that Chambers had proposed in his Designs of Chinese Buildings, Furniture, Dresses, Machines, and Utensils *(1757), a collection of garden designs and Oriental styles based on drawings he made while traveling in China.*

The pagoda towers over the rural landscape like a bizarre curiosity. Most of the details are the work of the architect's imagination, such as the roofs with curly edges, the gilded pinnacles, the dragons that originally chimed in the wind, and the lacy balustrades.

▲ William Chambers, Chinese Pagoda, 1757–61. London, Kew Gardens.

Tea, an exotic beverage at the time, was to be enjoyed in the shade of this odd structure, where, lulled by the chiming bells, one could pretend to be in China.

Luscious exotic plants grow in the background, underscoring the Oriental stamp of the garden. The image of an orientalizing building is here replaced by a sedan chair whose shape recalls a pagoda.

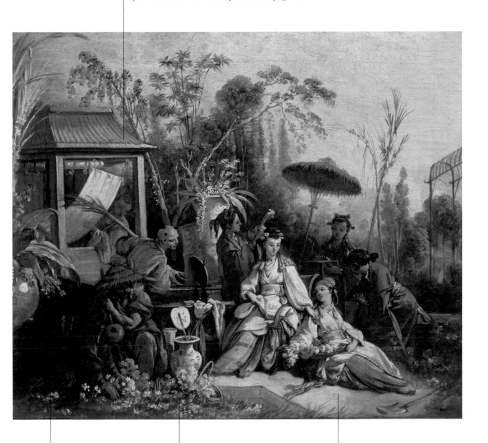

In France, the passion for exoticism focused primarily on China. Here the garden environment is freed from imposed symmetry, and the untamed vegetation grows in its natural disorder.

The decorative, elegant design and mellow, luminous colors, together with keen attention to detail, suggest that the taste for and appeal of chinoiseries *extended primarily to the material culture.*

This canvas was part of a series of models for tapestries. Painted by Boucher for the Beauvais Works directed by Jean-Baptiste Oudry, it was exhibited at the 1742 Salon.

▲ François Boucher, *The Chinese Garden*, 1742. Besançon, Musée des Beaux Arts.

Chinoiserie

In this "Chinese room," Tiepolo frames the groups of figures and the individual trees against a clear, luminous background, evoking human situations and landscapes with simple pictorial devices and a range of soft, refined colors.

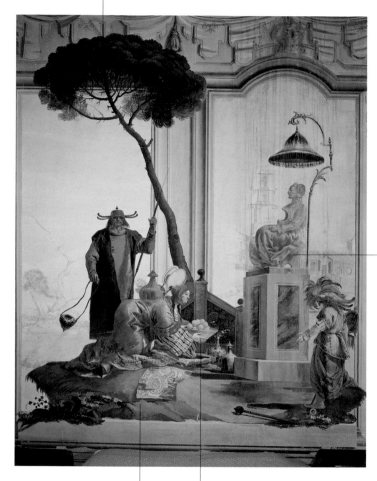

The purported fashions of Cathay were applied to decorations and architectural motifs, in feasts and gardens, even in the cuisine. Here Giandomenico Tiepolo illustrated for a noble provincial family a less sumptuous China, but one of the highest pictorial quality.

This is a fresco of the "Chinese Room" in the guest quarters of Villa Valmarana, one of the more interesting rooms of this building. The love of chinoiserie spread to all of 18th-century Europe, here with very original results.

The offering placed on embroidered silk at the feet of the goddess consists of fruits; a priest perfumes the air with incense.

▲ Giandomenico Tiepolo, *Offering to a Moon Goddess*, 1757. Vicenza, Villa Valmarana ai Nani.

Stucco played a major role in Rococo art, decorating the salons and boudoirs of aristocratic palaces throughout Europe with extraordinary results, thanks to the presence of highly skilled craftsmen.

Stucco

Stucco is a soft paste that solidifies quickly, an amalgam of ingredients such as marble powder, lime, sand, gypsum, or casein, depending on its use, whether for correcting flaws or decorating walls and ceilings. Known since antiquity, it is a step beyond the regularly patterned, symmetrical decoration typical of the Renaissance. Eighteenth-century Rococo used stucco widely in interior decoration, seeking to blend walls and ceilings with the decorative shapes.

Like sculpture, stucco became an essential element in interior design. The soft paste was shaped directly with the hands or with sticks, spatulas, or molds. Figures in the round were molded directly around iron or other metal frames. Because it cannot be worked in very cold or humid weather, stucco was not used in the winter, and workers executed the orders received only in the warm, dry months. Often the stucco workers used drawings or carved or painted models. Their skill and technical expertise went hand in hand with technical creativity: for example, sometimes they replaced hard metal frames with pressed cardboard, wood, or straw for greater plasticity.

Related entries
Saint Petersburg, Berlin-Potsdam, Dresden, Munich, Bavaria, Swabia, Residenzstädte, Vienna, Salzburg, Innsbruck, Paris, Madrid, Venice, Rome, Naples

Asam brothers, Carlone

◀ Karl Georg Merville, *The Fall of the Rebel Angels*, 1781. Vienna, Saint Michael's Church.

The Palermo sculptor has invented here a fanciful, original architectural form that projects a sense of expanded space animated by a continuously shifting luminosity.

Serpotta exploits the relative lightness of the material and the subtle, airy effects resulting from stucco's pale, lustrous tones; the sculptor would apply an allustratura, *a polish that enhances the formal purity of the stucco.*

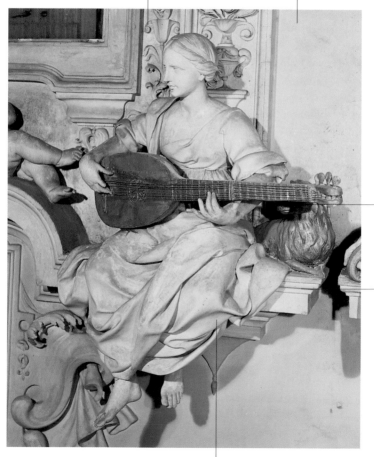

Here Serpotta reached a level of maturity that prefigures all his later work. The allegorical sculptures follow the dictates of Cesare Ripa's treatise Iconologia, *but their didactic quality is mellowed by the mischievous play of the chubby putti.*

The ornamental elements are no longer simply complementary to architecture. The artist tends to give a marked independence to sculpture, thus creating a new, animated type of architecture.

The modeling of drapery and anatomy becomes soft and flowing, and the entire ensemble demands its own autonomy from the more static architectural elements surrounding it.

▲ Giacomo Serpotta, *Allegory of Music,* 1686–88 and 1717–18. Palermo, Santa Zita, Oratorio del Rosario.

Quadratura, *which reached the height of its popularity in the 18th century, is a sort of architectural trompe l'oeil, a pictorial device that creates the illusion of grand, majestic interiors.*

Quadratura

Colonnades and balustrades painted from daring perspectives, soaring cupolas, majestic staircases that deceivingly pierce ceilings and walls, filling them with light, color, and wonder: painters achieved the illusion of very high or vaulted ceilings by directing the eye to an imaginary point on the ceiling, thus creating the appearance of height. *Quadratura* painters were inspired by the classical, stately, imposing architecture of the Renaissance. Architects-scenographers of the Emilian school who brought this decorative schema to its zenith carefully followed the rules of perspective to create illusory spaces that were never too daring to be credible. When the surface to be painted was very large, they used the multiple vanishing-point technique to prevent distortions. Generally, the mock architecture continued along walls, embellishing them with windows, balconies, doors slightly ajar on staircases or hallways, all animated by sculptures and human figures. *Quadratura* reached maximum trompe l'oeil effects in the work of great Venetian and Emilian artists, first among them Ferdinando and Francesco Galli, known as Bibiena after their home town. Theater architects and designers of stage sets and temporary installations, they had studied in depth the problems of perspective and *quadratura*'s effectiveness in creating optical illusions. In his stage sets, Ferdinando introduced the *veduta per angolo* (corner perspective), based on two lateral cross-vanishing points, an improvement over the Baroque fixed central-axis vanishing-point. This *maniera d'angolo*, which made possible the creation of what appeared to be infinite space, came to be much in demand throughout Europe by the end of the century; it was also employed by painters of urban *vedute* (views).

Notes of interest
Quadratura painters often worked with artists who specialized in the figure: one of the best-known collaborations is that of Gerolamo Mengozzi Colonna and Giambattista Tiepolo.

▼ Ferdinando Galli Bibiena, *Royal Atrium with Fountain Motif*, ca. 1705. Milan, Museo Teatrale alla Scala.

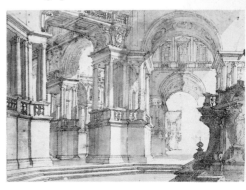

Quadratura

Mattia Bortoloni (1696–1750) exported the typically Venetian pictorial and decorative taste to Piedmont: his masterpiece there is the theatrical fresco decoration of the cupola of the Vicoforte shrine, near Mondovi.

Bortoloni created this fresco with the quadratura *artist Giuseppe Galli Bibiena (1696–1756). The elliptical dome, partitioned into rigorously architectonic sections, is filled with whirling figurative episodes added by Bortoloni.*

The Virgin is resplendent among the other figures, surrounded by angels resting on clouds; strongly backlit, she rises in a halo of light toward the red canopy. The group of musical angels, suspended on the clouds between light and shadow, provides a poetic counterpart.

The central theme of the fresco is the glorious Assumption of Mary before the Trinity, surrounded by saints and doctors of the Church who are dispersed around the cupola in small groups.

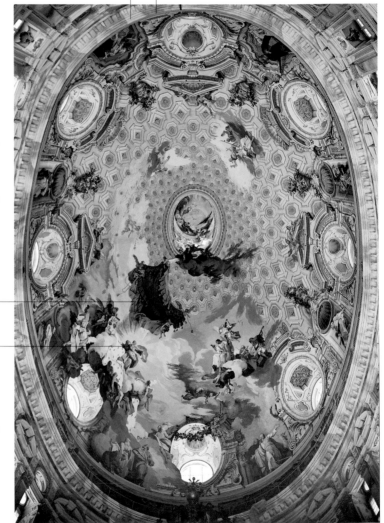

▲ Mattia Bortoloni and Giuseppe Galli Bibiena, *The Virgin in Glory*, 1745–48. Vicoforte (Cuneo), shrine.

Real structural elements become indistinguishable from the fancifully painted architecture, richly decorated with gilding and theatrical inserts of shells, flowers, leaves, and "corkscrew" scrolls. The frescoed architectural cornice completely dominates the room.

The Galliari resorted to the infinite, exuberant, and illusionistic decorative repertory that transfigures the space into a multiplicity of views.

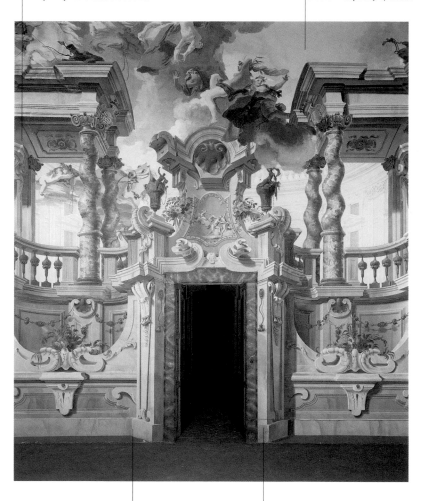

▲ Bernardino and Fabrizio Galliari, *Quadratura* Painting in the Ballroom, 1740–50. Castellazzo di Bollate (Milan), Villa Crivelli.

The Apollo Room in Villa Crivelli is one of the finest examples of Lombard quadratura: *the Galliari brothers have given free play to their spectacular scenographic imaginations.*

With the assistance of his brother Fabrizio (1709–1790) for the perspectival portion, Bernardino Galliari (1704–1794) in 1743 became the first scenographer of the Royal Ducal Theater of Milan, then of Turin, and in 1772 of Berlin at the request of King Frederick II of Prussia.

Quadratura

Gerolamo Mengozzi Colonna (1688–1772) worked with Tiepolo for many years, creating a happy duo of quadratura effects and figural painting, perspectival partitioning and lively scenery, such as the theatrical decorations of Palazzo Labia in Venice.

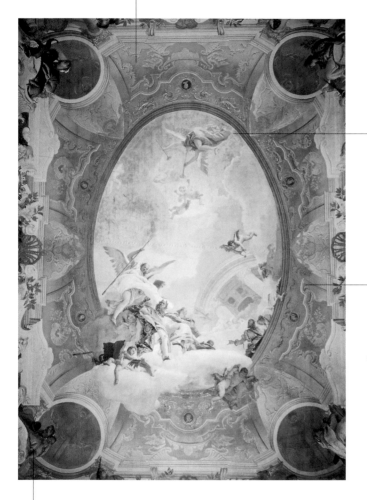

Even in this work Tiepolo was quick as lightning in his execution: it took him only eleven days' work on the scaffolding to paint the central portion.

Tiepolo executed this fresco in collaboration with the quadratura artist Gerolamo Mengozzi Colonna for the wedding of Ludovico Rezzonico and Faustina Savorgnan. A poem written by a Paduan abbot on the occasion of the wedding describes the noble theme of the fresco.

This fresco is the last of Tiepolo's Venetian works before he moved permanently to Madrid in 1762. The luminous quality of the colors and the superb pictorial execution carry through the entire composition, even in minor details such as the figures sitting on the cornices and framed in each corner by the oculi.

▲ Giambattista Tiepolo, Nobility and Virtue Accompany Merit to the Temple of Glory, 1757. Venice, Ca' Rezzonico.

The concept of a court theater reserved for the aristocracy and the literati became obsolete as a new type of audience emerged: Goldoni's "bourgeois comedy" was born, and new theaters were built.

Theater

Two radically divergent varieties of performances that originated in the 1700s became the preferred kinds of early-18th-century theater: the great Italian-style melodrama and the essentially mimetic Commedia dell'Arte play. In the latter, comic actors had set roles, each embodied in a unique character and name; the characters did not change from one play to the next, nor did the costume or the mask that covered half the face, leaving only the mouth free. Working within these constraints, the actors improvised their witty dialogue at each performance. Among the most celebrated Commedia dell'Arte masks are Harlequin, Pulcinella (Punch), Pantaloon, and Columbine. Carlo Goldoni (1707–1793) almost single-handedly reformed the theater, replacing the actors' improvised dialogue—often just clownish remarks—with a true written script set in a specific place, with realistically drawn characters taken from everyday contemporary life. Thus, Goldoni wanted to return a literary dignity to comedy that contrasted with the stately nature of tragedy and was based on the principles of true performance and genuine morality; the goal of comedy was to "correct vices and ridicule bad habits." Theater architecture also underwent important changes: the Italian-style model was adopted, with boxes replacing the seating tiers. This change became necessary with the shift to a paying audience, to prevent the different social classes from mingling. The earliest example of this type of theater is Bologna's Comunale, built by Antonio Galli Bibiena in 1763.

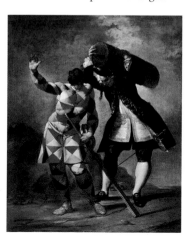

◄ Giovanni Domenico Ferretti, *Harlequin the Page*, 1742–60. Sarasota, The John and Mable Ringling Museum of Art.

Related entries
Saint Petersburg, Berlin-Potsdam, Dresden, Munich, Residenzstädte, Vienna, Salzburg, Innsbruck, Prague, Paris, Madrid, Turin, Venice, Rome, Naples, London

Hogarth, Kauffmann, Longhi, Panini, Reynolds, Giandomenico Tiepolo, Traversi, Watteau

Notes of interest
The theater became a place where the "useful" combined with the "pleasurable"; it was conceived as a tool for the moral and civic education of the audience, no longer just an amusement or the society event of the *ancien régime*. The Teatro alla Scala of Milan (1776–78), designed by Giuseppe Piermarini, became the model for all the theaters that were built starting at the end of the century, such as La Fenice in Venice (1788–92).

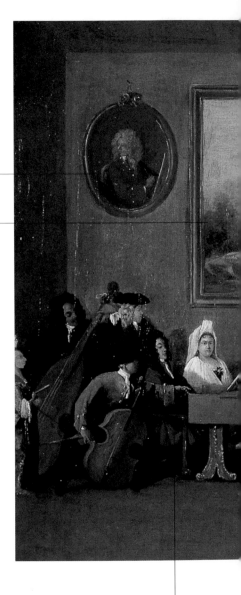

The two oval portraits that flank the painted landscape were identified as those of Marco Ricci (left) and his uncle Sebastiano (on the right).

The canvas on the wall—a true painting within a painting—was one of the many successful landscapes executed by Marco Ricci, who excelled in this genre.

The man playing the harpsichord is Nicolas Heim, who wrote the English adaptation of Alessandro Scarlatti's opera Pirro e Demetrio.

▲ Marco Ricci, *The Opera Rehearsal*, 1709–11. United States, private collection.

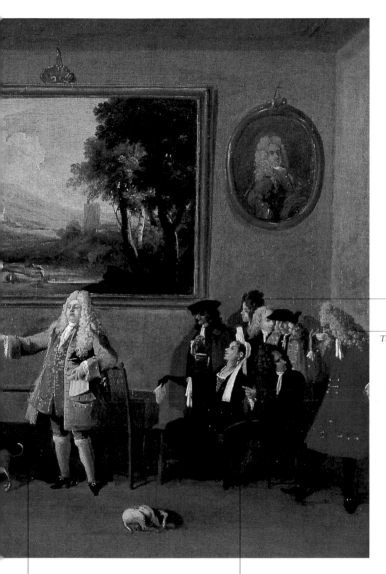

This painting belongs to a group of canvases inspired by the artist's set-design work at the London Haymarket Theater and his contacts with the Italian opera world. They are humorous, like the many caricature drawings that were collected by the Venetian consul Joseph Smith.

The man in red drinking tea is the theater impresario John James Heidegger (1666–1749).

The standing singer directing the orchestra has been identified as Nicola Grimaldi (1673–1732), known as Nicolini, who successfully debuted in London in Pirro e Demetrio, an opera by Scarlatti and Heim (English libretto by McSwiney). Marco Ricci and Giovanni Antonio Pellegrini were the set designers.

The seated woman in black is a singer, Francesca Margherita de l'Épine (1683–1764), while the woman in white seated on the opposite side could be her great rival Catherine Toft, future wife of Joseph Smith, the British Consul to Venice and an ardent collector.

This is one of the first paintings representing an English opera. It portrays a central scene in The Beggar's Opera *by John Gay (1685–1732); the opera was staged for the first time at the Theater Royal in Lincoln's Inn Fields (London), in 1728.*

In addition to comedies of manners, farce and satire were also quite successful in England: this opera by Gay is a ferocious satire.

Hogarth, a friend of the composer, the impresario, and the actors, as well as a theater devotee, has depicted a salient moment: the unscrupulous Macheath is about to be sentenced to Newgate Prison, here faithfully reconstructed. On the left, Lucy kneels before her father, the warden Lockit.

The Beggar's Opera, Gay's masterpiece, ushered in a new genre, "ballad opera," a parody of Italian lyrical music and of Handel, but also a political satire against Prime Minister Robert Walpole.

On the right, Polly Peachum kneels before her father and asks him to pardon the prisoner.

Important spectators (who have been identified as historical persons) are shown, according to contemporary custom, on each side of the stage.

▲ William Hogarth, *A Scene from "The Beggar's Opera,"* 1731. London, Tate Gallery.

The theater swarms with life: here is the high society of Rome, including the pretender to the throne of England and his son, twenty-one cardinals, and ambassadors and ministers, all deep in their plush chairs.

In 1729, Panini painted Feast in Piazza Navona for the birth of the Dauphin; in 1745, he executed Artificial Machine in Piazza Farnese for the Dauphin's first marriage, which was to Maria Teresa, the Spanish Infanta.

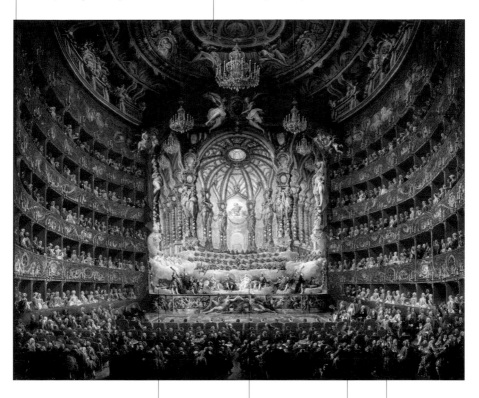

Their heads circled with laurel wreaths, the violoncello players close the composition at the bottom. Two children play the drums. At the center of the proscenium, two river gods hold hands, while on each side little Cupids crown lions and ride dolphins.

▲ Giovanni Paolo Panini, Feast at the Teatro Argentina in Rome in Honor of the Second Marriage of the French Dauphin, 1747. Paris, Musée du Louvre.

At center stage the seated singers personify, from left to right, Amor, Jupiter, Pallas, and Mars. Above them, sunk to the chest in fake clouds, the choir of Cupids and two choirs of Graces dressed in white are arranged in a semicircle.

The two prelates with their back to the boxes are the Cardinals of York and La Rochefoucauld, the latter the French king's minister at the Holy See and the commissioner of this painting.

The painter focuses on the intermission, when pages distribute beverages in sparkling crystal glasses. To the right in the orchestra, near the entrance door, is the artist, who has portrayed himself sitting in a chair and sipping a drink.

The rise of Mrs. Abington (ca. 1737–1815) from rags to riches and from anonymity to fame was quick indeed: she took up acting and became a woman who set fashion trends. Starting in 1764, Reynolds made several portraits of her.

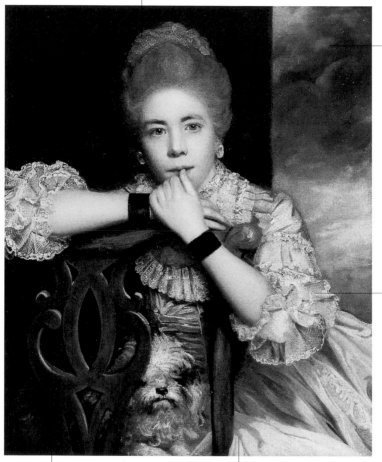

Reynolds was very close to the actress, and in 1775 he reserved forty seats for himself and friends, including Samuel Johnson, for a nonprofit show to benefit the latter. The show was a new farce with David Garrick, England's most famous actor at the time.

Reynolds is not interested in capturing a specific scene in the play. The leading actress, Mrs. Abington, apart from the role she played, was indeed like Miss Prue, a woman who yearned for sensual pleasure, as reported in the malicious accounts of her private life.

The actress sits on a Chippendale-style chair, her thumb raised to touch her slightly parted lips in a seductive, sensual gesture.

▲ Sir Joshua Reynolds, *Mrs. Abington as Miss Prue*, 1771. New Haven, Yale Center for British Art, Paul Mellon Collection.

Exhibited in 1771 at the Royal Academy, this painting portrays Mrs. Abington in her successful role, in the spicy comedy Love for Love, of a country girl who is seduced, not entirely against her will, by a greedy, stupid dandy.

Churriguerismo is a Spanish late Baroque term derived from the name of the Catalan family Churriguera, whose members created exceptional sculptures and architectural works.

Churriguerismo

Related entries
Madrid

Stonecutters originally from Catalonia, the Churriguera were active from the 17th to the 18th centuries. Three of the five brothers—José Benito, Joaquín, and Alberto—were especially talented as sculptors and architects. The first, a designer at the royal court of Madrid, built a palace in the city that is now the seat of the San Fernando Academy. At the end of the 1600s, he sculpted the splendid altars of the Segovia Cathedral and of San Esteban in Salamanca: the latter's tall spiral columns are clearly reminiscent of Bernini. Joaquín and Alberto were also active in Salamanca, where Alberto, in addition to working on the cathedral, designed the lovely Plaza Mayor (1728). Its square plan recalls the ancient plazas of Valladolid and Madrid: around the plaza are palaces heavy with sumptuous decorations derived from the *plateresco* style (from the Spanish *platero*, or goldsmith) that in the previous century had embellished Spanish churches and façades with stone, metal, and wood. One work emblematic of the Iberian late Baroque in all its complexity is the spectacular *El Transparente* (1721–32) in the Toledo Cathedral, by Narciso de Tomé. It is a sort of separate monumental retable placed between the altar and the choir; lit by a window in the vault, its sacrarium is visible from both sides. Roman Baroque had quickly reached the Iberian Peninsula, brought there by the Italian artists who had been called to work at the Madrid court. Soon, Spaniards were absorbing and reworking those new stimuli in a country that, though weakened politically by the English and Portuguese rivalry in the colonies, had lived its literary and pictorial golden age in the 1600s.

▼ Narciso de Tomé, *El Transparente*, 1721–32. Toledo, Cathedral.

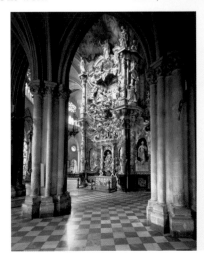

Born in France during the reign of Philip of Orléans, this decorative style marks a transitional phase between the monumental quality of the Baroque and the frothy excesses of the Rococo.

Regency

The years of the French regency of Philip of Orléans (1715–23) gave the name to a style of décor whose influence lasted until almost mid-century. Known to antiquarians as the "Louis XV style," it is transitional between late Baroque and Rococo. The final rigid, solemn years of Louis XIV's reign had reawakened a thirst for measure and proportion that is reflected in furnishings and decorations: the size of the vast reception rooms shrinks, replaced by rows of small drawing rooms and boudoirs that are intimate and secluded. Similarly, the furniture becomes more measured and manageable, with smooth, elegant lines. By contrast, the need for more wall decoration grows: the imposing 17th-century tapestries give way to rich, fanciful *boiseries*, while Bohemian crystal begins to replace the precious Murano glass that begins its slow decline. For these new interiors, Aubusson and La Savonnerie weave lovely carpets. The furniture is embellished by precious wood veneers and bronze trim. The preferred wood for the luxury furniture is oak, with rosewood for veneer work. The Regency taste produced marvelous marquetry with light, vividly colored geometric designs that stand out against the darker wood. Favorite motifs are geometric patterns with masks, shells, palmettes, and acanthus leaves. Renowned Regency-style architects and decorators were Gilles-Marie Oppenordt, François-Antoine Vassé, and Robert de Cotte; the supreme cabinetmaker of the time was Charles Cressent, a student of the great Boulle.

▼ Jean Courtonne, Hôtel Matignon, 1721. Paris, Rue de Varenne.

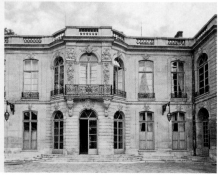

A student of Rigaud, Ranc was inspired by
northern models, especially Caravaggesque
Dutch art, in the careful use of light and
shadow, as this white parasol attests.

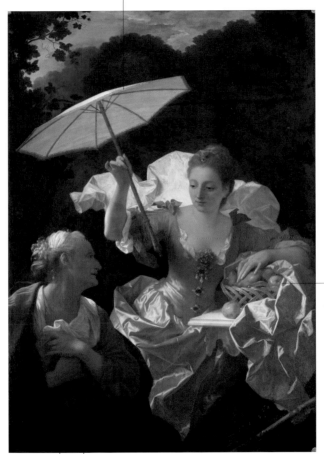

Pomona stands
next to a fruit
basket. It is one
of her attrib-
utes, as is the
pruning knife,
inserted in the
wicker basket.

The painter seems to waver
between a mythological
picture and a portrait in his
description of the women's
faces, painted in a careful,
naturalistic manner.

▲ Jean Ranc, *Vertumnus and
Pomona*, 1710–20. Montpellier,
Musée Fabre.

Ovid's Metamorphoses *narrates the story of
the Italic divinities that guarded gardens,
orchards, and fruit trees. Vertumnus courted
Pomona by presenting himself in various
bucolic disguises, but she always rejected him.
Here he approaches her in the form of an old
woman, another failed attempt. He finally
conquers her by appearing in his true guise,
a young and exceedingly handsome god.*

The style and themes of the works displayed in this painting illustrate early-18th-century taste, while the dark, stern portraits are from the 17th century. Religious paintings are also visible, mostly hanging in the upper rows where they are less prominent.

The long reign of the Sun King had ended in 1715. In a strong symbolic gesture, a worker is crating a 17th-century portrait of Louis XIV, now out of fashion, an explicit reference to a radical change in French taste and French history.

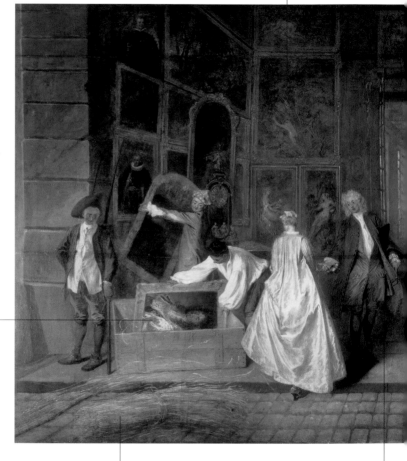

The bundle of straw is used for crating, but here it also has a perspectival function, as it points to the center of the composition.

A young gentleman gallantly invites a lady to enter the art gallery. The silvery rose reflections on the gown highlight the woman's elegant movement as she steps on the sidewalk and turns to look at a portrait of Louis XIV being crated.

▲ Jean-Antoine Watteau, *L'Enseigne de Gersaint (Shop-Sign of Gersaint)*, 1720. Berlin, Charlottenburg.

Madame Gersaint is explaining a painting to connoisseurs, some of whom look rather bored. The counter marks an exact perspectival angle; the painting actually is not symmetrical, but the street paving and the French doors in the center give the impression of perfect regularity.

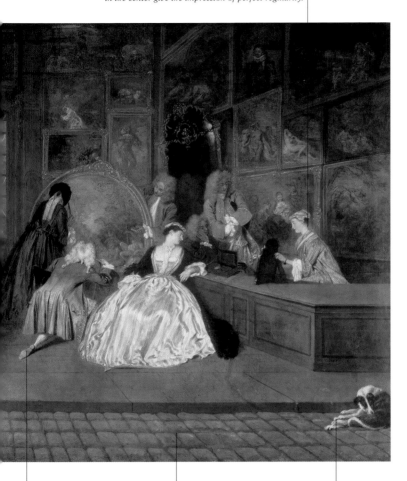

Prefiguring Hogarth, Watteau offers an ironic image of the high society of his time. Two art lovers are gazing at naked nymphs bathing, typical of the emerging style. Behind the painting is Gersaint himself praising the canvas.

This canvas, more than ten feet wide, is considered a masterpiece of French painting. It was commissioned to decorate the foyer of the "Au grand monarque" antique store owned by Watteau's friend Gersaint, in whose house the painter lived starting in 1719.

The street dog picking fleas adds a genuine note of realism, giving a quotidian aspect to this composition, which might otherwise seem too sophisticated.

A typically English style that met with great success in its home country and the United States, it is an eclectic blending of French Rococo elements with Palladian, Gothic, and Chinese motifs.

Chippendale

Notes of interest
Around 1770 the clean, restrained lines of Neoclassicism reached England, where they came to be known as the "Adam style" from the architect and interior designer Robert Adam; even Chippendale radically changed his style and adapted it to the new taste.

▼ Thomas Chippendale, Mahogany armchair, ca. 1760. Private collection.

Until mid-century, England lay under the spell of the clean, graceful Palladian style, inspired by Andrea Palladio's 16th-century architecture, and had little use for the Rococo fashion coming from France. Between 1750 and 1780, however, the Chippendale style took hold in Great Britain. Although the style incorporated Rococo's preference for elaborate ornamentation and inlay work, it was also inspired by the medieval Gothic tradition and the fashion for *chinoiseries*. It took its name from the English cabinetmaker Thomas Chippendale (1718–1779), who opened a store in London in 1754 and published in *A Gentleman and Cabinetmaker's Guide* the decorative patterns that he and his assistants Copland and Lock had designed. The book was expanded in later editions, and the cabinetmaker's name became a synonym for the successful style, especially in England and the United States. Chippendale used rich and refined fanciful elements, especially visible in the mahogany furniture pieces (the wood was imported from Central America) finished with inlays of precious materials and gilded bronze trim. Besides Rococo's beloved motifs such as shells, dolphins, acanthus branches, and masks, the style also incorporated Gothic motifs such as rosettes, coats of arms, and small ogives, and Chinese images such as pagodas or birds. Canopy beds with tall carved headboards came back in style, and pagoda-topped cabinets, desks with rows of drawers and generous bronze accents, and tables with legs finished in curlicues, leaves, and figures and topped by precious marble made their appearance. Chairs and sofas were also richly finished and carved, with seats and backs made of rush or upholstered in elaborate brocade, silk, or velvet. A reaction to this excessive style soon followed, and taste returned to the clean, well-proportioned lines of Neoclassical art.

The severe, theatrical French garden was still popular in the 18th century, though in England a new design, the "landscape garden," was emerging.

Parks and Gardens

A garden is never the direct product of nature. The medieval *hortus conclusus* had given way to the geometric Renaissance garden with water games and labyrinths, then to the large 17th-century parks such as that at Versailles. Rather than just an outdoor space, the garden was seen also as a source of visual pleasure and pastimes and a space for receiving guests. Its evolution can be classified under three major types: the "Italian style" Renaissance garden, the "French style," and the "English style." In the early 18th century, the French garden was still dominant with its perfect symmetries built between long straight paths, square well-kept lawns, and scenic rows of tall trees, all designed to created infinite illusionistic effects. In England, a preference for open spaces was filtered by the influence of Palladio's style and the need to reassess nature's spontaneity. The desire to re-create, even with deliberate and clever artifice, a place that evoked the mythical luxuriant Arcadian gardens was joined to a longing for a freer, wilder nature. Thus the park became an extension of the land, no longer contrasted with it as was the case for the French garden. The two leading English architects were William Kent (1685–1748) and Lancelot Brown (1716–1783), the latter nicknamed "Capability" for his incredible design skills and because he introduced the professions of modern plant expert and landscape architect. The trend toward idealized landscapes led to designs that included structures that evoked an ancient, lost time, as represented by ruined classical columns, small temples, medieval ruins, and picturesque corners. This type evolved into the 19th-century Romantic garden.

Related entries
Saint Petersburg, Berlin-Potsdam, Dresden, Munich, Vienna, Paris, Madrid, Turin, Rome, Naples, London, Bath, Edinburgh

Notes of interest
The rising popularity of the English garden was a result of the new scientific interest in the plant world, especially the study of rare and exotic plants imported from the colonies; many botanical gardens were created in this century.

▼ Jakob-Philipp Hackert, *The English Garden at Caserta*, 1792. Caserta, Palazzo Reale.

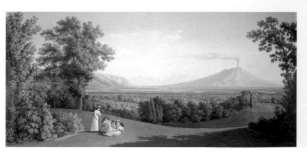

Parks and Gardens

This is the "garden as symbol" theorized by Palladian architects, who held that Palladio's harmonious solutions reflected motifs that they held to be universal.

To the west of the main villa was a semicircular grove with orange trees arranged around a lake, at whose center rose an obelisk.

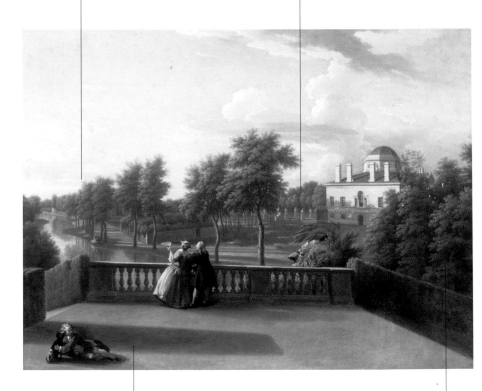

The Chiswick garden was the beginning of a trend that led to the "landscape garden." It was transformed in three major stages that aptly reflect the history of gardens generally.

The garden is part of an ambitious project by Richard Boyle, 3rd Earl of Burlington, a lover of the arts and a generous patron. He modified the garden between 1724 and 1733, when a mixture of Italian, or rather Neo-Palladian, motifs came to prevail, such as classical buildings, an exedra, and the grove. In 1733–36, further changes were made, building toward a nature-inspired garden.

▲ William Hogarth, *View of Chiswick Garden*, 1741. London, formerly Sotheby's.

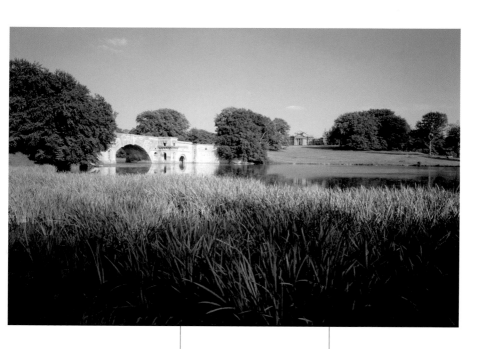

Lancelot Brown introduced the figures of the modern botanist and the landscape architect. He brought to parks and gardens gently rising, wide grassy expanses, skillfully arranged groves, and ponds with inlets and coves. This design was a precursor of the 19th-century Romantic garden.

Lancelot Brown, known as "Capability" for his extraordinary productivity as a designer, revolutionized the English art of the garden: he designed serene, well-proportioned compositions where natural grassy slopes and stretches of water created an atmosphere of quiet meditation. To him, architectural structures were not just "belvedere" look-out points, but were charged with moral significance.

▲ Lancelot Brown, Blenheim Palace Park, ca. 1764. Woodstock, Oxfordshire.

Parks and Gardens

Organized around a lake, the garden is dotted with buildings in the classical style: here the temple to Apollo follows the model of the Round Temple at Baalbek, Lebanon.

This exemplifies how the paintings of 17th-century landscape artists such as Claude Lorrain were used as models in garden planning.

The Pantheon was copied from Claude Lorrain's 1672 painting Seascape with Aeneas at Delos (London, National Gallery).

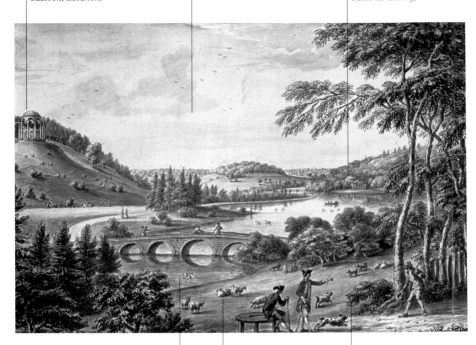

The lake recalls the Tiber River of Rome that appeared to Aeneas in a dream. The banker Henry Hoare II for the first time turned a landscape painting into a real garden, using nature's resources.

Claude Lorrain's paintings seem to come to life in this reproduction of Arcadian nature filled with classical buildings and freely grazing animals.

The Stourhead Garden was designed to be a place of memory, an imaginary voyage whose stages are marked by the buildings that overlook the lake: an ideal representation of the voyage of Aeneas.

▲ Coplestone Warre Bampfylde,
View of Stourhead, ca. 1760.
London, private collection.

▶ William Kent, Temple of British Worthies, 1731–35.
Stowe, Buckinghamshire.

The Temple of the British Worthies houses the busts of sixteen famous Englishmen: in the pursuit of virtue, the England of the past was no inferior to the civilization of ancient Greece.

Contemporaries such as the poet Alexander Pope were included, and politicians of integrity. They were considered the exemplars upon which the hope for England rested.

The Stowe Garden is the political and philosophical manifesto of Lord Cobham, a leader of the Whigs. It is a meditation on the relationship between virtue and politics. All around the monument, no longer circumscribed in stiff patterns, nature grows freely.

Inspired by the Temple of the Sibyl in Tivoli, the Temple of Ancient Virtue displayed the statues of the preeminent men of ancient Greece. Opposite stood the Temple of Modern Virtue— a half-ruined monument that alluded to the decadence of contemporary mores: inside was the headless bust of Robert Walpole, Cobham's fierce political foe.

In 1735 William Kent (1685–1748) received a commission to build the Stowe Garden. He planned a hermitage, a Temple of Venus, and Elysian Fields, all nestled in an Arcadian landscape and linked by an allegorical itinerary. The Temple of British Worthies was the culmination of the political message that Lord Cobham wanted to convey in this garden: an image of faith and hope.

Among the scenes on show in the Parc Monceau were a grove of tombs, Turkish and Tartar tents, a windmill, a castle in ruins, a lake equipped for fake naval battles, and an Egyptian pyramid. These places were designed to give the illusion, at a distance, that all the corners of the garden were larger than life.

The buildings clearly took on cultural significance: they were perceived as symbols of a time past or of a faraway land. The garden became a true outdoor encyclopedia: strolling along its paths, one could see different parts of the world.

Louis Garrogis, known as Carmontelle (1717–1806), designed Parc Monceau. A painter, art critic, garden designer, and playwright, Carmontelle created the garden between 1773 and 1778 for the Duke of Chartres, a great admirer of Anglo-Saxon culture.

Carmontelle conceived a garden art based on imagination and illusion: as the visitors strolled about, an infinite number of scenes appeared before their eyes, for according to the artist, a garden had to contain "all times and all places."

▲ Louis de Carmontelle, *Carmontelle Hands the Keys of Parc Monceau to the Duke of Chartres*, ca. 1790. Paris, Musée Carnavalet.

A Grand Tour of the major European cities, and of Italy in particular, was an educational trip popular with aristocrats and bourgeoisie alike in the 18th century; it also created a flourishing art market.

The Grand Tour

At the close of the 17th century, Richard Lassels wrote in *An Italian Voyage* that "only those who have taken the Grand Tour of France and traveled to Italy can understand Caesar and Livy." The expression "Grand Tour" soon became popular in European aristocratic and intellectual circles to denote a trip that was mandatory for completing one's cultural education, an experience that complemented humanistic studies and elite readings. After the sensational archaeological discoveries of Pompeii and Herculaneum, the tour was expanded to cover new destinations such as Naples, the Paestum ruins, and Sicily. Thanks to its treasures of ancient art and extraordinary panoramas in the Alps and on the Mediterranean coast, Italy became the preferred Grand Tour destination of wealthy Northern Europeans who came for sojourns lasting months or years. Rome was the city most visited, especially by antiquities collectors and artists who wanted to study the celebrated artworks on site and reproduce them from life. Having understood the importance of the Eternal City in educating painters and sculptors, the French minister Colbert opened a branch of the Parisian Royal Academy in Rome, the Académie de France, which immediately became a much frequented spot by all Europeans. Grand Tour travelers began to bring home souvenirs of their visits, such as objets d'art, clothing, rare texts, even rocks, stones, or dried flowers. Among the most popular mementos were portraits and painted, drawn, or etched views of the most famous sites, a fashion that helped create a flourishing market for this genre and for the reproduction of sculptures, but that also led to a growing trade in counterfeit works of art.

Notes of interest
The Grand Tour reached its greatest popularity between 1760 and 1780, when at least 40,000 foreigners were in Rome.

▼ Joshua Reynolds, *Sir William Hamilton, Ambassador of the King of England to Naples,* 1776–77. London, National Portrait Gallery.

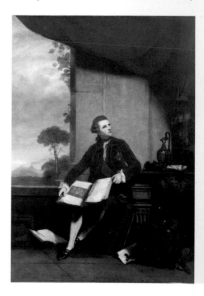

In his Roman studio located in Via Bocca di
Leone, Batoni painted many portraits of foreign
travelers who had come to Italy for the Grand
Tour, such as this English nobleman who leans
on a balustrade with his dog at his feet.

All around the English-
man are signs of Rome's
ancient grandeur: cornice
fragments, a column base,
the Medici Vase, and, on
the left in the shade, a cel-
ebrated archaeological
discovery, the Ludovisi
Mars. This find, a Roman
copy of a Greek original
from the 4th century B.C.
(now in the Museo
Nazionale Romano),
occupies the background
of several other Batoni
portraits, which he
painted on commission for
distinguished foreigners.

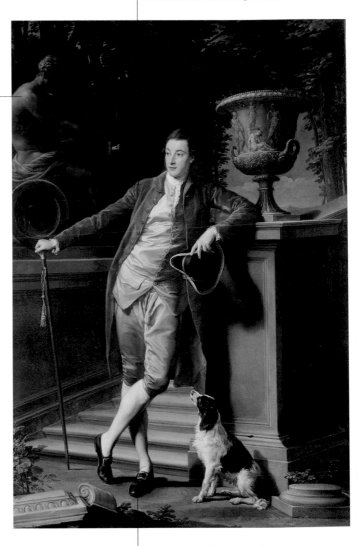

▲ Pompeo Batoni, *Portrait of John
Talbot, 1st Earl Talbot*, 1773. Los
Angeles, J. Paul Getty Museum.

The aristocratic, elegant figure is caught
in a casual pose, dressed in traveling
clothes, a three-cornered hat in one
hand and a walking cane in the other.

Townley's collection was considered a sight not to be missed when visiting London. When the British Museum purchased it, it became apparent that several statues were not Greek originals, but Roman copies.

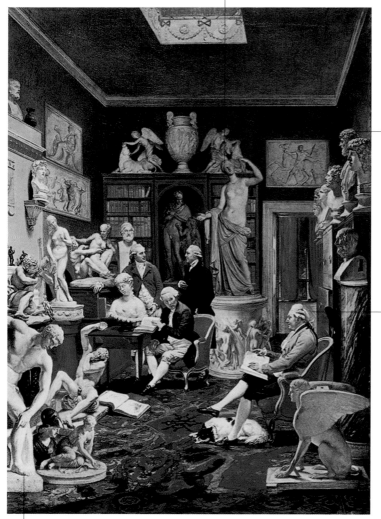

Every educated traveler dreamed of rebuilding ancient Rome in his own palace or town-house; the plans of many English houses were altered to include a gallery of ancient statuary.

The English collector Charles Townley (1737–1805) is portrayed in his library with three friends: politician and art lover Charles Greville; paleographer and British Museum curator Thomas Astle; and anti-quarian Pierre d'Hancarville, seated at the table.

The British Museum purchased this marble statuary collection upon Charles Townley's death. The Discus Thrower was added to the painting in 1798 at Townley's request after it was unearthed in 1791 in Hadrian's Villa at Tivoli.

▲ Johann Zoffany, Charles Townley in His Sculpture Gallery, 1781–83. Burnley, Townley Hall, Art Gallery and Museum.

The Grand Tour

Goethe (1749–1832), aged thirty-seven, is in the center foreground, seated on the stones of ancient monuments, wrapped in a long, light-colored cloak that shows him wearing tight knee breeches. He gazes at the open Roman countryside scattered with ancient ruins.

Among the finds visible behind him are a high-relief with Iphigenia, Orestes, and Pilades—a reference to the verse drama Iphigenia in Tauris that Goethe was writing at the time.

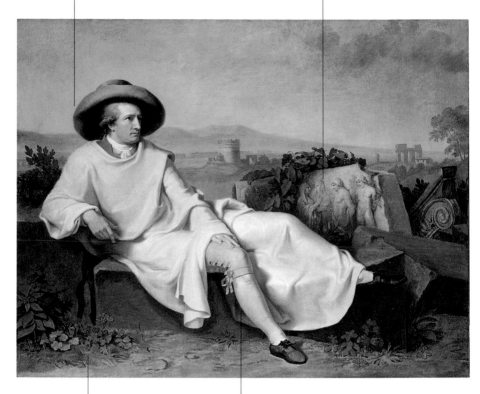

The man of letters and the painter had become friends in Rome, where they shared a house on the Corso for long stretches of time. Together they toured archaeological sites around Rome and Naples, where Tischbein was the director of the local academy.

Too large to be hung in a home, this portrait is a symbolic consecration of Rome's antiquity and of the Grand Tour, a life-changing experience for several generations, a sort of cultural initiation ritual of the educated European classes.

▲ Johann Heinrich Wilhelm Tischbein, *Goethe in the Roman Countryside*, 1787. Frankfurt, Städelsches Kunstinstitut.

In 1786, using a false name, Goethe left for his long-anticipated trip to Italy: he spent almost two years in Rome and in the South, even visiting Sicily. His travel narrative, Italienische Reise (Italian Journey), was not published until forty years later.

The author was a great admirer of Hackert for his skill in portraying nature and quickly giving form to drawings.

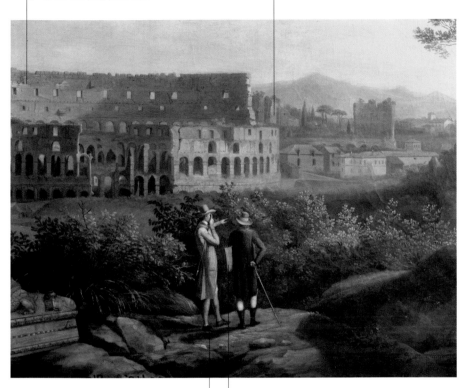

Goethe took drawing lessons from Hackert in 1787; together they toured Naples and Tivoli and socialized with Sir William and Lady Emma Hamilton. Hackert had suggested that Goethe be his student for a year, but they never crossed paths again, although they corresponded by letter.

The two tourists carry sheets of paper under their arms for drawing from life. Here they admire the Coliseum and the Roman ruins from a distance. Goethe and Hackert met for the first time in Naples in 1787, when Goethe and Tischbein visited him in Palazzo Francavilla.

▲ Jakob-Philipp Hackert, *Goethe Admires the Coliseum*, ca. 1790. Rome, Museo di Goethe.

This scene is set in the Protestant Cemetery in Rome located against the city walls near the pyramid of Gaius Cestius. The artist clearly reveals his mood in the title, which is inspired by Goethe's poetry.

In 1791, Sablet drew this burial scene near the pyramid, and Goethe, in a drawing, placed his own grave there. In the background is a stormy sky; the pyramid is the locus of poetic and figurative memory, Arcadia, with two shepherds and their flock visible in the distance on the right.

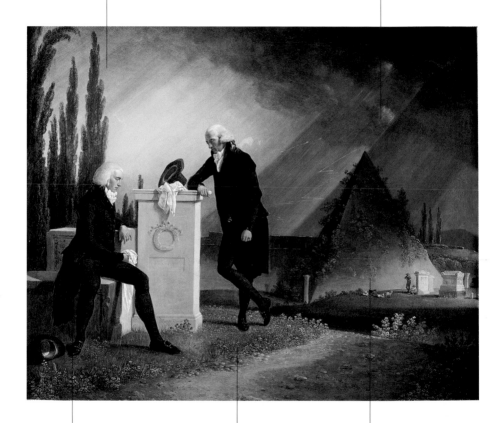

The two men weeping over a friend's tomb have been identified as the brothers Jacques-Henri and François Sablet, one of whom is thought to be the painter of this canvas.

▲ Jacques-Henri Sablet, *Roman Elegy*, 1791. Brest, Musée des Beaux-Arts.

Starting in 1738, the land around the pyramid was set aside as a burial ground for Protestants and other non-Catholics, though the funerals took place only at night.

A meditation on death, the "correspondence of amorous senses" in a mythical landscape is not the only meaning that the pyramid projects; it is also, perhaps, a Masonic symbol presented in a play of light and shadow.

A veduta (view) is the faithful representation of an actual urban or rural landscape, a painting genre that was highly successful thanks to prodigious artists such as Canaletto and Bellotto.

Vedutismo

"To draw *vedute* means to study, as painters do . . . walking around various corners of the countryside or famous city sites, and reproducing with a pen or stylus, or with China ink or water-colors, towns, sylvan dwellings, cities, rivers, and similar views," wrote art historian Filippo Baldinucci in 1681. The urban *veduta* with faithful reproductions of reality had already achieved the status of an autonomous genre in 17th-century Holland. The 18th-century fashion of the Grand Tour—a trip to the leading art cities, Italian in particular—created a growing demand for paintings or etchings to be purchased as souvenirs by foreign travelers. In addition, architects or simple amateurs wanted to own exact, almost documentary, reproductions of squares, palaces, monuments, excavations, and ruins. The focus of this phenomenon was Rome, the Grand Tour's favorite stop, where by the end of the 1600s the Dutch Gaspar Van Wittel had inaugurated a series of views that were much more accurate and true than earlier ones. In Venice, a popular destination of English intellectuals and collectors, *vedute* were in very high demand. Among the Venetian *vedutisti*, Luca Carlevarijs and Canaletto stand out: the latter, who had trained in Rome, preferred realistic landscapes to sceno-graphic or fanciful ones, which were also prized. *Vedutismo* painting required a superior knowledge of the laws of perspective, for only that allowed the artist to faithfully and completely reproduce the appearance of a place. Many artists used the *camera ottica*, which cast an accurate image of the view onto a plate of glass.

Related entries
Warsaw, Dresden, Munich, Vienna, Venice, Rome, Naples, London

Bellotto, Canaletto, Guardi, Hackert, Panini, Valenciennes

▼ Gaspar Van Wittel, *Panoramic View of Rome with the Villa Medici*, 1713. Private collection.

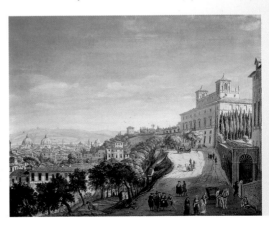

Vedutismo

An extremely wide panorama of Venice, this veduta encompasses the entire lagoon of San Marco, from the bell tower of the Basilica to the Marciana Library and the Giudecca.

A luminous sky with just one vast cloud is mirrored in the expanse of water plowed by boats. The firm perspectival lines that frame the expanded space and the diffuse luminosity make this an exemplar of Canaletto's work.

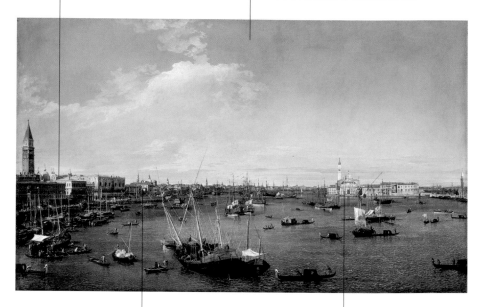

There is nothing dispersive or uselessly descriptive in this view: its clarity, almost didactic, belongs to the Enlightenment, for it projects the certainty of an objective, rational, and knowable truth.

Using the camera ottica to rationalize the view, Canaletto has multiplied the points of view with monumental, extraordinary results.

▲ Canaletto, *Lagoon of San Marco toward the West*, ca. 1738. Boston, Museum of Fine Arts.

Humiliated by the English naval victories, France strengthened its fleet and upgraded the ports of the kingdom, especially from the Peace of Aix-la-Chapelle in 1748 to the beginning of the Seven Years' War in 1757.

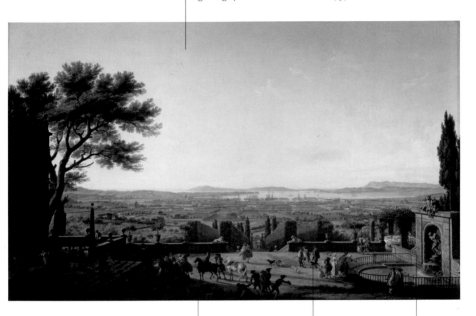

Art, too, participated in the new economic and political developments, with the commissioning by Louis XV in 1753 of a series of vedute *representing the ports of France from the famous painter Joseph Vernet. This* veduta *of Toulon belongs to that series.*

In ten years of exploratory travels, the artist created vast panoramas in which a luminous, serene nature frames the French ports with picturesque groups of busy people in the foreground.

This view of the city and port of Toulon was painted from a high terrace that overlooks the bay and leads the eye to a sweeping distant view of the anchored ships.

▲ Joseph Vernet, *View of Toulon*, 1754. Paris, Musée du Louvre.

Vedutismo

The care taken by the painter in recording reality suggests that he may have used a camera ottica to trace the architectural outlines of this scene. He faithfully reproduced the landscape without altering any part of it.

Created on six large watercolor sheets, this view is the artist's most daring work, not intended for the tourist market. He made the drawing and applied the colors on site, not at the studio, as was the custom.

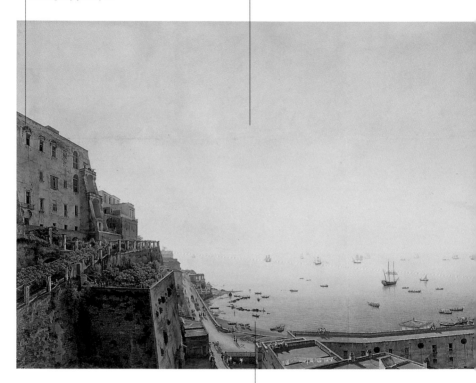

This veduta of the Bay of Naples looks southwest, from Pizzofalcone toward Posilippo. In 1791, Lusieri wrote to Hamilton in London that he had helped load a "large drawing" onto a ship; perhaps it was this one.

▲ Giovanni Battista Lusieri, *A View of the Bay of Naples, Looking Southwest from Pizzofalcone toward Capo di Posilippo*, 1791. Los Angeles, J. Paul Getty Museum.

This view could be enjoyed from Palazzo Sessa, the Neapolitan residence of Sir William Hamilton, English ambassador from 1764 to 1799 who may have commissioned this work so that he could enjoy the sunny Neapolitan view in gray England as well.

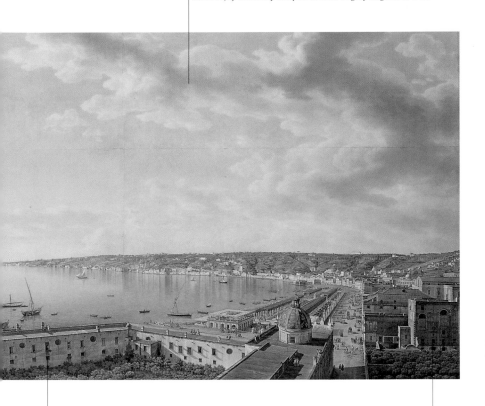

This painting is exhibited only rarely because the delicacy of the medium causes the colors to fade when they are exposed to light.

Notwithstanding the urban development of the two succeeding centuries, much of the bay's topography can still be identified today.

The port is plowed by landing and departing ships; more ships are moored; on the left, a sailing vessel is anchored in the bay before the walls of "Castellamare"; on the docks in the foreground the artist has captured scenes from daily life.

In the center is the protagonist of this painting: the unique profile of Monte Pellegrino with the road leading to the shrine of Saint Rosalie, the city's patron saint.

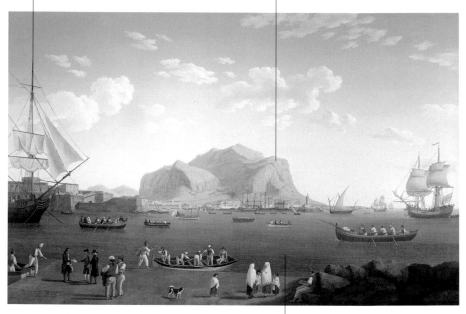

This canvas belongs to the series Ports of the Kingdom of Naples *that Hackert painted between 1787 and 1793 for King Ferdinand IV. The artist, who had been in Sicily earlier in 1777, had the good fortune to visit the island on an official mission, which allowed him such benefits as use of the viceroy's winter residence.*

▲ Jakob-Philipp Hackert,
The Port of Palermo, 1791.
Caserta, Royal Palace.

A type of landscape, the capriccio includes fantastic architectural elements created for decorative purposes. One variant, the veduta ideata *(imaginary view), pleasingly combines reality and fantasy.*

Capriccio

In the 1700s, vedute kept growing in popularity, thanks to the many foreign visitors taking the Grand Tour who wanted to take home souvenirs. Coinciding with this fashion was a taste for ruins; the remains of ancient buildings were thought to bear witness to a noble, grand past that was longed for but irretrievably lost. Thus a specific genre within a genre developed, not painted from life like *vedutismo*, but invented, a genre that sought to represent ideal landscapes enlivened by figures and architectural elements. Created still within the Rococo spirit, its function was mainly decorative, and its attraction lay precisely in the fact that it was the fruit of the imagination. Capriccios represent idealized worlds that are first of all aesthetically pleasing and can arouse the viewer's imagination and sense of wonder: the painter has created a bizarre, picturesque world that takes the place of reality. Among the capriccios, or "whimsical inventions," as they were often called, we recall the splendid *Grottesche* and *Imaginary Prisons* by Giovanni Battista Piranesi, several Venetian views by Canaletto, Guardi, and Bellotto, and Roman views by Giovanni Paolo Panini, who also painted an unusual kind of capriccio with imaginary elements or features added to a real landscape, the *veduta ideata*. In 1759, Count Algarotti, a Venetian, wrote of a painting by his compatriot Canaletto: "A new genre of painting [exists] which consists in drawing a site from life and adorning it with beautiful buildings taken from here or there, or invented."

Related entries
Venice, Rome, Naples

Bellotto, Canaletto, Guardi, Panini, Piranesi, Robert, Giambattista Tiepolo, Watteau

▼ Jean-Baptiste Lallemand, *The Pyramid of Gaius Cestius*. London, Sir John Soane's Museum.

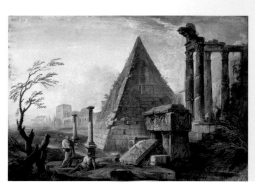

Capriccio

This complex capriccio with plastic and architectural elements and figures displays a taste for the theatrical. Strong chiaroscuro contrasts animate the scene, with the view of the ruins in the distance bathed in light.

All the ancient structures are fragmentary; even the marble equestrian monument is incomplete and its base has a gaping hole.

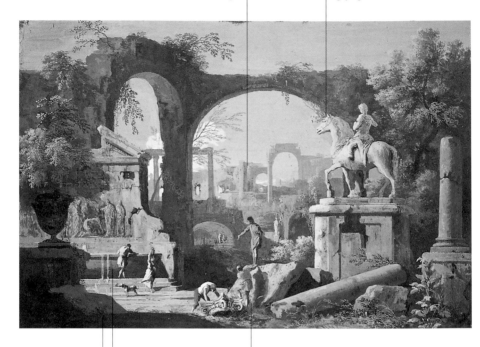

The artist's sensitivity to the effects of natural light is evident in the warm light of the Roman sun, which leaves the left foreground in shadow.

The fountain on the left is similar to fountains included in other works by this painter.

Marco Ricci painted with tempera on parchment. This technique allowed him to lighten the chromatic ranges and create new atmospheres in his views, both real ones of places that he visited and imaginary ones such as this.

▲ Marco Ricci, *Capriccio with Roman Ruins*, ca. 1725. Washington, D.C., National Gallery.

Magnasco's unbridled imagination frames the scene in a long, diagonal perspective of ancient ruined temples with broken capitals and columns, falling stones, and fragments of acroteria.

The scene represents an offering to the divinity in the foreground niche, with some figures bowing before the god and others raising thuribles that send incense smoke toward heaven.

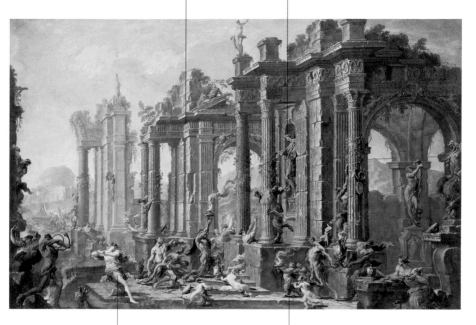

Here Magnasco shows his most personal style: figures rendered as elongated silhouettes and set on canvas with quivering brush-strokes against a theatrical, grandiose setting.

The taste for capriccio, for vibrant, dynamic settings and inventive freedom, is based in an imaginary architectonic vision that stirs the viewer to wonder about bizarre, unreal worlds.

▲ Alessandro Magnasco,
Mythological Scene, 1726–28.
Saint Petersburg, Hermitage.

The popularity of this style is corroborated by the many copies of the same theme, created for a flourishing foreign market.

In the background is the Column of Trajan, topped by the statue of the emperor silhouetted against the sky.

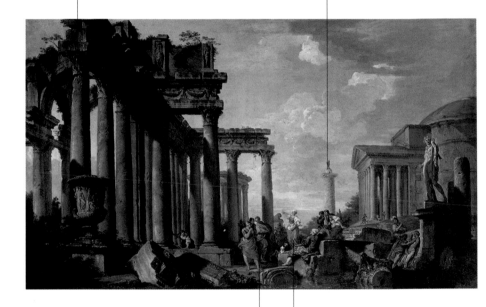

The Sibyl is preaching among the ancient ruins and a group of people has stopped to listen. Panini framed this scene inside neat perspectival lines, but this is secondary to the rendering of the space and the architectural elements.

Ancient prophetess and priestess of Apollo, the Sibyl communicated the deity's oracle. On the right, in fact, Panini has placed the statue of the Apollo Belvedere as the guardian god of prophecies.

▲ Giovanni Paolo Panini, *Prophesy of the Sibyl amid the Ruins of Rome*, 1745–50. Saint Petersburg, Hermitage.

The remains of ancient buildings take on aesthetic value in land-scape paintings and in the design of gardens and parks, evoking the myth and the attraction of an ancient world that is forever lost.

Ruins

A liking for "ruins" developed hand in hand with archaeological discoveries and the study of the Graeco-Roman Classical world: it was an aesthetic that exalted ancient remains, sacred testimony of a grand but lost heritage. Adding a ruin to a painted landscape or to a real garden could at least recover the spirit of the noble past. A landscape so transformed gained intense symbolic value and an intellectual flavor that went beyond mere aesthetic pleasure. The settecento penchant for ruins revived the preceding century's *memento mori*, a meditation on the world's transience—this time by means of a sort of architectural *vanitas*. The inclusion of ancient ruins—faithfully reproduced extant ruins and, especially, invented ones in imagined places—in painted landscapes became customary. The architectural backdrops gave the paintings an ineffable feeling of nostalgia, of noble, heroic values fading along with most of the physical remnants. Connections with the past were also sought by aristocrats and scholars, who wanted their portraits to include traces of antiquity sufficient to bestow upon the subjects moral and intellectual greatness. Most Grand Tour travelers asked to have their portraits made next to ancient ruins: in Rome, Pompeo Batoni became a key figure in this genre. The love of ruins was not limited to Classical architecture: in English paintings and gardens the remains of medieval Gothic buildings began to appear; their steep, looming profiles are a prelude to the "picturesque" taste that became popular toward the end of the century and prepared the way for Romanticism.

Related entries
Paris, Rome, Naples

Batoni, Canaletto, Fuseli, Hackert, Jones, Panini, Piranesi, Robert, Valenciennes

Notes of interest
Ancient ruins were also appreciated in the Neoclassical period: Carlo Marchionni built the suggestive, ruined Tempietto in the Villa Albani in Rome in 1756–63.

▼ Charles-Louis Clérisseau, Drawing for the Room at Trinità dei Monti, ca. 1760. Cambridge, Fitzwilliam Museum.

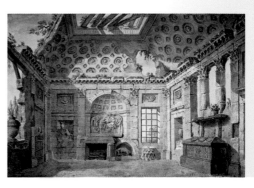

Servandoni (1695–1766) was one of Giovanni Paolo Panini's first students, around 1720. As a matter of fact, this composition follows the same rhythms of his teacher's capriccios. More famous as an architect than as a painter, Servandoni designed the façade of Saint-Sulpice in Paris (1732–45).

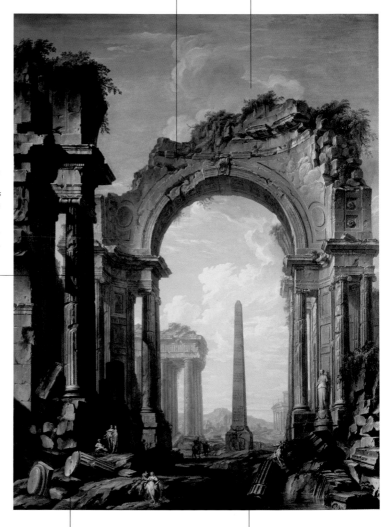

▲ Giovanni Servandoni, *Ruins of Ancient Monuments*, 1731. Paris, École Nationale Supérieure des Beaux-Arts.

In this scene the ruins, studiously arranged in a theatrical perspectival design, crowd the foreground with broken columns, fragments of capitals, and shattered pediments.

The Egyptian obelisk closes the perspectival fugue, rising backlit against the bright sky.

Joli (ca. 1700–1777), along with Servandoni, was among Panini's first students in Rome; they both perfected the "ruins" genre that was to have so much success outside Italy.

The self-confident talent of his scenographic inventions is displayed here, as the viewer is violently swept up in the sudden collapse of the building.

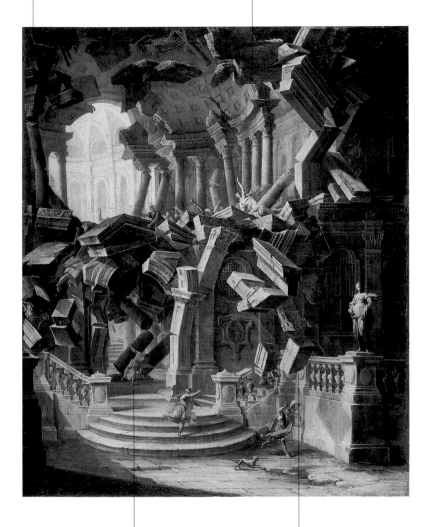

▲ Antonio Joli, *Samson Demolishes the Philistine Temple*, 1725–32. Modena, Galleria Campori.

Samson is embracing a column he has just split in two, causing the entire building to collapse and kill him. Indeed, he chose to sacrifice his life in order to destroy numerous Philistines, the enemies of his people.

The shattered pieces falling suddenly to the ground show the artist's skill in the art of perspective and scenography.

71

Ruins

In this painting there is no taste for scenography or for framing ancient ruins in daring perspectives; the ruins are merely observed as protagonists of the view, without any imaginary scaffolding.

The Coliseum seen in the distance locates the exact position where Jones painted this work during his Roman sojourn from 1776 to 1780.

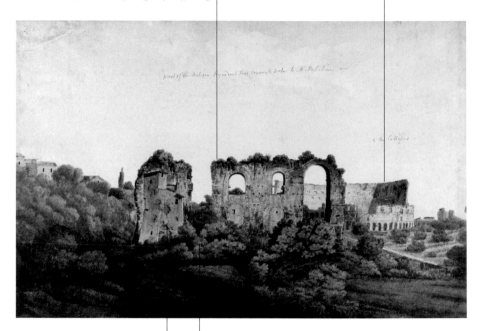

For Jones, the attraction exerted by ancient ruins did not lead to philosophical or intellectual considerations: it was lived merely as a visual experience, a chance to make the antique an integral part of experiencing nature.

The ruins of the aqueduct are rendered as masses of color, almost without drawing, decorated with colored paint, like the vegetation in which they are submerged.

▲ Thomas Jones, *The Claudian Aqueduct and the Coliseum*, 1778. New Haven, Yale Center for British Art.

The young ladies are dressed in the fashions of the times, with large hats that shield them from the sun.

Unseen, three men watch them from the top of the hill.

The statue of Minerva, complete with helmet and shield, has lost her spear; she is the guardian of science and the arts, in which the young women are engaged.

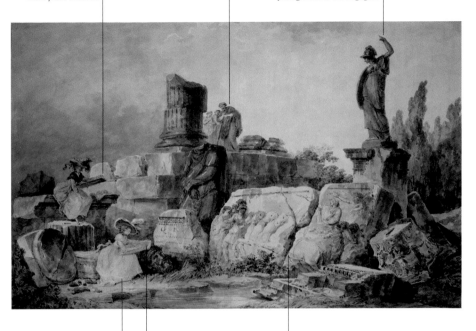

Two young aristocratic women, perched on the ruins, are drawing the ancient bas-reliefs that are piled up near a stream.

Drawing was an important part of the education of the aristocratic classes, an aid in understanding the fundamentals of art by copying ancient examples. The young students of the many academies that were founded in this century followed this practice.

A quadriga advances in the center of the shattered frieze.

▲ Hubert Robert, *Two Young Women Drawing among the Ruins*, 1789. Paris, Musée du Louvre.

Joseph Michael Gandy, a student of John Soane, made this watercolor based on his master's project for the dome of the Bank of England building.

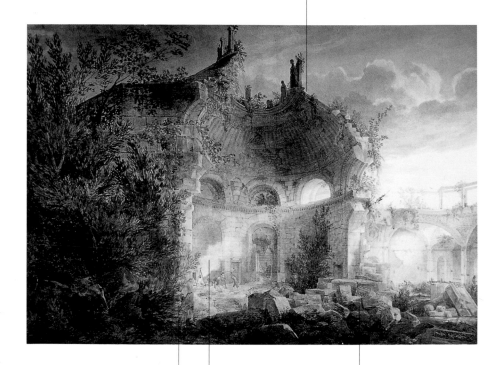

This view unintentionally predicted the tragic end of the Bank of England whose buildings (built by Soane) were demolished around 1920.

John Soane (1753–1837) was one of the most original English architects. In 1788 he was appointed head architect of the Bank of England and, as such, developed many versions of domes. Here his student draws it in ruins, shattered in half, with the sun flooding the interior.

This view already embodies a Romantic vision of ruins and the passion for the lost worlds of antiquity and the Middle Ages.

▲ Joseph Michael Gandy, *John Soane's Sketch as a Ruin*, 1798. London, Sir John Soane's Museum.

Herculaneum and Pompeii were first excavated in the early 18th century; almost at once, a fever for antiquities seized Europe, and archaeology made extraordinary advances.

Archaeological Discoveries

The settecento is the century in which the passion for studying ancient finds struck an ever-growing number of intellectuals, until archaeology began to differentiate itself as an autonomous discipline. In 1738 the well-preserved remains of Herculaneum came to light, and the same happened only ten years later at Pompeii. An ancient tragedy caused by the tremendous eruption of Mount Vesuvius in A.D. 79 had preserved the two cities for centuries under a blanket of ash, saving them from change and from the plunder and devastation of war. The cities reappeared in their full splendor: in Pompeii, for example, the Villa of the Mysteries has the largest known cycle of wall paintings from the ancient world. Soon, scholars and amateurs went beyond Italy: in 1755 the Englishmen James Stuart and Nicholas Revett reached Athens and wrote *The Antiquities of Athens*; their compatriot Robert Wood traveled to the Near East and published *The Ruins of Palmyra* (1753) and *The Ruins of Baalbek* (1757) about the peculiarities of Roman architecture in the provinces. A few years later the Frenchman Charles-Louis Clérisseau published the results of years of research on the antiquities of Roman Gaul in *Antiquités de Nîmes* (1778). The in-depth studies of the German Johann Joachim Winckelmann, who is regarded as the first authentic scholar of Classical antiquities, helped to establish the foundations of archaeology as a separate discipline and to define the Neoclassical aesthetic ideal that was to shape the end of the century in Europe, marking a definitive break with the long Baroque and Rococo season.

Related entries
Rome, Naples

Canova, Hackert, Piranesi, Robert

Notes of interest
Many ancient statues in Italy were believed to be Greek originals, but at the end of the 18th century they were found to be copies made in the Roman period. The news caused a sensation; but no scholar of antiquities had as yet been to Greece.

▼ Jakob-Philipp Hackert, *The Herculaneum Gate on the Via dei Sepolcri at Pompeii*, 1794. Leipzig, Museum der Bildenden Künste.

A sense of impotence and emotion clearly distinguish Fuseli's work from the Neoclassical emphasis of Piranesi. He was already on a trajectory toward the Romantic.

The sketch emphasizes the painful comparison between the unequaled, unreachable greatness of antiquity and a seemingly inadequate present.

The artist has drawn the foot and the hand of the Colossus of Constantine: these giant fragments are still visible today in the courtyard of Rome's Palazzo dei Conservatori on the Campidoglio.

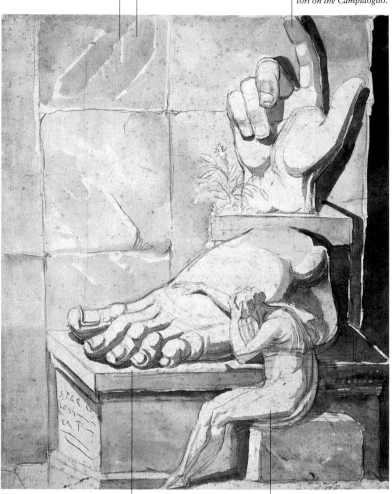

The perception of a faraway past, now lost and in ruins, awakened in Fuseli a sense of confusion, which he conveys to the viewer by juxtaposing the insignificant scale of the human figure with that of the two colossal fragments.

Unlike other artists who, following Winkelmann, felt the attraction of the "quiet greatness" and magnificence of Classical antiquity, Fuseli was filled with a sense of frustration and impotence.

The maritime pine frames and closes the view in accordance with traditional compositional models.

The documentary exactness of this view allows us to identify the site from which the artist painted this watercolor. The Baths of Caracalla are viewed from Ciriaco Mattei's 16th-century villa on the slopes of Mount Celius.

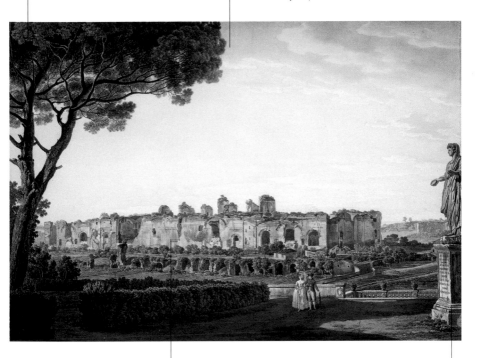

There was great interest in the Baths of Caracalla at the time due to the excavations that were being conducted by the engraver Giovanni Volpato.

To the right we see one of the statues that decorated the façade of Villa Mattei, the balustered terrace, and an elegant couple strolling about.

◄ Henry Fuseli, *The Artist Despairs before the Greatness of Ancient Ruins*, 1778–80. Zurich, Kunsthaus.

▲ Giovanni Battista Lusieri, *The Baths of Caracalla*, 1781. Providence, RISD Museum.

Archaeological Discoveries

Goethe wrote of Pompeii: "Many disasters have happened in the world, though few have caused so much joy to posterity."

This painting still hangs today in the country home of the descendants of the English nobility for whom it was first painted.

Hackert included Pompeii's ruins in a wide view of the gulf, summing up the entire tempera series.

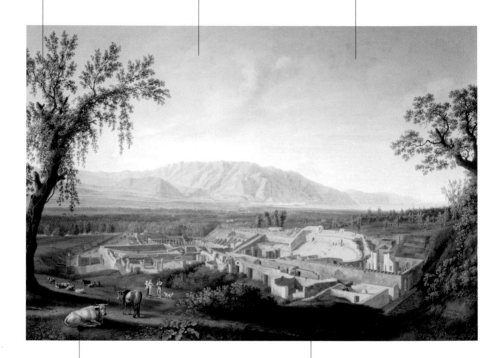

The grazing cattle add a bucolic touch of rural life, which has remained unchanged from the time of ancient Pompeii.

Between 1792 and 1794, Hackert painted several temperas on the theme of the excavation of Pompeii, which were later engraved by his brother Georg. This canvas dates from a few years after the series, and its size is twice that of the temperas.

▲ Jakob-Philipp Hackert, *View of the Excavation of Pompeii*, 1799. Attingham Park, Berwick Collection.

Valenciennes has painted the unusual atmospheric effects produced by the contrasts of the blue sky, the dark green cypresses, and the architectural elements of rose- and ocher-colored bricks.

The surviving structure is the palace of Settimius Severus on the Palatine Hill on which a belvedere rises. The view was painted from the southeastern end of the Circus Maximus, near the Capena Gate.

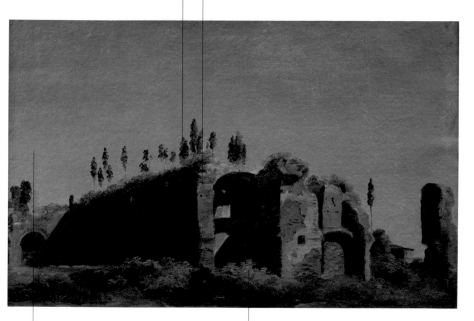

The clear sky fills more than half of the painted surface, capturing the immaterial quality of the light. The artist has filtered reality with rational exactness in order to capture, in a rapid study from life, its unstable, meteorological aspect.

At the time of Valenciennes, these architectural remains were known as "Nero's Baths."

▲ Pierre-Henri de Valenciennes,
Ruins at Villa Farnese, 1782–84.
Paris, Musée du Louvre .

Behind a taste for the "picturesque" is the variety of nature and a love for ancient ruins, freighted with nostalgia. The trend was spread by English artists in the second half of the 18th century.

The Picturesque

Notes of interest
The great French landscape architect Carmontelle wrote this about a "picturesque" locale: "The majestic must be balanced by the elegant, the regular by the chaotic, the pleasant by the melancholy, so that each emotion is followed by its contrary."

After 1750, a new meaning of "picturesque" took hold that was more than just a synonym of "pictorial." According to Alexander Cozens, the term referred to a specific taste that was increasingly detached from the classical ideal of beauty. It arose from a renewed interest in landscape architecture, particularly in the Anglo-Saxon world. A sort of *pathos* was discerned in the natural world, a wholly new spirit close to human sensibility that not only shared the visitor's emotions, but even aroused them. On his canvas the artist evoked the picturesque, including in that small space all the natural and non-natural elements whose blending created a harmonious ensemble that could arouse wonder: a succession of groves, brooks, caves, arbors, ancient ruins, and small temples, all under changing, sometimes stormy skies. Unlike the serene, bucolic atmosphere of the traditional idealized landscapes that invited the viewer to quiet contemplation, the picturesque conveyed an intense emotional drive heavy at once with nostalgia and restlessness. The English garden was designed and built following the same principle, attempting to give a semblance of naturalness and casualness to what instead was the result of a careful plan: a doctrine that recalls the ideas of the contemporary philospher Jean-Jacques Rousseau, according to whom behind the apparent naturalness of the child was hidden the methodical activity of his educators.

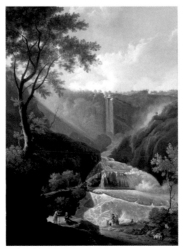

► Thomas Patch, *The Waterfall at Terni*, 1755–60. Cardiff, National Museum and Galleries of Wales.

Foreign artists, English, in particular, such as Wright of Derby, were the first to paint these views of Italian nature still untamed by human hands. One can well understand the wonder and attraction felt by these artists who came from such a cold, gray country.

The sun's rays filter inside the sea cave, creating a cone of light amid the dark, shadowy rocks with a suggestive, poetic effect. The sight of this natural grotto creates a strong emotion in the viewer, exactly what the "picturesque" taste demanded.

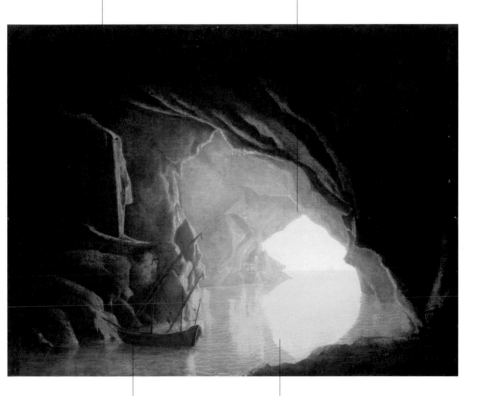

A small boat stands inside the cave, rocked by the soft waves coming in from the open sea.

To an idealized classical land-scape, Wright of Derby pre-ferred "variety" and the sort of dramatization of nature—a new idea of beauty—that could arouse continuous, contrasting emotions.

▲ Joseph Wright of Derby, *Sunset in the Grotto*, 1780–81. New Haven, Yale Center for British Art.

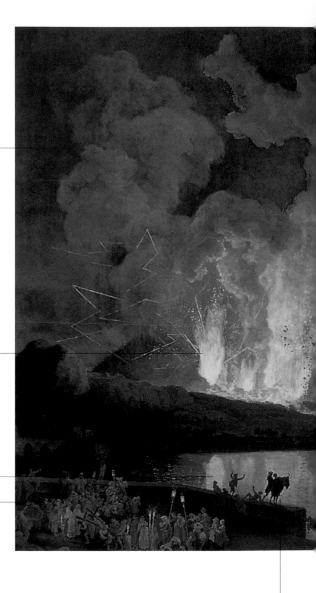

In 1769 the painter moved to Naples, where he specialized in depicting the nightly eruptions of Vesuvius. After it spewed lava in 1766, the volcano was the subject of many paintings by foreign artists.

Volaire depicts the eruption in moonlight, playing on the contrast between the colors of the flaming lava and the dark shadows of the night.

The scene, dense with anecdotal details and refined chromatic and lighting solutions, arouses strong emotions and sentimental reactions in the viewer.

This view of the eruption was from the Maddalena Bridge. A crowd with lit candles had gathered to watch at the Stations of the Cross, hoping to thus placate the terrible volcano.

▲ Pierre-Jacques-Antoine Volaire, *Eruption of Vesuvius*, 1782–90. Naples, Museo Nazionale di San Martino.

The men standing on the parapet, backlit in front of Vesuvius, were often the patrons who commissioned the work. Many foreigners, after watching the overpowering spectacle in person, wanted to bring back home a memento of their trip to Naples.

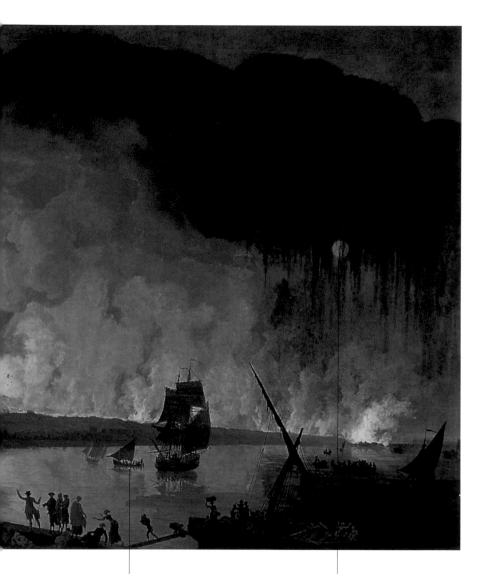

Some anchored boats are watching the show, perhaps the 1769 or 1767 eruption that damaged Portici and forced the king and his court to seek shelter in Naples. In all probability, however, this eruption was not painted from life but is rather a composition of elements observed on different occasions and assembled in the studio, midway between reality and fantasy.

The moon peeps through clouds of dust and lapilli; the sky is crossed by flashes of lightning.

The Picturesque

One example of the interest in this natural phenomenon is the book published in 1776 by Hamilton in Naples, Campi Phlegraei: Reflections on the Volcanoes of the Two Sicilies, illustrated with watercolor drawings by Pietro Fabris.

One place near Naples that was popular with foreigners was the Phlegrean Fields, at one time sung by Virgil and Horace. The Austrian Michael Wutky (1739–1822) arrived in 1782 and often visited them with William Hamilton and the painter Thomas Jones on their scientific excursions.

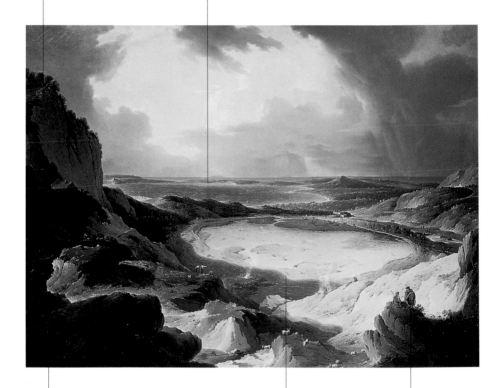

This canvas is suggestive of the power of a mighty, still-mysterious nature that the artist captured numerous times in other versions. The earth, the sea, and the sky come together in this incomparably beautiful scene.

The flattened crater, misshapen and broken by the pounding sea, is dotted by vapors rising from the underground, an indication of volcanic activity.

The shepherds and their goats, glimpsed from the celebrated lookout point, humanize the place, forming a contrast with the terrifying volcanic activity and bradyseism.

▲ Michael Wutky, *View of the Phlegrean Fields*, ca. 1782. Private collection.

It is the aesthetic feeling produced by the perception of some-thing immeasurably powerful and beyond the rational control of humans and to which they are terribly attracted.

The Sublime

Since the beginning of the century an ongoing debate dissected the real nature of the Beautiful, whether it was possible to define its exact properties and fix its contours. While most intellectuals simply identified beauty with the classical ideal based on harmony, grace, and proportion, others mused about an unfathomable variety and complexity inherent in it and the impossibility of reaching a universally comprehensive definition. In issues related to taste and its rules, the English thinker Edmund Burke (1729–1797) had a pivotal role, for in his *Philosophical Enquiry into the Origin of Our Ideas of the Sublime and the Beautiful* (1757), he held that next to a positive, traditional idea of beauty resting on principles of harmony and perfection, there is undeniably another idea dictated by passions and feelings that mixes pleasure with pain and fear: it is the Sublime. While rational, intellectual activity prefers a harmonious, positive beauty, one cannot deny that humankind possesses a powerful emotional universe that can be seduced by what is seen as threatening or arouses fear or insecurity. The Beautiful and the Sublime are therefore set in a kind of antithesis, like reason and feeling, yet their roots, in the final analysis, are the same: it is pleasure, the attraction felt by the senses. In the wake of the polemics unleashed by this theory, a taste began to develop in art for a beauty that is no longer harmonious, but ambiguous and unsettling. The absolute protagonist is nature captured in its wildest, most frightening aspects, such as ravines, high thunderous falls, or gloomy skies. In these paintings, the human figure is increasingly small and secondary with respect to the great triumphant landscape: man, no longer the master of a purely rational universe, is often at the mercy of the dark forces of nature.

Related entries
Rome, Naples, London, Edinburgh

Blake, Fuseli

Notes of interest
"The pleasure of the Sublime . . . includes wonder and appreciation, and thus deserves to be called negative pleasure" (Kant, *Critique of Aesthetic Judgment*, 1790).

▼ Joseph Mallord William Turner, *Tintern Abbey*, ca. 1794. London, British Museum.

The Sublime

The Swiss painter Caspar Wolf (1735–1783) was one of the first masters of Alpine landscapes. His deep knowledge of the Swiss Alps acquired in numberless excursions and his contacts with erudite naturalists are clear from his paintings, which were based on studies from life.

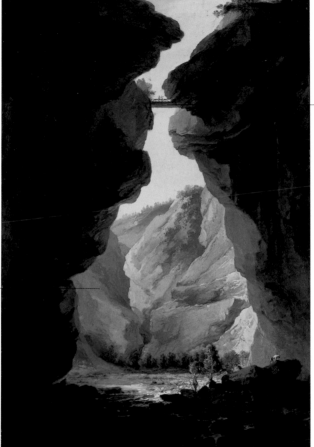

On the bridge suspended above the gorge, two figures lean down and almost seem to greet two other figures standing at the bottom of the gorge.

The contrast between the threatening vertical plane in the shadowy foreground and the lit background conveys a deep sense of vertigo and of nature's sublime grandeur.

▲ Caspar Wolf, *The Bridge and Gorge of Dala at Loèche, Seen from Above*, 1774–77. Sion, Musée Cantonal des Beaux-Arts.

Followed by their dog, two travelers stand on the rocks in the stream admiring the scenery. The ocher and brown tones gradually change from the most intense point of light to the darkest shadows.

Wüest (1741–1821) based his paintings on drawings from life. The end of the 18th century, thanks to the English in particular, saw a burgeoning and passionate interest in mountains and glaciers; earlier they had been treated as mere white spots on a map.

In 1776, commissioned by an Englishman, some books were published about the Valais Canton and the Mont Blanc area, illustrated with etchings made from sketches drawn on site by Wüest.

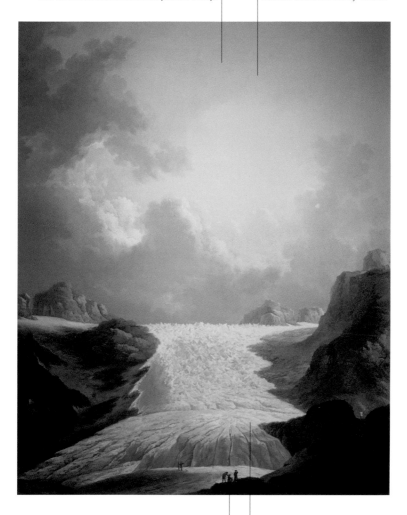

▲ Johann Heinrich Wüest, *The Rhône Glacier*, 1795. Zurich, Kunsthaus.

Some tourists have stopped to admire the imposing glacier, shocked and frightened by this presence, whose immense scale dwarfs that of humans.

Rational man, who can organize and control everything, cannot bear the immeasurability of nature: from this arises a feeling of the Sublime.

The solemnity of the biblical theme, the fall of the angels and of man, is here transfigured into a fantastic, disturbing, and fiendish vision.

With a quick, athletic leap the Archangel Michael has immobilized the monster. Blake highlights the angel's musculature and his twisting body, recalling the Michelangelesque figures that often appear in his works.

▲ William Blake, *The Archangel Michael Chains Satan*, ca. 1800. Cambridge, Fogg Art Museum.

The figure of Satan projects the heroic energy in which Blake strongly believed.

Blake made this watercolor as an illustration for Paradise Lost, *John Milton's tragic poem written in 1655–60. Here Blake illustrates the verse "Through Chaos hurled, obstruct the mouth of Hell / For ever, and seal up his ravenous jaws" (Book 10).*

The triumph of reason over prejudice and superstition, the proclamation of man's freedom and equality: these were the conquering weapons of the new class, the bourgeoisie.

The Enlightenment

"Enlightenment is man's emergence from his self-imposed minority. . . . Minority is the . . . lack of resolution and courage to use . . . one's own understanding. . . . Dare to be wise! Have the courage to use your own understanding! This is the motto of the Enlightenment." Thus Immanuel Kant in 1784 defined the cultural movement that sought a radical renewal of thought, supporting man's free and responsible use of reason against conditioning, prejudice, and superstition. Man must seize his right to analyze and criticize everything that surrounds him; only thus can modern man be born, after shedding the false values that for centuries have oppressed him. Driving this new revolutionary thought was a slow evolution in society: a new bourgeois class, thirsty for independence and economic power, was undermining the supremacy of the aristocracy. The Enlightenment was one intellectual weapon chosen by the bourgeoisie to wage its war: it ushered in a rational, scientific approach to reality, the only one that could lead to genuine progress, abolishing established hierarchies in favor of a future of freedom and equality. These principles would be the building blocks of the French Revolution. The Enlightenment also affected the arts and the role they were to play in a modern world, for art must take stock of moral and civic values and defend and disseminate them wherever an obscurantist or reactionary mentality prevailed. Thus art is a vehicle for transmitting values, but it is first and foremost useful and functional: the self-serving precious decorations and ornaments that had dominated the Baroque and Rococo scene have no more reason to exist. The concept of "useful" art that can socially educate—we should not forget that the art-consuming public was expanding into the middle classes—was to influence much of the art of the late 18th century.

Related entries
Paris, Milan, Venice, Naples, London

Canaletto, David, Goya, Hackert, La Tour, Liotard, Robert, Wright of Derby

Notes of interest
Denis Diderot, the author of the *Encyclopédie*, wrote of art's new goals: "To make virtue attractive and vice hateful: this is the purpose of any honest individual who takes into his hands a pen, a brush, or a chisel."

▼ Jean-Antoine Houdon, *Portrait of Voltaire*, 1778. Paris, Musée du Louvre.

The importance of Rousseau's writings on nature and man is clear from the overwhelming influence he had on 19th- and 20th-century authors.

This pastel by La Tour conveys the intelligence and liveliness in the philosopher's eyes, as if he were engaged in a direct dialogue with the viewer.

▲ Maurice-Quentin de La Tour, *Portrait of Rousseau,* ca. 1753. Geneva, Musée d'Art et d'Histoire.

After Rousseau died and while a tomb in the Panthéon was being prepared for his remains, the city of Paris built a cenotaph in the center of the Tuileries Gardens. On it was carved: "Here lies the man of nature and of truth."

Key to the thinking of Jean-Jacques Rousseau (1712–1778) is the problem of man and nature, their relationship to each other and to civilization, for in the latter the philosopher sees the origin of all evil.

A monument to the technological, artistic, and scientific knowledge of the Enlightenment, it approaches theology, philosophy, and politics from new points of view.

Encyclopédie

On July 1, 1751, the first volume of the *Encyclopédie or Systematic Dictionary of the Sciences, Arts, and Crafts* was published in France. Edited by Denis Diderot and Jean-Baptiste d'Alembert and with 3,123 woodcut illustrations, this work was the fundamental vehicle for promoting the doctrines of the Enlightenment. The idea was conceived by a Paris bookseller who wanted to translate a dictionary of arts and sciences that had been published in England. Diderot, already well known for his critical reviews of the Salon—the public art exhibitions that were a novel society event in Paris—decided to radically change both the contents and the purpose of the encyclopedia. With this *Encyclopédie* the French philosopher and man of letters wanted to break with a traditional culture based on rigid conservatism, both political and religious, and inaugurate a modern, scientific approach to knowledge. All hierarchical principles were banned in the name of a perfect equality of all fields and tools of knowledge: the entries referring to the sciences, crafts, religion, and art were arranged one next to the other with accurate definitions written by a roster of expert contributors that included the leading French intellectuals of the day. At the heart of this endeavor was the intent to create a useful tool for the education of modern man. The arts, too, were urged to be first and foremost a vehicle for shaping sensibility and morals: they were to educate their public socially. Finally, for the first time, even humble trades were treated in an appreciative light. After the second volume was published in 1752, production was halted by a public outcry, in particular from the religious sector, which felt threatened by the work's secular approach.

Related entries
Paris

Notes of interest
Among the renowned contributors to the *Encyclopédie* were Montesquieu, who wrote about *Taste*, and Turgot on *Etymology* and *Existence*. Voltaire wrote several entries in the first volumes, then, like d'Alembert, who wrote the preface, abandoned the project.

▼ Maurice-Quentin de La Tour, *Portrait of d'Alembert*, ca. 1770. Paris, Musée du Louvre.

Together with d'Alembert, Denis Diderot (1713–1784) led the greatest intellectual enterprise of the century, the Encyclopédie, *an exceptional tool for disseminating the culture of the Enlightenment.*

Diderot's physiognomy as depicted by Fragonard corresponds to what we know from other sources. He is caught in motion, as if suddenly called by someone who stands outside the painting.

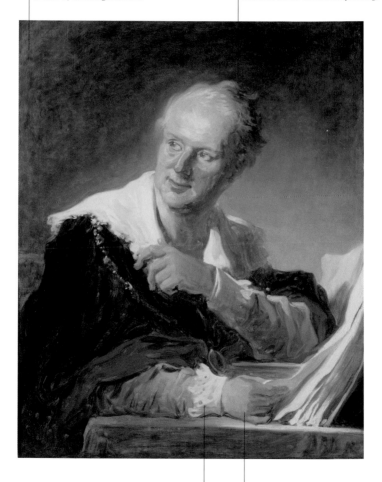

▲ Jean-Honoré Fragonard, *Portrait of Diderot*, ca. 1769. Paris, Musée du Louvre.

This is one of several half-portraits that Fragonard painted with quick, darting strokes. The white of the collar, cuffs, and edges of the pages are marked by thick brushstrokes.

Diderot passionately loved all kinds of painting; he was a critic at the Salons, the shows organized by the Académie Royale in Paris. An admirer of Fragonard, he asked to be portrayed at his desk, with his books, the tools of his knowledge.

Thanks to the interest shown by Madame de Pompadour, the Encyclopédie continued to be published, despite defamation and criticism by religious authorities who felt threatened by its secular approach.

This etching is dedicated to the baker who prepares, kneads, and bakes the dough. In the lower part of the page, his tools are illustrated with scientific precision: from the mortar to the sieve, from the small molds to the rolling pin.

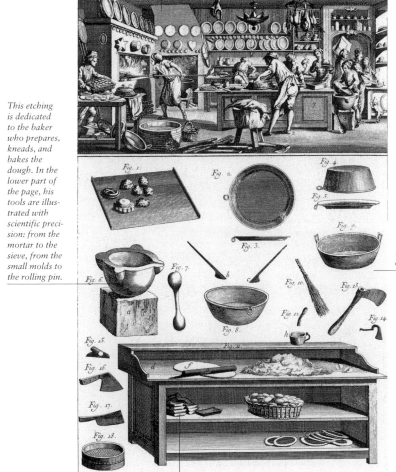

Although the Encyclopédie was expensive, all 4,250 printed copies were sold.

When the Encyclopédie was written, the preeminent model of production was still craft work; a number of royal decrees sought to include the free trades in the guilds. Each and every craft has its own table with an illustration and a description of the tools at the bottom.

▲ Etching for the entry *Batissier* (Baker), from the *Encyclopédie* by Diderot and d'Alembert, first Italian edition (Leghorn, 1770–79).

The Encyclopédie *broke with traditional culture and with the political and religious conservatism that had structured knowledge and social life into indisputable hierarchies. It was the first scientific and rational attempt to dismantle consolidated prejudices and power.*

Throughout the Encyclopédie, the artist's educational mission shines through: art must communicate its moral and social contents; the artist must also be a philosophe and express the educational value of art, thus contributing to human progress.

This page illustrates in detail the tools of the turner: double die, die plate, and compasses. One entire chapter is dedicated to a lengthy analysis of the turner's activity, the lathe, and its many accessories.

The arts, crafts, and occupations follow one another in the entries, refuting the traditional separation between thought and technique, theory and practice. The encyclopedists revalued the physical occupations in light of the universal category of the common good.

▲ Etching for the entry *Turner*, from the *Encyclopédie* of Diderot and d'Alembert, first Italian edition (Leghorn, 1770–79).

"To educate a nation means to civilize it; to stifle its knowledge means to push it back to a primitive barbarian condition," wrote Diderot on the new concept of public education.

Academies and Nudes

The century saw a proliferation of cultural, scientific, and literary institutions, often nonreligious, that were gradually shedding their elite character to become public schools. This phenomenon also touched the arts, with the establishment or, in some cases, the restructuring of fine arts academies: in 1720 there were nineteen in all of Europe; in 1790, over one hundred. In the first half of the 18th century, the most prestigious art school—the Académie Royale of Paris, founded in 1648—became the paradigm for European cities that were opening their own academies. The Académie Royale regularly held exhibitions, called Salons, and awarded prizes, the most prestigious being the Prix de Rome, which awarded the artist a free training period at the academy's branch in Rome. These institutions shared many common elements, in particular curricula designed to give young students a technical and theoretical background and to familiarize them with the latest trends in the arts. The academy's goal was to turn out highly trained artists: the program included science and liberal arts courses such as anatomy, perspective, geometry, philosophy, and history. They also offered courses for craftsmen, renewing the link between the arts and the trades, endowing the applied arts with a new artistic dignity and improving the overall quality of manufactured products.

Related entries
Saint Petersburg, Warsaw, Berlin-Potsdam, Dresden, Munich, Vienna, Paris, Madrid, Turin, Milan, Venice, Rome, London

Batoni, Boucher, Canova, David, Goya, Kauffmann, Mengs, Nattier, Reynolds, Robert, Subleyras, Zoffany

▼ Giambattista Tiepolo, *The Artists' Academy*, ca. 1718. Private collection.

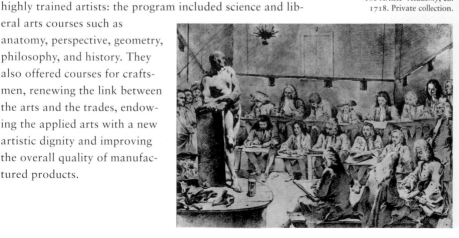

The woman has her head bowed, the body bent somewhat upon itself, the feet crossed in a natural, spontaneous pose for a model who has been posing for hours.

The tendency to endow subjects with grand, noble qualities as if they were religious altarpiece figures coexists in Subleyras's work, as with that of all great masters of the past, with everyday themes devoid of religious or political meaning, as in this amazing female nude.

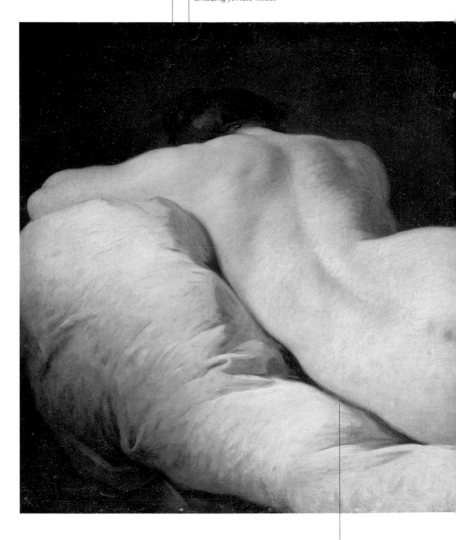

▲ Pierre Subleyras, *Female Nude*, ca. 1740. Rome, Galleria Nazionale d'Arte Antica.

This canvas exhibits the painter's predilection for the subtle chromatic plays of white on white, rose and brown, skillfully shaded one into the other as the light changes imperceptibly.

The subtle, rosy flesh is treated with a masterly attention to light and to the whirlpools of shadow between the body and the white sheet, and between the articulated curves of the female body.

This daring reclining form is one of the loveliest nudes in the entire history of art. The painter has spared this young woman from the ravages of time, creating a work so ageless that one could easily misdate it by a century or more.

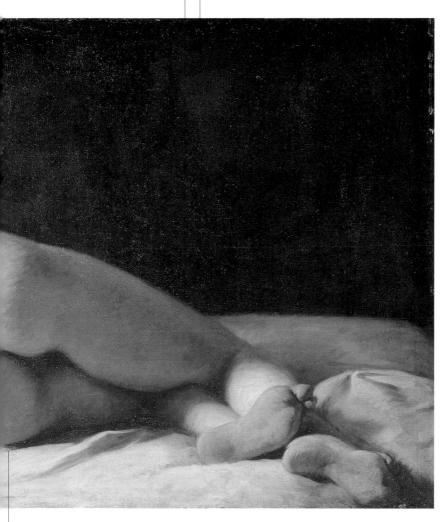

Subleyras self-confidently displays his total command of human anatomy, here explored and rendered with an attentive eye to each luminous shade of muscle and skin.

The psychological incisiveness of this self-portrait and the excellent draftsmanship are even more noteworthy when we consider that Meléndez worked almost exclusively in the genre of still life.

The artist proudly shows a drawing of a male nude on ivory paper as proof of his skill, honed day after day by the study of human anatomy.

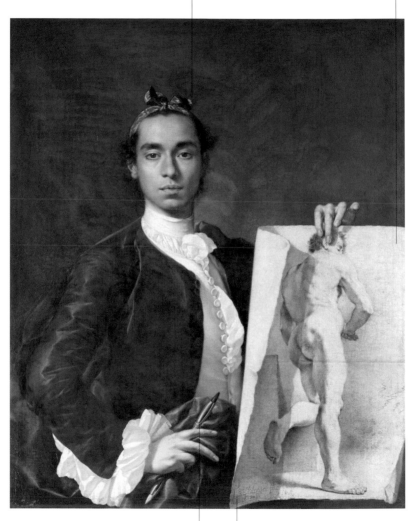

The Spanish painter has painted himself as an arrogant, self-assured young man, holding in his left hand an excellent academic drawing and in his right a mechanical pencil, the key tool of his craft.

The core of the academy's teaching is the perfection of draftsmanship, which required exactness, respect for proportions, and variety in the expressions of the model.

The painter Robert had a close relationship with the Louvre: in 1784 he was appointed curator of the royal collections and charged with organizing and lighting the future museum.

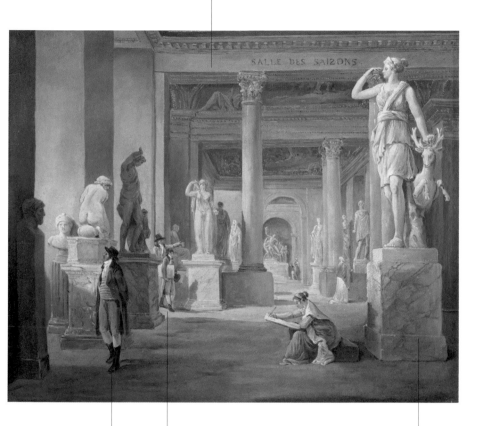

Robert lived at the Louvre and drew its halls numerous times. Here he portrays a number of visitors walking around the sculpture gallery and a young female student drawing a statue.

A young man walks among the statuary, a sketchbook under his arm. In the back of the hall is the Laocoön group and in the foreground, Diana with a Deer.

The practice of drawing ancient sculpture was an important stage in the training of the artist, before he went on to practice drawing live models at the academy.

◀ Luís Eugenio Meléndez, *Self-Portrait with Drawing*, 1746. Paris, Musée du Louvre.

▲ Hubert Robert, *Hall of the Seasons at the Louvre*, ca. 1802. Paris, Musée du Louvre.

Wright of Derby explored the effects of natural and artificial light. In this canvas he focuses on the beam of light that illuminates the statue.

The artist has left almost the entire composition in the shadow of the studio, illuminating only the white gesso statue from a window in the upper left corner. He has thus created a suggestive, almost nocturnal atmosphere that moves the light onto the girl's whiteness.

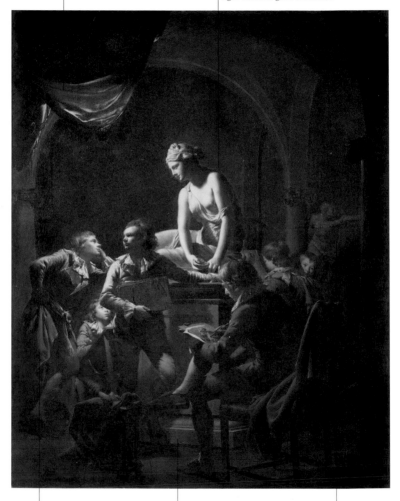

One enraptured student dreamily admires the statue.

This scene takes place in a painter's studio or in the academy, around a copy of the famous statue Nymph with Conch *(Paris, Musée du Louvre); the young students are practicing drawing it.*

In the shadowy background we glimpse a copy of the Borghese Gladiator.

▲ Joseph Wright of Derby, *Drawing Lesson*, 1768–69. New Haven, Yale Center for British Art.

The Salon was a painting and sculpture exhibition held regularly in Paris from the end of the 1600s on; it soon became the world's most famous art show.

Salon

The word Salon refers to official exhibitions of works of art held regularly, usually at the fine arts academies, and open to the general public. Until well into the 1700s, artists worked only on commission from either the aristocracy or the clergy: their names made the rounds of restricted circles such as the European courts, and the public at large was cut off from art collecting. In 1673 King Louis XIV inaugurated regular exhibitions of paintings in the courtyard of the Palais Brion, which were immediately successful. The shows lasted a few days, there was no admission charge, and the venue was prestigious. Official artistic production was part of a French government program aimed at consolidating and strengthening the country's preeminence in Europe. Paintings on historical themes, followed by mythological scenes, were considered the loftiest in a hierarchy of genres and effective tools to teach morals. Landscape and still life were appreciated but still considered inferior.

From 1704 to 1737, the Salon was suspended; when it resumed, it became a biennial event. Starting in 1791, after the French Revolution, the requirement that an exhibiting artist had to be a member of the Academy was dropped and the doors were thrown open to anyone who wanted to display work. This freedom, however, was short-lived; the Salon jury was to become increasingly strict until well into the late 19th century.

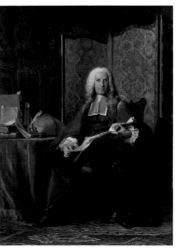

Related entries
Paris

Chardin, La Tour

Notes of interest
In tandem with the growing popularity of the Salon, the figure of the art critic who objectively reviewed the displayed works was also developing. In the 19th century, he would play a key role in the diffusion of new movements; Denis Diderot was one of the first and most illustrious of such critics.

◄ Maurice-Quentin de La Tour, *Gabriel Bernard de Rieux*, 1739–41. Los Angeles, J. Paul Getty Museum.

The king inaugurated the Salon on August 25, Saint Louis Day, and it ran for twenty days. A catalogue, the livret, *was printed with the artists' names listed in order of importance, from the king's official painter to the last artist admitted to the Academy, along with the price of each work.*

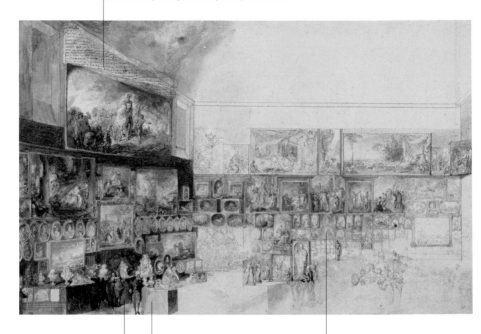

This unfinished water-color shows the Salon of 1765. It is a unique primary source that shows how the works were arranged in the available space during the exhibition.

In the center of the hall, tables were set up with busts and sculptures, while the canvases were arranged on the walls practically edge to edge, from floor to ceiling, with larger works closer to the ceiling.

Initially the Salon was set up in the Louvre's Grande Galerie; in 1737 it was moved to the Salon Carré that gave it its name; until 1791 only artists admitted to the Academy were allowed to exhibit.

▲ Gabriel de Saint-Aubin,
The Salon of 1765. Paris,
Musée du Louvre.

Having reached the height of his career, Chardin was asked by his peers at the Academy to arrange the hanging of the works at the Salon (accrochage) in 1755.

Diderot's critiques were perceptive comments on light and color, later collected in the book Les Salons. *Negative reviews sometimes led to the removal of individual works of art from the walls.*

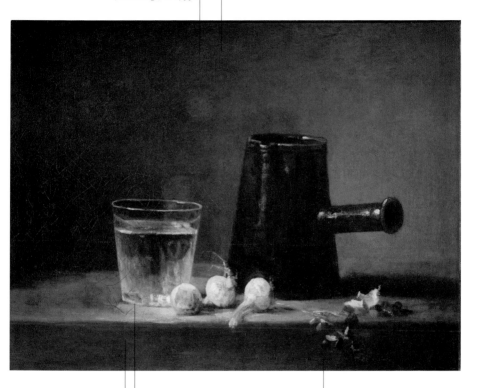

Starting with the Salon of 1753, Chardin greatly increased the number of still lifes he exhibited, due to the great success they enjoyed. Finally in 1764 he began to receive official orders for works in this genre.

The glass of water, three-quarters full, is an amazingly correct optical rendering that projects a milky reflection on the table's wood surface. From the catalogue of the Salon it is difficult to identify precisely which still-life paintings Chardin exhibited, since the titles are usually vague.

From 1759 until 1781, Diderot was one of the Salon's most enthusiastic reviewers, thus creating a new literary genre: modern art criticism. He praised the works of Chardin, Fragonard, Greuze, Vernet, Robert, and the young David.

▲ Jean-Baptiste-Siméon Chardin, *Glass of Water and Coffee Pot*, ca. 1760. Pittsburgh, Carnegie Museum of Art.

Caricatures were wildly popular in the 1700s, in England especially. At once amusing and serious, they denounced public and private conditions that concealed weakness, selfishness, and greed.

Satire and Caricature

Related entries
Paris, Milan, Venice, Rome, Naples, London, Edinburgh

▼ Pier Leone Ghezzi, *Caricature of Montesquieu*, 1729. Vatican City, Biblioteca Apostolica Vaticana.

Although the satirical image had already made its appearance in Italy in the 1600s, mainly as an amusement, the following century saw it mature into a painting genre, especially in England. There the public enjoyed freedom of expression and of the press earlier than in other European states, which were still absolutist. Artists such as James Gillray, Thomas Rowlandson, and William Hogarth embraced satire with bitter intensity, targeting political and intellectual figures as well as the false morality flaunted especially by the middle and upper bourgeoisie. The painter and engraver Hogarth turned out expressive satires: his inspirations were contemporary literary figures such as Jonathan Swift and Alexander Pope, and the English theater, which played out human foibles dictated by pride and vanity on stage. Hogarth's paintings narrate a story's evolution with bit-

ing images. The six canvases of *Marriage à la mode* (1744) tell the story of an ill-fated arranged marriage, while the eight-canvas series *A Rake's Progress* (1733–35) follows a wealthy idler from high living to the asylum. In 18th-century Italy, the best satirists and caricaturists were Pier Leone Ghezzi in Rome, and Anton Maria Zanetti the Elder and Giandomenico Tiepolo in Venice. Ghezzi's favorite targets were high prelates, intellectuals, politicians, and foreigners traveling to Italy, especially the English, all portrayed in long, exhilarating series of drawings, many of which, unfortunately, have been lost.

The artist has dressed the monkey in contemporary fashion, including a feathered tricorn. This work was exhibited at the Salon of 1740 along with the companion piece, Monkey Antiquarian.

Watteau painted a similar subject with a pendant Monkey Sculptor (1709–12, Orléans, Musée des Beaux-Arts).

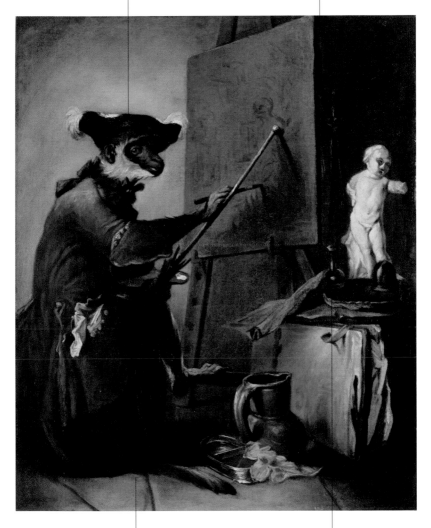

▲ Jean-Baptiste-Siméon Chardin, *Monkey Painter*, ca. 1740. Paris, Musée du Louvre.

Chardin's painting is a sort of French retort to the Flemish singeries (paintings with monkeys) in the manner of Teniers, which were popular in Paris throughout the 18th century.

The satirical intention, a rebuke to the "aping nature" movement, was part of the aesthetic criticism of the official taste of the times.

Reynolds spent two years in Rome copying the works of the great masters, Guido Reni and Raphael in particular. This work is a parody of the famous Raphael fresco The School of Athens, *which decorates the Vatican Stanze (papal rooms).*

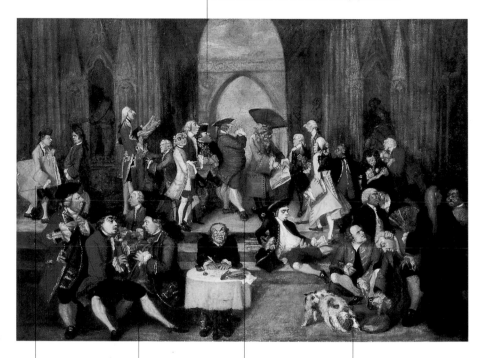

An artist enters with a portfolio of his works under his arm. The satirical intent is clear from the strong caricature elements in the faces and poses.

A group of musicians enlivens the scene, which is no longer set in a harmonious, classical Raphaelite setting, but inside a Gothic building.

Instead of Aristotle and Plato, Reynolds has painted an English gentleman making the Grand Tour and a probably unscrupulous art dealer.

Instead of illustrious ancient men, Reynolds has painted figures typical of his time, to poke fun at the characters that trailed the foreigners making the Grand Tour in Italy.

▲ Joshua Reynolds, *Parody of "The School of Athens,"* 1751. Dublin, National Gallery of Ireland.

The shadow of the second candidate, also carried on his supporters' shoulders, appears in the background, on the wall of city hall.

A series of episodes denounces political corruption: the winner risks falling from his chair as his bearers are upset by the cudgels of a man fighting a sailor with a peg leg, and the sudden appearance of a sow with her piglets.

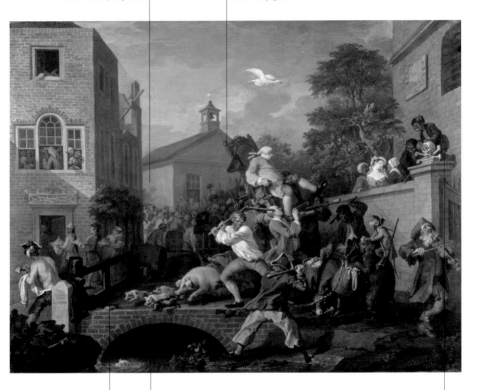

The servants enter the house at left with dishes for a banquet, and some guests watch the procession from the window.

This is the last in a series of four paintings on the theme An Election. The two parties are the New Interest and the Old Interest, mirroring liberals and conservatives. John Soane purchased the four works from David Garrick, a celebrated English actor.

Two chimney sweeps amuse themselves on the church's boundary wall. They put spectacles on a skull and pee on the monkey; a lady faints at the sight and is helped by her maids; on the sundial a Latin inscription reads: "We are dust and shadow."

▲ William Hogarth, *Chairing the Member*, 1754. London, Sir John Soane's Museum.

Thomas Rowlandson (1756–1827) devoted
his career to drawing caricatures of public
figures in the leading newspapers of the time.
His social and political subjects are treated
with keen insight and a bitter satirical accent.

The best-known series of his
drawings was published in
1812, and even the title is
satirical: "Tour of dr Syntax
in Search of the Picturesque."

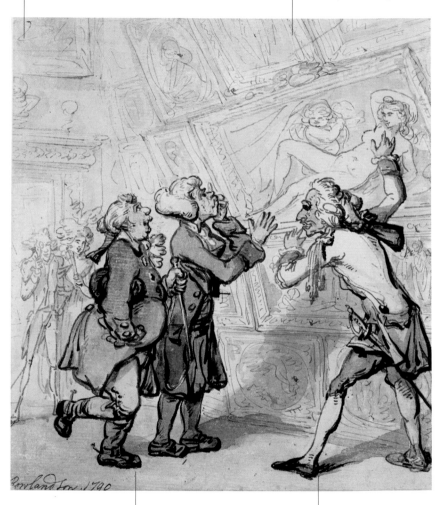

▲ Thomas Rowlandson, *Tourists
Admiring the Paintings*, 1790.
Private collection.

In an art gallery, two English gentlemen
inspect a large canvas of Naked Venus,
painted in Italian cinquecento style.
They are visitors to Italy on the Grand
Tour, bent on purchasing artwork to
take back to their homes in England.

The art merchant is lavishing
explanations on the painting
in the hope of selling it. The
Grand Tour had generated a
flourishing market for works
that were sometimes forgeries
or mediocre in quality.

"The only path to becoming great and, if possible, unequaled, is to imitate the ancients," wrote Winckelmann: a return to the "noble simplicity and serene grandeur" of ancient art.

Neoclassicism

In the latter part of the 18th century a new art movement, Neoclassicism, was maturing, born in the context of the Enlightenment and renewed interest in Classical antiquity. The very term reveals the desire to recover not just ancient styles in the figurative arts and architecture, but also ancient ethical and civic virtues. Archaeology and Enlightenment thought therefore provided the foundation for many theoretical writings and essays; although these were written primarily in Italy and France, their influence eventually reached other European countries and the United States. The center where the new style developed was Rome, a capital both ancient and modern, rich in well-preserved and extraordinarily important historical monuments. Neoclassicism was also a fitting segue to the rejection of Baroque and Rococo redundancy and excess that were now felt to be anachronistic and unfit to represent the new thinking of the Enlightenment *philosophes*. Besides Greek and Roman objects, Egyptian and Etruscan artifacts recovered in archaeological digs were also studied. Neoclassical theory began with writings on the concept of the Beautiful by the Germans Johann Joachim Winckelmann and Anton Raphael Mengs, who were both in Rome in the 1750s. In his *Reflections on the Imitation of Greek Art* (1755), Winckelmann, who is regarded as the founder of the discipline of archaeology, argued for the superiority of the Greek style, inaugurating a dispute between pro-Hellenes and pro-Romans that was to last a long time. Much more than a mere imitation of an ancient stylistic repertory, Neoclassicism sought to recover and transmit the ethical and political ideals of that heroic past.

Related entries
Paris, Rome, London, Bath, Edinburgh, United States

▼ Anton von Maron, *Portrait of Winckelmann*, 1768. Halle, Staatliche Galerie Moritzburg.

Three arms ready to take the oath stretch toward the father, who holds the swords he will give his sons to defend the fatherland. The three brothers embrace, united by a bond that makes them equal, already the symbol of a collectivity, a common will.

The old father invokes the gods, knowing that he is sending his own sons to die against the Curiatii; this will have dramatic consequences for both clans, who were related by marriage.

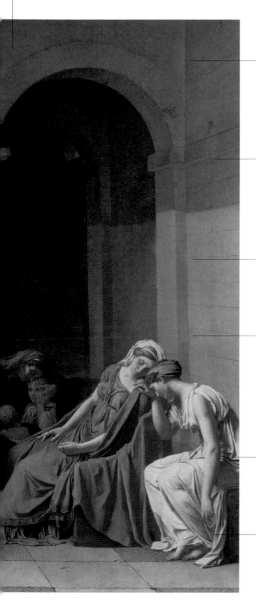

There is no exhibitionism of touch or bravura in this painting: everything stands still inside the contours David has carefully drawn. As it should be with all rational processes, there is no blurring or ambiguity.

To paint this large canvas, commissioned by the king, David returned to Rome, taking with him his young student Germain Drouais. The theme is solemn: an oath, evoked in the sober moral climate of the Roman Republic, not the luxury of imperial Rome.

Artists, Roman collectors, and foreigners flocked to the painter's studio near Piazza del Popolo until the canvas was crated and shipped to Paris for exhibition at the Salon of 1785. It was dubbed "the most beautiful painting of the century."

As in an ancient Roman bas-relief, the main figures are lined up on a single plane so that their gestures appear to be linked together. The brothers who swear the oath are connected visually and thematically to their father, who clasps their swords, but are separated from the weeping women, distraught over the forthcoming battle between the two related families.

For the first time, the principles of Neoclassicism were forcefully expressed in a painting, thanks to the restrained setting, the solemn eloquence, the dramatic tension, and the sense of impending crisis.

The scene is bare, devoid of decoration. Each of the solemn sequence of arcades frames an episode. On the left is the virile representation of the warriors uniting in combat. Counterpoised on the right, just as noble, is the feminine scene of grief, expressing the protagonists' impotence in the face of fate.

Dressed in white, Camilla, who loves one of the Curiatii, leans her head on the shoulder of Sabina, a Curiatia who had married a Horatius, while the mother of the three brothers soothes the grandchildren.

◄ Jacques-Louis David, *The Oath of the Horatii*, 1784. Paris, Musée du Louvre.

This fresco, detached from the wall and applied to canvas, is the most famous fake antique of the 18th century. At a time of widespread enthusiasm for antiquity, skillfully made counterfeits were common.

While the young cupbearer serves the wine, Jupiter embraces him as if to kiss him. Ganymede seems reluctant, his eyes avoid the god's, and he holds his lips tight.

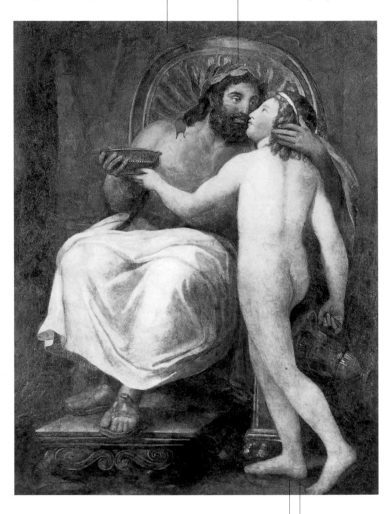

▲ Anton Raphael Mengs, *Jupiter Embracing Ganymede*, ca. 1760. Rome, Galleria Nazionale d'Arte Antica.

Perhaps Mengs wanted to demonstrate his vast knowledge of ancient art and his skills of imitation. Less probable is the theory that he intentionally meant to deceive his friend Winckelmann, who was sensitive to this erotic subject.

This scene could be read as the erotic encounter of a mature man and a beardless youth, following the fashion of the intellectual and artistic circles of the time.

Caught in the act of kissing, the couple is joined in an embrace. With her arms, Psyche holds the head of her beloved, who supports her nape and with the other arm cradles her breasts.

Psyche's encircling movement flows into the wings of Cupid. The marble has been polished so that it has become translucent.

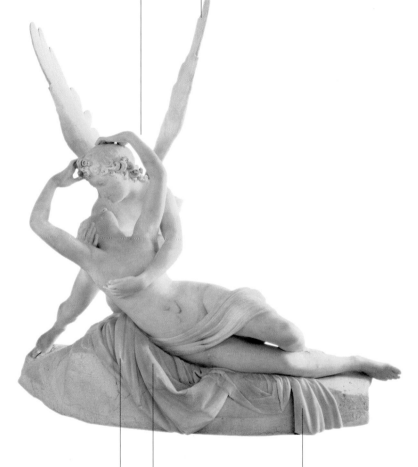

The artist was inspired by a painting recovered in Herculaneum; more than any other sculpture, it expresses Canova's adoption of Winckelmann's teachings.

▲ Antonio Canova, *Cupid and Psyche*, 1787–93. Paris, Musée du Louvre.

In this group, Canova imitates ancient sculpture: its limpid, absolute beauty seems detached from time, ethereal, without body or weight (indeed, Psyche means "soul"). We sense the almost imperceptible shiver of a subtle sensuality that stirs around the couple, as if caressing them.

The subject is drawn from the Metamorphoses by Apuleius. The lovely Psyche had made Venus envious; the latter sent Cupid, with his bows and arrows, to make Psyche fall in love with an insignificant man. Instead, it was Cupid who fell desperately in love with her.

The bridal decorations are in accord with both the symbolism of fertility and the contrast between Rococo decoration—floral festoons, cornucopias, and pearls, like a painting by Nattier—and the Classical model with the vase and rams.

In this architectural and decorative construction, Petitot has dressed an unlikely bride with an ironic invitation to a masked ball, linked to the taste for antiquity that was popular in cultural and artistic circles.

The Lyons architect Petitot (1727–1801) dedicated the nine plates of his Mascarade à la grècque (1762) to the French Prime Minister of Parma, Du Tillot, an enlightened reformer of the Duchy of Parma.

The passion for everything à la grècque—for example, holding elaborate, Greek-inspired banquets for only one night, as the painter Elisabeth Vigée-Lebrun did in 1788— became a pastime of the cultured and the literati.

▲ Ennemond-Alexandre Petitot,
The Bride à la Grècque, 1771,
etching by Benigno Bossi. Parma,
Museo Glauco Lombardi.

For the first time in history, there was the will to build a world based on freedom, equality, secularism, and scientific progress. The arts tried to express the heroic ideals of the Revolution.

French Revolution

Although it had been ruled for centuries by one of the most absolute and prestigious monarchies in the world, 18th-century France evolved socially and politically toward the progressive, libertarian ideals expressed by Montesquieu and Rousseau. Chasing Italian primacy in arts, letters, and philosophical thought, France asserted itself as a paradigm of modernity and progress: Paris grew ever more fashionable while Rome entered a period of slow decline, especially after the middle of the century. The Enlightenment was now the front-rank movement, the pride of the *philosophes* whose writings reached and seduced many among the European elite. Even the French language became popular with the cultivated classes abroad. In art, the Enlightenment found its ideal expression in Neoclassicism, whose finest practitioner was the Frenchman Jacques-Louis David, seen as an extraordinary precursor of those civic and political virtues that inspired the Revolution of 1789.

David had been seduced not by imperial Rome, but by the Rome of the Republic, with its clear-cut rigor, austere style, and civic virtues, an era when "the good of the people" was "the supreme law." With the Declaration of the Rights of Man (1789), the dreams of freedom, equality, and brotherhood were realized. Like the classicism preferred by the revolutionaries, the new art adopted pared-down, solemn representational tones. Alongside the great paintings, the revolutionary period produced an extensive Republican iconography that went hand in hand with new social and political achievements. Rejecting superfluous decoration, architecture now concentrated on public works that embodied function, usefulness, and a certain sober monumentality in the new France that was now at the service of its people.

▼ Jean-Louis Laneuville,
Bertrand Barère Demands the King's Head, 1793.
Bremen, Kunsthalle.

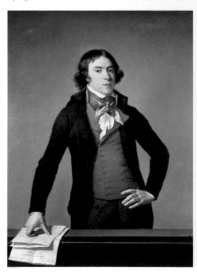

The Bastille was demolished immediately after it was stormed in 1789. From the top of the towers, its merlons and stones were thrown into the moat, and all of Paris ran to see the Bastille reduced hour by hour.

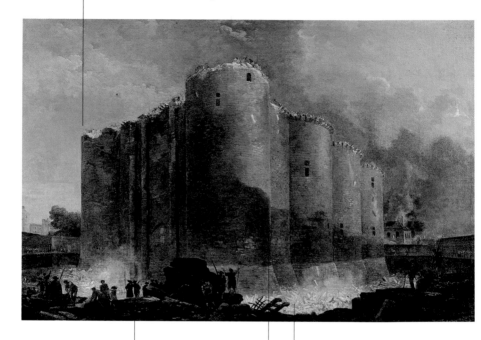

Robert wanted to document the spectacular scene of the destruction of the ancien régime symbol, dating the moment depicted as precisely July 20, 1789.

Wreathed in smoke and partially lit up by flames, the imposing building fills the foreground. It is not the chaotic assault by the revolutionaries that is represented, but the gradual, tangible collapse of a symbol of the past. The viewer is filled with an epic sense of participation in this revolutionary moment.

A merchant purchased all the stones of the demolished Bastille for resale. The Concordia Bridge was partially built with them; the smaller ones, "petites Bastilles," were sold as souvenirs.

▲ Hubert Robert, *The Demolition of the Bastille*, 1789. Paris, Musée Carnavalet.

Boilly has left us many accurate and odd scenes of everyday life during the revolutionary years.

This sans-culotte *is Chenard, a popular singer who used to strike up songs such as* The Marseillaise *or* Ça ira *in city squares and theaters. This symbolic figure of the common hero is the new sacred image of the Revolution.*

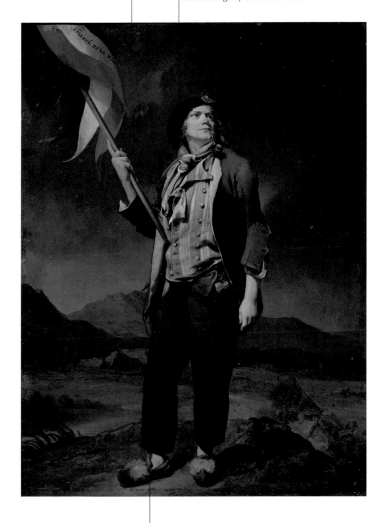

▲ Louis-Léopold Boilly, *Sans-culotte,* 1792. Paris, Musée Carnavalet.

Sans-culotte *was originally a term of contempt applied by the French aristocrats to the revolutionaries who wore long pants instead of the knee breeches (*culottes*) favored by upper-class men. Later, the revolutionaries willingly adopted the term to describe themselves.*

The heroic nudity, the bare, solemn composition, and the search for an everlasting quality in a contemporary event are the results of a protracted study that David had conducted in Italy on seicento painters.

Marat is arranged in the tub as if in a sarcophagus, wrapped in a shroud. With David, contemporary history enters political and social life, with no concession to elements of illustration or pathos.

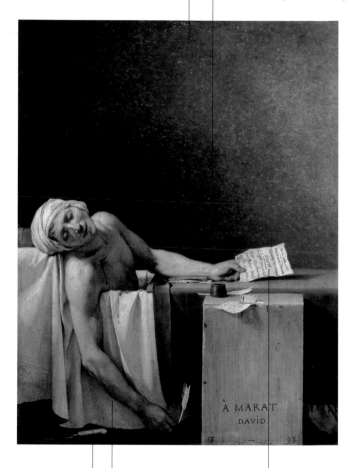

David, who was a friend of Marat's, designed the painting around the rational values of classicism, where details are essential elements in re-creating the tragic event: the tub with the lifeless body, the sheet, the bloody knife, the inkwell, the quill pens, and the plank used as a desk.

Marat's fallen arm recalls that of Jesus in Caravaggio's Deposition and in Guido Reni's Beggars' Altarpiece, both of which David had drawn repeatedly. Marat became almost a new Christ to be placed on the altars of the Revolution. In fact, the canvas hung for two years in the Convention Assembly Hall.

On July 13, 1793, under the pretext of submitting a petition—the paper Marat holds in his hand—the Girondist Charlotte Corday murdered Jean-Paul Marat, hero of the French Revolution and "friend of the people."

The assembly took place at night, under torches hung from the walls that lit up the vast hall with suggestive effects.

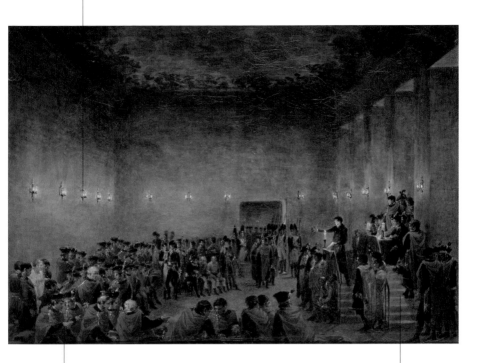

This scene represents the coup d'état of the 18th Brumaire, in the eighth year of the Revolution (November 9, 1799), which put an end to the Directory. After hastily leaving Egypt, Napoleon thus formed a government that only slowly crept toward adopting a constitution.

It was resolved that the councilors be moved under military escort to the Castle of Saint-Cloud, near Paris. Bonaparte was greeted with hostile shouts, most of the deputies were dispersed by the soldiers, and those who remained voted to hand over power to three consuls: Bonaparte, Sieyès, and Ducos.

◀ Jacques-Louis David, *The Death of Marat*, 1783. Brussels, Musées Royaux des Beaux-Arts.

▲ Jacques-Henri Sablet, *The Council of the Five Hundred*, 1799. Nantes, Musée des Beaux-Arts.

Pure geometric forms dominated by the sphere are central to the projects of an architecture whose symbolic lines were also meant to transmit new political and social ideals.

Utopian Architecture

Notes of interest
Akin to science fiction is Claude-Nicolas Ledoux's *Project for the Foresters' House* (1790): the three-level building is perfectly spherical and owes its stability to the exterior flying-buttress stairs that recall the legs of a spaceship. Its architect loved pure geometric lines on a monumental scale and almost without ornament.

In the renewal of the arts spurred by the Enlightenment that resulted in the late-century Neoclassical style, architecture, too, tried to find a language consonant with the new ideology. This renewal entailed not just an inspiration and a return to the rigorous ancient Graeco-Roman world but also innovative projects that would join the purity of classicism with the aspirations of modern man. There was, first of all, an attempt to return to restraint and functionality. Artists now tried to shed the superfluous in search of a product that would be "useful" to man. Therefore, next to an architecture that retraced ancient styles, a new, "utopian" or "visionary" architecture began to take shape, so called because most of its designs stayed on paper and were never executed. In such cases, the architect was less interested in the usefulness of the building than in its symbolic function. The leading interpreters of this trend were the architects and essayists Étienne-Louis Boullée (1728–1799) and Claude-Nicolas Ledoux (1736–1806). Boullée was a professor of engineering and the author of several theoretical works; he designed a few buildings in Paris that no longer exist. We can, however, learn about his ideas from some of his surviving large drawings. He sought to achieve a total geometric lucidity of form and a decorative restraint. He used Classical architecture, which he studied intensively, in pursuit of a singularly personal vision—rigorous, geometric buildings so large as to preclude construction. One design, *Project for a Royal Library* (1785), featured an extremely long colonnade and an immense, coffered barrel vault.

▼ Claude-Nicolas Ledoux, Barrière de La Villette, 1785–89. Paris.

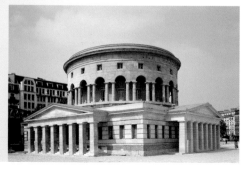

This project was never built. It is an example of an ambitious Neoclassical architecture that wanted to measure its strength with great works that would be worthy of Imperial Rome.

The perforated vault filters the rays of the sun, creating, with the aid of nature and without painted artifice, the impression of a starry sky.

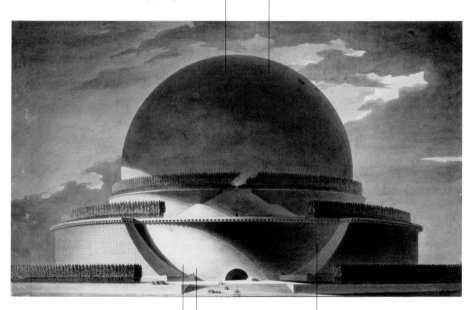

A gigantic globe, symbol of the immensity and perfection of the universe, is supported by a cylindrical, terraced base. Post-revolutionary France praised Boullée's ideas, in which it saw the principles of a new architecture.

The inventor of "shadow architecture," as he himself defined it, Boullée designed a cosmic sphere sparkling with light as a cenotaph for Newton, who had discovered order in the infinite and thus was a hero of Neoclassical values.

Boullée wrote: "O Newton, with your vast wisdom and your sublime genius, you determined the shape of the earth; and I conceived the idea of enclosing you in your own discovery."

▲ Étienne-Louis Boullée, *Design for Newton's Cenotaph*, 1784–85. Paris, Bibliothèque Nationale.

PLACES

Central and Eastern Europe
Saint Petersburg
Warsaw
Berlin-Potsdam
Dresden
Meissen
Munich
Bavaria
Swabia
Residenzstädte

Mediterranean Europe
Paris
Sèvres
Madrid
Turin
Milan
Venice
Rome
Naples
Constantinople

Hapsburg Empire
Vienna
Salzburg
Innsbruck
Melk and Sankt Florian
Prague

Anglo-Saxon Lands
London
Bath
Edinburgh
United States

◄ Bernardo Bellotto, *Vienna from the Belvedere* (detail), 1758–59. Vienna, Kunsthistorisches Museum.

Central and Eastern Europe

Saint Petersburg

Warsaw

Berlin-Potsdam

Dresden

Meissen

Munich

Bavaria

Swabia

Residenzstädte

The capital of the czarist empire, Saint Petersburg was to be a city to model Russia's political and cultural greatness. Summoned by the czars, great artists came from all over Europe to build it.

Saint Petersburg

Saint Petersburg, the "window on Europe," was founded in 1703 by Peter the Great. Its sumptuous palaces were to remind the West of the wealth and political power of Russia. The enormous projects attracted workers from all over Europe. In 1752, construction began on one of the largest projects of 18th-century Europe, the Winter Palace ; the plan also called for rearranging the surrounding area and building three squares. The main architect was Bartolomeo Francesco Rastrelli, who came to Russia in 1715 with his father, the czar's favorite Italian sculptor. A man with a deep knowledge of the arts, Bartolomeo had in 1741 become court architect to Empress Elizabeth and in that role had perfected an original style that combined French Rococo with Baroque and traditional Russian decorative motifs. In those same years, the Fine Arts Academy was founded. Around 1760, the decorative and architectural trends turned more temperate and measured, but not less elegant. Continuing Peter the Great's policy, Catherine II had instituted an enlightened absolutism: she modernized the empire culturally and economically, raising it to the level of the leading European powers, opening the doors to the new classicizing language, and completing an urban plan that encompassed many public buildings, streets, and squares, including the Fine Arts Academy headquarters. In 1763, the empress asked Giacomo Quarenghi to build a pavilion to be called the Hermitage, inspired by the fashion of situating guest quarters in green areas: the small building was erected in the park of the Winter Palace, and she had about ninety paintings hung there— the original nucleus of the future great museum.

Notes of interest
In designing the court theater in the Hermitage (1783–87), the Italian architect Quarenghi, following the Neoclassical fashion, decided to eliminate the traditional 18th-century boxes and drew from the amphitheater plan that Palladio had designed for Vicenza's Teatro Olimpico.

◀ Bartolomeo Francesco Rastrelli, Winter Palace, 1753–62. Saint Petersburg.

Nattier ended his career having lost favor with both the public and Diderot. The latter was the leading consultant to Empress Catherine II in creating the collection that was to become the core of the Hermitage.

Nattier's nimble, elegant brush easily captures the czar's imperious look without lingering on his psychological traits, which were not required in a celebratory portrait such as this one.

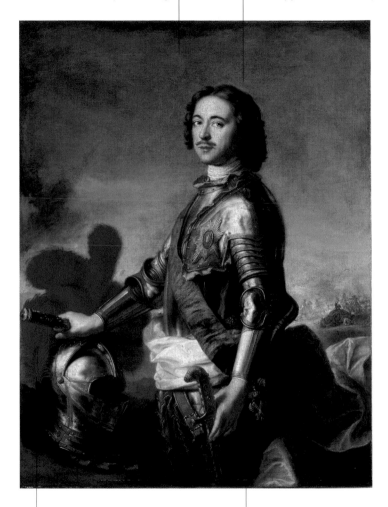

The red, fluffy feathers on the czar's helmet are a brilliant pictorial and chromatic invention, a strong counterpoint to his serious posture.

The portrait was done in 1717 while the czar was in Holland. Wanting to introduce Western customs and habits to his country, Peter repeatedly invited Nattier to Russia, but the artist refused.

▲ Jean-Marc Nattier, *Peter the Great*, 1717. Saint Petersburg, Hermitage.

This portrait was commissioned by the institution that benefited from Demidov's donations, the Moscow House of Education, which hung the picture in its boardroom.

Prokofy Demidov (1710–1786) enjoyed the favor of Catherine II and created his own botanical garden in Moscow with many rare plants.

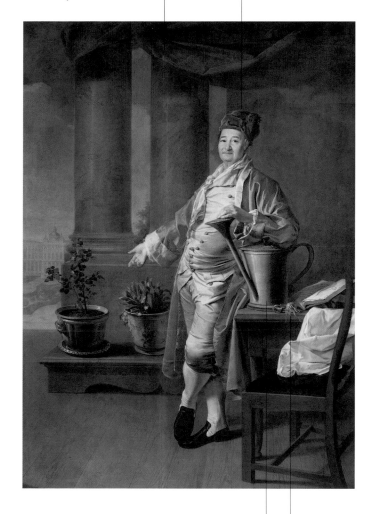

The Russian painter Levitsky (1735–1822) executed this rather original portrait: Demidov is dressed in his robe, surrounded by flowerpots and leaning on a watering can.

The objects in this canvas, such as the bulbs on the table and a book on plants, are concrete examples of the taste of this passionate naturalist and his ingenious, unique personality.

▲ Dmitri Levitsky, *Portrait of Prokofy Akinfievish Demidov*, 1773. Moscow, Tretyakov Gallery.

In the background under the small, circular, Neoclassical temple is a statue of Minerva, protector of the arts.

Giovanni Battista Lampi (1751–1830) was a celebrated portraitist active in several European courts, including Vienna, Warsaw, and Saint Petersburg. In addition to portraits of Catherine II and leading Russian court figures, he painted this portrait in Saint Petersburg, where he had come in 1791.

This lady is portrayed standing next to one of her own drawings and holding a mechanical pencil. On the table are a bust portrait, scattered papers, and books—all signs of the intellectual and artistic pursuits of the aristocracy.

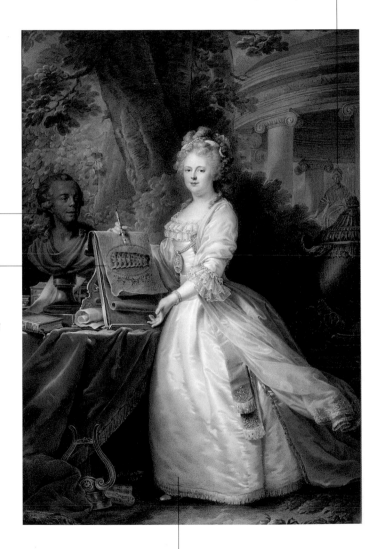

▲ Giovanni Battista Lampi, *Portrait of Maria Feodorovna*, 1795. Saint Petersburg, Pavlovsk Palace Museum.

The white silk skirt has a shiny, bright texture and is highlighted by brushstrokes where the light reflects. The long, embroidered veil flutters above the orange-colored overskirt.

Warsaw's population quadrupled in the 18th century, and the city became Poland's leading political, scientific, and artistic center.

Warsaw

In the early part of the century, under the rule of the electors of Saxony who had also become kings of Poland in 1697, the city developed close artistic ties with the court of Dresden. Karcher was called to expand the royal castle, joined in 1728 by Longuelune and Pöppelmann; the latter had created Dresden's Zwinger Palace and was asked to draw up a plan for the Saxon Palace. There were also fertile contacts with Italy, many of whose architects and painters worked in Warsaw, and France; in particular, entire palace interiors, such as the *boiserie* designed by Meissonier for the Bielinski Palace, were ordered from Paris. Under the reign of Stanislaus Augustus Poniatowski (1764–95), the arts reached their zenith. The king was a collector and an amateur artist, and he encouraged the latest European trends by inviting artists such as Victor-Nicolas Louis, André Lebrun, Jean Pillement, and Per Kraff to work on the new projects and to organize the Fine Arts Academy that would train Polish artists. Italians were dominant at the time: from 1765, Marcello Bacciarelli (1731–1818) and Domenico Merlini da Valsolda (1731–1797) were, respectively, the court's first painter and architect. They were joined in 1767 by Bernardo Bellotto, who painted twenty-six city landscapes. In these years, the model of the Neoclassical palace was defined with a colonnaded portico, a characteristic design that prevailed throughout Poland until the middle of the 19th century: one such example is Villa Lazienki, set inside an English-style park.

Notes of interest
At the end of World War II, ninety percent of the city lay in ruins. The reconstruction that followed was based on documentary evidence, especially Bellotto's drawings and views, which are precious and accurate proofs of the city's original appearance.

▼ Bernardo Bellotto, *View of Krakowskie Przedmiescie from Swiat Street*, ca. 1778. Warsaw, National Museum.

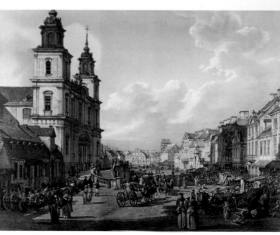

According to the Latin poet Horace, Fortune is the lady of the seas, whose waves strike fear in sailors. In fact, the artist has painted a boat in the background, a clear allusion to the changeable winds.

Fortune is a fickle goddess who unpredictably hands out wealth and favors; for this reason, she is painted blindfolded. According to Apuleius, she was "blind, actually without eyes."

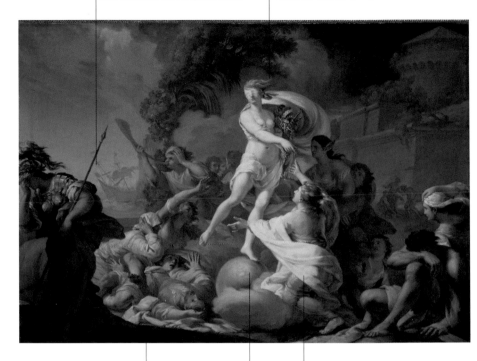

The Polish painter Tadeusz Kuntze-Konicz (ca. 1731–1793) created some of his works in his home country, such as altarpieces for churches in Krakow and Warsaw, then moved to Rome, where he died. In Rome he was known as Taddeo Polacco.

Fortune is poised on a sphere, symbol of instability and of the world over which her dominion extends.

As is clear from the style of this painting, the artist adopted the late Roman Baroque style. In 1756 he worked at the Church of Saint Stanislaus of the Polish in Rome, painting colorful popular scenes.

▲ Tadeusz Kuntze-Konicz, *Fortune*, 1754. Warsaw, National Museum.

▶ Jacques-Louis David, *Count Stanislaus Augustus Poniatowski*, 1781. Warsaw, National Museum.

Under Stanislaus Augustus Poniatowski a "Polish Enlightenment" developed, sustained by a group of French-educated intellectuals; the Italians, however, dominated the art scene.

A brilliant azure punctuates the skillful arrangement of soft white, yellow, and gray tones, from the sash fluttering in the wind to the saddle and the pretty ribbons decorating the horse's mane and tail.

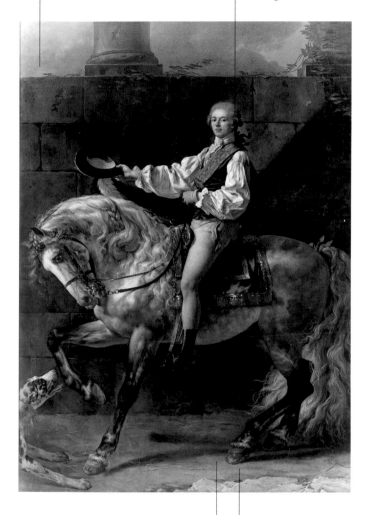

The Polish king organized weekly banquets at court, in which artists—mostly Italian—participated; hence the name "Italian dinners."

This exuberant portrait recalls lessons of Rubens and Van Dyck for achieving a highly sensitive, almost pre-Romantic pictorial energy, very unlike the measured production of late Neoclassicism.

Berlin became a cultural and artistic center, a symbol of the political and military power that asserted its prestige. Kings and aristocrats alike built sumptuous Baroque palaces there.

Berlin-Potsdam

Notes of interest
One building in Potsdam's Neuer Garten designed by the architect Andreas Krüger in 1792 was known as the "ice warehouse." It was shaped like a large Egyptian pyramid with hieroglyphics that referred to the planetary symbols of the Rosicrucian tradition.

▼ Georg Wenzeslaus von Knobelsdorff, Music Room, 1745–50. Potsdam, Sanssouci Palace.

Toward the latter part of the 17th century, Prussia, the strongest German state, was asserting its political and military power over the rest of Europe. Ruled since the 15th century by the Hohenzollern family, lovers of art and culture, the Brandenburg-Prussian state had always attracted artists. As the capital of the new Prussia, Berlin was being transformed by impressive urban plans and architectural projects. In 1698, Andreas Schlüter had planned the restoration of the ancient castle that rose on the Spree River Island. It was to be part of a much larger project, but after the new park-side wing was completed, work was suspended as the country fell into a deep economic crisis because of the huge sums that Frederick I had squandered in his delusions of grandeur. Fortunately, Frederick II the Great resumed his predecessor's promotion of arts and culture; he had a predilection for French Rococo. It was a flourishing time for culture: the court architect Georg von Knobelsdorff built the classical-style Opera Theater (1741–43) and the Sanssouci Palace at Potsdam (1745–47). The king loved the spirited French Rococo, and even the name of the palace— *sans souci* means "carefree"—is reminiscent of it. Sanssouci had

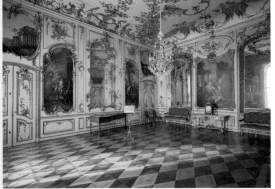

originally been designed as the king's country residence, a sort of *maison de plaisance* (leisure house) away from the rigid protocols of court life in Berlin. In 1786, Frederick William II took the throne and continued to support the arts, promptly turning to Neoclassicism. In 1788, Carl G. Langhans built the new Brandenburg Gate at the end of Unter den Linden Boulevard in pure Neoclassical style.

In 1740, Frederick II, a lover of philosophy, music, and architecture, asked the architect Knobelsdorff to expand Charlottenburg Palace, urging him from the battlefields of the Silesian War to finish the works.

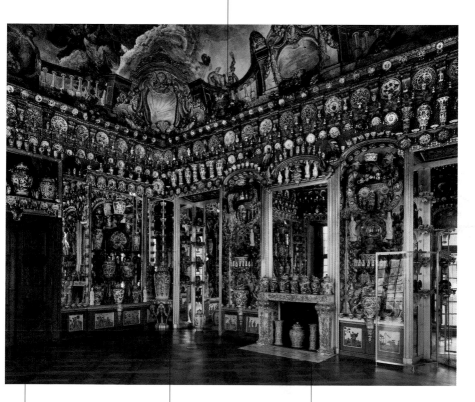

The growing imports of precious objects from India, China, and the Far East—ivory, lacquer, and porcelain objects, in particular— helped create an aristocratic taste for collecting. The opening of European porcelain factories in the early part of the century was an explicit alternative to the Eastern porcelains, even to the point of plagiarizing them.

This Berlin Wunderkammer contains an exceptional collection of Chinese and Japanese objects. The room was designed to house the precious collection, with showcases, shelves, and niches from the floor to the high ceiling moldings for displaying as many pieces as possible.

Charlottenburg Palace is one of the few surviving structures in Berlin that bears witness to the splendor of the Hohenzollern court. Sophia Charlotte wanted a summer residence next to the city and transformed it into a salon for intellectuals and artists. At her death in 1705, her husband, Frederick I of Prussia, changed the name of the palace and the surrounding village to Charlottenburg in her memory.

▲ Porcelain Room. Berlin, Charlottenburg Palace.

In 1794, Goethe called Dresden "an unbelievable treasure"; others called it "Florence on the Elbe." In the Saxon capital, Heinrich von Kleist felt as if he were "under Italian skies."

Dresden

Frederick Augustus I, the Strong (1670–1733), and his son Frederick Augustus II (1696–1763), who delegated his powers to the prime minister, Count Brühl, so that he could devote himself fully to his passion for art, transformed Dresden into a precious treasure. The two electors used the wealth of the Saxon state, whose traditional mining activities were being converted into metallurgical and mechanical industries. Under the direction of the best architects, an urban plan took shape on both sides of the Elbe River, culminating in the Zwinger residence designed by Matthäus Daniel Pöppelmann and Balthasar Permoser. Pöppelmann was also responsible for the exotic-looking Japanese Palace (1737), designed to house the royal porcelain collection. In the meantime, the print collection and the antiquarian sculpture museum with original Greek works of art were being formed. The most ambitious project was the Gemäldegalerie: created for pure aesthetic pleasure, it is one of the few royal collections not formed from war spoils. Its core was the Este ducal collection, purchased by Frederick Augustus II in 1746: five caravans packed with 100 paintings, including Raphael and Correggio masterpieces, left Italy for Dresden. And it was in Dresden in 1755 that Winckelmann published his *Reflections on the Imitation of Greek Art*, the first manifesto of Neoclassicism. Around the end of the century, distinguished travelers could be admitted to visit the

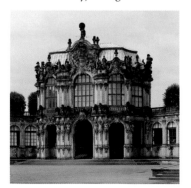

Münzkabinett, a coin collection that had been started 200 years earlier, or the Green Vault treasure of jewels and goldwork with uniquely cut precious stones and objets d'art. In the 18th century, Dresden went from being a *Wunderkammer* to a *Wunderstadt*: a city of wonders.

▶ Matthäus Daniel Pöppelmann, Zwinger Pavilion, 1709–28. Dresden.

The coach stops in front of the building on the left, the sumptuous royal gallery. The paintings were hung one adjacent to the next, as was the custom then, separated into Northern European and Italian schools.

In the background is the dome of the Frauenkirche, built between 1726 and 1743 by George Bähr. Sitting inside the golden coach pulled by six white horses, Augustus II is greeted deferentially by some bystanders.

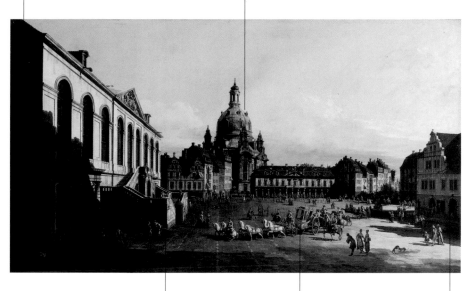

Frederick Augustus II placed an order with Bellotto for fourteen views of the city, to be duplicated for his prime minister, Count Brühl. Unable to have the painter at her side, Catherine II of Russia purchased most of the canvases painted for Brühl at an exorbitant price. They still hang today at the Hermitage.

This painting is one of the richest representations of the Saxon capital. Tn the center of the square the artist has placed the elector's coach heading toward the Johanneum.

The view captures the still, cold, crystalline light, with alternating lights and shadows, bright and dark bands, and the shadows of clouds and buildings.

▲ Bernardo Bellotto, *New Market Square in Dresden*, 1749–52. Saint Petersburg, Hermitage.

This painting was made during Bellotto's second stay in Saxony; it depicts with extraordinary optical clarity the destruction of the Gothic Church of the Holy Cross, one of the city's greatest monuments. The church would be rebuilt a few years later in Rococo style.

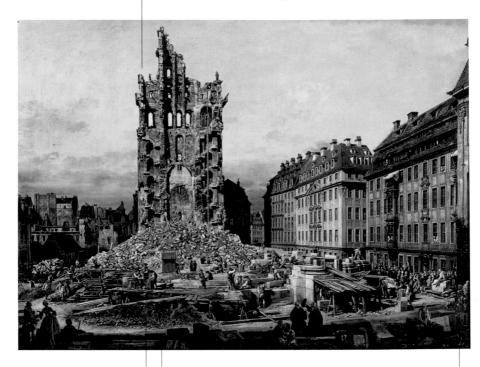

The church was destroyed by Prussian bombs on July 19, 1760, during the Seven Years' War. This canvas is one of the most powerful antimilitary statements in the history of art.

This image of destruction, almost an anatomical dissection of the ruined building, reappeared two centuries later when Dresden was devastated by the Allied bombings at the close of World War II.

Bellotto moved to Dresden in 1747 when he was only twenty-six years old, invited by Frederick Augustus II, elector prince of Saxony. Augustus wanted him to paint panoramas of the city, setting on canvas the city's ambitious monuments and modern architecture.

▲ Bernardo Bellotto, *Ruins of the Kreuzkirche in Dresden,* 1765. Dresden, Gemäldegalerie.

Meissen owes its fame to the discovery of porcelain, a fascinating story in itself. Thanks to this discovery, extremely fine and elegant pieces were produced in Europe starting in the 18th century.

Meissen

This town bloomed after Augustus I ordered the establishment of a factory for the production of porcelain, a precious material for which the European aristocracy had increasingly clamored since the previous century. No one knew the formula, which was a closely guarded secret of the Celestial Empire. The elector prince of Saxony, Augustus I, attracted by the precious material, commissioned Friedrich Böttger, a Meissen alchemist who was rumored to know how to manufacture gold, to discover the formula for porcelain. A first effort by Böttger produced a highly resistant dark-red *grès* that could be polished to a high smoothness and faceted like glass. The alchemist combined white kaolin and calcinated alabaster to produce the first European-made porcelain, wholly similar to the Chinese porcelain, on January 15, 1708. Two years later, the first Königliche Porzellan Manufaktur (Royal Porcelain Manufactory) was founded: it was a proud moment that aroused intense envy in the other European courts. Although Augustus I kept Böttger under the strictest surveillance to prevent him from revealing the secret formula, after the alchemist died in 1719 two workers stealthily fled Meissen and secretly sold the formula to the Viennese competition. At this point, Johann Klinger, from the Vienna Manufactory, visited the Meissen factory in disguise and stole the processing and painting secrets. The last details were obtained when Johann Ringler, the keeper of the Meissen formula, was relieved of his precious notebook while drunk. It was at this point that porcelain began to be produced in many European factories with truly extraordinary results.

▼ Johann Joachim Kändler, Double Candlestick, ca. 1765. Castle of Mosigkau (Dessau), Staatliche Galerie.

Subjected to a number of transformations and expansions, Munich in Bavaria became an aristocratic, refined city with elegant Baroque palaces and, at the end of the century, fine Neoclassical buildings.

Munich

Notes of interest
The Altes Residenztheater
(court theater), designed
by François de Cuvilliés,
is a jewel of Munich
Rococo: the hall is richly
decorated in ivory and
gold, and the ceiling was
frescoed by Johann
Baptist Zimmermann.

Several Italians were among the leading players in Munich's architectural transformation and helped introduce the Baroque to Bavaria. Among them were Agostino Barelli and the young Enrico Zuccalli, who worked on the 17th-century Church of the Theatine Fathers. Also well known at the time was Joseph Effner, an architect who, like François de Cuvilliés, loved French Rococo. In 1725, Cuvilliés was appointed city planner by the elector of Bavaria and worked on numerous buildings, including the Holstein Palace (later the Archiepiscopal Palace), the façade of the Church of the Theatine Fathers, and Amalienburg, in the park of Nymphenburg Castle, residence of the Bavarian kings until 1718. The Amalienburg great hall is lined with lavish arched mirrors and wide windows, with ornate silver-painted stucco in a variety of shapes. The Baroque style, which was connected to the Counter-Reformation imposed by Rome, found fertile soil in Catholic Bavaria. The Asam brothers, considered the great masters of trompe l'oeil and among the best interpreters of the German late Baroque style, decided in 1733 to build a church in Munich dedicated to Saint John Nepomuk. The building they owned was only thirty feet wide; still, they used spiral columns, elegant balustrades, and dizzying galleries, all decorated with gilded stucco arabesques and frescos. In the second part of the century, classicizing lines replaced the late Baroque: at the same time, urban planning came to the fore, in part due to pressure exerted by the upper bourgeoisie, who wanted structures that reflected them as well. Thus Munich built new districts with plain houses decorated in Neoclassical style.

▼ François de Cuvilliés, Hunting Lodge, 1734–39. Munich, Amalienburg.

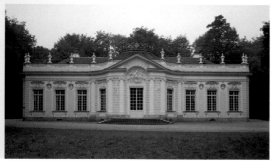

The western façade of the summer residence of the elector of Bavaria is depicted here. The symmetrical gardens occupy the area in front of the villa and are arranged in ornamental flower beds and paths.

In the distance, the city's profile is visible, in particular the Theatinerkirche and the Frauenkirche.

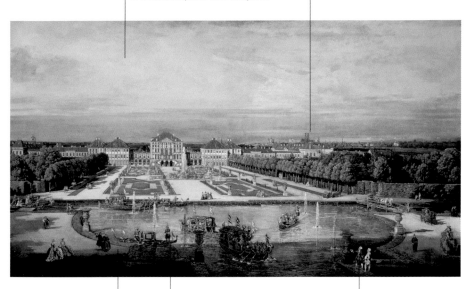

In addition to three large panoramas, one of Munich and two of Nymphenburg, Bellotto painted this canvas for Elector Maximilian III Joseph to decorate his Munich Residenz.

The four gondolas and their gondoliers came from Venice: the prince had them imported to provide pleasure excursions for the court ladies and gentlemen. The lower edge of this drawing cuts off the rectangular reservoir where the pleasure boats and gondolas, decorated in white and blue, the national colors of Bavaria, arrived and departed.

This canvas may have been painted to commemorate celebrations organized in 1761 by Elector Maximilian III Joseph for the visit of Charles Theodore, Palatinate Elector, both visible in the lower right.

▲ Bernardo Bellotto, *Nymphenburg Palace Seen from the Park*, 1761. Washington, D.C., National Gallery.

The interior projects a scenographic effect, like a Bernini theatrum sacrum, a unique ensemble of architecture, sculpture, and painting.

This church is known as Asamkirche because it was entirely built and decorated at their own expense by the Asam brothers.

Although the space was small, the Asam brothers filled the church with spiral columns, elegant balustrades, and tall, narrow galleries embellished with frescoes and gilded stucco arabesques. Their skills recall those of Borromini, who knew how to work with the most varied shapes in small spaces.

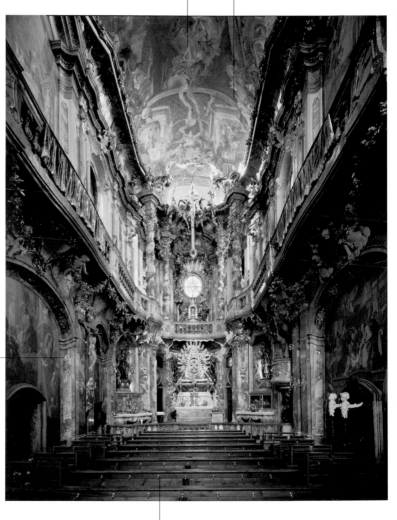

▲ Cosmas Damian Asam and Egid Quirin Asam, Interior of the Church of Saint John Nepomuk, 1733–35. Munich.

The nave opens up to the faithful a rich décor in an illusionistic interior ending with a barrel vault lit by two windows. Trained in Rome, the brothers were well acquainted with the Italian Baroque and the scenographic effects that could be created by architectural perspectives.

The chalice with the snake is an attribute of Saint John. The priest of the Temple of Diana in Ephesus had given a poisoned cup to the saint in order to test his faith, since two men had already died after drinking from it. Not only was John not affected, but he also resuscitated the two men.

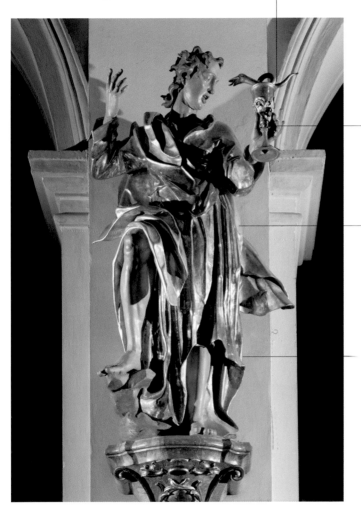

Starting in the Middle Ages, this attribute became symbolic, with the chalice representing the Church and the snake, Satan.

Ignaz Günther, the leading Rococo sculptor in southern Germany, also worked at Saint Peter's, carving the wooden altars. The nervous, almost flickering drapery of the saint draws from his style.

Saint Peter's is in Marienplatz, the heart of the city. It is the oldest parish church in Munich. Inside are frescoes and stucco work by Johann Baptist Zimmermann and statues of the four doctors of the Church sculpted by Egid Quirin Asam (1732). The elegance and refinement of the nave harmonizes with the church's plastic and pictorial décor.

▲ Joseph Proetzner, *Saint John the Evangelist*, ca. 1767. Munich, Saint Peter's.

From the end of the 17th to the middle of the 18th century, religious architecture flourished in Bavaria, creating an original Baroque language that was among the most refined in Europe.

Bavaria

Notes of interest
One typical feature of Bavarian churches is the dissimilarity between the outside structure and the interior: one expects a certain kind of space and finds a different one, very scenographic and complex, some also with illusionistic effects.

▼ Johann Baptist Zimmermann, *The Incarnation of Christ and His Sacrifice*, detail of the vault fresco, 1744–54. Wieskirche, near Steingaden.

The Baroque style that matured in Catholic Italy after the Counter-Reformation was meant to attract the beholders, involving them emotionally through a sense of wonder and bewilderment. For this reason, the Church of Rome made the style into an effective instrument of faith, in opposition to the bare austerity of the "heretical" Protestant Reformation that had turned iconoclasm into a point of pride. While the houses of worship of northern Germany were built to reflect austerity and the belief in direct contact between the believer and God preached by Luther and Calvin, in Bavaria to the south the Catholic tradition produced extraordinarily rich and original art. The proximity to France and Italy, furthermore, facilitated contact with artists and craftsmen from those countries: a large number of Italians worked for years in the Catholic principalities north of the Alps in close contact with native craftsmen. While the bare northern churches offered few challenges commensurate with the skills of painters and decorators, in Bavaria the need to build new, sumptuous houses of worship stimulated the adoption of the Baroque language with its refined, exuberant, sometimes almost cloying results. We can admire some of these examples in the churches of Steingaden (Wieskirche), Rohr, and Ottobeuren. In keeping with a theatrical, scenographic intent, the interiors of these luminous Rococo churches must be admired dynamically, moving around to capture ever-changing, spectacular perspectives. To restore the church of the Benedictine Abbey of Ottobeuren, the most famous architects of the time were consulted, including Dominikus Zimmermann. The convent church of the Augustinian Canons of Rohr has on the altar an astonishing *Assumption of Mary* (1732) sculpted by Egid Quirin Asam, an excellent example of Baroque theatricality, with extraordinarily animated trompe l'oeil effects.

The Wieskirche (church in the meadow) rises between the woods and grasslands. According to the custom of the time, the church's space had two zones: the ground floor, symbolizing Earth, with the statues of the fathers of the Church and the Virtues; and the raised pulpit, where the Word is proclaimed. The latter rises like a stairway to Heaven, where Christ triumphs.

In 1738, a statue began to weep; this miracle caused the monks of the nearby monastery of Steingaden to build a shrine to accommodate the crowds of pilgrims. The project was assigned to Dominikus Zimmermann, a stucco artist who designed the entire décor and collaborated with his older brother Johann Baptist, who executed the stuccoes and the vault fresco.

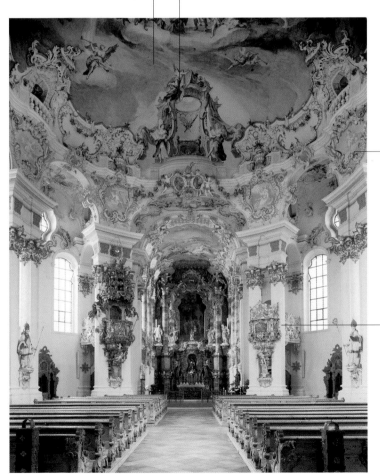

The rich stucco decoration in the rocaille style almost dissolves the architectural structure: the white and gilded stuccoes are part of the architecture, creating an indissoluble oneness.

The architect has chosen to arrange the oval plan of the church on coupled columns of an unusual quadrangular shape and has added a long chancel to increase the perspectival effect.

▲ Dominikus Zimmermann, Interior of the Wieskirche, 1745 54, near Steingaden.

In a triumph of resplendent white and gilded stuccoes, the figures are refined and elegantly shaped; the drapery has a nervous, mobile plasticity.

Steeped in the family tradition, the Asam brothers were the leading Rococo decorators of the Catholic churches of southern Germany.

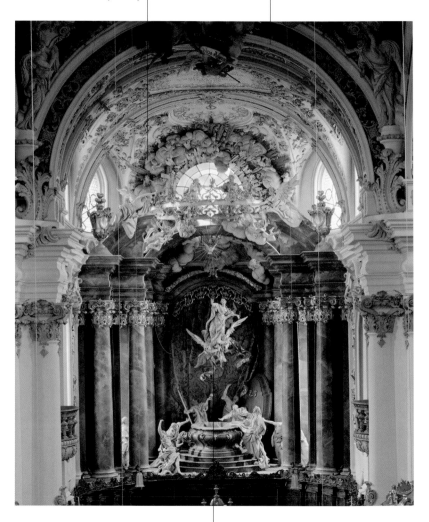

▲ Cosmas Damian Asam and Egid Quirin Asam, *Assumption of Mary*, 1723. Rohr, Church of the Augustinian Convent.

The imposing high altar construction in the late Baroque style reaches an intense theatrical vortex in the fusion of architecture, sculpture, and décor. The ascending Virgin, supported by two angels, rises over the empty sepulchre and the emphatically gesturing apostles.

The abbey's exterior is restrained, with dynamic multilinear outlines.

The reconstruction took place in two phases: first the monastic buildings (1717–31), then the spectacular church. The perspectival frescoes by Johann Jakob Zeller alter the perception of space, and the décor and sculptures project a rich overall sense of movement.

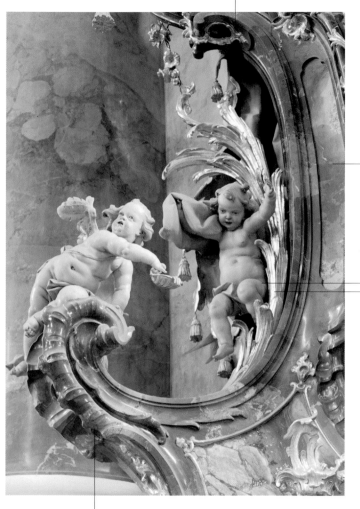

Two stucco cherubim play among the curly frames, suspended in mid-air.

The altars, pews, monks' stalls, and organ stand were all fashioned by the sure hand of Johann Michael Feuchtmayr.

A masterpiece of the Bavarian Rococo, the church of the millenarian Benedictine Abbey of Ottobeuren is an amazing blend of architectural structures and decorative elements that change one's perception of space.

▲ Joseph Anton Feuchtmayr,
Cherubim, 1757–64.
Ottobeuren, Abbey.

145

Many religious buildings built or restored in Swabia are in the dominant Baroque style, with rich libraries that house precious ancient manuscripts.

Swabia

▼ Joseph Anton Feuchtmayr, *Putto Sucking Honey*, 1748–50. Birnau, Church of Our Lady.

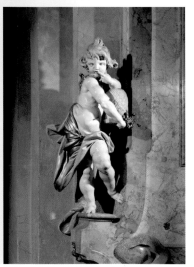

From Austria to Bohemia, the new sacred architecture spread to Franconia, Swabia, Switzerland, Bavaria, and Saxony, thanks in part to the commissions by monastic orders that were augmenting the real-estate holdings of their monasteries with investment potentials not unlike those of the aristocracy. Many Benedictine, Cistercian, and Premonstratensian convents were rebuilt in whole or in part, often on a scale and with proportions that equaled lavish princely residences. In Swabia, the architectural structure tended to fuse and become one with the stucco decoration and with sculpture and painting, a sort of *Gesamtkunstwerk* (total work of art) that created a deep impact on account of the powerful dynamism it projected. The construction of new churches in southwestern Germany was led by the Vorarlberg Civil Engineering School. The architects drew from theoretical and practical teaching and collaborated with the stucco craftsmen of Wessobrunn in designing buildings densely decorated with white and gilded stucco. Architects, sculptors, stucco workers, and painters of high distinction were involved, such as the Zimmermann brothers, Peter Thumb, Januarius Zick, and Joseph Anton Feuchtmayr. Near the medieval town of Biberach an der Riss (known as the "Baroque paradise of Upper Swabia" for its many sumptuous buildings), the Zimmermann brothers built a true masterpiece in 1728–33, the church of Steinhausen. The exterior of the church is white and compact, while inside is a scenographic oval nave surrounded by a ring of tall composite pillars. Dominikus decided to highlight the upward movement by asking his brother to paint a large fresco on the vault, with prodigious trompe l'oeil effects.

The bright white dazzles the faithful in the nave, while overhead in the oval vault, the colors are brilliant.

Thanks to the stucco decorations and figures, the heavenly vault that is inaccessible to the faithful appears close at hand because of the great variety of birds and animals that fill the connecting spaces between nave and vault.

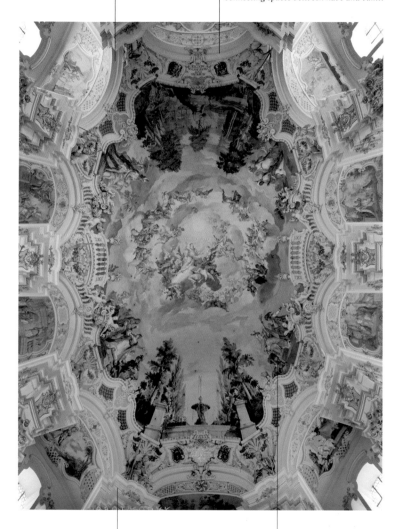

▲ Johann Baptist Zimmermann, *The Four Continents Pay Homage to the Virgin*, 1731. Steinhausen, Church of Saints Peter and Paul.

Dominikus Zimmermann, the painter's brother, designed the church between 1728 and 1733 as an elongated elliptical plan with ten isolated, spectacular pilasters that highlight the height of the building.

Johann Baptist Zimmermann painted in fresco the allegory of the four continents and the symbolic image of the Garden of Eden.

In 1744, Martin Kuen frescoed the vault (not pictured) with an allegorical celebration of classical and Christian knowledge.

It was not just emperors and princes who built libraries to conserve knowledge, but the monastic orders, too, including the Benedictines and the Cistercians, who had a millenarian tradition as keepers of knowledge.

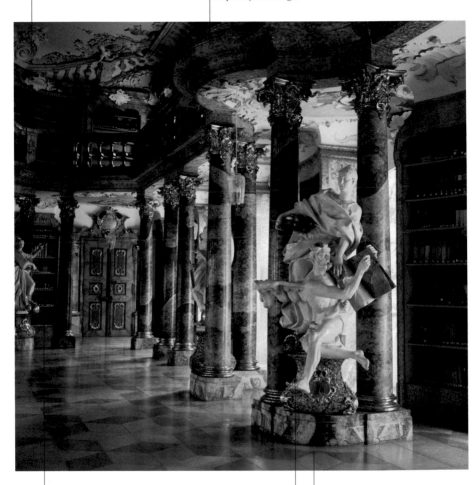

The books are arranged on shelves in a decorative and monumental exuberance that recalls royal palaces.

▲ Benedictine Monastery Library, ca. 1744. Wiblingen (Ulm).

The allegorical representations of the Virtues and the sciences are sculpted on each side of the room.

In the middle of the 18th century, the Wiblingen Benedictine monastery built its library, perhaps using a design by Christian Wiedemann. The room, arranged in a winding gallery pattern, is marked by thirty-two columns in red and green marbleized wood topped by rich gilded capitals.

The German princes built private residences as lavish as royal palaces, since architecture and pomp were essential elements in the political and economic power game.

Residenzstädte

The scenographic splendor of the Residenzstädte, or city-residences, is a symbol of the autonomy of local power and its fragmentation into many small principalities. They are also examples of how the boundaries between the different arts (architecture, painting, sculpture, interior décor) were erased and subsumed into one powerful means of expression. In Pommersfelden, the Weissenstein Castle (1711–18) was designed by Johann Dientzenhofer and Johann Lukas von Hildebrandt as the summer residence of the prince-bishops of Bamberg. The more innovative, theatrical space is the monumental staircase covered by a vast vault and enriched with stucco decorations. According to Dientzenhofer, the staircase had a strategic function in receiving guests: it was meant to welcome them and act as a proper reception area. Hildebrandt added an arched, airy gallery that highlighted the verticality of the space, ending in the large fresco by Johann R. Byss. One of the most celebrated residences is in Würzburg, a small Bavarian town that flourished between the 17th and 18th centuries thanks to the patronage of the prince-bishops Schönborn. Around 1720, the prince commissioned the architect Balthasar Neumann to build a gigantic family palace. Neumann designed the plan, harmonizing the overall proportions: the central part of the building, the eight-sided Kaisersaal, is surrounded by other areas, including a triple reception staircase. It is among the most majestic examples of the northern Baroque. After seeing Weissenstein, Neumann planned this space to be freestanding. The viewer is dazzled by the elegant balustrades supported by large arches and further embellished with dynamic sculptures, as well as by the extraordinary ceiling fresco that Tiepolo painted in homage of the prince.

Notes of interest
In addition to the many splendid Baroque rooms designed for the opulent society life of the princes, the Residenzstädte had lovely French-style gardens with flower-beds, ponds, and fountains, and long shaded *allées* lined with sculptures and copses.

▼ Johann Dientzenhofer and Johann Lukas von Hildebrandt, Mirror Room, 1711–18. Pommersfelden, Weissenstein Castle.

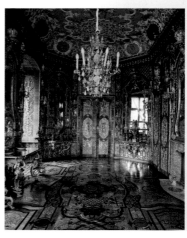

François de Cuvilliés, architect at the court of Munich, was called to complete the project. He created a French-style country residence with elegant Rococo interior decorations.

On the ceiling, Carlo Innocenzo Carlone painted in 1743 The Apotheosis of Wittelsbach. He also frescoed the ceiling of the grand staircase, the chapel, and several other rooms for the large sum of 5,325 thalers.

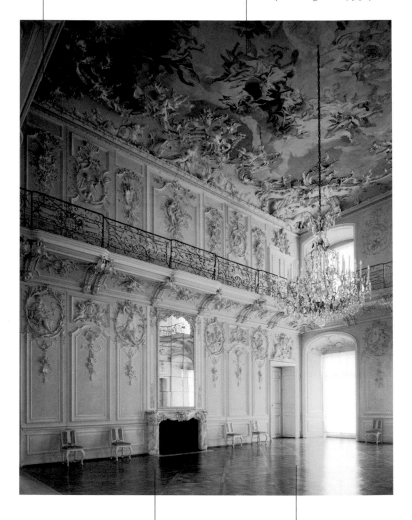

▲ François de Cuvilliés, Dining Room, 1728–43. Brühl, Augustusburg Castle.

This residence, a masterpiece of French-Bavarian Rococo, unique in the Rhine region, was commissioned by Archbishop and Elector Prince Clement Augustus, and was named after him.

In 1741–44, Balthasar Neumann designed a scenographic staircase with a vestibule of dynamic lines and curves, twin columns, and amazing figured pilasters (not pictured).

Along the cornice and in the vast vault, Tiepolo has put on display an impressive, dizzying summa *of geographic and natural science knowledge. It is the largest fresco ever painted.*

Leaning on the cornice are allegories of Europe, Africa, Asia, and America, each one surrounded by references to their part of the globe, immersed in a phantasmagoric world of fauna and flora, a truly unique pièce de resistance.

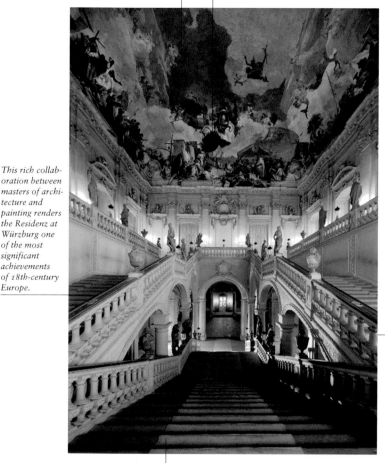

This rich collaboration between masters of architecture and painting renders the Residenz at Würzburg one of the most significant achievements of 18th-century Europe.

For their residence, the members of the Schönborn family evaluated the plans of architect Neumann, who had even traveled to Paris and Vienna to document his proposal.

▲ Balthasar Neumann, Staircase, and Giambattista Tiepolo, Fresco, 1737–53. Würzburg, Residenz.

At Würzburg, Neumann built a "theater of light" with the scenographic staircase at the center. The three flights of stairs rise under Tiepolo's vault. The palace rooms and the frescoed vaults follow one another in a spectacular mise en scène *designed specifically for the palace.*

Residenzstädte

Assisted by his sons Giandomenico and Lorenzo, Tiepolo created rigorous architectonic backdrops on which crowds of characters in extravagant costumes move, following carefully composed arrangements.

Under a wide theater curtain of white and gilded stucco, designed by Tiepolo and executed by the Ticinese artist Antonio Bossi, Tiepolo has drawn an episode from the city's history, chosen by the patron to provide historical legitimacy to his position as prince and bishop.

Tiepolo's activity at the court of the prince-bishop of Würzburg opens with the frescoes of the imperial room—an explosion of light and color. The complex iconographic ensemble in which Greek mythology, the Germanic Middle Ages, and the tradition of local episcopal power converge is transformed into a dazzling tour de force.

Carefree figures of pages, heralds, and soldiers lean on the cornices, with a movement that is both airy and highly inventive.

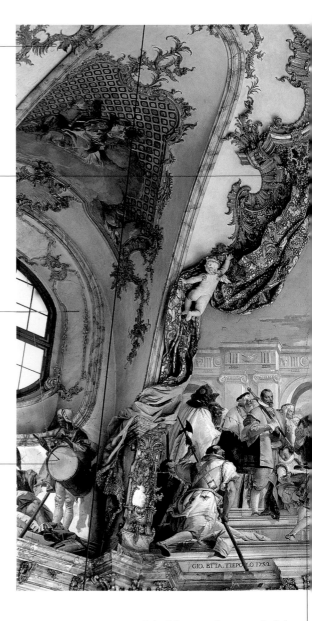

GIO. BTTA. TIEPOLO 1752

▲ Giambattista Tiepolo, *Investiture of Bishop Herold*, 1751–52. Würzburg, Residenz, Kaisersaal.

Behind the page, who seems to look down at the viewer, under a triumphal arch is the imperial treasurer with the deed of investiture; next to him, the princes of the empire and the marshal of Franconia.

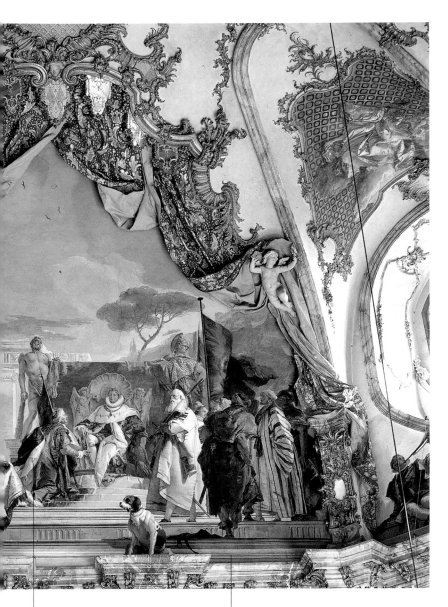

Bishop Herold received, in 1168, the duchy of
Franconia from Emperor Frederick Barbarossa
at the Diet of Würzburg. The figure of the
bishop resembles the reigning prince in the
mid-18th century, Carl Philipp von Greiffen-
klau, who commissioned the work.

A dog sits on the throne steps and
looks toward the viewer, more
interested in the visitors than in
the stately celebration of power.

Hapsburg Empire
Vienna
Salzburg
Innsbruck
Melk and Sankt Florian
Prague

In 1685, the Hapsburg dynasty chose Vienna as their primary residence. Thus, the city became a vast construction site of splendid aristocratic palaces that gave it an elegant, wealthy air.

Vienna

After defeating the Ottoman army that had besieged the city in 1683 and a few years later freeing Hungary once more from the Turks, Austria, on the threshold of the new century, was experiencing strong economic growth and territorial expansion. This engendered a desire to make Vienna into a capital of European standing, which opened the door to building projects and to many foreign artists. The best Austrian architects were Johann Bernhard Fischer von Erlach (1656–1723) and Johann Lukas von Hildebrandt (1668–1745), both of whom were hired in different years as chief architects at the imperial court. They worked for many years in the planning and construction of palaces for the aristocracy and the imperial family, although Fischer's reputation is linked above all to a sacred building: Saint Charles Borromeo Church, begun in 1715 as an *ex voto* of Charles VI after a plague epidemic, is considered the purest example of Viennese Baroque. The sumptuous quality of the church, especially powerful in the apse area, marries perfectly with the façade, which projects the rigorous elegance of Classical temples; flanking the imposing hexastyle pronaos, two magnificent columns with reliefs narrating the life of Saint Charles are reminiscent of Trajan's Column in Rome. The Baroque palaces that were built in Vienna between about 1690 and 1750 are all embellished with rich paintings and sculptures. A large altarpiece by Sebastiano Ricci and another by Giovanni Antonio Pellegrini, both in Saint Charles's Church, evoke the Italian-style tradition, Venetian in particular; they served as exact formal models for the local artists. Large frescoes decorating the vaults became quite fashionable, and as a result the painters Johann Rottmayr and Daniel Gran were in great demand. In 1757 Bernardo Bellotto arrived at court; he painted very beautiful *vedute* until 1761.

Notes of interest
In 1695, to celebrate the defeat of the Turks, a royal palace with a large park was commissioned; it was to become the Austrian Versailles. The first, lavish project was set aside for a more modest but still elegant and sumptuous one: Schönbrunn Castle, with 1441 rooms, lived its most prestigious hour during the Congress of Vienna.

▼ Johann Bernhard Fischer von Erlach, Saint Charles Borromeo Church, 1715–37. Vienna.

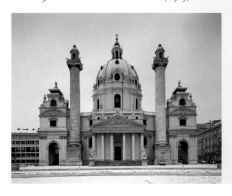

Aurora and Apollo were among the allegorical personifications best loved by the court aristocracy because they represented the prince's fair and ethical actions in a cosmological context.

Having moved to Vienna in 1715, Carlone was introduced to Viennese society by Prince Eugene of Savoy, who commissioned him to paint compositions for his new palace.

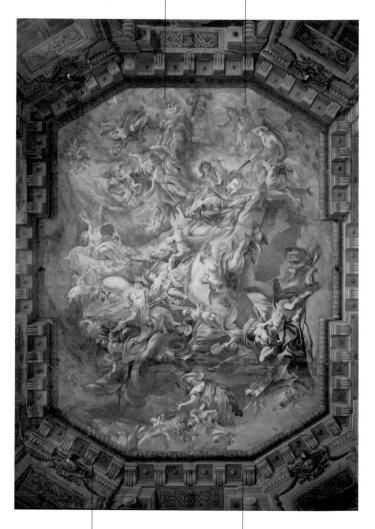

In this fresco, Carlone's nimble, spirited brush has created an eddying ensemble of figures—angels, putti, clouds, and drapery—as darting and cutting as those of the preparatory sketches.

Eugene of Savoy commissioned Hildebrandt to build him a palace to be used as a summer residence: the plan called for two buildings, the Lower Belvedere (1714–16) and the Upper Belvedere (1721–22), connected by a garden.

▲ Carlo Innocenzo Carlone, *Apollo and Aurora*, ca. 1715. Vienna, Belvedere Palace.

This sculpture, part of the Mehlmarkt (Flour Market) fountain and one of the artist's best known works, was commissioned by the city of Vienna. Providence is surrounded by four putti playing with fish.

Four figures, including this one, were originally arranged around the fountain's border and personify the most important tributaries of the Danube, which the fountain's water represents. The originals are now in museums, and copies were made for the fountain.

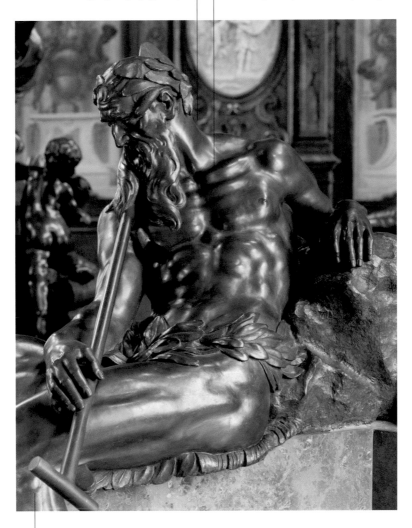

Donner (1693–1741), a preeminent late Baroque Austrian sculptor, favored a shiny, soft lead alloy. The river personification, in a resting position, is elegantly proportioned with full plastic modeling.

▲ Georg Raphael Donner, *The River Enns*, 1737–39. Vienna, Osterreichische Galerie.

This canvas is part of a series of thirteen views of Vienna made by the artist for Empress Maria Theresa during her stay in the capital. This particular view was drawn from the Upper Belvedere, the magnificent palace of Prince Eugene of Savoy.

The bell tower of Saint Stephen's Church rises above the roofs of the city's center, dividing the visual surface of the painting in half.

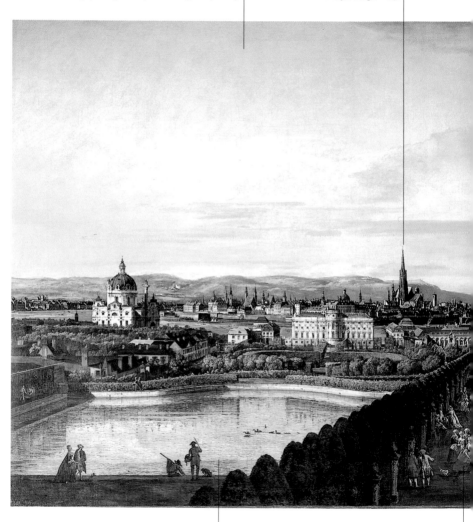

The city opens up to the onlooker in its full amplitude. The architectonic structure is presented by a close-up view of two gardens: that of the Schwarzenberg Palace on the left and of the Belvedere on the right.

In the garden, the lady dressed in flaming red attracts the attention of two gentlemen passersby. The carefree, light-hearted image projected by the figures is a distinctive trait of court life, which Bellotto has captured in other views of Vienna.

The scenic composition presents both human and architectural elements, protagonists in a complete fusion of theater and life.

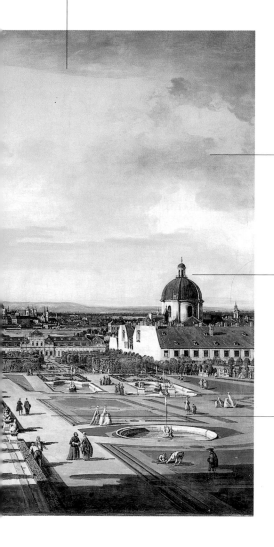

Bellotto describes everything as sharply as possible: the hills in the background, the monuments rising above the old town, the buildings, the people, the lights, and the shadows. The painter looks out from the terrace and leaves us an everlasting view of the city.

When Bellotto, then thirty-nine years old, reached Vienna in 1758, the city was the leading center of Baroque architecture and culture. The cupolas of Saint Charles, on the left, and of the Salesian Church, on the right, define the painting's borders.

The artist has chosen to paint the city in the late afternoon light so as to direct the viewer's eye to the whitewashed façades of the two churches on each side and lengthen the shadows of the nobles strolling in the gardens.

▲ Bernardo Bellotto, *Vienna from the Belvedere*, 1758–59. Vienna, Kunsthistorisches Museum.

New Baroque churches and palaces endowed the city with the elegant, aristocratic look it still has today. Leading this change was the architect Fischer von Erlach.

Salzburg

Between the 17th and the 18th century, a number of ancient buildings were restored or restructured. Salzburg underwent extensive urban planning thanks to the city's archbishop, Johann Ernst Thun Hohenstein, a nobleman who dreamed of making it into the "Rome of the North" and built several religious and residential buildings. The architect at the center of this ambitious project was the Austrian Johann Bernhard Fischer von Erlach. The son of an appreciated sculptor, he had studied sculpting for years in Rome, but after seeing the majestic works of Bernini and Borromini, he had become smitten with architecture and the innovative, fanciful Baroque language. Back in his home country, he put to use what he had learned in Rome, adapting it to a local taste that was flavored with Nordic elements. In 1694, Fischer was called from his home in Vienna to Salzburg to build four churches: Trinity Church and the churches of Saint John, of the Ursulines, and of the College. His Salzburg work solidified his reputation, and he became a model for many architects who followed him. Trinity Church has a concave front opening inside on

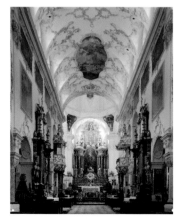

▶ Interior of the Church of the Benedictine Abbey of Saint Peter, 1753–85. Salzburg.

an oval nave that ends at the high altar, above which rises a perfectly proportioned dome. Two years later, Fischer began the Collegiate Church, for which he designed an original convex façade flanked by two large towers. After these two churches, Fischer von Erlach (by then he had received a title of nobility) was called back to Vienna to build the great Church of Saint Charles Borromeo.

The archbishop of Salzburg assigned Fischer the task of beautifying the city. The architect focused on the harmonious, aesthetic, and functional relationship between new and pre-existing buildings.

Fischer created a strong contrast between the two lateral towers and the façade, giving the latter a convex form and making it appear to move forward from the perimeter line.

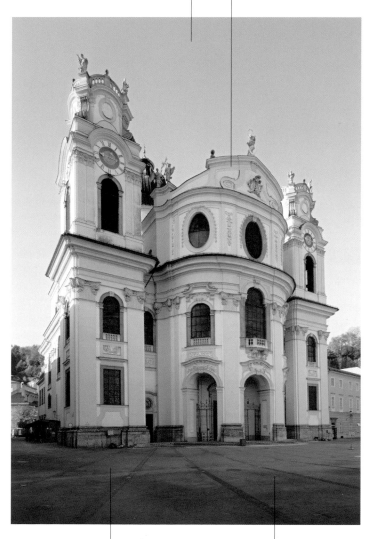

▲ Johann Bernhard Fischer von Erlach, Collegiate Church, 1696–1707. Salzburg.

The inspired ratio between the powerful façade and the small square in front created the most monumental space in the city.

Fischer studied how to introduce the mobile, multilinear scenographic fronts of his buildings into the existing architecture. This church is a successful example.

Innsbruck bears artistic traces of her illustrious past. The season of frothy Austrian Rococo brightens the imperial palace and many other buildings, both sacred and secular.

Innsbruck

Notes of interest
In Herzog-Friedrich-Strasse, the most distinctive street in the city's old town, stands the 15th–16th century house where Mozart lived in 1769.

▼ Matthäus Günther, *Judith with the Head of Holofernes*, 1755. Innsbruck, parish church of Wilten.

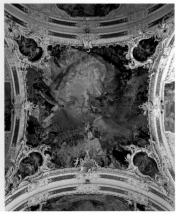

The residence of the princes of Tyrol and an episcopal seat, Innsbruck lies at the intersection of two strategic natural routes: the Inn River Valley that leads to Switzerland and the valley that joins the Italian Val d'Adige to Bavaria. These two arteries made it an important center of Hapsburg power over the centuries. In the 18th century, the city grew with new religious and residential buildings designed in the pervasive architectural style coming from Italy and the German Catholic regions: in fact, the entrance to the old town is marked by a triple barrel-vaulted triumphal arch built in 1765 and completed with Balthasar Moll sculptures that celebrate the wedding of Leopold V of Tuscany (the future emperor Leopold II) and at the same time the death of Francis Stephen of Lorraine, husband of Empress Maria Theresa. It was a busy time for architecture, for ornamental sculpture with elaborate stucco and woodwork, and for painting. Besides the monumental decorations commissioned by princes or powerful monastic orders, a large number of small-size paintings were also produced along with preparatory canvases, sketches for larger compositions, and compositions painted with fresh immediacy and quick brushwork. Among the leading interpreters of Austrian Rococo are Paul Troger and Franz Anton Maulbertsch: in 1775, the latter painted the vast reception salon of the Hofburg, the imperial palace used as summer residence, with *The Triumph of the Hapsburg-Lorraine Dynasty*. Much earlier, in 1708, Carlo Innocenzo Carlone had come to Innsbruck to fresco the Church of the Ursulines and bring to local painting the modern Italian taste, leaving a benchmark to which other artists would refer throughout the century. The Parish Church of Wilten, a jewel of Tyrolean Rococo, was decorated with Feuchtmayr stuccoes and, in 1755, with the surprising aerial perspectives of Matthäus Günther's frescoes.

Ambitious projects signaled the restructuring of medieval abbeys similar to the joining of the sacred and the political under the Hapsburgs and the Holy Roman Empire.

Melk and Sankt Florian

Abbeys of such refined and ostentatious architectural and artistic splendor are rare outside Austria. The powerful abbots not only had the same financial resources as princes but also the same passion for flamboyant artistic endeavors. The plan and the interior decoration of the monasteries resemble those of the princely mansions, with elegant apartments, staircases, halls, and libraries filled with stuccoes and frescoes. Much of the monastic architecture of this period was planned by sculptors, stonecutters, and craftsmen who worked in easy accord with the suggestions of the cultivated abbots, instead of refined court architects. Such was the case for the most dramatic of all abbeys, the Benedictine Abbey in Melk, built by the Tyrolean sculptor Jacob Prandtauer (1660–1726) on a rocky spur high above the Danube. Prandtauer also worked on the Augustinian Abbey of Sankt Florian, south of Linz, designing a wing with a richly sculpted portal and a staircase that led to the emperor's quarters. The Benedictine Abbey of Kremsmünster was renovated between 1709 and 1713 by Carlo

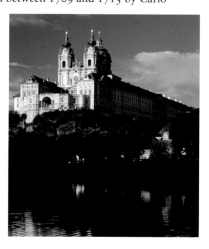

Antonio Carlone, who had previously worked at Sankt Florian and built the imperial salon, and by Prandtauer, who designed the entrance courtyard. Between 1748 and 1760, an extraordinary seven-story observatory was built for the academy of young noblemen, a modern scientific school that competed with the more renowned Jesuit academy.

Notes of interest
Not far from Vienna, Klosterneuburg Abbey is a masterly example of *unio mystica et terrena,* the fusion of God and the world in the empire. Rebuilt in 1730 by Charles VI with the intent of making it a "Hapsburg Escorial," the decorative elements celebrate the empire and Vienna as the center of the world, both understood as a pole forever in opposition to France and Paris.

◄ Jacob Prandtauer and Joseph Munggenast, Melk Abbey, 1702–38.

The structure of the load-bearing archi-tectural elements and the molded stucco decorations stand out in the generous light pouring from the wide windows of the nave and from the drum of the dome.

The theatrical effect of the exterior, rebuilt between 1702 and 1738 on a rocky outcropping above the Danube, continues in the interior of the church.

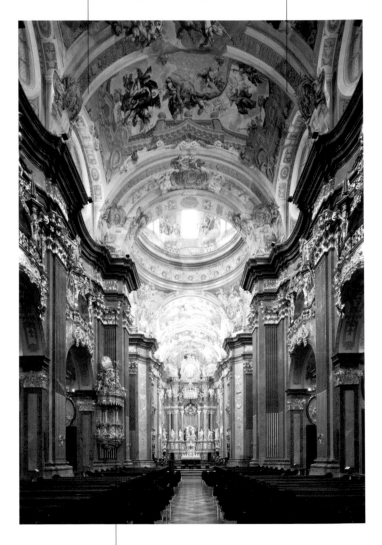

▲ Jacob Prandtauer and Joseph Munggenast, Church Interior, 1702–38. Melk Abbey.

The combined white and yellow chiaroscuro effects of the exterior, which reflect in the waters of the Danube, are recalled here in the glittering gold of the interior. The symbolic centrality of the church appears clearly in the building complex.

This elegant reception salon is one example of the decorative and pictorial exuberance that embellishes the entire abbey.

The frescoed ceiling is the work of Martino Altomonte (1658–1745) and represents Prince Eugene of Savoy triumphing over the Turks, thus highlighting both imperial power and that of the Church.

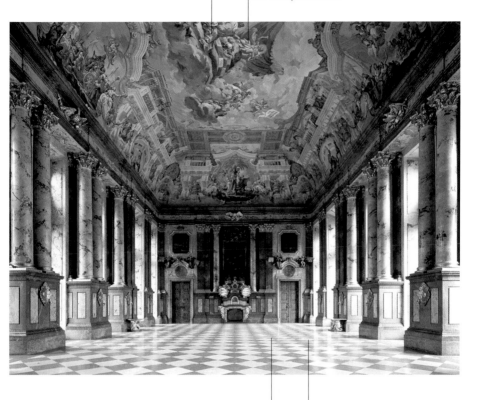

Prandtauer built a wing with this elegant marble room that extends beyond the convent's perimeter. He thus wanted to establish a close iconographic link with the abbey church, for there Faith triumphs, and here in this room, Unbelief is defeated.

After the death of Carlo Antonio Carlone, who had begun reconstruction of Sankt Florian Abbey in 1686, the Augustinian canons called Jacob Prandtauer to finish the project in 1706.

▲ Jacob Prandtauer,
Marble room, 1706–24.
Sankt Florian Abbey.

A putto with a lit torch stands before the lowered curtain of the Turkish headquarters, the crescent on top of the torch.

The rooms of the imperial apartment are connected by means of an elegant double staircase decorated with arcades and a powerful columned arch, designed by Prandtauer.

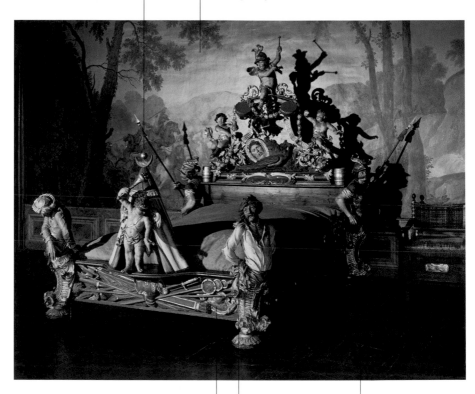

This extravagant piece of furniture is in the imperial quarters of Sankt Florian Abbey. Customarily, the most important monasteries kept an apartment for the emperor, should he decide to visit.

The bed is of finely carved wood. On the headboard, figures of soldiers and putti extol victories; on the footboard are carved two defeated Turks.

The figured decorations recall the victories of the Hapsburg Empire led by Eugene of Savoy against the Ottoman Empire, with brilliant expressiveness and marked realism.

▲ The Turkish Bed, 1707.
Sankt Florian Abbey.

Architecture takes pride of place in Prague, thanks to experienced professionals with backgrounds primarily in Italy and France. The result is an unusually elegant, refined Baroque.

Prague

Prague had two especially prosperous periods: the Middle Ages, when it became the capital of the Holy Roman Empire, and the Baroque era. Among the outstanding architects are the members of the Upper Bavarian Dientzenhofer family, who worked in 17th- and 18th-century Prague. After the political and cultural influence of the Catholic Austrian Hapsburgs waned, Prague had to fill the need for new Catholic churches: many were built in those years, such as the churches designed by Christoph Dientzenhofer (famous for the Church of Saint Nicholas, a jewel of Prague Baroque), and his son Kilian Ignaz, whose masterpiece is the Church of Saint John of the Rock (1718–44). The latter is notable for the unusual solution of two bell towers placed diagonally, giving the façade an unusual scenographic effect. Kilian Ignaz Dientzenhofer also designed Villa Amerika, a summer residence (now the Dvořák Museum) built in 1720 for Count Wenzel Michma, and the chancel, dome, and bell tower of Saint Nicholas: when it was completed in 1745, it was hailed as one of the most beautiful churches in Europe. The Hapsburg modernization program required the transformation of many Gothic churches, sometimes radically, to harmonize with the new aesthetic. A singular case is architect Johann Santin-Aichel: fascinated by medieval architecture, he left many sections in their original state, creating amazing syntheses and harmonies between the two very different styles. The Austrian Fischer von Erlach also worked in Prague, designing the Klam Gallas Palace (1707–12), whose portal is topped by an imposing *Atlas* statue, the work of his compatriot Matyas Bernard Braun. The Baroque construction brought with it a sculptural reflowering: one masterly example is the choreographic Charles Bridge on the Vltava (Moldau) River, decorated by very beautiful, precious statues.

Notes of interest
The paintings from this period are not as sublime as the architecture. Nevertheless, two great painter-decorators who worked in Prague deserve mention: Václav V. Reiner and the German Franz Anton Maulbertsch; the latter, who had trained in Vienna, became one of the best Rococo fresco painters in Europe.

▼ Christoph Dientzenhofer, Shrine of Our Lady of Loreto, from 1721. Prague.

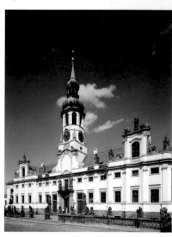

Mediterranean Europe
Paris
Sèvres
Madrid
Turin
Milan
Venice
Rome
Naples
Constantinople

In the 18th century, Paris was the leading light in architectural and artistic styles, the great capital of Europe, a political and cultural beacon, and a city of aristocratic splendor and bourgeois achievements.

Paris

From Rococo to Neoclassicism, Paris dictated the rules of good taste, both in the rich decorations and refined interiors of the first half of the century and in the clear, geometric perfection of the second half. Rococo reached the summit of expressiveness in the Princess Room, designed for the wife of the Prince de Soubise. It is a round room with mirrored wall panels, light and gilded-stucco figures and arabesques, and large windows. In 1742, Ange-Jacques Gabriel inherited his father's position as first architect to King Louis XV. Among his most ambitious projects was Place de la Concorde (originally Place Louis XV), lined with classical-style buildings of majestic symmetry and elegance. Also classically inspired was the style Jacques-Germain Soufflot chose in 1755 for the Church of Sainte Geneviève: a monumental central plan with a large dome resting on walls punctuated by light-filled windows. The windows were walled up during the Revolution when the building was deconsecrated and renamed the Panthéon. The style follows faithfully the severity of ancient temples, with imposing colonnades and a tympanum decorated with sculptures. Around 1780, the Odéon Theater, with its wide, austere, column-shaded façade, was built by de Wailly and Peyre. At century's end, the utopian projects of Ledoux and Boullée, inspired by the values of the Revolution, were prominent. The Parisian 18th century was also marked by the work of painters whose influence was to extend to all of Europe: the vibrantly colored *fêtes galantes* of Watteau inaugurated the new century, which continued with the erotically tinged paintings of Boucher.

▼ German Boffrand and Charles-Joseph Natoire, Princess Room, 1735. Paris, Hôtel de Soubise.

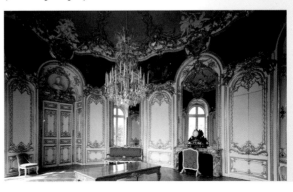

La Tour documented the ostentation
and the official face of contemporary
Parisian life with professional mastery
and dazzling chromatic brilliance.

Excelling in the difficult, delicate
pastel technique applied to portraits,
La Tour followed the example of
Rosalba Carriera, who brought the
technique to Paris around 1720.

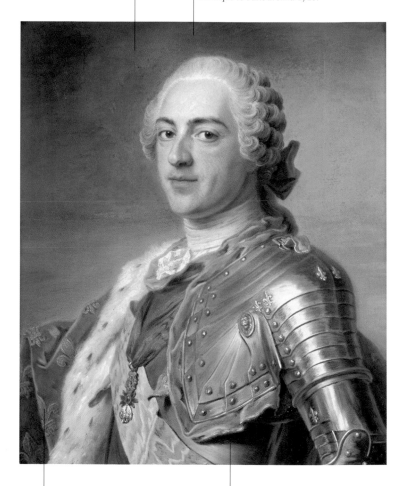

The mantle edged with ermine fur bears
French fleurs-de-lys embroidered in
gold. The king wears, tied to a ribbon,
the golden ram, signifying his member-
ship in the Order of the Golden Fleece.

The search for refined, elegant
effects pursued with skillful virtuos-
ity does not compromise the fresh-
ness of the pastel, even in the more
formal, celebratory works such as
this portrait of the king of France.

▲ Maurice-Quentin de La
Tour, *Portrait of Louis XV,*
1748. Paris, Musée du Louvre.

The library bookcases are reflected in the mirror, signifying, like the open book she holds in her hand, the marquise's love of culture.

The elegance and psychological insight that the artist—the marquise's favorite—brought to this portrait are extraordinary; he has created an elegant, natural, unaffected image of a woman who is yet conscious of herself and her cultivation.

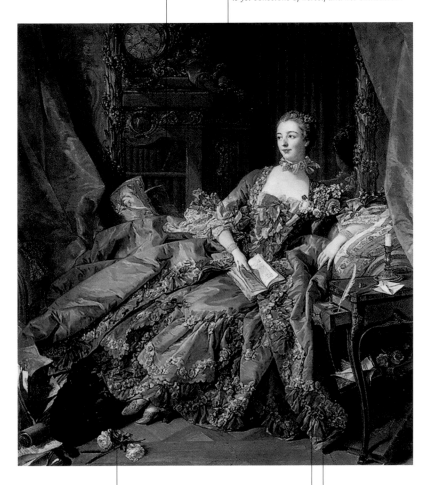

On the wooden parquet are a mechanical pencil and the drypoint, drawing, and etching tools that bear witness to the marquise's love and practice of those arts.

▲ François Boucher, *Portrait of Madame de Pompadour*, 1756. Munich, Alte Pinakothek.

The beautiful, cultured, and elegant Marquise de Pompadour (1721–1764) became Louis XV's mistress in 1745. A lover of the arts, she was also a patron of philosophers and intellectuals such as Voltaire and Rousseau and enabled the publication of the Encyclopédie to continue, notwithstanding a suppression order.

The sumptuous gown embroidered with tiny roses takes up a large part of the canvas. The surrounding objects reveal a private locale, with books, musical scores, writing implements, and a faithful little dog

171

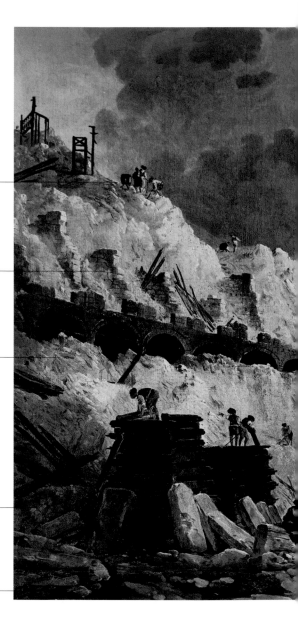

After climbing the mountain of rubble, some laborers are working on top. Robert was fascinated by dilapidated stones, their crumbling, worn texture, and he painted other demolitions that took place in Paris in the wake of the Revolution.

The light reflects on the powdery white of the sun-baked stones, while the other side of the bridge decays in the shade.

The long, white mound of stone rubble becomes dematerialized in the thick paint, like soft, powdery snow.

After spending about ten years in Italy, Robert submitted a canvas to the Salon of 1767 that depicted an assemblage of famous decrepit Roman monuments. Upon seeing it, Diderot exclaimed, "Oh, the lovely, the sublime ruins!" They were ancient ruins; here they are new, but the artist's taste has not changed.

Starting in the early part of the century, after the Rococo excesses, Paris was infused with new architectural trends that drew from classicism and from the rationalism of the Enlightenment.

▲ Hubert Robert, *The Demolition of Houses on the Exchange Bridge*, ca. 1788. Paris, Musée Carnavalet.

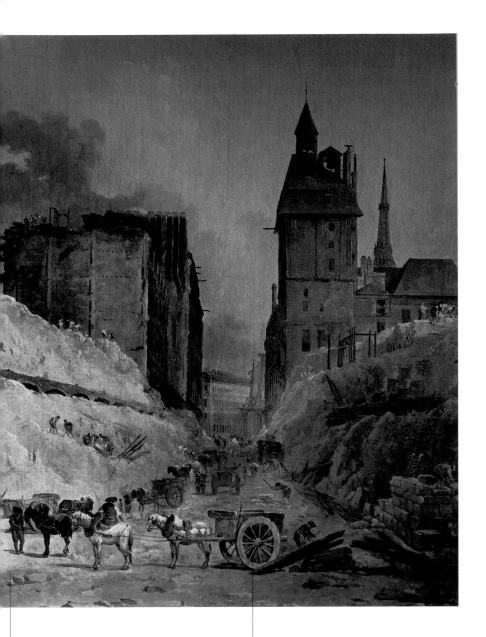

All the bridges of Paris had shops and
houses, except the Pont Neuf. The houses
were demolished to give a new look to the
city, in keeping with the new urban planning.

The carts are waiting to
be loaded with the larger
stones that will be resold
for use in new buildings.

Henri IV, whose statue rises on the high
pedestal in the center of the composition,
inaugurated the Pont Neuf in 1607.

On the right is the massive
Louvre complex.

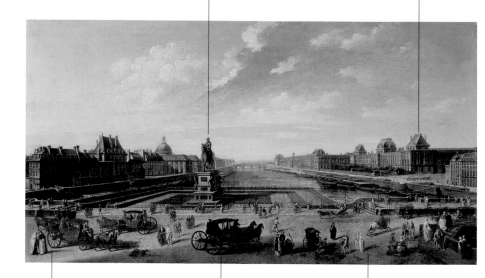

The Pont Neuf is in the
foreground; the view takes
in the buildings along the
Seine, leaving space for a
sky that fills more than
half the canvas.

The name notwithstanding,
the Pont Neuf is the oldest
bridge in Paris, having
been built to connect the
Louvre to the Abbey of
Saint-Germain-des-Prés.
A lively scene with coaches
and pedestrians in motion
fills the bridge.

Raguenet (1715–1793)
painted another view of
the city as a companion
to this one; it portrays the
Île de la Cité and hangs
in the same museum.

▲ Jean-Baptiste Raguenet, *A
View of Paris from the Pont
Neuf*, 1763. Los Angeles,
J. Paul Getty Museum.

▶ René-Michel Slodtz,
*Funerary Monument of
Languet de Gergy*, 1753.
Paris, Saint-Sulpice.

The sculptor Slodtz (1705–1764) shows on the one hand the formal influence of the Roman Baroque, and on the other, a preclassicist style similar to that of Bouchardon.

After a protracted stay in Rome, from which he took the nickname Michel-Ange, he became a court sculptor in Paris. His best works were religious and funerary pieces such as this tomb.

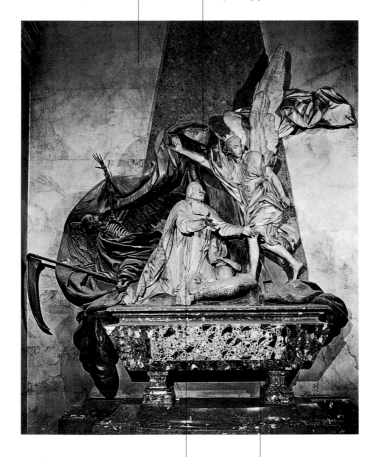

This monument projects strongly and is animated by the dialogue among the dying ecclesiastic, the Angel, and Death. Instead of sculpting the effigy of the deceased in a reclining position, Slodtz represents him kneeling as he peacefully welcomes either his successor or Eternal Life, which has wrested him from the horrible skeleton of Death.

The sarcophagus and the pyramid are in the classical funerary tradition, as are the marbles of different colors.

Site of a major porcelain factory, Sèvres was distinguished for the refined quality of the products that decorated aristocratic palaces throughout Europe.

Sèvres

▼ Étienne-Maurice Falconet (after a subject by François Boucher), *The Education of Eros*, 1763, Sèvres porcelain. Private collection.

Long before the secret of hard-paste porcelain was discovered in Meissen in 1708, some French manufactories had succeeded in producing "soft-paste" porcelain by combining white clay and vitreous material. Soft-paste is more delicate and has a warmer look than hard-paste porcelain, but it is not as bright. A soft-paste manufactory was established in Vincennes in 1738 with a twenty-year monopoly on products that were at first inspired by Meissen's. Subjects in blue on a white and gold-leaf background were inspired by Watteau's and Boucher's paintings. The production was so successful that in 1756 King Louis XV declared it a Royal Manufactory and moved it to new prestigious headquarters in Sèvres. During the Seven Years' War (1756–63), the Meissen Manufactory was temporarily closed, and this made the fortune of the Sèvres works. The manufactory was greatly expanded also thanks to Madame de Pompadour, whose refined taste influenced production. Sèvres was a magnet for artists such as the sculptor Étienne-Maurice Falconet. It became renowned especially for its highly refined solid-color backgrounds and its unusual gold-leaf work. Initially inspired by an affected Rococo, the items produced followed the dominant taste, becoming soberly classical starting in the 1760s, both in decoration and in forms inspired by antiquity. Products included dinnerware and hot beverage sets, vases, figurines, grooming articles, chandeliers, and watch cases. The most prestigious set, consisting of 744 pieces, was made for Catherine II of Russia. The background colors, whose unusual hues were protected by royal charter, were especially successful: the famous *bleu lapis* or *bleu de Vincennes*, a dark, brilliant blue used in the 1750s; *bleu céleste*, a well-known turquoise shade introduced in 1753; *bleu royal*; and Pompadour pink.

Artists and architects of the first order worked intensely in Madrid in this century, which culminated in the Tiepolo frescoes of the royal palace and closed with Goya's new, powerful art.

Madrid

Expanded in the 16th century, Madrid was chosen by Philip II in 1561 to be the capital of his kingdom. Thus began a long season of urban planning that was meant to make the city an embodiment of Spanish power. After a long dynastic war, Philip V of the House of Bourbon, a nephew of Louis XIV, ascended the throne. A century of artistic development then began, although the country's political power was overshadowed by France, England, and Austria, the new major European powers. The Bourbons called to court the best Spanish and foreign artists, including many Italians. The projects for the Aranjuez and La Granja residences and for the royal palace, to be rebuilt on the site of the Arab *alcázar* destroyed by a fire in 1734, were designed in 1735 by Filippo Juvarra; after his death the following year, he was replaced by his student Giovan Battista Sacchetti. At the royal palace worked Corrado Giaquinto, Giambattistsa Tiepolo, and Anton Raphael Mengs. Tiepolo was invited to Madrid by Charles III in 1762; by then, Giaquinto had left after a ten-year sojourn and Mengs had arrived. In addition to the above-mentioned architecture, the second half of the century saw the construction of the Prado, among other edifices. By then, the influence of Neoclassicism had toned down the excesses of the Baroque style. In this phase, the architects Rodriguez, Sabatini, and especially Juan de Villanueva, the royal architect who built numerous palaces including the Prado and the Astronomical Observatory, stand out. The great protagonist of the closing years of 18th-century Spain is Goya, who trained on the Italian models he found at court. In 1799, a year after he frescoed the dome of San Antonio de la Florida, Charles IV appointed him "first royal painter."

Notes of interest
The Prado Palace, begun in 1785, was designed to house the natural science collections of King Charles III and the Academy of Science; it became the Royal Painting Museum only in 1819, by fiat of Ferdinand VII.

▼ Antonio Joli, *The Madrid Royal Palace* (detail), ca. 1750. Naples, Palazzo Reale.

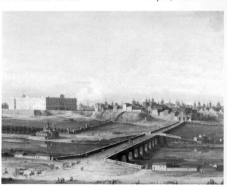

This sovereign had a straightforward royal career: first he was duke of Parma and Piacenza through his mother, Elisabetta Farnese; in 1734, he became king of Naples and Sicily; and finally, in 1759, king of Spain with the name of Charles III.

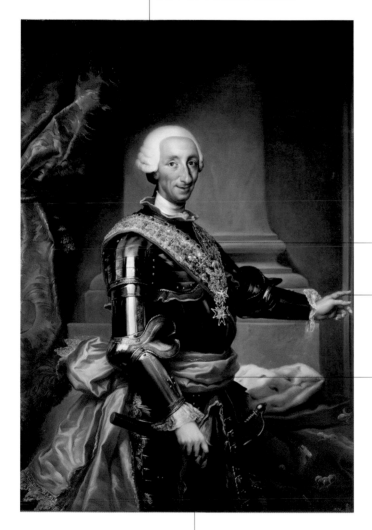

Having inherited the precious Farnese Collection in Parma, he moved it to Naples as soon as he became king. His name is linked especially to the excavations at Herculaneum and Pompeii, which he promoted and supported starting in 1738.

Mengs made several portraits of the king after he moved to Madrid in 1761.

Charles III inherited from his mother's family, the Farnese, a great interest in the arts. He commissioned the Shelter for the Poor in Naples and the royal palaces of Capodimonte and Caserta.

▲ Anton Raphael Mengs, *Charles III, King of Spain*, ca. 1762. Madrid, Prado.

In his right hand, the king holds the scepter of command; his armor is resplendent, and around the neck he wears the Golden Fleece and stars of other orders. This portrait is in the tradition of ruler portraits, especially those of the Bourbons of France, that began with the portrait work of Hyacinthe Rigaud and Nicolas de Largillière.

The faces of the Madrilenian women are fascinating and inviting for their position on the canvas and for the unsettling, direct gaze that three of them cast at the viewer.

This painting is the work of Lorenzo (1736–1776), Giambattista Tiepolo's younger son and Giandomenico's brother. Lorenzo moved to Madrid in 1762 to follow his father and worked on the decorative enterprises at the court of Charles III.

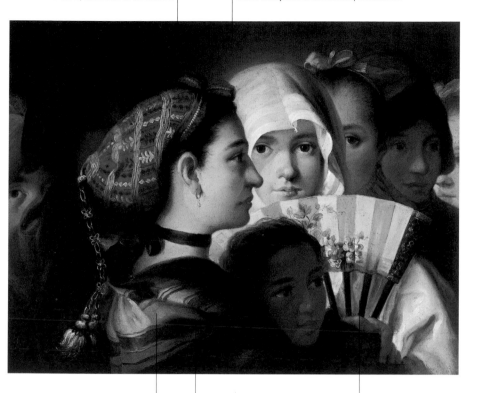

In Madrid, together with Giandomenico, Lorenzo witnessed the shift in taste, from his father's happy eclecticism to Mengs's sober, orderly classicism.

The Spanish years of the Tiepolo family are important for the contact that the young Goya had with their interpretative model of reality, for there are echoes of this type of work in his earliest attempts.

The white veil, the painted fan, and the hair gathered in the elegant net are described with quick brushstrokes and careful attention to every nuance of light.

▲ Lorenzo Tiepolo,
Madrilenian Types, before
1773. Private collection.

The woman in the center per-
sonifies Spain: winged putti
kicking about in the bright
sky are about to crown her.

Tiepolo spent his final years, from 1762 on, in the
service of Charles III. Already sixty-six years old, he
was still climbing the scaffolding to paint frescoes in
the throne room of the Royal Palace, in the queen's
antechamber, and in the halberdier room.

In the vast ceiling
of the throne room,
over 3,000 square
feet, the artist has
painted the apoth-
eosis of the Spanish
monarchy, using
patterns from his
repertory in a
fantasy of ever-
evolving narrative
imagination and
inexhaustible
compositional skills.

On the thick milky
and rose-colored
clouds are myriad
allegorical personifi-
cations: poetic
geniuses, the Virtues,
and allegories of
Charles III's virtues,
to which the inscrip-
tion at the base of
the pyramid alludes.

▲ Giambattista Tiepolo, The
Apotheosis of Spain (detail),
1762–64. Madrid, Royal Palace.

The Spanish provinces are arrayed all along the
cornice, with their products: America is repre-
sented with her typical products and with the
gifts brought back by Christopher Columbus.

Even in his frescoes, Goya exhibits a free, self-assured, smooth, and easy brushstroke.

The church of San Antonio de la Florida, designed by architect Filippo Fontana, had just been built when Goya painted the dome fresco in 1798.

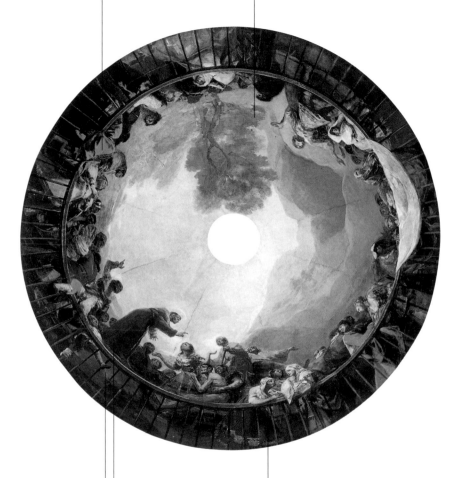

Although Goya was in poor health at the time, he once more bravely climbed the scaffolding.

This cycle depicts the miracle of Saint Anthony of Padua. The saint is hearing the confession of a man who had been murdered and whom he has resuscitated; the saint's father was the alleged killer.

All around, a chorus of spectators witnesses the miraculous revelation. Men, women of the lower classes, children, and beggars crowd the space along the balustrade that keeps them from falling over the edge, in a total absence of architectural elements.

▲ Francisco Goya, Frescoes in San Antonio de la Florida, 1798. Madrid.

181

Turin

An exception to the slow decline suffered by many Italian cities, Turin, capital of the flourishing kingdom of Savoy, grew in size and beauty thanks to the work of important artists and architects.

▼ Claudio Francesco Beaumont, *Celebration of Aeneas*, ca. 1740. Turin, Palazzo Reale.

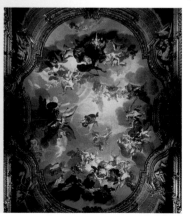

As a result of the Peace of Utrecht in 1713, the small duchy ruled by Victor Amadeus II freed itself from French interference and became the independent kingdom of Savoy. Turin, born as a fortress city, now aspired to change its image and rise to the dignity of capital of the new kingdom. Thanks to its transformation, the city grew, doubling in population in just seventy years; by the end of the century, the Turinese numbered almost one hundred thousand. The leaders of this transformation were Filippo Juvarra and Benedetto Alfieri. The former was called from Rome in 1714 by Victor Amadeus II, who wanted him to create buildings that wed classical elegance with intelligent, spare, and proportioned use of Baroque and Rococo decoration. Juvarra's sensitivity to classical works and his love of scenographic effects—which he had learned in Rome as a designer of sets, a painter of *vedute*, and a creator of temporary installations—are visible in his Turin works. These include the façade and access staircase of Palazzo Madama, the Superga Basilica (mausoleum of the House of Savoy) with its central plan and Michelangelesque cupola, the hunting lodge of Stupinigi, and the Church of the Carmine. In Turin, Juvarra also rearranged whole districts on the outskirts of the city. In later years, Benedetto Alfieri continued his older colleague's work for the Royal Theater, Palazzo Madama, and the royal palace, as well as the building that housed the State Secretariat and the Royal Riding School. The new prestige enjoyed by Savoy attracted artists and craftsmen who worked on the many construction projects in Turin. Royal manufactories for ceramic and tapestries were established, as were new craftsmen's workshops, especially under Charles Emmanuel III; the latter even invited to his court the famous cabinetmaker Pietro Piffetti, who created true furniture masterpieces for him.

Located in a strategic position at the mouth of the Susa Valley, this castle, first erected in the Middle Ages, was a Savoy residence. Later it became part of the "circuit of delights" and was used by the aristocracy for hunting and entertainment.

The painting shows a view of the castle envisioned in a restoration project proposed by Juvarra, the court architect, but which was never carried out.

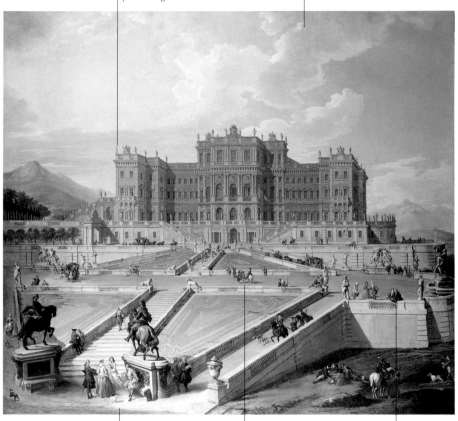

Juvarra's project designs, prepared in 1715–27, envisioned gradually sloping terraces to solve the problem of the incline. Some paintings by Marco Ricci envision the interior decorations that were never executed.

Panini filled the scene with noblemen and coaches, drawn with fine dexterity and a keen power of observation.

On the right, next to the balustrade, the painter has portrayed himself and architect Juvarra in conversation.

▲ Giovanni Paolo Panini,
The Rivoli Castle according to Filippo Juvarra's Project, 1723.
Turin, Castello di Racconigi.

Turin

The northern side of the royal palace, as it still stands today, is clearly visible, with the Dome of the Holy Shroud towering above it and behind, the Duomo's bell tower.

Painted in the summer of 1745 for Charles Emmanuel III of Savoy, the canvas is a companion to the artist's View of the Ancient Bridge over the Po. The city is seen from the Bastion Verde and from the royal palace façade that looks toward the gardens.

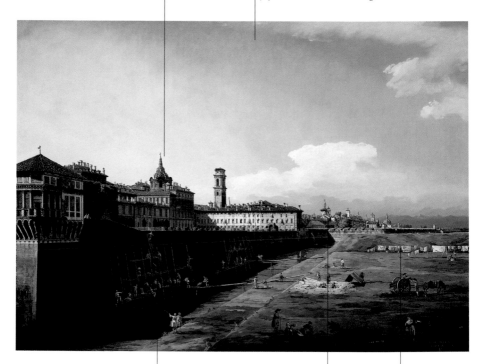

This composition is off center but full of everyday details, such as the workers on the scaffolds busy repairing the walls, the women hanging out the laundry, and the small figures in the meadow.

In the distance also are the bell towers of San Domenico, Sant'Agostino, and Sant'Andrea, the dome of Santi Maurizio e Lazzaro and that of the Consolata.

In the distance are the two keeps flanking the Palatine Gate.

The clean light underscores the majestic structures to the left, while the whites light up the façade of the building in the background and the wash hanging out to dry.

▲ Bernardo Bellotto, *View of Turin from the Side of the Royal Gardens*, 1745. Turin, Galleria Sabauda.

Milan was a crossroads of progressive ideas coming from France and of many artists who moved there to work on the buildings commissioned by the new Austrian government and the local aristocracy.

Milan

In 1713, the Peace of Utrecht placed Milan under Austrian rule. The enlightened government of Maria Theresa of Hapsburg and her firstborn son Joseph II enacted many fiscal, economic, and administrative reforms, modernized the roads, and began an intense construction program. The city began the new century by welcoming the late Baroque and Rococo styles, and some important buildings and artifacts from that time still survive. Many artists gravitated toward the Lombard capital. In 1731, Giambattista Tiepolo came to decorate Archinto Palace (destroyed in 1943) and the Casati (later Dugnani) and Clerici Palaces. Work on the Duomo, begun centuries earlier and whose works had come to a standstill in the mid-1600s, was resumed by the Austrian government, and several elegant Rococo sculptures were created for its interior. Enlightenment and Neoclassicist ideas reached Milan after 1750 and were absorbed by the city's progressive circles. *Il Caffè*, a periodical that began publication in 1764, conducted in-depth analyses of problems that cried out for literary, civic, and social renewal. Intellectuals rebelled against a rigid academic tradition and turned to Enlightenment ideals that had originated in France, pledging to spread them in Milan. An important place for the diffusion of the new culture was the Fine Arts Academy of Brera, founded in 1776, the same year that the Neoclassical architect Giuseppe Piermarini was beginning work on the Teatro alla Scala, Milan's first public theater. In 1771, the archduke and his court took up permanent residence in Milan, influencing architectural styles of the local nobility. Piermarini signed the plans for the archducal palace and a new country residence in Monza, now the royal villa.

Notes of interest
Piermarini brought innovative elements to La Scala, making it a prototype for the new theaters in Europe; to the traditional space he added office space, toilets, heating, and lighting, and improved the acoustics of the theater by lowering the height of the ceiling.

▼ Alessandro Magnasco and assistants, *The Verzière Market*, ca. 1733. Milan, Castello Sforzesco, Civiche Raccolte d'Arte Antica.

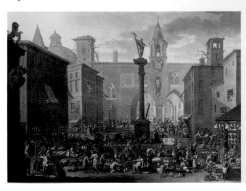

In 1740, Giambattista Tiepolo frescoed The Chariot of the Sun *on the low, narrow vault. In an ocean of diffuse light, the Sun's quadriga, driven by Mercury, lights up the four corners of the world among dolphins, naiads, and tritons.*

Dazzling gold and lacquer sparkle in the natural light and reflect in the mirrors, while Tiepolo's painted light reaches everywhere like the true light of the sun.

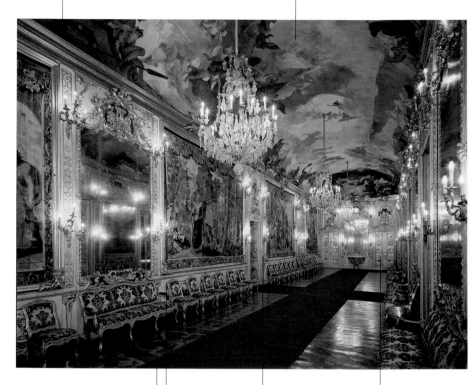

Marquis Giorgio Clerici transformed his family palace into the most lavish residence of the Milanese aristocracy. In 1772, Archduke Ferdinand of Austria and his wife, Beatrice d'Este, representatives of Empress Maria Theresa in the Duchy of Milan, chose it as their temporary residence until the royal palace was completed in 1778.

The gallery's boiserie is one of the more spectacular examples of rocaille décor in all its implications of taste and style. It was unique in the Lombardy of its time for the quality, harmony, and variety of the decorations.

The walls are entirely lined with a dense sequence of moldings, jambs, doors, mirrors, and window shutters, all masterfully arranged to form a unitary decorative ensemble in an organic blend of woodwork and painting.

The wood carvings illustrating episodes from the epic poem Gerusalemme liberata *(Jerusalem Delivered) were supervised by the Milanese Giuseppe Cavanna and his studio.*

The lowered horizon leaves a vast space for the sky and the snow-topped mountains.

The esplanade in the foreground isolates the irregular mass of walls, towers, and castle keeps and gives the composition a subtle and disturbing feeling of desolation.

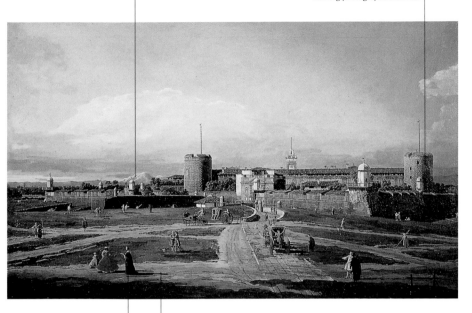

In the foreground are visible muddy paths that crisscross the space, among expanses of grass and small, isolated figures.

The great, empty space of earth and sky that reduces the fortress to a mere strip is the true subject in this view of Milan, purposely pared to essentials and bare of monumental elements.

◄ Tapestry Gallery, ca. 1740–50. Milan, Palazzo Clerici.

▲ Bernardo Bellotto, *The Sforzesco Castle in Milan*, 1744. Námest nad Oslavou (Czech Republic), Castle.

A soft touch, rich with transparencies and pastel tones, is typical of this artist.

The family shows pride in Luigi Castiglioni's scientific work (he was a botanist); there is no allusion to their wealth or social status.

The painting commemorates Luigi Castiglioni's trip to America in 1785–87. The scene is set in a plain, Neoclassical interior, with the scientist's library visible to the right.

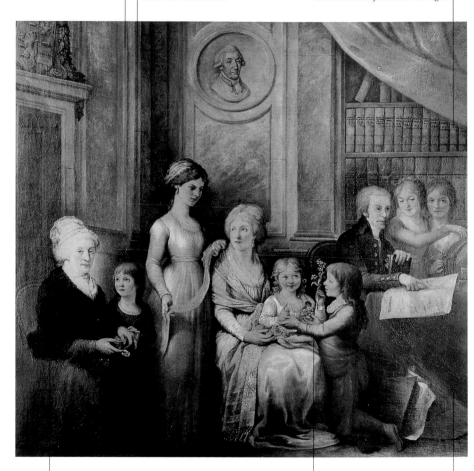

The elderly lady on the left is most likely Teresa Verri, Pietro Verri's sister and mother of the two Castiglioni brothers. Unfortunately, the canvas was cut and other portraits removed.

The younger children hold rare plant specimens, perhaps flowers from a locust, a plant that Castiglioni brought back from America and introduced in Lombardy.

Luigi Castiglioni sits at a desk and retraces his travels on the map while the two girls at his side follow the itinerary on the globe.

▲ Francesco Corneliani,
The Castiglioni Family,
1790–95. Private collection.

With the decline of her political and commercial prestige, Venice sank into a nostalgic memory of the past, though painting lived a brilliant season of chromatic splendor and optical precision.

Venice

Venice was weakened economically and politically by a slow decline. With the loss of her monopoly over Mediterranean trade, the mercantile business waned and less capital was available in the city. Napoleon, in 1797, wrested the city from its last doge, ending Venetian independence. The culture, which resisted the progressive ideas of the French Enlightenment brought by foreign intellectuals, reflected the general crisis. The Palladian creed continued to be hegemonic, despite the Baroque fashion: the work of Giorgio Massari, such as the Gesuati Church or Palazzo Grassi, and the work of Temanza and his student Selva, who designed the Teatro La Fenice, reveal a sober, classicizing taste. Venetian painting, like music and theater, enjoyed an age of splendor, thanks to the talent of its leading interpreters and the support of a few passionate patrons such as Joseph Smith, the English Consul to Venice. A lover of the arts, Smith enlivened the social scene by inviting the more progressive spirits to his well-stocked library and supporting several painters to expand his already extensive collection. He encouraged the work of Sebastiano and Marco Ricci, of the portraitist Rosalba Carriera, of Zuccarelli and Canaletto. The vibrant painting of Giovanni Battista Piazzetta influenced Giambattista Tiepolo, who revealed his extraordinary talent for decorating aristocratic interiors with trompe l'oeil effects.

Vedutismo developed in Venice, and painters like Canaletto and Bellotto began to be appreciated all over Europe. Pietro Longhi, by contrast, turned his artistic gaze to domestic life, portraying it with a keen power of observation.

Notes of interest
Abbott Filippo Farsetti threw open his large collection of casts of ancient statues to artists and students alike, thus playing an important role in the diffusion of the classical ideal and in the training of Antonio Canova, the greatest Neoclassical sculptor.

▼ Luca Carlevarijs, *Regatta in Honor of Frederick IV of Denmark*, 1709. Hillerød (Denmark), National-historiske Museum.

Antonio Visentini made etchings of these canvases in 1742, having seen them in the collection of Joseph Smith, British Consul in Venice and Canaletto's official agent. In fact, it was Smith who organized the painter's English sojourn a few years later.

Canaletto has captured with an infallible eye each shifting hue in the moving waters of San Marco's wharf and the impact of the sunlight on the white tents and stones of the Zecca and Santa Maria della Salute in the distance.

The painter discloses a sunny, colorful window on his world: the eye scrutinizes every detail, the mind differentiates, and the hand executes, adjusting each tone on the canvas.

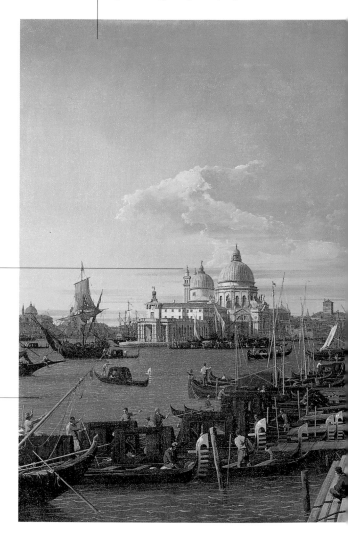

▲ Canaletto, *The Wharf toward the Zecca with the Column of Saint Theodore*, before 1742. Milan, Castello Sforzesco, Civiche Raccolte d'Arte Antica.

This canvas is a companion to the view of Riva degli Schiavoni and the Column of Saint Mark, conserved in the same museum: two complementary and opposite vedute.

The inspired narrative synthesis creates a harmonious balance between the famed architectural setting and the many commoners busy on the wharf.

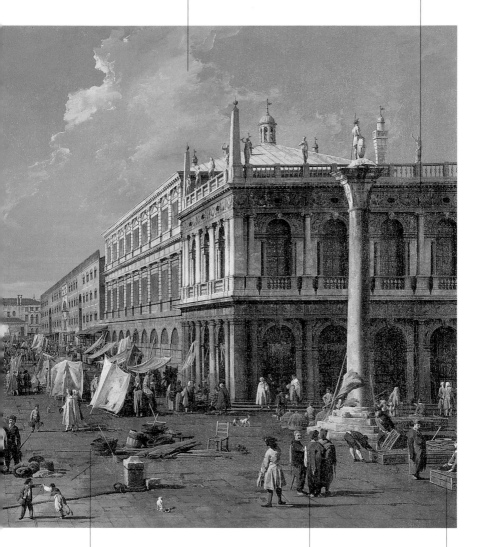

In the shadow of the tarpaulins, some stands sell wares; nearby is an amazing still life of barrels, planks, baskets, and brooms.

In the foreground three men, perhaps Dalmatian sailors, stand in conversation.

Canaletto has added a touch of red in the market's wooden cages to mark the cockscombs.

With his fresh, bright touch, Guardi releases his inventive streak, giving life to the characters of the adventure poem with theatrical poses, such as that of Herminia, who has just dismounted.

The composition is part of a group of canvases that illustrate scenes from the epic poem Gerusalemme liberata *(Jerusalem Delivered), drawn from Piazzetta's etchings. Rodolfo Siviero recovered this painting in Bantry House after World War II.*

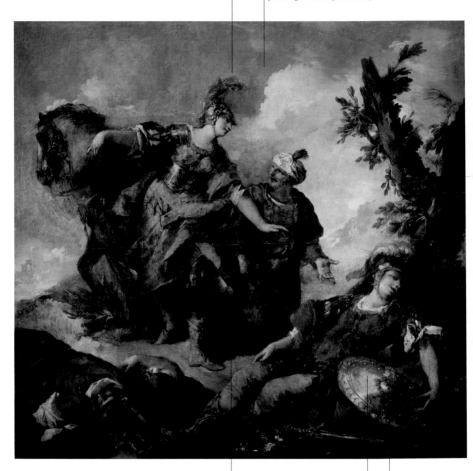

Vafrino is Tancred's groom; he is wearing Eastern garb because he has just returned from the Egyptian camp, where he spied on the enemy.

The painter, older brother of the better-known Francesco, depicts the scene in which Herminia runs into Tancred, her beloved, who has been wounded in a duel with the Circassian warrior Argante.

Tancred lies spent next to his weapons, which shine with jagged metallic reflections.

▲ Antonio Guardi, *Herminia and Vafrino Encounter the Wounded Tancred*, 1750–55. Venice, Gallerie dell'Accademia.

The allegorical figures in the background allude to the virtues of the Pisani family, such as Justice holding the scales.

Son of the more famous Pietro, Alessandro Longhi assimilated the example of official portraits and those of his father, in which all family members pose for the portrait.

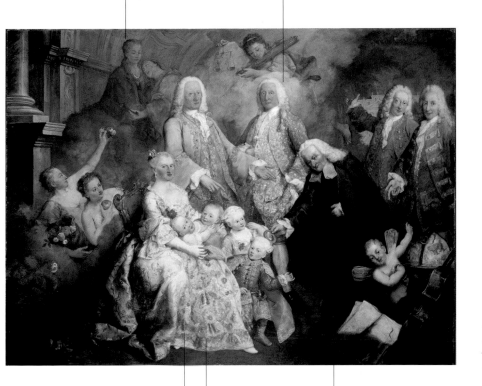

Paolina Gambara is surrounded by four children and her husband, Luigi, a solicitor, who stands next to his father, Doge Alvise Pisani.

In this early work, Alessandro Longhi reveals his ease in capturing the physical and psychological traits of each character.

The two men on the right may be Luigi Pisani's brothers, while the man in black who offers a sweet to the children could be Abbot Giovanni Gregoretti.

▲ Alessandro Longhi, *The Family of Solicitor Luigi Pisani*, ca. 1758. Venice, Gallerie dell'Accademia.

Rome was a reference point throughout the 18th century, especially because of its antiquities. In this century, Rome was once more transformed by new architectural works.

Rome

Notes of interest
Anton Raphael Mengs and Johann Joachim Winckelmann, the leading exponents of Neoclassicism, met in the salons of the Villa Albani; from their discussions was born the first important theory of the Neoclassical movement.

▼ Carlo Labruzzi, *The Coliseum Seen from the Palatine*, ca. 1790. The State Museum Reserve "Tzarskoje Selo," Catherine Palace (near Saint Petersburg).

With French prestige rising rapidly and other European cities growing, Rome entered a phase of slow decline, although until the end of the century it remained one of the most influential cities in Europe. Architectural activity remained intense, with new construction, restoration work, and the completion of existing projects. The new buildings thus contributed to the evolution of the city's identity: the theatrical monumentality and cheerful refinement of the Baroque blended with a new yearning for classical clarity and elegance. This presence of numerous styles enriched the Eternal City with very diverse works, such as the flight of steps of Trinità dei Monti (1721–25), the Trevi Fountain (1732–63), and the façades of San Giovanni in Laterano (1733–36) and Santa Maria Maggiore (1741–43). In the world of the academies, a taste was developing for the severe classicism that would boom in the second half of the century, prefigured by the austere, symmetrical lines of Villa Albani, designed to house the antique sculpture collection of Cardinal Albani, nephew of Pope Clement XI. In 1773, the Pope saw fit to establish the Museo Pio-Clementino at the Vatican and open it to the general public. Numerous Italian and foreign painters worked in Rome. Next to the majestic images of the elderly Maratta, the new century began with the intimate, gentle,

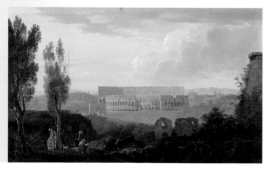

sentimental art of Trevisani and the seicento-type classicism of Benefial. Landscape painting flourished, especially of urban *vedute* and views of antiquities, from Panini to Piranesi. In portraiture, a fashionable genre in those years, Pompeo Batoni excelled. The century came to a close with the Neoclassical masterpieces of Canova, who lived in Rome from 1779 to 1798.

The Trevi Fountain is depicted as if it were already completed when the visit took place. In actuality, the central statues were completed the following year and the work continued until 1762.

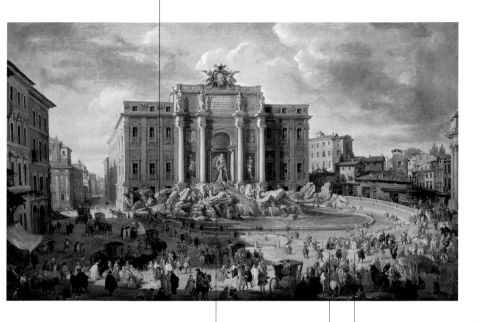

Panini did not paint the fountain from life: he used a model that he may have had at home, because in 1751, after architect Salvi's death, the pope asked Giuseppe, Panini's son, to complete the fountain, which he did.

Nicola Salvi, the fountain's architect, kneels before the pope.

This canvas documents a historical event: the visit of Pope Benedict XIV to the Trevi Fountain in June 1744. In the foreground are coaches and passersby. The pope is visible in the midground on the right, protected by a red parasol.

▲ Giovanni Paolo Panini, *Benedict XIV Visits the Trevi Fountain*, ca. 1755. Moscow, Pushkin Museum of Fine Arts.

The marquise had a keen interest in science and museums and owned the fundamental texts of modern European culture. She had a liaison with Alessandro Verri, with whom she lived in a palace she owned in Via di Arcione in Rome.

Rare shells, coral, fossils, minerals, scientific instruments, and antique vases and statues are openly displayed, a sign of the marquise's passion for the sciences. Here she is about to unveil the most precious of her butterfly collections.

This portrait is well-known for its setting, which provides a wealth of information about the interior décor and fashions of the period. In point of fact, the marquise is posing next to finely decorated furniture designed by Piranesi and inspired by ancient Egypt.

The lady wears an English-style dress in the latest practical, comfortable fashion, without the farthingale. This suggests that she did not follow the conventions of the aristocracy of the time but was an individualist, and that she had suppliers who brought her the latest novelties.

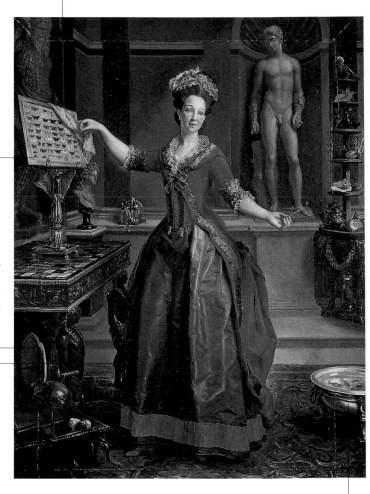

Goldfish are swimming in a bowl.

▲ Laurent Pécheux, *Portrait of Marquise Margherita Gentili Sparapani Boccapaduli*, 1777. Private collection.

Flaming sparks send red and orange streaks into the dark Roman night, while the diffuse mass of light highlights the outline of Saint Peter's.

During his Roman sojourn, Joseph Wright of Derby was fascinated by these fireworks, so similar to the Vesuvian eruptions that he painted in at least twenty-seven different versions.

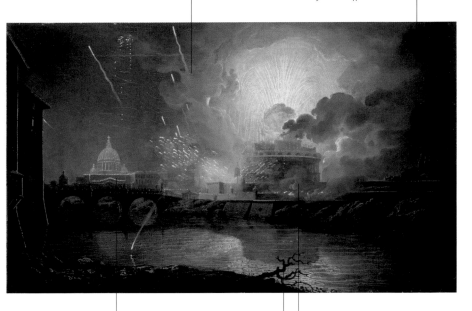

The amazing spectacle of fire, light, and smoke attracted large crowds and, as they reported in their travel diaries, stimulated the imaginations of Grand Tour travelers in Rome.

For maximum theatrical effect, the fireworks were held near the Tiber River, so that its waters might reflect the play of light.

This painting depicts the fireworks at Castel Sant'Angelo, the girandola *(shower), the play of colored flames that was held in the capital for important festivities.*

▲ Joseph Wright of Derby, *Fireworks at Castel Sant'Angelo*, ca. 1777. Birmingham (England), Museum and Art Gallery.

The settecento was for Naples a century of great expansion in both art and architecture, thanks to the patronage of the House of Bourbon, the new dynasty that ruled the Kingdom of the Two Sicilies.

Naples

Notes of interest
Naples gained European fame partly on account of its new royal manufactories, which produced tapestries, semiprecious stones, and soft-paste porcelain.

▼ Luca Giordano, *Triumph of Judith*, 1704. Naples, Certosa di San Martino.

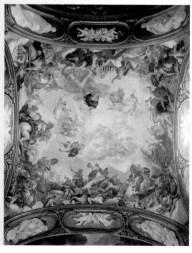

One of the most populous cities in Europe, Naples revived as a result of important political events: after the end of Spanish hegemony, Naples fell under Austrian rule from 1707 to 1734; it then passed to Bourbon rule under Charles III. In addition to effecting reforms in the administration and the economy, Charles III, an enlightened absolute monarch, renewed the appearance of this city, which for a century had been enjoying an active artistic life. Until 1750, artists such as Ferdinando Sanfelice, famous for his open, scenographic staircases, and Domenico Vaccaro created late Baroque works. The prestigious Teatro San Carlo was built in those years, as were the royal palaces of Capodimonte and Portici, both filled with royal collections from Parma (Charles was the son of Elisabetta Farnese). The preeminent painter of the time was Francesco Solimena, who renewed the seicento tradition and the lessons of Luca Giordano to create a powerful, generous style. His painting influenced not just his students, but also the sculptors who built altars and tombs from his drawings. After mid-century, Charles III called on architects willing to go beyond the late Baroque and offer a more modern style. Ferdinando Fuga and Luigi Vanvitelli, both engaged in a more lucid classicism, came from Rome to the court. Ambitious public works were begun, such as the Albergo dei Poveri (Shelter for the Poor) and the famous Granili (public granary and arsenal), both by Fuga, and private works such as the royal palace of Caserta, in which Charles III wanted to include barracks, offices, and cultural institutions. Only the royal palace was completed, decorated with elegant Rococo touches and scenographic solutions, such as panoramic vistas and an imposing Grand Staircase of Honor in the central rotunda.

Bonito (1707–1789), along with Vanvitelli, was a central figure of Neapolitan artistic life under King Charles, the Tanucci regency, and King Ferdinand IV.

Bonito was a genre painter who depicted the masquerades of the Neapolitan alleys, street scenes, and garden or drawing-room entertainments.

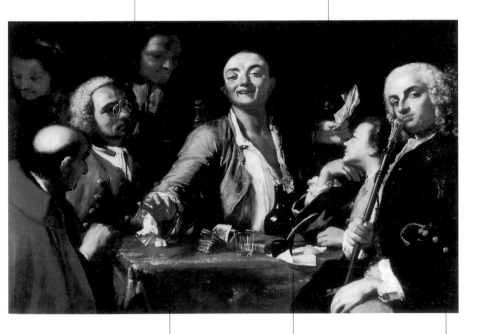

This scene from daily life depicts a cross-section of the Neapolitan world at mid-century. Works such as these were important for the new generation of artists that was maturing at the time, especially Gaspare Traversi.

This type of painting was targeted to an audience that looked with good-natured curiosity at episodes from everyday life.

Seated around a table, a group of men listens to a poet declaim his verses. A gentleman holds his walking stick and looks at the viewer with subtle irony.

▲ Giuseppe Bonito, *The Poet*, 1738–40. Madrid, formerly in the collection of the duke of Remisa.

A large crowd watches the game from the balconies of the buildings that overlook the field.

Joli moved to Naples in 1762 to work as set designer for the Teatro San Carlo; he lived there until his death in 1777. He painted scenes of court life in the city and in other royal residences, as well as very lucid urban vedute.

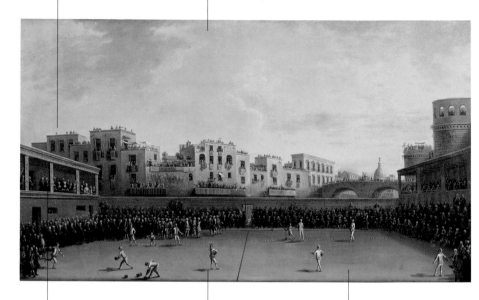

The court and the aristocracy watched the game from the covered grandstand, away from the sun. An orchestra also played.

The artist has painted a match of the most popular sport of the period, called variously pallon grosso (big ball), pilotta, pelota, or pallone elastica: two teams face each other and hit the ball back and forth using a wooden cylinder worn over the arm.

This ball game has an ancient origin and was the most popular in Italy, played with some variants from region to region, until the advent of soccer. Place names linked to the game still survive in many cities.

▲ Antonio Joli, *The Ball Game*, 1765–70. Naples, Museo di San Martino.

The symbolism of this sculpture is clear: the angel, personifying intellect, frees man from the net of deceit. The allegory fuses themes from Christian symbolism and from the new secular world of the Enlightenment and Freemasonry.

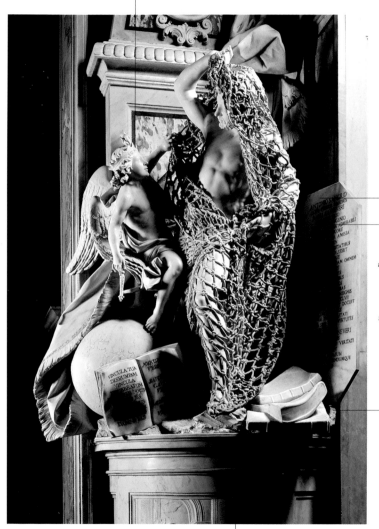

In 1749, Raimondo di Sangro, prince of Sansevero, began renovations of the family chapel, entrusting the work to the Venetian Antonio Corradini and the Genoese Francesco Queirolo, who took over from 1752 to 1759.

Queirolo's astonishing technical virtuosity is truly unequaled: the statue has been sculpted from a single block of marble and fully enveloped in a thick rope net that touches the figure only at certain places.

In the center of the chapel is the renowned Veiled Christ (1753; not pictured) by Giuseppe Sanmartino.

▲ Francesco Queirolo, *Il Disinganno* (Undeceived), 1752–54. Naples, Sansevero Chapel.

The "Pietatella" (a nickname of the Sansevero Chapel) is a precious anthology of Neapolitan sculpture at mid-century.

Naples

In planning the grand royal palace of Caserta, Vanvitelli surpassed late Baroque language by using a restrained and rigorous architectural discipline.

Called to Naples in 1751 by King Charles III of Bourbon, Vanvitelli had already worked in Rome as the architect of Saint Peter's.

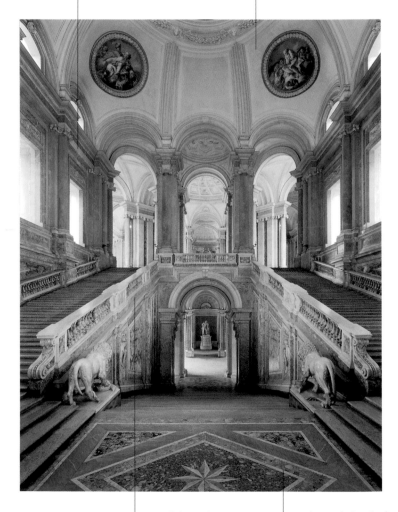

▲ Luigi Vanvitelli, Grand Staircase of Honor, 1752–74. Caserta, Palazzo Reale.

Vanvitelli designed a vast rectangular fabric with four symmetrical courts where, after crossing the austere entrance, one entered a majestic atrium filled with the inclined planes of the double staircase.

Joined to Naples by a boulevard running on an axis with the building and the park, the Caserta palace was meant to house the court and also act as a decentralized seat of the kingdom's administrative and government offices.

This canvas portrays the family of Ferdinand IV (1751–1825) and his wife, Maria Carolina (1752–1814), surrounded by their children. The king commissioned it in 1782, and the painter went to Naples to execute it on site.

A tall classical vase sits behind the king and queen, who were well-known patrons of the arts.

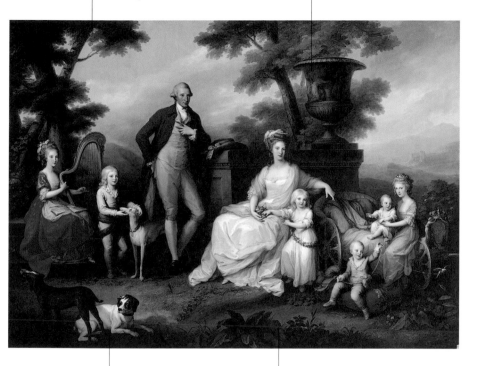

The painting is very far from the tradition of official portraits of the Bourbon court: Angelica Kauffmann has introduced a new genre of portrait painting to Naples, one set in an Arcadian landscape and with the royal family posed simply and naturally.

The preliminary compositional sketches were done from life in Naples, while the final version was completed in Rome in the studio of the painter. She then delivered it in person at the Caserta palace in 1784.

▲ Angelica Kauffmann,
Portrait of the Royal Family of Naples, 1783. Naples,
Museo di Capodimonte.

With a population of almost seven hundred thousand, Constantinople was the largest European city. Different cultures and ethnicities cohabited under the last gleams of the Ottoman Empire.

Constantinople

Notes of interest
Jean-Baptiste Vanmour
spent almost forty years in
Constantinople, where he
arrived in 1699 in the ret-
inue of the marquis de
Ferriol, ambassador of the
French king. In 1707, the
ambassador commissioned
one hundred paintings
from the artist: portraits
of state dignitaries and of
the many ethnic groups in
their traditional costumes.
Back in France, in 1714,
Ferriol oversaw publica-
tion of prints produced
from the paintings. The
collection was so success-
ful internationally that it
became the major inspira-
tion for the *turqueries* of
many artists, including
Watteau and Guardi.

The peace of Passarowitz (1718) marked Turkey's repudiation of her designs to conquer Europe and the emergence of the new Russian enemy. The century opened under Ahmed III (ruled 1703–30) with the "era of the tulips," the final bright years of the Ottoman Empire. Influenced by the Western Baroque and Rococo, the city's architecture was lively and creative: examples are the entrance fountain of the Topkapi Palace (1728) and the Nur-i Osmaniye (Light of Osman) Mosque (1755): its prayer room, although conventionally square and domed, is preceded by a sophisticated curvilinear courtyard. The palaces began to show the influence of European art: on the walls of some *yali* ("water houses") on the Bosporus and in the imperial harem, Italian-style fantasy landscapes started to appear, replacing the traditional Iznik ceramics. In 1722, French architects were called to build the Sa'adabad (Eternal Happiness) Palace, and the garden was designed in the style of Versailles. The European ambassadors commissioned Western artists to create paintings that celebrated the power and attraction of this city, the court ceremonies, the exotic costumes, and daily life. Among the best artists who lived in Constantinople and were captured by her magic spell were Vanmour, Liotard, de Favray, Cassas, Mayer, and Melling.

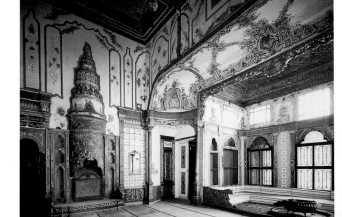

▶ Abdülhamid I Room,
1774–89. Istanbul,
Topkaki Palace, Harem.

The Englishman Richard Pococke (1704–1765) pioneered
the field of Middle Eastern and Egyptian archaeology; he
also played a role in developing mountain climbing. In 1737
he went to the East; the following year, in Constantinople,
he met the painter Liotard, who had just settled here.

On the far horizon, the
Princes Islands are visible.

In the background are visible
the fortifications and the
cloister of the old seraglio.
These identify the painter's
position as Pera, the city's
European district on the other
side of the Golden Horn.

Pococke is dressed like a court official
and leans on an ancient altar, signifying
his passion for archaeology. This is one
of the few life-size standing portraits
painted by Liotard.

In the middle
ground is the slender
minaret of the
Tophane Mosque.

▲ Jean-Étienne Liotard,
Portrait of Richard Pococke,
1738–39. Geneva, Musée
d'Art et d'Histoire.

Constantinople

Hélène Glavani, from a prominent Pera family, is wearing a Tatar costume from Crimea, where her father served as French consul.

Miss Glavani is playing the tanbur, *a type of guitar.*

Liotard, *who lived in Constantinople from 1738 to 1742, has drawn objects symbolizing Ottoman pleasures: a lute (*cura*), a perfume diffuser, and a censer.*

▲ Jean-Étienne Liotard, *Mr. Levett and Miss Glavani,* ca. 1740. Paris, Musée du Louvre.

The small table is a precious writing box worked with tortoiseshell and mother-of-pearl intarsia.

Mr. Levett is smoking a long jasmine-wood pipe and holding coral "komboloi," or worry beads.

Levett, a friend of Liotard's, was an English trader who lived in Constantinople. He wears a fur-lined turban and robe, symbolic of his wealth along with his desire to adopt Ottoman habits.

Painted during Liotard's sojourn in Constantinople, this is a fascinating double portrait in an atmosphere suffused with the pleasures of music, smoking, and the scent of roses.

Anglo-Saxon Lands
London
Bath
Edinburgh
United States

London experienced a political and cultural renaissance concomitant with a modernization of the arts—literature, architecture, and painting—leading to the birth of a modern, autonomous language.

London

At the turn of the century, the architectural style tended toward the elegant, aristocratic, clean lines of Palladianism, whose application in Britain was called the "Georgian style." Two architects were especially active in disseminating it: Colin Campbell, with his essay *Vitruvius Britannicus* (1717–25), and Lord Burlington, who actively promoted the construction of several buildings in London and collaborated with fellow architects such as William Kent, a renowned garden designer and the architect of the Horse Guards building at Whitehall, which was completed after his death. In the second half of the century, other architects carried on the Palladian heritage, such as William Chambers, who designed Somerset House, Robert Adam, and John Soane, one of the most eclectic voices. The care expended in coordinating the planning and construction projects ensured a harmonious mixing of the different styles in the city. This period saw the birth of a strong national school: the biting, sharp compositions of William Hogarth, the wonderful high-society portraits of Thomas Gainsborough and Joshua Reynolds, the intense landscapes of Alexander Cozens and the idyllic ones of Joseph Wright of Derby proved to Europe that England, too, was a major player in the art of painting, with its own well-developed language. In 1768, the Royal Academy was established in London, and Reynolds was elected its first president. One student at the Academy was William Blake, the engraver, painter, and poet whose visionary experience and passion for the Middle Ages and literature make him an important precursor of European Romanticism.

▼ Lord Burlington and William Kent, Chiswick House, ca. 1725. London.

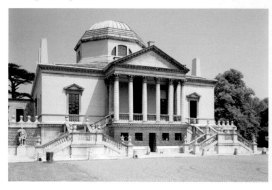

Christopher Wren's cathedral is one of London's best-known monuments.

Light and shadow mark the architectural volumes of the church: the façade is in the sun while the left side is in stark shadow. Over everything, the immense cupola soars tall and powerful in the sky.

Canaletto remained in England until 1756, painting views of London from different perspectives for the English nobility.

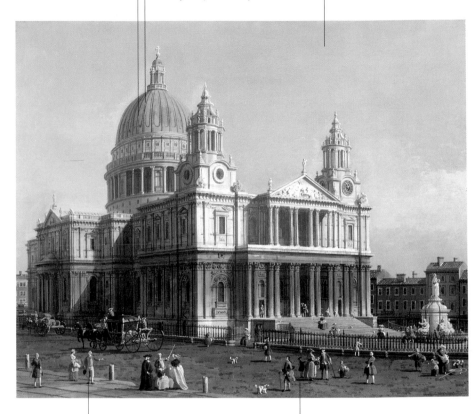

Lively London life goes on in the street; figures animate the foreground, breaking up the imposing mass of the cathedral. The two centers of attention balance one another: the colorful passersby in motion and the still, white architecture.

In 1746, Canaletto left for England to follow his clientele, with the support of Smith, the British consul to Venice, who wrote to Owen McSwiney recommending his protegé.

▲ Canaletto, *Saint Paul's Cathedral*, 1754. New Haven, Yale Center for British Art.

In the background, Westminster Abbey rises massively. It is a very elongated, perspectival view, with a lowered horizon that recalls the Dutch school.

In 1744, Joli settled in England, where he resided until 1749. He worked as set designer for the Italian Theater in London.

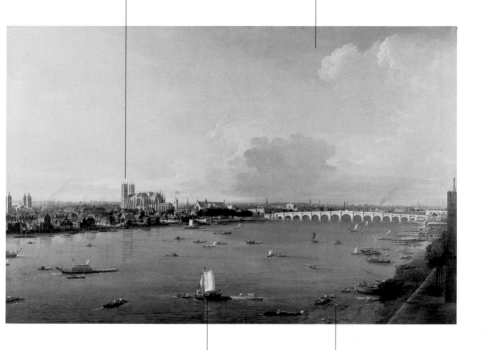

The Thames River is busy with the boat traffic, since it was the main access and supply route for the capital.

Joli painted numerous urban vedute, which found a ready market in London. Many Italian painters had already settled in London to meet the demands of the British, who were calling for, in particular, painters of vedute and artists skilled in fresco.

▲ Antonio Joli, *View of the Thames at Westminster*, ca.1745. London, Bank of England.

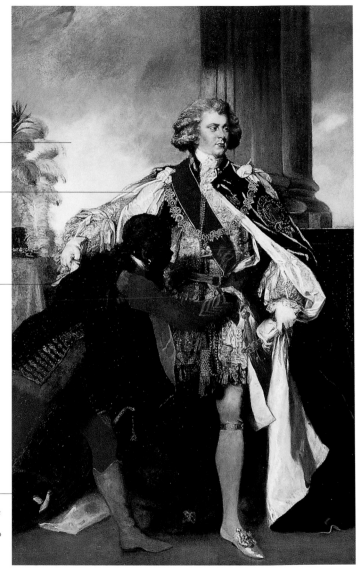

This portrait of the Prince of Wales created a sensation in the English press even before it was completed; it was exhibited at the Royal Academy in a place of honor.

The play of white-on-white in the silk, lace, and feathers on the table is in stark contrast to the servant's dark skin.

The young black servant is a co-protagonist in this composition, and his obliging gesture captures the viewer's full attention. Some believe that Reynolds included him intentionally in the picture, aware of the polemics he would unleash at a time when the first fiery debates on the abolition of slavery were being held.

This work received strongly negative criticism on account of the black servant, who is bending to arrange the prince's ceremonial uniform. All the London press published sarcastic commentary.

▲ Joshua Reynolds, *Prince George with a Black Servant*, 1786–87. Arundel Castle.

The Georgian style inspired by Palladian classicism was widely applied in Bath in architectural models that were much imitated in the United Kingdom and the United States.

Bath

The first architect who applied the Palladian style to an urban project was the Englishman John Wood, with his plan for expanding Bath, a health resort. Already known to the Romans for the curative properties of its waters, this small town nestled between wooded hills and the Avon River became at the turn of the 18th century an aristocratic vacation and health resort. Just before 1730, Wood submitted his classicizing plans for the construction of several buildings and the rearrangement of roads. These projects kept him busy for many years and were continued by his son. The spa, considered the town's center, expanded with new rooms and halls for meetings, entertainment, and dancing. A road lined with elegant Georgian buildings connected the rectangular Queen Square (1729) to a Coliseum-inspired round space called King Circus, surrounded by refined palaces with three orders of coupled columns. With the Royal Crescent residential complex (1767–75) that faced a wide meadow linking it to the town, John Wood, Jr., introduced the crescent, a semicircular row of buildings attached to one another, about six hundred feet long. Their relatively low height and the one hundred imposing Ionic columns alternating with wide windows gave uniformity and elegance to the entire complex. Within fifty years, Bath was totally changed, and the architectural rigor, elegant decorations, and orderly arrangement of streets and squares became a model for future city planning in England and across the ocean, from then through the end of the 19th century.

Notes of interest
Almost every small English town has its "crescent" and often also a "circus" modeled on those in Bath; in 1776, Thomas Baldwin built the great Guildhall with the lovely Banqueting Hall, an elegant, formal salon decorated with coupled Corinthian columns, all in a refined play of beige and gold tones.

▼ Thomas Malton, *The Royal Crescent*, 1777. Bath, Victoria Art Gallery.

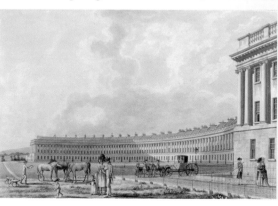

The Scots built a new city in Edinburgh and linked it to the old town: it was the most successful urban plan of the century.

Edinburgh

After England and Scotland united in 1707, several projects were begun to extend the old town beyond the city walls. A contest was held in 1767 to develop the land north of the city; the winner, James Craig, prepared a plan for New Town, the new suburb. It was designed around a principal axis, along which are eight blocks that link two squares, one at each end: Charlotte Square, built by Robert Adam in 1791, and Saint Andrew Square. The Register House, designed by Robert Adam in 1772–92, is the reference point of the road axis connecting the suburb to the old town through the North Bridge. Thus, several buildings were constructed, designed by Craig and also by William Chambers; Chambers designed the 1771 house for Sir L. Dundas, now the headquarters of the Royal Bank of Scotland. This urban complex, noteworthy for the high quality of the construction, mostly of local gray stone, was clearly built for the bourgeoisie. The need for quality residential housing was married to a restrained aesthetic uniformity in which no building stands out from the others in a lavish display of wealth—unlike the contemporary custom of the European aristocracy, who tended to flaunt their wealth.

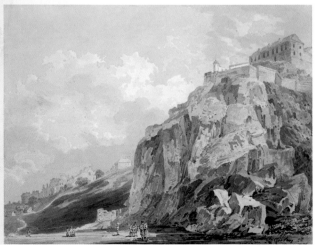

◄ Thomas Girtin, *The Castle Rock*, ca. 1793. Cambridge, Fitzwilliam Museum.

A model that inspired this painting was The Skater *(1782)* by Gilbert Stuart, now at the National Gallery in Washington but in Edinburgh at the time.

The elegant pose is the result of extensive training and required substantial skill, even if the artist has made the execution appear easy.

In the cold winter season, one could skate on many iced-over lakes around Edinburgh.

▲ Henry Raeburn, *Reverend Robert Walker Skating on Duddingston Loch*, ca. 1795. Edinburgh, National Gallery of Scotland.

This enchanting portrait, symbol of the Scottish museum, depicts Reverend Robert Walker, who loved skating and joined the country's first skating club in 1780.

Raeburn scratched the canvas to simulate the markings left on the ice by the blades.

Coming from the left, the light illuminates only half the figure, leaving the right side in the half-light and then in the dark, in an atmosphere reminiscent of a medieval castle.

Hanging on the wall are shield, swords, hunting horn, and rifle: everything suggests the power of the Glengarry clan.

Glengarry (1771–1828) appears pleased with his rifle and his outfit, symbols of his passion for the costumes and social structures of the ancient Gaelic culture of the Scottish Highlands.

The artist was a friend of the author Walter Scott, who wrote about Scottish pride and traditions in his novel Waverley.

This painting was exhibited at the Royal Academy in 1812.

▲ Henry Raeburn, *Colonel Alastair MacDonell of Glengarry*, ca. 1811. Edinburgh, National Gallery of Scotland.

Until 1776, the United States was a British colony on the eastern coast of the American continent; until the middle of the 19th century, they followed European taste and fashions in the arts.

United States

The United States followed the evolution in the arts through drawings and reproductions that circulated between the old world and the new. There was a desire to build in a linear, elegant style adapted to the new, relatively unpopulated cities. The Palladian style, a direct import from England, met with great success. Wood was gradually replaced in the more stately buildings with brick or stone: Independence Hall and Christ Church in Philadelphia, Boston's Town House (Old State House), and St. Paul's Chapel in New York imitated the British Georgian style. Some French influence, more affected and refined, prevailed in the South. In the years after the War of Independence, the European Neoclassical style was warmly received. After an early period in which he adopted the Palladian style, Thomas Jefferson decided to deepen his knowledge of ancient Roman art, in whose style he saw a reflection of republican virtues. In Richmond, Virginia, he built the Capitol, inspired by the Roman Maison Carrée of Nîmes. He also used a classical style for his home, Monticello, and for the University of Virginia in Charlottesville, designing for the latter a circular structure and tympanum supported by a Corinthian colonnade. Among Neoclassical architects, Henry B. Latrobe is memorable for his design of the nation's Capitol. Eighteenth-century American painting consisted mostly of small portraits and landscapes. More stately historical and mythological themes also became popular, especially because artists like John Trumbull were returning from Europe, where they had studied in the finest academies. Trumbull is best known for his sketches of the Revolutionary War and his portraits of George Washington.

Notes of interest
Among the major 18th-century American painters are Charles Peale and Gilbert Stuart, talented students of Benjamin West, and Ralph Earl, John Vanderlyn, and Washington Allston.

▼ Thomas Jefferson, Monticello, 1769–1809. Monticello, Virginia.

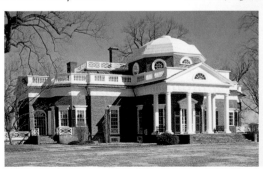

This Native American is the chief of an Ohio Valley Cherokee delegation, who had come to London on a diplomatic mission. Communication between the Indian and Reynolds was limited because the Native American interpreter died during the journey to England.

Perhaps Reynolds wanted to add this portrait to the many celebrated ones he had in his gallery.

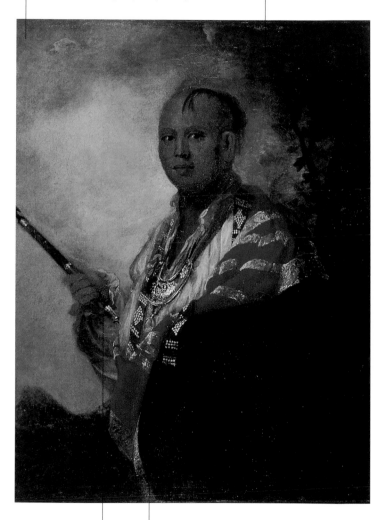

The tomahawk held in his right hand resembles a marshal's stick and confers on the Indian chief the look of a European general.

Since verbal communication proved impossible, the attention of the English public turned to the Indian's exotic, folkloric aspects.

▲ Joshua Reynolds, *Scyacust Ukah*, 1762. Tulsa, Gilcrease Museum.

Peale directed the excavation work to recover the bones of a mammoth in the region north of New York. The undertaking lasted three months.

This is one of the earliest and more important genre scenes of American painting at a time when an independent school of painting was emerging.

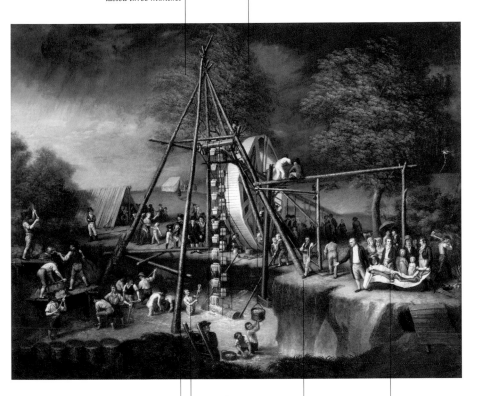

The American painter Charles Peale was also interested in medicine and natural science and organized the recovery of the fossil illustrated in this canvas.

A laborer is raising a bone he has just found underwater.

The execution of the painting was challenging as well: about half of the people depicted are real portraits.

Scientists are showing the life-size drawing of an animal bone.

▲ Charles Peale, *Exhumation of the Mastodon*, 1799. Philadelphia, Peale Museum.

LEADING ARTISTS

Robert Adam
Asam Brothers
Pompeo Batoni
Bernardo Bellotto
William Blake
François Boucher
Canaletto
Antonio Canova
Carlo Innocenzo
Carlone
Rosalba Carriera
Giacomo Ceruti
Jean-Baptiste-Siméon
Chardin
John Singleton Copley
Giuseppe Maria Crespi
Jacques-Louis David
Fra' Galgario
Jean-Honoré
Fragonard
Henry Fuseli (Johann
Heinrich Füssli)
Thomas Gainsborough
Corrado Giaquinto

Francisco Goya
Jean-Baptiste Greuze
Francesco Guardi
Ignaz Günther
Jakob-Philipp Hackert
William Hogarth
Jean-Antoine Houdon
Thomas Jones
Johann Joachim
Kändler
Angelica Kauffmann
Maurice-Quentin de
La Tour
Jean-Étienne Liotard
Pietro Longhi
Alessandro Magnasco
Franz Anton
Maulbertsch
Luis Eugenio Meléndez
Anton Raphael Mengs
Franz Xavier
Messerschmidt
Jean-Marc Nattier
Giovanni Paolo Panini

Balthasar Permoser
Giovanni Battista
Piazzetta
Jean-Baptiste Pigalle
Giovanni Battista
Piranesi
Joshua Reynolds
Sebastiano Ricci
Hubert Robert
George Romney
Francesco Solimena
Pierre Subleyras
Giambattista Tiepolo
Giandomenico Tiepolo
Gaspare Traversi
Cornelis Troost
Pierre-Henri de
Valenciennes
Elisabeth Vigée-Lebrun
Jean-Antoine Watteau
Benjamin West
Joseph Wright of
Derby
Johann Zoffany

◄Hubert Robert, *Artists before
the Tivoli Falls* (detail), 1794.
New York, private collection.

*Inspired by ancient Roman stucco decorations and Renaissance
"grottesche," Robert Adam created in England some of the
most important and imitated interiors of early Neoclassicism.*

Robert Adam

Edinburgh 1728–
London 1792

**Principal place
of residence**
London

Travels
From 1754 to 1758 in
France, where he became
friends with the painter
Clérisseau; in Italy (Rome,
1756); and in Dalmatia

Principal works
Syon House (1762,
Middlesex); Harewood
House (1765–69, York-
shire); Osterley Park
(1761–77, Middlesex);
Adelphi (1768–72,
London, demolished in
1937); Portman Square
Palace (1775–77, London,
today the seat of the
Courtauld Institute of Art)

Links with other artists
In Rome, he was struck
by Piranesi's drawings
and prints; in London, he
founded an architecture
studio with his two
brothers, James and
William, who were his
lifelong collaborators.

▶ Robert Adam,
Kenwood House,
Library, 1767. London.

After studying ancient Roman ruins and preserved interiors at
Herculaneum and Pompeii under the guidance of Clérisseau and
Piranesi, Adam wrote an accurate archaeological study of Diocle-
tian's Palace in Split. Already in Italy, in 1755–57, he contacted
potential clients, members of the English nobility who were on the
Grand Tour. Once back in England, in 1761 he began to build or
renovate city residences and country houses, creating a style that
became a lasting exemplar. Adam's architectural language, derived
from Lord Burlington's Palladian work and from his study of
antiquities and Renaissance architecture, achieved its most original
results in interior décor: in well-proportioned rooms, he created a
sense of cultivated, measured wealth, what the Continent believed
was the "English style," seen in the exemplary Syon House in
Middlesex (1762) and Kedleston House in Derbyshire (1765).
Here, Adam drew from the vast repertory of ancient wall decora-
tion and designed niches with ancient statues, apses enclosed by
columns, pastel-colored walls and ceilings, bright white stucco and
gilded friezes, Pompeian- or Etruscan-style paintings, furniture,
and carpets. His interiors perfectly answered the needs of comfort
and restrained elegance of his cultivated English clientele.

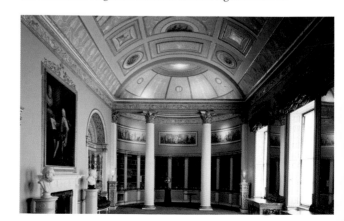

Spatial illusion in service of Catholicism reached dizzying heights with the Asam brothers, who, inspired by Italian models, staged perfect illusions, blending architecture, sculpture, and painting.

Asam Brothers

Cosmas Damian Asam and Egid Quirin Asam followed in their father Georg's footsteps (he was an esteemed fresco painter) and went on to become the leading artists of the great Rococo season in the Catholic regions north of the Alps, especially in southern Germany. Architects, painters, sculptors, and stucco workers, they translated into exuberant, affecting forms the late Baroque love of theatricality, working most notably in the imposing abbeys that they rebuilt and decorated with overall continuity of sculpture, stucco work, frescoes, and furnishings. After their father's death in 1711, the brothers spent about two years in Rome, where they astutely and carefully studied the majestic Baroque structures, Bernini's masterpieces in particular. Cosmas Damian preferred to paint, while Egid Quirin sculpted and modeled altars, statuary groups, and ornamental stuccoes. They constructed trompe l'oeil views in perfect perspective, illusionistically expanding the closed interior space of a church with a studied tension toward the top of the architectural fabric, using sculpted and painted decorations and a diffuse light that illuminates them and opens the eye to a spectacular, otherworldly architecture. Among their best joint work is the Church of Saint John Nepomuk in Munich, known as the Asamkirche (1733–39), which they built near their home.

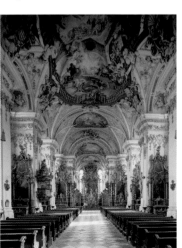

◄ Cosmas Damian and Egid Quirin Asam, Church of the Cistercian Abbey, ca. 1721. Aldersbach.

Cosmas Damian, Benediktbeuren 1686–Weltenburg 1739

Egid Quirin, Tegernsee 1692–Mannheim 1750

Principal place of residence
Munich

Travels
Rome (1711–13)

Principal works
Abbey Church (1716, Weltenburg); Abbey Church (1718–20, Weingarten); Abbey Church (ca. 1721, Aldersbach); Church (1721–23, Rohr); Saint John Nepomuk Church (1733–39, Munich)

Links with other artists
During their stay in Rome, the Asam brothers studied the illusionistic art of Carlo Maratta, Andrea Pozzo, and Pietro da Cortona; their older sister, Maria Salomè, (1685–1740) was an established artist as well.

The monastery of Saint Emmeram, one of the most prestigious medieval scriptoria of the Carolingian era, became in 1812 the residence of the Princes von Thurn und Taxis.

From 1731 to 1733 the Asam brothers also decorated the three-nave abbey church with frescoes and stucco work.

In the four pendentives are the symbols of the arts: Painting, Sculpture, Architecture, and Music.

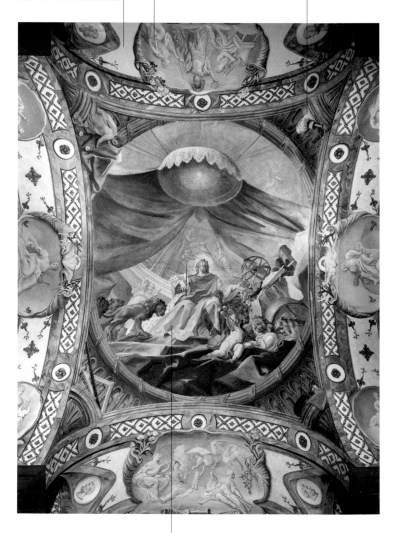

▲ Cosmas Damian Asam,
King Solomon, 1731–33.
Regensburg, Monastery of
Saint Emmeram.

King Solomon, proverbial personification of wisdom, sits on an ebony throne covered in gold and is crowned under a canopy; he is flanked by his traditional symbol of two lions.

The uncontested king of the Roman school: Batoni's international fame as a portraitist put him in great demand by the English and German aristocrats who passed through Rome on the Grand Tour.

Pompeo Batoni

In Rome from 1727, Batoni learned the proper academic rules of composition that were strongly influenced by the Roman Raphaelite style of Maratta's art. His early years and training in Lucca, Tuscany, gave him a taste for highly refined draftsmanship and a clear luminosity without striking chiaroscuro contrasts. He drew from both classical and contemporary statues repeatedly, refining his unequaled drawing skills. He developed a network of foreign clients, travelers who came to Rome, bought his drawings of antiquities, and commissioned life-size portraits of themselves standing next to celebrated ancient statues. In this genre he had no rivals and filled foreign private collections, of Englishmen in particular, with works of art. He sought recognition as the prime figurative painter in the Rome of his times, an heir of Maratta and Raphael. He strove to master all the fine qualities of Renaissance and seicento Roman painting, as we know from his consciously elaborate altarpieces inspired by very dissimilar examples, from Raphael to Maratta, from Annibale Carracci to Reni and Guercino. Batoni gave these a unified style through his flawless draftsmanship and use of luminous colors.

Lucca 1708–Rome 1787

Principal place of residence
Rome

Principal works
Paintings for the Quirinale Coffee House (*The Evangelists* and *The Delivery of the Keys to Saint Peter*, 1742–43); *The Fall of Simon Magus* (1746–55 for Saint Peter's, now at Santa Maria degli Angeli); *Lord John Brundenell* (1758, Boughton House, Northamptonshire); *Colonel William Gordon* (1766, Fyvie Castle, Aberdeenshire)

Links with other artists
His unequaled dexterity made him one of the last true masters of the Italian school; this left him unscathed by the emerging polemic between the imitators of late Baroque and participants in the rising Neoclassicism.

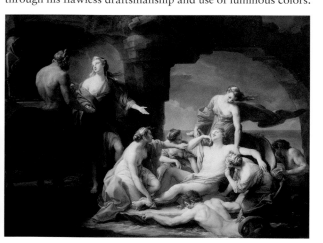

◄ Pompeo Batoni, *Thetis Removes Achilles from the Centaur Chiron*, 1770. Saint Petersburg, Hermitage.

225

In this colossal canvas, over nine feet
high by six feet wide, Razumovsky
(1728–1803), then thirty-eight years old,
proudly displays the insignia that attest
to the important positions he held.

The count decided to have
his portrait painted next to
famous ancient sculptures
that were then on display in
the Belvedere courtyard of
the Vatican: Laocoön, *the*
Apollo Belvedere, *the so-*
called Antinous *(actually, a*
Hermes*), and* Ariadne.

The count reached Rome in
1766 on his Grand Tour;
during his stay, he purchased
two pictures from Batoni,
including Hercules at the
Crossroads, *which now*
hangs in the Hermitage.

The international aristoc-
racy stopped by Batoni's
Roman studio near the
Spanish Steps to have a
portrait made by the most
famous painter of the time.

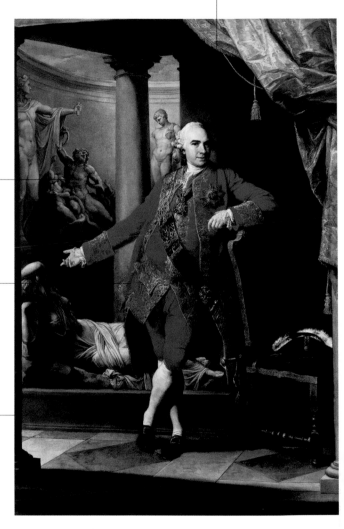

▲ Pompeo Batoni, *Portrait of Count*
Kirill Grigoriewitsch Razumovsky,
1766. Saint Petersburg, Hermitage.

He painted the capitals of 18th-century Europe. His vedute *are filled with a cold luminosity, dense with matter and volumes that almost anticipate 19th-century natural science research.*

Bernardo Bellotto

Bellotto was introduced to art by his uncle, Canaletto, whose nickname he later adopted. He was in Rome in 1742 to draw antiquities and several cityscapes, such as *The Tiber at Castel Sant'Angelo* (Detroit Institute of Arts) and *The Tiber at San Giovanni dei Fiorentini* (English private collection), following in the footsteps of Van Wittel. In 1744 he went to Lombardy, where he painted intensely naturalistic landscapes in which he made a full break from his uncle's style, achieving his own independent language. This is clear in his two *Views of the Gazzada* (Milan, Pinacoteca di Brera). Bellotto's most personal phase began in 1745 with views of Turin and Verona that are marked by wide horizons and a clear, cold light that makes each detail stand out as if in relief. Having been summoned to the court of Saxony, he traveled to Dresden in 1747 and then, from 1759 to 1761, to Vienna, where he painted seven urban *vedute* for Empress Maria Theresa. He was in Munich in 1761 at the behest of King Maximilian II of Bavaria: for him he painted three *vedute* of the capital and of Nymphenburg. He returned to Dresden, where he painted several views of the city. From 1767 until his death he lived in Warsaw as court painter, and there he created his last works: the panoramic views of the city that record architectural details and scenes of contemporary life.

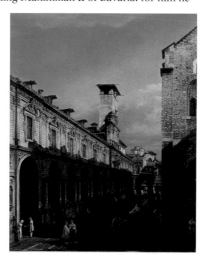

Venice 1721–
Warsaw 1780

Travels
Rome (1742); Milan
(1744); Turin and
Verona (1745);
Dresden (1747, 1762–67);
Vienna (1759–61);
Munich (1761);
Warsaw (1767–80)

Principal works
*Views of Vaprio and
Canonica d'Adda* (1744,
New York, Metropolitan
Museum of Art); *Views
of the Gazzada* (1744,
Milan, Pinacoteca di
Brera); *The Zwinger
Moat* (ca. 1754, Dresden,
Gemäldegalerie); *Vienna
from the Belvedere*
(1759–60, Vienna,
Kunsthistorisches
Museum); *Election of
Stanislaus Augustus*
(1778, Warsaw,
Royal Castle)

Links with other artists
He apprenticed in Venice
with his uncle, Canaletto.

◀ Bernardo Bellotto,
*Palazzo dei Giureconsulti
and the Broletto in Milan,*
1744. Milan, Castello
Sforzesco, Civiche
Raccolte d'Arte Antica.

227

Bernardo Bellotto

This composition is balanced by the fortress clinging to the massif that rises steeply from the banks of the Elbe and the immense stretch of clear sky.

Over the centuries, the fortress was a shelter for the king and the electors in times of war and a stronghold for their treasures and art collections.

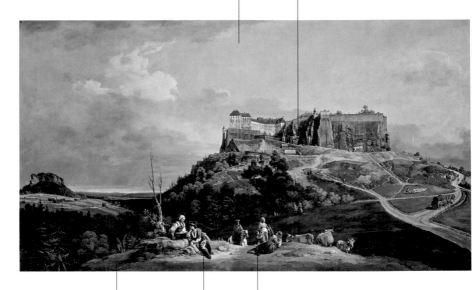

The human figures and the animals soften the heroic atmosphere of the painting, creating a melancholy pastoral feeling.

At first sight, Bellotto's style resembles his uncle Canaletto's; this makes it difficult to attribute his early works. Bellotto's style, however, is distinguished by its colder, clearer light and richer, denser matter.

This is one of the five great views of the ancient Königstein fortress near Dresden, which Bellotto painted at the behest of Augustus III, king of Poland and elector of Saxony as Frederick Augustus II. This rich vein of commissions dried up in 1756, when Frederick the Great of Prussia invaded Saxony.

▲ Bernardo Bellotto, *Königstein Fortress*, 1756–57. Washington, D.C., National Gallery.

A poet, painter, and engraver, Blake pursued metaphysical and theological ends: for him, art offered a metaphysical vision of the world and was invested with a redemptive power for humankind.

William Blake

William Blake turned to art and literature at a very young age. He apprenticed first as an engraver and briefly attended the Royal Academy in 1779. A rebel and visionary spirit, he sought to blend poetry and the figurative arts into a unitary expression of his prophetic genius. Starting in 1787–88, Blake began to experiment with illuminated printing, engraving both text and illustrations, which he then colored by hand. He tried to unify poetry and painting by developing a unique relief etching technique: he made highly resistant copper masters from which he printed the number of copies he needed in his shop. The text is illustrated by miniatures, decorative details, borders, and drawings between the lines. His fantastic, irrational art is filled with Neoclassical elements, pre-Romantic restlessness, complex symbolism, and original imagery, the poetry of the Sublime and English Gothic art, and the influences of Dürer and Michelangelo, Fuseli and Flaxman. His works are permeated with symbolic, literary elements drawn from the Bible, Dante, Milton, and Shakespeare. His themes are the freedom of the imagination, the will to discover the abyss of the unconscious, the restlessness hiding in the depths of the human soul. When he died in 1827, Blake was almost unknown. He was rediscovered in the middle of the 19th century by the Pre-Raphaelites, in particular by Dante Gabriel Rossetti, who recognized in him a precursor of symbolism.

London 1757–1827

Principal place of residence
London

Principal works
The prophetic books: *Vision of the Daughters of Albion* (1793), *America* (1793), *Europe: A Prophecy* (1794), *The Book of Ahania* (1795); *Large Colour Prints* (1795–1804), of which *Newton* is one (1795, London, Tate Gallery); the mystical poems *Milton* (1804–8) and *Jerusalem* (1804–20); illustrations for Edward Young's *Night Thoughts* (1796–97), *The Divine Comedy* (1825), and *The Book of Job* (1821–26)

Links with other artists
He was appreciated by John Flaxman (1755–1826), a leading exponent of English Neoclassicism, who partially financed the publication of his first poetry collections.

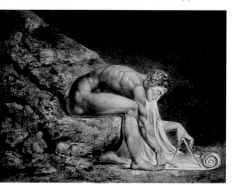

◄ William Blake, *Isaac Newton*, 1795. London, Tate Gallery.

229

An interpreter of the refined court of Louis XV, Boucher applied his inventive style with success to historical and landscape painting, mythological and amorous subjects, and subtle portraits.

François Boucher

Paris 1703–1770

Principal place of residence
Paris

Travels
Italy, 1728–31

Principal works
The Triumph of Venus
(1740, Stockholm,
Nationalmuseum);
*Portrait of the Marquise
de Pompadour* (1756,
Munich, Alte Pinakothek,
p. 171)

Links with other artists
He was a frequent visitor
to Lemoyne's atelier and
admired Watteau; he
taught drawing, painting,
and engraving to Madame
de Pompadour (1721–
1764); Diderot at the
Salon and later the
Neoclassicists criticized
him as a frivolous,
superficial painter.

▶ François Boucher,
*The Painter in His
Studio*, 1753. Paris,
Musée du Louvre.

Boucher apprenticed as an illustrator. Intending to master as many techniques as possible, he studied drawing, engraving, and painting. Although his art was clearly influenced by Watteau and Sebastiano Ricci, even in his first dated work, *Venus Requesting Arms for Aeneas from Vulcan* (1732, Paris, Musée du Louvre), Boucher had developed an unmistakable personal pictorial language, both for the subjects represented and for his free, flowing technique coupled with a knowing palette of light colors. It was the beginning of a long, brilliant career that in 1765 would see him director of the Academy and "the king's first painter." The proliferation of official court commissions was to force him, as the head of a large atelier, to experiment with the most disparate techniques. He worked for the Beauvais tapestries directed by Oudry and for the Gobelin tapestries as well, for the Vincennes

and Sèvres porcelain factories, and on theater and opera stage sets. All his best-known paintings with mythological, gallant, or erotic themes, such as *The Triumph of Venus* (1740) or *Diana Bathing* (1742), exalt grace, female sensuality, and the eroticism of soft, rosy flesh, rendered with brushstrokes shining with color and paint.

This scene is one of a series of four canvases portraying the different times of a noblewoman's day: morning, noon, afternoon, and evening.

The objects seemingly in disarray are for the lady's grooming: the little hat, the steaming teapot behind her, the Chinese screen, even the garters on the fireplace mantel.

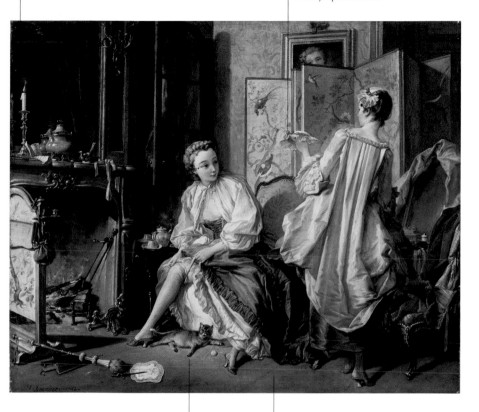

The typically gallant touches include the cat playing at the lady's feet while she fastens a garter, and the love letter placed on the mantel.

The painting was commissioned by Count Carl Gustav Tessin, Swedish ambassador to Paris and a frequent visitor and admirer of Madame Boucher.

▲ François Boucher, *La Toilette*, 1742. Madrid, Museo Thyssen-Bornemisza.

François Boucher

This canvas was painted as a preparatory cartoon for a Beauvais tapestry: Boucher, who was director of the tapestry works, has a bright, mellow style.

In the background is the Temple of the Sibyl in Tivoli. Although Boucher lacked a classical sensibility, antiquities were usually included in pastoral scenes such as this one.

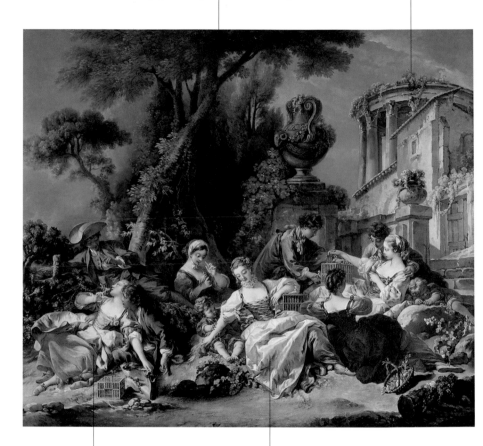

Queen Marie Antoinette loved to dress as a shepherdess and amuse herself in the gardens of Versailles. She even had a small village built, with shepherds and farmers.

This is a typical Arcadian scene in which Boucher depicts the leisure activities of the nobility. Here, they are playing with birds.

▲ François Boucher, *The Bird Catchers*, 1748. Los Angeles, J. Paul Getty Museum.

The exceptional erotic charge of this canvas is heightened by the sense of mystery about a possible spectator who is not in the painting. The canvas is filled almost entirely by the nude body.

The young woman portrayed here is in all likelihood Marie-Louise O'Murphy, nineteen years old at the time. She became the mistress of Louis XV after the artist showed him this canvas.

The untidiness at the foot of the sofa and the daring, sexy yet naïve pose give the impression that the painter has caught a secret, intimate moment in the life of this girl.

The masterly hues shaping the curvaceous flesh and the variously colored and textured fabrics are part of Boucher's usual style: he is the sensuous interpreter of his epoch.

▲ François Boucher, *Nude on the Sofa*, 1752. Munich, Alte Pinakothek.

He precisely reproduced the urban topography and also the atmosphere, air temperature, corroded walls, faded plaster, and constantly shifting light: the very essence of the city of Venice.

Canaletto

Giovanni Antonio Canal
Venice 1697–1768

**Principal place
of residence**
Venice

Travels
Rome (1719–20);
England (1746–56)

Principal works
Reception of the French Ambassador (1727–30, Saint Petersburg, Hermitage); *The Doge's Procession to San Rocco* (ca. 1735, London, National Gallery); *Interior of the Ranelagh Rotunda in London* (1754, London, National Gallery)

Links with other artists
He had a major influence on European *vedutismo*; his nephew Bernardo Bellotto was his most faithful disciple; Francesco Guardi and Michele Marieschi imitated him.

Canaletto studied art with his father, who was a painter of theater sets. In 1726, the Irish impresario Owen MacSwinney commissioned him to paint the architecture in two large paintings, part of a series of twenty-four canvases depicting imaginary funerary monuments for recent English historical figures. Canaletto gained a solid private clientele and in 1730 met Joseph Smith, who later became British consul in Venice and one of the painter's most important clients as well as his agent in the English market. From 1729 to 1734, Canaletto painted twelve views of the Grand Canal in which he discarded the strong chiaroscuros of his earlier works for a lighter, more luminous palette and adopted an objective, optically true rendering. In the 1740s, he worked mostly for Consul Smith, to whom he dedicated an album of etchings and thirteen *vedute ideate*, which today are part of the English Royal Collections. In 1746, Canaletto moved to England, where he spent about ten years. In London he painted many cityscapes including the four famous *Warwick Castle* scenes that were to have a strong impact on English landscape painting. He returned to Venice in 1760; his last works were panoramic *vedute* of Venice. Smith's entire collection of his paintings was purchased by King George III of England.

▶ Canaletto, *The Bucintoro Returns to the Wharf on Ascension Day*, 1730–35. Windsor, Royal Collections.

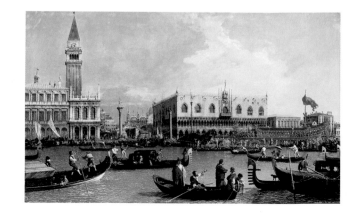

The church in the background is Santa Maria della Carità, with the Gothic Scuola della Carità on one side, today incorporated into the Gallerie dell'Accademia and served by the adjacent Accademia Bridge. The bell tower fell in 1744.

The clarity of the Venetian landscape contrasts with the thick brushstrokes of the foreground. The painter's eye leaves out nothing, not even the sheets hanging out to dry in the sun.

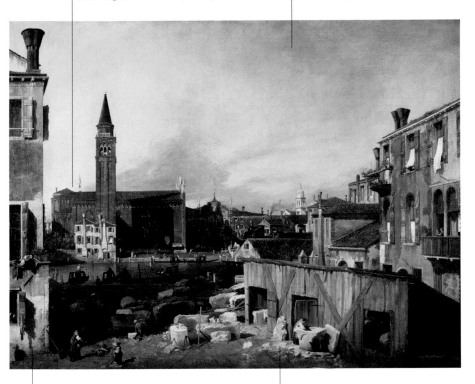

The modest building that serves as backdrop, the rectory, was to be demolished and rebuilt in a new form as part of a larger plan that was to include the erection of the marble façade of San Vidal.

The provisional nature of the site is hinted at by the stonemasons' shop and the presence of marble blocks and rough-hewn architectural pieces.

▲ Canaletto, *The Stonemasons' Yard in Campo San Vidal*, 1725. London, National Gallery.

Canova embodies a Neoclassicism of polished, smooth perfection. Beloved by popes and emperors, he evoked the ancient sense of the Beautiful, which in his sculptures reached sublime heights.

Antonio Canova

Possagno (Treviso)
1757–Venice 1822

**Principal place
of residence**
Rome

Travels
Rome (from 1779);
Naples, Paestum, Pompeii,
and Herculaneum (1780);
Vienna (1798 and 1805);
Paris and London (1815)

Principal works
Funerary monument of
Clement XIII (1783–92,
Vatican City, Saint Peter's);
Hercules and Lica
(1795–1815, Rome,
Galleria Nazionale d'Arte
Moderna); *Paolina Borgh-
ese Bonaparte as Venus
Victrix* (1804–8, Rome,
Galleria Borghese)

Links with other artists
In Rome he met Batoni,
Gavin Hamilton, the
engravers Giuseppe
Volpato and Raffaello
Morghen, and the
architect Selva.

▶ Antonio Canova,
Penitent Magdalene,
1793–96. Genoa, Museo
di Sant'Agostino.

Canova apprenticed in Venice. Very early in his career he fell in love with ancient Roman statuary and this feeling informed all his work. With the support of influential patrons, he went to Rome in 1779 to study both ancient and modern art. The lively cosmopolitan environment stimulated his style toward the formal perfection and proportion of classical art and completed his education. Canova embodies the Neoclassical theories developed by Winckelmann and Mengs and perfected in the refined environment of Villa Albani. The appreciation of foreign intellectuals brought Canova prestigious commissions from abroad as well. For Archduchess Maria Christina of Austria he designed a novel funerary monument with grieving allegorical figures entering a marble pyramid almost twenty feet high. His marble mythological statues seem to soften under the elegant form and restrained sensuality in which grace and measure are the leading guidelines, and these qualities contributed to his international fame. For Napoleon, the artist made half-length portraits of the imperial family. He was also an important cultural diplomat. In 1815, he was sent to Paris to negotiate the return of artworks that had been plundered by Napoleon's armies when they invaded Italy, thus asserting with a very modern sensibility that there is a link between a work of art and the place for which it was created.

For Canova, imitating ancient sculpture
was not a passive stylistic exercise but the
mandatory starting point upon which to
graft the exquisite grace of the settecento.

The three feminine figures
embody the Neoclassical
ideal of beauty: the slow,
flowing movements arise
one from the other and
dissolve into a calm
rhythmic movement that is
elegant and harmonious.

Canova's technique
produced an incredibly
smooth marble sur-
face, as polished as a
mirror and, like it,
capable of absorbing
and reflecting light.

This marble group was
made for Josephine
Beauharnais,
Napoleon's first wife,
who never saw the
completed work.

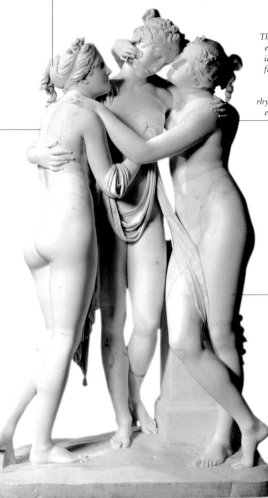

▲ Antonio Canova, *The
Three Graces*, 1813. Saint
Petersburg, Hermitage.

Carlone is an exemplar of the cosmopolitan Italian pictorial language that spread throughout the Catholic countries across the Alps during the 1700s, with uncontested success.

Carlo Innocenzo Carlone

Scaria d'Intelvi (Como)
1686/87–1775

Travels
Study periods in Venice and Rome; for thirty years he traveled in Austria, Bavaria, and Bohemia; after 1735 he returned to Italy, moving between Como and Scaria and worked intensely in both Venetian- and Austrian-ruled Lombardy

Principal works
Ludwigsburg Castle (1730–33); frescoes: Monza Duomo (1738–40), Augustusburg Castle, Brühl (1750–52), Asti Duomo (1766–68)

Links with other artists
The "Barocchetto" capricious style and somewhat sour palette he invented influenced Maulbertsch, Sigrist, and Baumgartner.

Carlone was born into a family of architects and stucco workers. He probably spent some time in Rome to complete his studies, and there met Francesco Trevisani, whose elegant, delicately nuanced style is echoed in his early works. In 1708, Carlone was working in Austria, painting frescoes in the Church of the Ursulines in Innsbruck. For more than thirty years he painted large frescoes in Austria, Bavaria, and Bohemia. He was very active in Vienna, where he moved in 1715. There, together with the *quadraturista* Marcantonio Chiarini of Bologna, he painted *The Glorification of Prince Eugene of Savoy* in the prince's Belvedere residence. In 1727, he was in Prague to decorate the Klam Gallas Palace, then in Würtenberg to complete the decorations of the Ludwigsburg Castle. He also found time to paint in the Ticino area and the region around Como because he often returned to his homeland in winter. In 1735, he moved back to Italy once and for all and worked on several commissions in Lombardy, opening his style to a new dialogue with Venetian painting, especially the works of Pittoni and Tiepolo, always stressing, however, his distinctive Lombard mark with compositions full of scalene angles and cool, shifting tonalities. He worked with his brother Diego, an elegant stucco artist. Together they decorated the entire parish church of their native village, Scaria d'Intelvi.

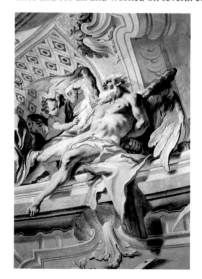

▶ Carlo Innocenzo Carlone, *Saturn in Chains*, detail of the staircase fresco, 1747–50. Brühl, Augustusburg Castle.

238

Cronus, the god of time, brutally kidnaps the young woman, since her life has come to an end. The allegorical meaning of the painting is the ravishing of Youth by Time.

A young, half-naked woman leans on a cloud after admiring herself in a mirror. From the floral wreath and the weeping Cupid, we understand that she is a bride.

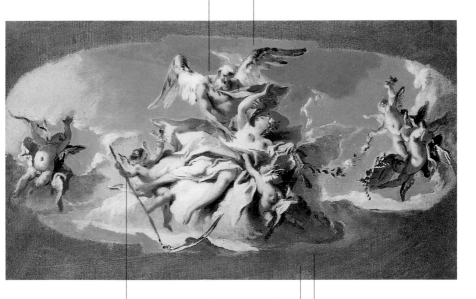

In this late work, done as his brilliant, successful career was winding down, the color palette lightens, the contrasts are toned town, and the whimsical capriccios so characteristic of his earlier work are on the wane, as we see in this sketch done with hasty workmanship and more than a touch of improvisation.

The putto at the girl's feet carries an hourglass and a long scythe, traditional symbols of death.

In the sketches done without the support of a preparatory drawing, Carlone's brush is nimbler, quicker, and more cutting, as we can see from the girl's rose-hued drapery and even the clouds' silhouettes.

▲ Carlo Innocenzo Carlone,
The Ravishing of Youth by Time, 1760–70. Bavaria, private collection.

A portraitist famous in Europe and a subtle interpreter of the ideals of grace and elegance, Rosalba Carriera took the delicate, refined strokes of the miniature to a higher level using the pastel technique.

Rosalba Carriera

Venice 1675–1757

Principal place of residence
Venice

Travels
Paris (1720–21); Modena (1723); Gorizia (1728); Vienna (1730)

Principal works
Portrait of Anton Maria Zanetti (1700, Stockholm, Nationalmuseum); *Girl with Dove* (1705, Rome, Accademia di San Luca); *Portrait of Metastasio* and *Portrait of a Man* (ca. 1725, Dresden, Gemäldegalerie); *Self-Portrait* (1744, Windsor, Royal Collections)

Links with other artists
She introduced the art of the pastel, especially in France, and set an example for the great pastel artists of the century such as Liotard and La Tour; in Paris she met Watteau.

We have little documentation about her training, and many of her works cannot be dated with certainty. Her earliest pastel production—supported by Joseph Smith, the British consul in Venice and a passionate collector—predates 1700, which is when her *Portrait of Anton Maria Zanetti* was executed. A small ivory miniature, *Girl with a Dove*, submitted to the Accademia di San Luca in Rome as an *oeuvre de réception*, dates from 1705. The prestigious commissions of Duke Christian Ludwig of Mecklenburg, the Palatinate Elector Johann Wilhelm Pfalz, and King Frederic IV of Denmark sealed her fame as a fashionable portraitist among the European aristocracy, in particular the foreign notables who visited Venice. During her stay in Paris she met Coypel, Watteau (she painted his portrait), Detroy, and Largillière, all of whom influenced her work, directing it toward the international-style French Rococo. Her half-length, three-quarter portraits, unequaled for their fine touch and the delicate transitions and shading, fully interpreted the ideals of grace and

▶ Rosalba Carriera, *Self-Portrait*, 1746. Venice, Gallerie dell'Accademia.

elegance of contemporary high society and brought a sharp psychological and emotional introspection to the individual portrayed. Some of her best works are *Portrait of Metastasio*, *Portrait of a Man*, and her *Self-Portrait* (Windsor, Royal Collections). She continued to work until 1747, when her eyesight gradually began to fail.

240

This pastel was one of a series dedicated to the four parts of the world: Europe, Asia, *and* America *were lost when Dresden was destroyed.*

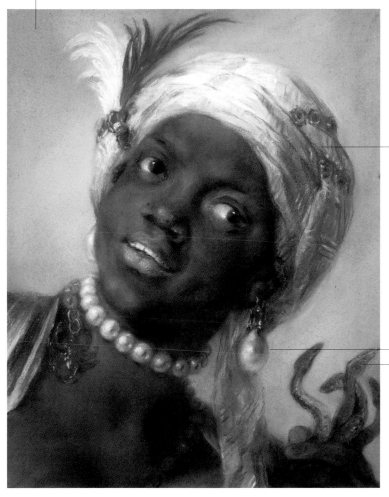

The special effects of radiance, fragility, and transparency could be achieved with pastels, a material imbued with light that is robust and airy at the same time.

The precious pearl-like iridescence of turban, necklace, and large earrings is achieved with a skillful and experienced use of the pastel technique.

This dark-skinned girl is an allegorical representation of the African continent; the tangle of snakes she holds in her hand and the scorpion pendant are traditional attributes of wildness.

▲ Rosalba Carriera, *Allegory of Africa*, ca. 1730. Dresden, Gemäldegalerie.

"Portraits of common, unhappy men, with no comments, but large as life," wrote Roberto Longhi about this heir of the Lombard tradition of painting "real things from nature."

Giacomo Ceruti

Milan 1698–1767

Principal place of residence
Brescia and Milan

Travels
There is little documentation about his travels. He was in Brescia starting in about 1720; Venice in 1736, then Padua; Milan in 1742–43, then Piacenza.

Principal works
Evening in the Piazza (ca. 1730, Turin, Museo Civico d'Arte Antica); *The Porter (Il Portarolo)* (ca. 1735, Milan, Pinacoteca di Brera); *Young Girl with Fan* (ca. 1740, Bergamo, Accademia Carrara)

Links with other artists
The pauperist style became popular thanks to painters such as Magnasco, Cifrondi, and Cipper but, unlike Ceruti, they still stressed the anecdotal, humorous, or moral aspects of the genre.

Almost forgotten by the literature of his time and by the 19th century, Ceruti was rediscovered by art historian Roberto Longhi in 1927. He first made his reputation in Brescia when the Venetian *podestà* Andrea Memmo commissioned from him a series of historical portraits (now lost) to be hung in the Broletto Palace. Ceruti began at this time an intense meditation on poverty. Often his canvases on this theme are large, thus bestowing on beggars and wretches a sort of majestic dignity, a very different approach from the ironic, often picaresque portraits of common folk by Todeschini and Cifrondi. In these works, and particularly in the cycle originally painted for the Avogadro family, Ceruti displays a deep knowledge of the French and Dutch "pauperist" painting of the previous century (from Le Nain to the *bamboccianti*, in the Italian works of Michiel Sweert and Eberhard Keil), but unlike them, he became very attuned to the more perceptive, modern currents of Italian progressive Catholic thought of those years. In 1736, he was in Venice as a protégé of Marshal Matthias von Schulenburg, whose portrait he painted. In his later works, Ceruti exhibited a more elaborate and refined pictorial quality built upon the suggestions of the Venetian art of his day, from Ricci to Pittoni, Piazzetta, and Tiepolo. In his mature works he painted pastoral themes and the new Arcadia with limpid, chromatic applications of paint, often drawing inspiration from prints of the same themes by Bloemart and other old Flemish and Dutch masters. These late works in turn influenced Londonio, Corneliani, and other artists of the Lombard Enlightenment.

▶ Giacomo Ceruti, *Still Life with Bread, Salami, and Walnuts*, 1750–60. Private collection.

The two beggars look the viewer in the eye: Ceruti does not intend to seek compassion but portrays a disenchanted, lucid j'accuse.

The painter inherited Lombard realism and an interest in the world of humble folk, mindful of the 16th-century examples of Moretto and Moroni.

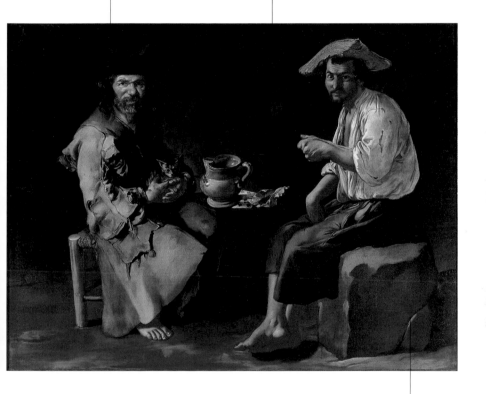

The spare furnishings consist of a straw-covered chair, a stone block, and a bleak table with a pitcher, yet the setting is monumental, like a large altarpiece.

▲ Giacomo Ceruti, *The Two Beggars*, ca. 1730. Brescia, Pinacoteca Tosio Martinengo.

Giacomo Ceruti

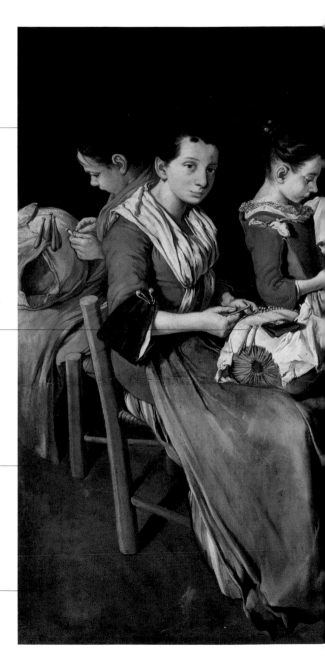

The little girl standing in the center of the group seems to break the monotony of the work by reading out loud from an open book.

The "sewing school" theme was rather popular in genre painting because of its pauperist implications. It was probably introduced by Eberhard Keil (known as Monsù Bernardo), a Danish painter who was very active in northern Italy.

This is one of the most well-known and moving scenes from the so-called Padernello cycle, discovered by Delogu at Salvadego in 1931. It originally hung in the Brescia residence of the aristocratic Avogadro family.

The lesson takes place in a bleak setting without any spatial elements. The scene becomes disturbing as one realizes that all the women bear a physical resemblance to each other.

▶ Giacomo Ceruti, *The Sewing School*, 1720–30. Brescia, private collection.

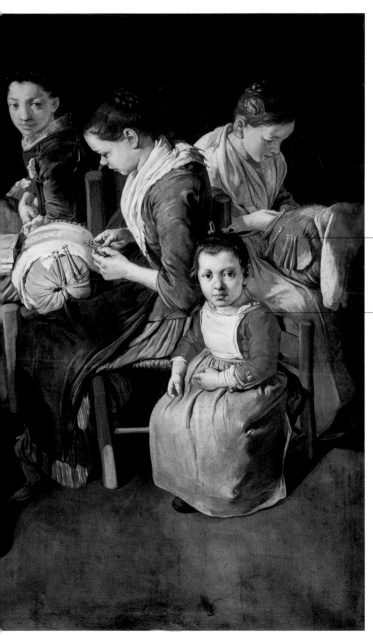

The women, plainly dressed and seated on plain straw-covered chairs, still project great dignity and are well groomed, as we can see from the rose a girl has arranged in her hair and the pretty striped skirts of two of the girls.

Some of the girls look at the viewer with a directness mixed with melancholy and resignation, almost an invitation to human understanding and solidarity, as if the artist had immersed himself in the unhappy existence of these women.

Chardin created a world out of time, silent and well-ordered, by using simple techniques such as rubbing lead-whites, browns, and blues across the humblest everyday objects.

Jean-Baptiste-Siméon Chardin

Paris 1699–1779

Principal place of residence
Paris

Principal works
The Buffet and *The Race* (1725–26 and 1728, Paris, Musée du Louvre); *The Young Schoolmistress* (ca. 1736, London, National Gallery); *The Card Castle* (1737, Washington, D.C., National Gallery); *Morning Grooming* (1745, Stockholm, National-museum); *The Peach Basket* (1768, Paris, Musée du Louvre)

Links with other artists
Today's readers may detect analogies with modern artists such as Cézanne or Morandi. Manet was one of the first to rediscover his teaching: in 1867 he painted *Soap Bubbles* after a 1739 painting by Chardin.

▶ Jean-Baptiste-Siméon Chardin, *Self-Portrait*, 1775. Paris, Musée du Louvre.

A master of silence and light, Chardin's work is the antithesis of the Parisian court art and the fashions of his time. He is one of the few great artists who did not make the prescribed trip to Rome or attend regular courses at the Academy. His success in 1728 from his first still lifes—studied geometric compositions—gradually brought him fame. The intimate, touching poetry of his still-life paintings is amazing. There are understated arrangements made precious by whites and pale blues, a slight blurring that throws a gentle mist over the profiles, a thin layer of dust falling silently on things—everyday, humble, banal household implements and tools. Starting in 1732, he began to paint genre scenes, which were considered more elevated than still lifes because they included the human figure; in doing so, he turned to 17th-century Flemish and Dutch art, choosing an understated range of muted, monochrome colors to paint carefully observed scenes of bourgeois family life, daily habits, repetitive gestures, and restrained emotions. His

brushstroke is thick with dense impastos, the light is vibrant and warm. In 1771, he turned to pastels, a technique that he used only for portraits, in which he scrutinized his subjects' features with the same Cartesian care and optical precision that he used when painting fruits or game in his still lifes.

The almost monochromatic background works very well at setting off the plastic rendering of the young girl.

It was precisely paintings such as this that made Chardin greatly successful at the Salon of 1737, when he exhibited seven paintings of genre scenes.

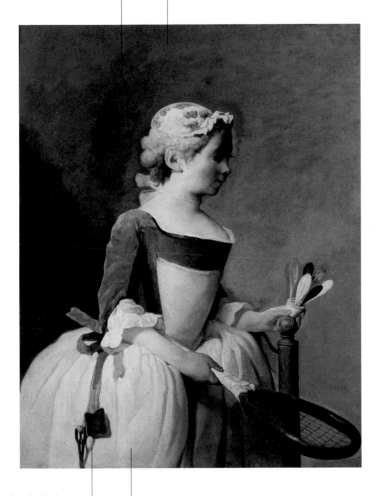

The refined, chromatic arrangements of the whites in the skirt, the browns in the corset and the chair, and the rosy color of the flesh appear heightened by the touches of blue in the ribbon, from which hang a small pair of scissors and a pin cushion.

The rational, essential vision of Chardin's world is expressed in compositions that exist outside time and space: here, the girl is like a vision, endowed, however, with an exact, even if sometimes evasive, sense of solidity.

▲ Jean-Baptiste-Siméon Chardin, *Young Girl with Shuttlecock*, 1737. Florence, Gallerie degli Uffizi.

Caught in a faraway memory, an emotion, or simply lost in thought, this servant participates as a protagonist in this extraordinary "still life" in which every utensil is rendered with supreme mastery.

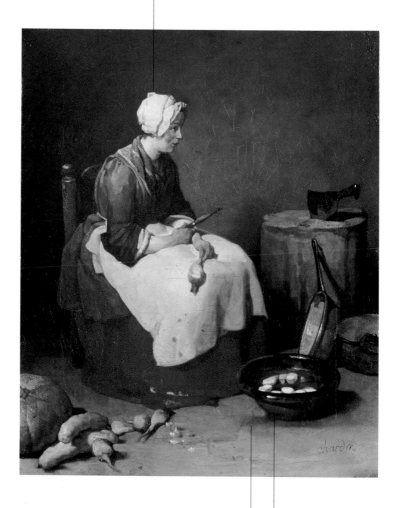

▲ Jean-Baptiste-Siméon Chardin, *The Cook*, ca. 1740. Munich, Alte Pinakothek.

The domestic interiors are filled with the humble implements favored by 17th-century Dutch painters, but here they lose their allegorical significance: the cook is simply peeling turnips.

Although Chardin stayed away from academic notions, this composition in the classic pyramid shape reveals a solidity of form and color that would speak to Cézanne a century and a half later.

Pigalle's Mercury, *a symbol of sculpture,
is set between the attributes of painting
(the color palette and brushes) and of
architecture (plans and measuring tools).*

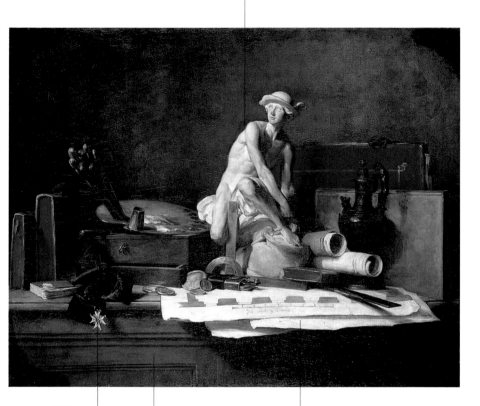

*The honors
bestowed upon the
arts, such as the
medal of the Order
of Saint Michael
awarded to the
sculptor Pigalle in
1765, are also
included in this
composition.*

*Chardin closely scrutinizes
each material, each color
nuance. He makes tangible
the texture of the volumes
and the incandescence of the
light that envelopes them.*

*Catherine II ordered this canvas
for the main salon of the Saint
Petersburg Fine Arts Academy
but was so pleased with it that
she chose to hang it in her private
quarters in the Winter Palace.*

▲ Jean-Baptiste-Siméon Chardin,
Still Life with Attributes of the Arts,
1766 Saint Petersburg, Hermitage.

His portraits found much favor with the upper class of New England, at the time still an English colony. In London, Copley began a new career as a painter of contemporary historical events.

John Singleton Copley

Boston 1738–
London 1815

**Principal place
of residence**
Boston and, after
1775, London

Travels
New York (1771);
London, Paris, Genoa,
and Rome (1774–75);
London (1775–1815)

Principal works
The Copley Family
(1776–77, Washington,
D.C., National Gallery);
*The Death of Major
Peirson* (1782–84,
London, Tate Gallery);
*The Three Younger
Daughters of George III*
(1785, Windsor, Royal
Collections)

Links with other artists
He trained on the English
art that was available to
him through prints and
by contacts with local
painters. Urged by his
contemporary and fellow
countryman Benjamin
West, in 1774 he
embarked on the Grand
Tour of Europe.

▶ John Singleton Copley,
*Brook Watson and the
Shark*, 1782. Detroit,
Institute of Arts.

Copley apprenticed around the middle of the century in the middle-class mercantile town of Boston, a major port for trade with the mother country. His early apprenticeship in half-tone etching shaped his manner of gradually distributing light and shadow in search of a subdued, refined *colorismo*. In his portraits we see the will to fuse a formal, classical vision of society with the search for an everyday, natural spontaneity. His trip to Europe was crucial to his career. He never returned to the States, for after learning of the American War of Independence, whose first skirmishes had been seething in Boston since 1770, he moved to London with his family in 1775. There he fell into the good graces of King George III and became a member of the Royal Academy. In his London period, the artist still made portraits, but they lacked the concrete, intimate sweetness of psychological sympathy with the portrait subjects, which were salient traits of his American period. Following Benjamin West, his interests now turned to contemporary historical subjects; his vocation for current events was strengthened along with his determination to find in the present the same examples of civic

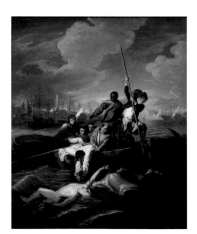

virtue, moral pride, and dignity that were in the ancient models spread by Neoclassical art throughout Europe. Significant examples of his later interests are *The Death of Major Peirson* (1782–84, London, Tate Gallery) and *The Siege of Gibraltar* (1783, London Guildhall Art Gallery).

On April 7, 1778, during a debate in the House of Lords on the American Revolution, the Earl of Chatham, who opposed recognizing the independence of the American colonies, suffered a stroke and died a few days later.

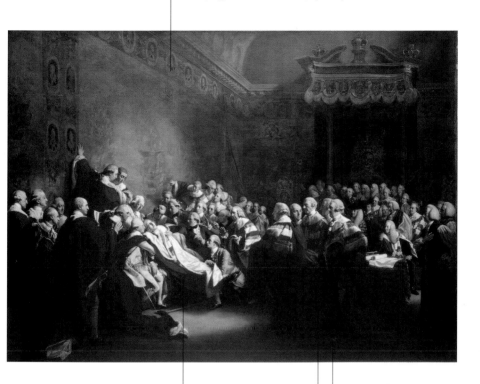

The earl was the war minister, and with him the English succeeded in recapturing the supremacy of the European seas and destroying France's hegemony in India and in North America, specifically Canada.

Returning to a theme already explored by Benjamin West a year earlier, Copley advanced the "realist revolution" inaugurated by the latter: he even added into the painting authentic portraits of the men who witnessed the event.

William Pitt (1708–1778), 1st Earl of Chatham, was a fierce opponent of Horace Walpole. He argued for the need to wage war against the French and Spanish naval powers and became an advocate for British imperial aims.

▲ John Singleton Copley, *The Death of the Earl of Chatham,* 1779–80. London, Tate Gallery.

Departing from academic rules, Crespi touched with vigorous naturalness and smiling bonhomie on everyday, popular themes, painting them in a quivering light full of contrasts.

Giuseppe Maria Crespi

Bologna 1665–1747

**Principal place
of residence**
Bologna

Travels
Study trips to Parma,
Urbino, and Venice;
Pistoia (1691); Leghorn
(1708); he was a guest
of Grand Prince Ferdinand
in the Medici Pratolino
Villa (1709)

Principal works
The Poggio a Caiano Fair
(1709, Florence, Gallerie
degli Uffizi); *The Scullery
Maid* (1710–15, Florence,
Gallerie degli Uffizi); the
series *The Sacraments*
(ca. 1712, Dresden,
Gemäldegalerie)

Links with other artists
A student of Canuti and
Cignani, he shared an
atelier with Antonio
Burrini, the fieriest of the
Bolognese painters; he
was attracted by the spon-
taneous, natural work of
the early Guercino.

Early in his career, Crespi was already distancing himself from the tradition of Guido Reni. Composed in dark tonalities and strong contrasts, his early altarpieces show a new meditation on the origins of the Bolognese school, poised between Ludovico Carracci and Guercino. In the first years of the century, he painted two frescoes in the Palazzo Pepoli in Bologna. He became part of the group of favorite painters of Grand Prince Ferdinand of Tuscany and pre-sented him in 1708 with *The Slaughter of the Innocents* (Florence, Gallerie degli Uffizi). It was well received for the *sprezzato*, unfin-ished touch, which was as daring as the canvases of Magnasco, a protégé of the prince. The works Crespi created for his patron reveal his intelligent curiosity about the many Dutch and Flemish paintings that he studied in the Medici collections. He increasingly turned to these for an approach that gradually became less academic and more keenly focused on everyday themes. This new bent was imme-diately reflected in *The Confession*, which sources say he painted without commission, simply out of a desire to capture on canvas a light effect he had casually noticed in the shadow of a Bolognese church. Cardinal Pietro Ottoboni saw the canvas and liked it so much that he suggested that Crespi paint a full series of the seven

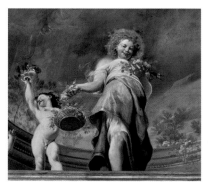

▶ Giuseppe Maria Crespi,
Spring, detail from *The
Triumph of Hercules*, ca.
1707. Bologna, Palazzo
Pepoli Campogrande.

sacraments. Crespi contin-ued to alternate church or mythological subjects with genre scenes, often favoring bizarre, Rembrandtesque lighting effects in a brown-ish, dark palette and reach-ing a populist naturalism that further turned him away from the conformity of the Clementine Academy.

These two fictive bookcases full of dusty music books and musical scores, hastily leafed through and rearranged, are an authentic masterpiece of the European settecento still-life genre.

This canvas was probably commissioned by Father Giovan Battista Martini, a well-known Bolognese musicologist and music critic who was respected and feared throughout Europe.

▲ Giuseppe Maria Crespi, *Shelves with Music Books*, ca. 1725. Bologna, Civico Museo Bibliografico Musicale.

Giuseppe Maria Crespi

The liberties that Crespi took in the usual hierarchy of genres also apply to the religious themes of The Sacraments series: the approach to the divine is intentionally situated in the quotidian sphere and is devoid of rhetoric.

This painting was purchased in Bologna in 1743 by Charles Emmanuel III of Savoy. It is a later version of a painting on the same theme that now hangs at the Dresden Gemäldegalerie.

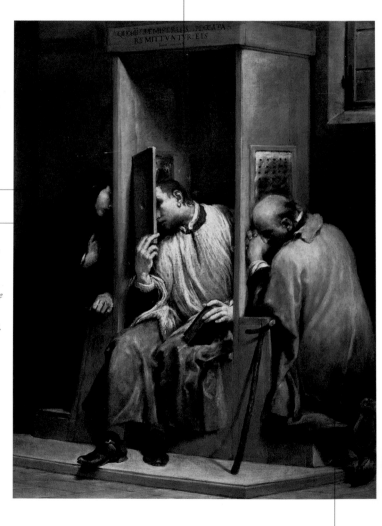

▲ Giuseppe Maria Crespi, *Saint John Nepomuk Hears Confession from the Queen of Bohemia*, ca. 1740. Turin, Galleria Sabauda.

The close focus, the simplified composition, and the few, essential figures suffice to express the sacred nature of the event; accordingly, the light from above falls only on the confessor and on the man who has already received absolution and is now praying.

"What I had to do for France, I did. I founded a brilliant school; I created classical works that all of Europe will study. I have done my duty" (David).

Jacques-Louis David

David, like Canova, found in Rome a new way of making art. Coming into direct contact with ancient sculpture and with Italian masters such as Raphael and Guido Reni, he freed his canvases of decorative and anecdotal elements enthusiastically. He embraced the Neoclassical imperatives of an art that tended toward the synthesis, severity, and spare monumentality of Greek and Roman antiquity, an art that could stimulate civic and moral virtues, thanks to examples from the past. In this sense, *The Oath of the Horatii* (1784; p. 110) was seen as the work that prefigured the 1789 Revolution. David became the representative painter of Neoclassicism, an artist actively engaged in political life and one who believed completely in the Revolution's ideals. In 1799, during the Directory, in sharp contrast with the Salon, David organized the first art show that charged an admission fee, and displayed his large canvas *The Sabine Women* (Paris, Musée du Louvre), evidence of his growing interest in the purity of Greek statuary and in a more nuanced palette than his previous works. He hailed Napoleon as the embodiment of the libertarian demands of the New France and became his official painter.

Paris 1748–Brussels 1825

Principal place of residence
Paris

Travels
Rome (1775–80, 1784); in exile in Brussels (1816–25)

Principal works
Hector (1778, Montpellier, Musée Fabre); *The Lictors Bring to Brutus the Bodies of His Sons* (1789, Paris, Musée du Louvre); *The Oath of the Tennis Court* (unfinished; 1781, Versailles, Musée National du Château); *The Death of Marat* (1793, Brussels, Musées Royaux des Beaux-Arts; p. 118); *The Crowning of Napoleon and Josephine* (1805–7, Paris, Musée du Louvre)

Links with other artists
On Boucher's advice he began to work in Vien's atelier and traveled with him to Rome in 1775.

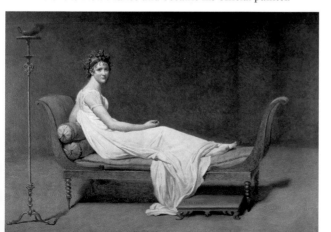

◄ Jacques-Louis David, *Portrait of Madame Récamier*, 1800. Paris, Musée du Louvre.

The sketchbook belongs to Marie-Anne-Pierrette Paulze, the chemist's wife; she may have been a student of David's and illustrated her husband's work.

In 1755, Antoine-Laurent Lavoisier enunciated the law that still bears his name, the Lavoisier Law of Conservation of Mass: "In a chemical reaction in a closed system, the mass of the reactants must always equal the mass of the products."

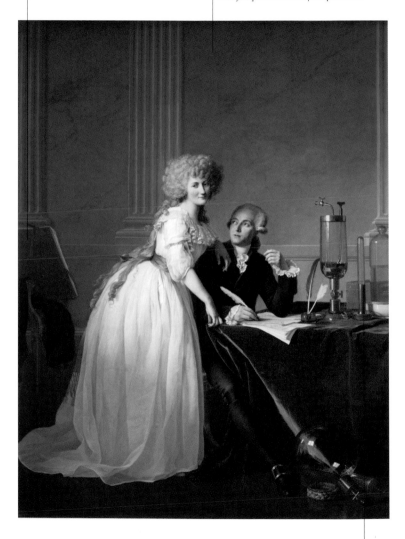

▲ Jacques-Louis David, *Monsieur and Madame Lavoisier*, 1788. New York, Metropolitan Museum of Art.

David gives us an affable, almost domestic image of the couple: the scientist sits at the desk surrounded by research instruments and writes, while his wife looks on with an amiable, understanding expression.

On May 20, 1800, Napoleon Bonaparte and his 32,000 chosen men crossed the Alps at the Great Saint Bernard Pass en route to his second Italian campaign.

David saw in Napoleon the reincarnation of a classical myth: the celebration of his splendor was an occasion for grandly evoking an entire era and illustrating the apotheosis of an ideal figure.

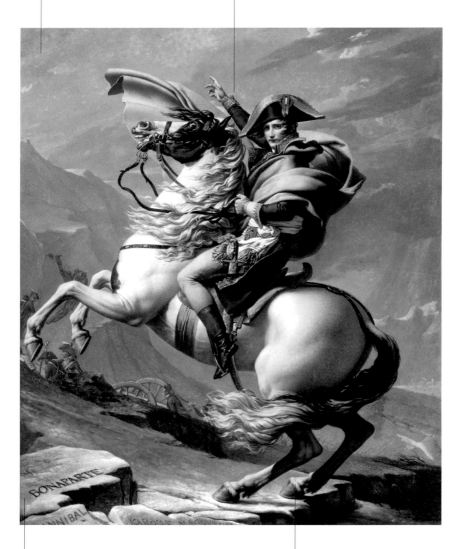

On the rocks are inscribed the names of the great leaders who crossed the Alps: Hannibal, Charlemagne, and now Bonaparte.

Napoleon's vitality is heightened by the lines of strength directed upward: even the mantle and the horse's mane obey the movement imparted by Napoleon's command.

▲ Jacques-Louis David, *Napoleon at the Great Saint Bernard Pass*, 1800. Malmaison, Castle.

The portrait reached its highest expressive form thanks to his unequaled blend of technical dexterity and introspective acumen, revealing the weaknesses and vanities of humankind.

Fra' Galgario

Vittore Ghislandi,
Bergamo 1655–1747

**Principal place
of residence**
Bergamo

Travels
To Venice from 1675,
and after 1689 for about
twelve years; returned to
Bergamo (1702–5); to
Bologna (1718–19)

Principal works
*Portrait of a Young
Painter* (ca. 1725,
Cologne, Wallraf-Richartz
Museum); *Portrait of a
Knight of the Order of
Constantine* (ca. 1740,
Milan, Poldi Pezzoli)

Links with other artists
In Venice he frequently
visited the studio of the
Friuli portraitist Sebastiano Bombelli. He was in
contact before 1709 with
Salomon Adler, a painter
active in Bergamo and
Milan, and with Giuseppe
Maria Crespi in Bologna.

Trained in Venice, Fra' Galgario entered the religious order of Saint Francis of Paola. He returned to Bergamo (the date is uncertain), where he joined the Galgario convent of his order, from which he took the nickname. His Venetian works, mentioned in sources, are lost. In Bergamo, his reputation was as a portraitist of the rich local gentry, as can be seen in his series of full-size portraits of the Rota and Secco Suardo families. These works, which show strong Venetian influence, Bombelli's especially, are filtered through the local 16th-century naturalistic tradition that had its best representative in Giovan Battista Moroni. Fra' Galgario's free application of paint, an objective, analytic rendering of his subjects, a disenchanted, ironic outlook, and refined chromatic arrangements are characteristic of his early 18th-century works. He also painted "character heads," usually of boys, that are mostly decorative but sometimes have moralizing undertones. In addition to being popular with the local Bergamo aristocracy, he had numerous prestigious foreign clients that included the Austrian governors of

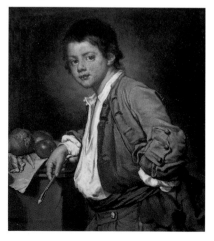

Milan. His mature work shows heightened psychological penetration and increased brilliance in color, the latter from using lacquers of his own invention. His latest canvases, drenched in light, exhibit free-flowing paint that he often applied with his fingers and a sharp physiognomic and psychological portrayal of his subjects.

▶ Fra' Galgario, *Portrait of a Young Painter*, ca. 1732–35. Bergamo, Accademia Carrara.

Little is known of Count Vailetti's life, only that he was listed as a "chapel deputy" in a contract drawn up with Giambattista Tiepolo for the frescoes of Episodes of the Life of Saint John the Baptist *in the Colleoni Chapel in Bergamo (1733).*

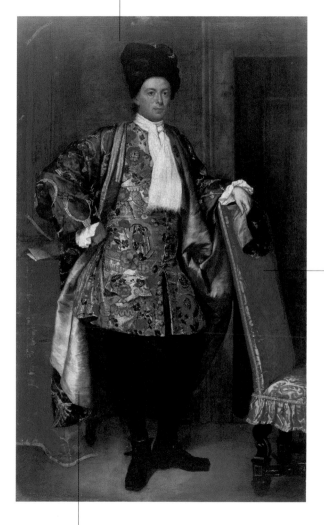

Setting aside his usual austerity, Fra' Galgario created one of his most sumptuous paintings here: the wealth of chromatic arrangements is clear in the cross-references and pairing of the rich gown, the chair upholstery, and the red velvet that covers the table in the back.

Over a long red-and-gold damask silk tunic, the man wears a black fur hat and an ornate, full-length chamber robe (the zimarra) *with gold designs.*

▲ Fra' Galgario, *Portrait of Count Giovan Battista Vailetti,* ca. 1720. Venice, Gallerie dell'Accademia.

Fra' Galgario

Even in this private moment, the gentleman on the left projects an air of self-confidence, with his clothes unfastened and no wig.

The rich colors and confident brushstrokes are a constant in Fra' Galgario's portraits.

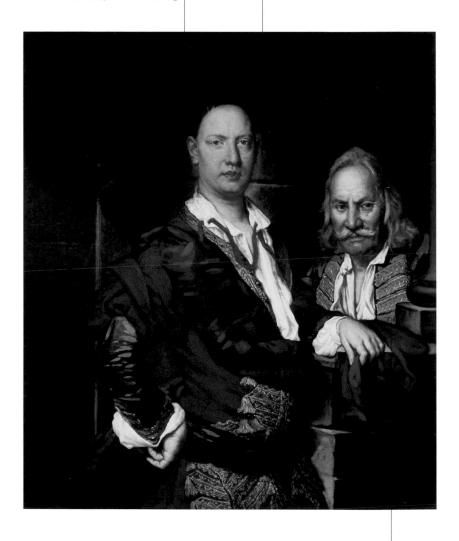

▲ Fra' Galgario, *Portrait of Count Giovanni Secco Suardo with His Servant*, 1720–22. Bergamo, Accademia Carrara.

Behind him is the keen-eyed servant, a lively presence even though he is relegated to the background. In contrast to the proud demeanor of his master, his face expresses a working man's awareness of life experience and humanity. He is a sort of alter ego to the count.

The traditions of Venetian painting and Rembrandt inspire his plays on light and his free, nervous brushstrokes. In Arcadian scenes, coy ladies and their lovers play seductive, allusive games.

Jean-Honoré Fragonard

His early paintings, such as *A Young Woman Crowns a Bagpipe Player* (ca. 1752, London, Wallace Collection), already reveal the enthusiasm and exuberance that would mark his art. Fragonard's Italian years (1756–61) were the most prolific of his entire career. He came into direct contact with the great masters, who continued to inspire him, and saw natural landscapes that he drew in very sensitive sketches. He soon gave up an academic career to devote his time to a clientele of art aficionados who hailed mostly from the financial world and the theater. In the 1760s he made many paintings for their boudoirs with seductive, erotic, Arcadian themes and genre scenes. His fertile imagination reached its apex with *Fantasy Portraits*, about fifteen of them painted from 1769 to 1770 and often completed in just one hour's work. The quick, nervous strokes form densely colored stripes moved by a frenzy that resembles the brushstrokes of Franz Hals, like slashes of light applied without a preparatory sketch. After 1770, artistic taste took a turn toward a new austerity that did not agree with Fragonard's spontaneity and free execution. Assisted by his former student David, who helped him secure the post of curator of the soon-to-be-built museum (the future Louvre), Fragonard renewed his style and inspiration in the direction of a pre-Romantic discovery of strong emotions.

Grasse 1732–Paris 1806

Principal place of residence
Paris

Travels
Italy (1756–61); Holland (ca. 1772); Provence, Italy, and Austria (1773–74)

Principal works
The Bathers (1763–64, Paris, Musée du Louvre); *Portrait of the Abbot of Saint-Non* (1769, Paris, Musée du Louvre); the series *The Progress of Love* (1771–73, New York, Frick Collection); *The Latch* [Le verrou] (ca. 1777, Paris, Musée du Louvre)

Links with other artists
He was Boucher's student and a friend of Hubert Robert and the Abbot of Saint-Non, a young, rich art lover; with the latter he explored Italy. He was inspired by the light effects and brushstrokes of Rembrandt and Hals.

◀ Jean-Honoré Fragonard, *Girl with a Dog (La Gimblette)*, 1765–72. Munich, Alte Pinakothek.

Jean-Honoré Fragonard

The young man steals a quick kiss after stealthily entering the room from a side door and raising the young girl from her sewing work. Fragonard has masterfully created the sensation of a quick moment in the life of the lovers.

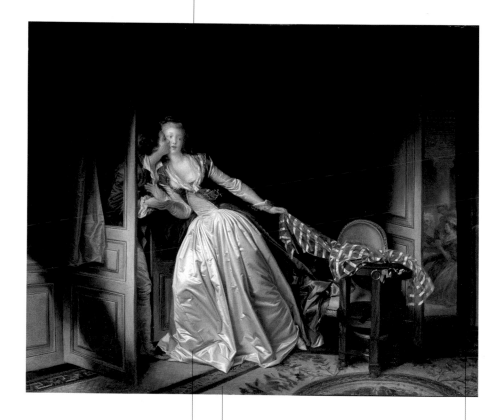

Fragonard's exceptional technical talent is evident in the rendering of the many surfaces of this canvas: from the silk of the dress to the shiny wood of the small table, from the airy transparency of the veil to the velvety shine of the carpet.

This canvas, once owned by Stanislaus Augustus Poniatowski, the last king of Poland, is directly inspired by the genre painting of the 17th-century Dutch school, for it depicts a gallant scene from everyday life set in a bourgeois context.

Behind the door, people are playing a game, unaware of what is transpiring in the room; this solution evokes Flemish models in the way one room opens into another.

▲ Jean-Honoré Fragonard,
The Stolen Kiss, 1765–70.
Saint Petersburg, Hermitage.

This is a typical scene from bourgeois life, part of a series portraying young women absorbed in private activities, modeled after similar Flemish compositions of the previous century.

This young woman, seen in profile on a neutral background, has an absorbed expression; her hand holding the small book has an intentionally affected pose.

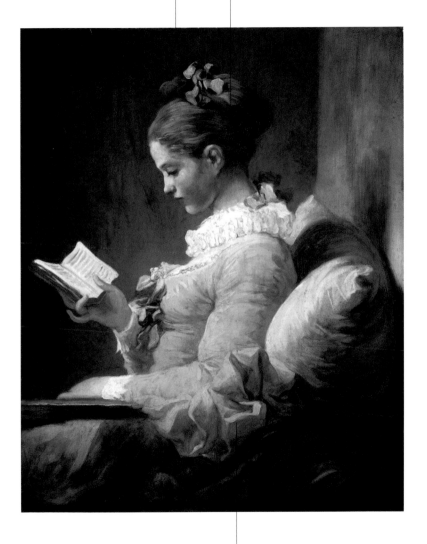

The fluid touch and the rich nuancing in this symphony of yellows recall Boucher's work while also seeming to anticipate Impressionistic qualities, especially those of Renoir.

▲ Jean-Honoré Fragonard, *A Young Girl Reading*, ca. 1776. Washington, D.C., National Gallery.

Fuseli painted hallucinatory, unreal visions: an interpreter of the restlessness of a generation that bridged the two centuries, he was a harbinger of the incipient Romantic sensibility.

Henry Fuseli

Born Johann Heinrich
Füssli
Zurich 1741–
London 1825

**Principal place
of residence**
London

Travels
Berlin and Swedish
Pomerania (1763);
London (1764); Rome
(1770–78); permanently
in London from 1779

Principal works
The Three Witches (1783,
Zurich, Kunsthaus); *Thor
Slaughters the Serpent
Midgard* (1790, private
collection); *The Nightmare*
(1790–91, Frankfurt,
Goethe Museum)

Links with other artists
He translated Winckel-
mann's *Reflections on the
Imitation of Greek Art* into
English (1765) and wrote a
polemical essay on the art
of Rousseau (1767). In
Rome he studied Michelan-
gelo; in 1816 Canova
admitted him to the Accad-
emia di San Luca.

▶ Henry Fuseli, *The Oath
of the Three Confederates
on the Rütli*, 1780.
Zurich, Kunsthaus.

The last decades of the 18th century saw the eruption of emotional, irrational elements that signaled the emergence of a new, pre-Romantic sensibility. Fuseli's work belongs to this tendency. Educated in classical literature in Zurich, he turned to painting in London, in 1768. After eight years in Rome spent studying both ancient and modern art, he developed a style that remained unchanged throughout his long career: he dedicated his work to the sublime, to what was dark, spectral, or magical. He was even described as "the most important mind and painter in the service of the devil." The dream is a constant theme, as in *The Nightmare* (1781, Detroit Institute of Arts), drawn from his reading of English poets such as Shakespeare and Milton. For the first time, an artist painted the subconscious and its ravines, and in his work the spirits

and ghosts of the night become concrete, frightful presences. In 1786, Fuseli showed his canvases with Shakespearean subjects in a collective exhibition, *The Shakespeare Gallery*. This was followed in 1799 by his *Milton Gallery*—a financial fiasco, though it won critical praise. His theory of art is illustrated in the twelve academic lessons he gave from 1801 to 1823 and in the posthumously published aphorisms about the most important artistic debates of his time.

On the left, two fairies dressed in contemporary garb act as ladies-in-waiting. Bottom allows his ass's head to be stroked by Peaseblossom, who is also in contemporary dress.

This scene is drawn from Shakespeare's A Midsummer Night's Dream *and is part of the series of canvases executed for* The Shakespeare Gallery.

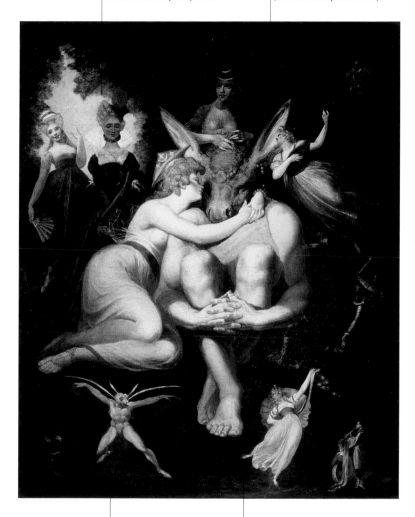

▲ Henry Fuseli, *Titania and Bottom with the Ass's Head,* 1793–94. Zurich, Kunsthaus.

The group is surrounded by fairies and musical and dancing sprites, including one in the foreground in the form of an insect, drawn from Jacques Callot's Dancers of the Commedia dell'Arte *series.*

The comedy takes place in a fabled time and place in which elements from Latin literature are fused with English folklore. The leading characters are Oberon and Titania, respectively king and queen of the fairies, and the sprite Puck. At the end, after contretemps and misunderstandings, everyone meets in a forest at night.

An inspired master of portraiture and painting the English countryside, he discovered the value of atmosphere and of closely fusing figures and the natural landscape.

Thomas Gainsborough

Sudbury (Suffolk) 1727–London 1788

Principal place of residence
Bath and London

Travels
London (1740–48); Sudbury (1748–52); Ipswich (1752–59); Bath (1759–74); London (1774–88)

Principal works
Mr. and Mrs. Andrews (ca. 1750, London, National Gallery); *The Artist's Daughters* (1760–61, London, National Gallery); *The Harvest Wagon* (1767, Birmingham (England), Barber Institute); *Mrs. Grace Dalrymple Elliott* (ca. 1778, New York, Metropolitan Museum of Art)

Links with other artists
A rival of Reynolds, he studied paintings in English collections by such masters as Van Dyck, Rubens, Van Ruysdael, Murillo, Watteau, Fragonard, and Greuze.

He trained in London on the French Rococo art that was popular in 18th-century England and began his career making portraits for the gentry of his native Suffolk, but even then he did not neglect landscape painting, his favorite genre. He used Dutch compositional techniques combined with a sympathetic observation of nature and carefully reproduced natural effects of light and shadow, which he captured in numerous sketches from life. Throughout his career he displayed his genius in both genres, achieving in each a perfect integration of nature and culture, spontaneity and artifice, luministic sensitivity and psychological insight. In 1759, he moved to Bath, a famous spa and an ideal spot for a portraitist. In 1774, he settled permanently in London, where his work reached the highest refined elegance at the service of prestigious clients such as King George III and Queen Charlotte. He was clearly inspired by the Van Dyck portraits that hung in English collections: from him

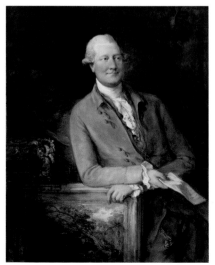

he took the flowing, free brushstroke, the virtuosity of clothing details, the compositional organization, the monumental settings, and the harmonizing with landscape elements in the background. Years later, Gainsborough's style would become more restrained and spare, closer to the intimate, profound essence of the landscape and of the men and women he portrayed.

▶ Thomas Gainsborough, *Portrait of James Christie*, 1778. Los Angeles, J. Paul Getty Museum.

Landscape painting, one of Gainsborough's passions, finds its optimum expression here, fused with an intimate psychological scrutiny of the individuals.

Elizabeth wears an ivory silk dress fastened at the waist by a black sash and an extravagant hat with a wide band and ostrich feathers. Lacework and satin are rendered with swift strokes.

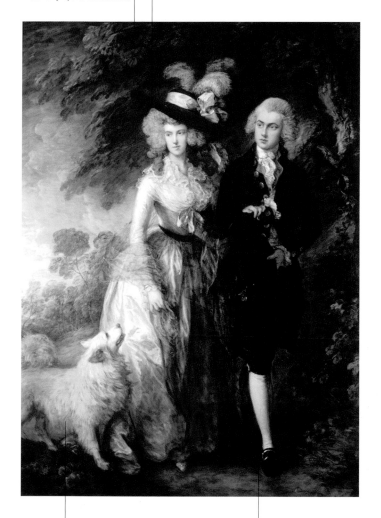

Commissioned by William Hallet for his wedding to Elizabeth Stephen in 1785, the painting portrays the couple in their wedding garb, with a spitz dog at their heels, a breed depicted often by the artist.

William wears a black silk-velvet suit, has powdered his hair, and holds a black hat in his hand.

▲ Thomas Gainsborough,
The Morning Walk, 1785.
London, National Gallery.

Thomas Gainsborough

In the muff the actress holds in her hand, Gainsborough seems to have wanted to convey a sense of real animal fur.

The most celebrated tragic actress of the second half of the 18th century and the leading lady of several theater seasons starting in 1782, Sarah Siddons posed for the best artists of her time. Reynolds painted her likeness in 1784 as a "tragic muse" still wearing her stage clothes.

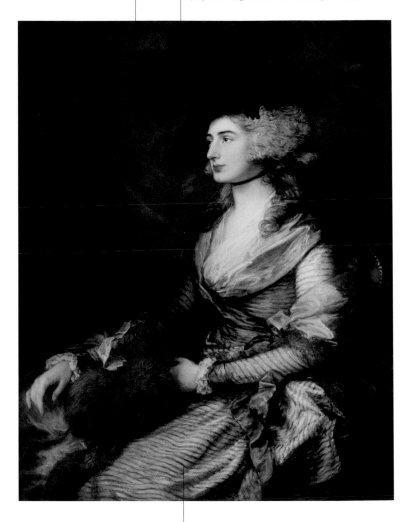

▲ Thomas Gainsborough,
Portrait of Sarah Siddons, 1785.
London, National Gallery.

Unlike Reynolds, Gainsborough liked to concentrate on the everyday qualities of his sitter rather than a costume. Mrs. Siddons wears a long, elegant white-and-blue-striped dress, a gold silk stole, and a black hat with ostrich feathers.

He was one of the greatest interpreters of European Rococo. The success he enjoyed among his contemporaries made him one of the wealthiest painters of his day, much in demand by collectors.

Corrado Giaquinto

Giaquinto spent the best years of his career in Rome, where he developed a style midway between classicism and Barocchetto ("Little Baroque") alongside Conca, Trevisani, and Mancini. He absorbed the great seicento Baroque decorative art of Pietro da Cortona, Gaulli, and Lanfranco. He displayed unusual skill in Rococo fresco during his two sojourns in Turin, where he had moved at the invitation of Juvarra and where he met Beaumont, Crosato, Van Loo, and De Mura. One of his masterpieces from those years is the altarpiece for the Trinità degli Spagnoli (1742–43), in which he moved toward a classicizing composition that echoes the manner of Luca Giordano and Mattia Preti. Painting commissions came from other Italian cities, such as Naples, Molfetta (his native town), Cesena, and Pisa. His international fame was confirmed in 1753 when he was invited to succeed Jacopo Amigoni as official painter at the Spanish court.

There he created his largest fresco cycles, great scenographic compositions that displayed his decorative skills and brilliant coloring, which influenced the young Goya. He left Spain in 1762 when Mengs and Tiepolo were settling in. Giaquinto's many sketches and drawings document his academic training and the preparatory precision he brought to the work. Sometimes he even made sketches after a painting was finished, to meet the pressing requests of collectors.

Molfetta (Bari) 1703–Naples 1766

Principal place of residence
Rome

Travels
Naples (1721–27); moved to Rome in 1727; Turin (1733, 1736–38); Madrid (1753–62); Naples (1762–66)

Principal works
In Rome: decorations in San Giovanni Calibita (1741), Santa Croce in Gerusalemme (1741–43), and Ruffo Chapel in San Lorenzo in Damaso (1741–43). In Madrid: royal chapel, hall of columns, and central staircase of the royal palace (1755)

Links with other artists
He apprenticed in Nicola Maria Rossi's and later Francesco Solimena's studio, together with Bonito and De Mura.

◄ Corrado Giaquinto, *Mercury*, detail from *Aeneas Spurred by Mercury into Leaving Carthage*. Rome, Palazzo del Quirinale.

Corrado Giaquinto

From a passage in Virgil's Aeneid, *this canvas depicts the episode in which Venus appears to her son, the hero Aeneas, to deliver his weapons.*

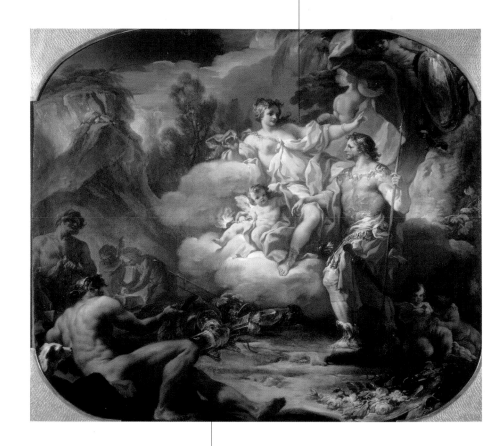

The artist left Madrid in 1762, the year of Tiepolo's arrival. Giaquinto's quick brush and sketchy style are an important precedent for Goya's early work.

▲ Corrado Giaquinto, *Venus Delivers the Weapons to Aeneas*, 1740–42. Rome, Palazzo del Quirinale.

He prefigured and interpreted the radical shift in art at the end of the settecento from the self-congratulatory, fresh Rococo to the threshold of 19th-century realism.

Francisco Goya

Goya's personal and artistic journey included a tortuous series of experiences, anticipating cultural tendencies that later swept Europe. His trip to Italy acquainted him with a broad figurative culture that shines through in his early Saragoza frescoes. Taking up Tiepolo's style, he interpreted with smiling levity the gallant world of 18th-century Madrid in a series of cartoons drawn for tapestries commissioned by the royal court. Success made him the most celebrated Spanish painter of his time, and in 1789, the king appointed him official painter. Goya's portraits gradually lost the chromatic richness and self-confidence of the early years, becoming set in empty spaces, in a hallucinated fixity. While the single individuals portrayed seem closed within themselves, Goya observed with great sensitivity the mobility of crowds and folk customs, interpreting proverbs with fine irony. In 1808, Napoleon invaded Spain: Goya narrated this tragic event in the dark *Disasters of War* and in the two paintings that chronicle Madrid's insurrection. After 1810, Goya's brushwork became agitated and troubled, the colors grim and blackened, with a growing sense of bitterness that overflowed in the dramatic "black paintings" with which he covered the walls of his country home.

Fuendetodos (Aragona) 1746–Bordeaux 1828

Principal place of residence
Madrid

Travels
Italy (1770–71);
Andalusia (1817);
Bordeaux (1824–28)

Principal works
La Maja Vestida (1796–98, Madrid, Museo del Prado); *May 3, 1808* (1814, Madrid, Museo del Prado); *Pilgrimage to San Isidro* (1820–21, Madrid, Museo del Prado)

Links with other artists
The work of Giaquinto and Tiepolo in Madrid were important for his education; he always had in mind the example of Velázquez. His last sojourn in Bordeaux contributed to his more direct influence on the development of 19th-century French painting. Manet was inspired by his methods and subjects.

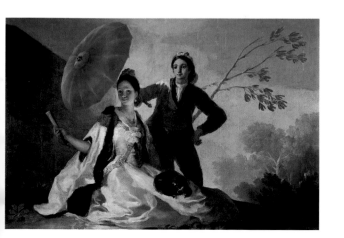

◄ Francisco Goya, *The Parasol*, 1777. Madrid, Museo del Prado.

Francisco Goya

The woman in this painting is the Duchess of Alba (she is no longer believed to have been Goya's mistress). She poses without false modesty, in all her physicality. With this work, Goya created a true modern icon of feminine beauty.

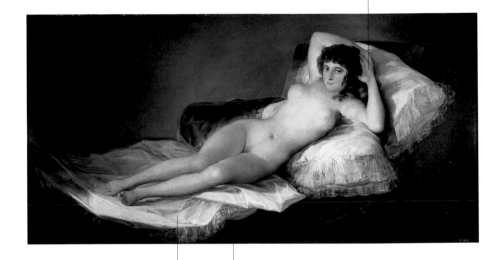

This canvas was quite likely a pendant to La Maja Vestida, *designed to be attached by a double-frame system that moved to uncover one image or the other.*

Titian's and Velázquez's famous nudes were reference points in the conception of this painting; Maja, in turn, was to be a model for the artists of the following century, especially Manet's Olympia.

▲ Francisco Goya, *La Maja Desnuda*, 1796–98. Madrid, Museo del Prado.

► Francisco Goya, *Portrait of the Countess of Cinchón*, 1800. Madrid, Museo del Prado.

The countess wears a bonnet decorated with unripe wheat stalks, a symbol of fertility and good luck in childbirth.

The daughter of Infante Don Luis Antonio of Bourbon and a niece of King Charles III, the countess at the age of seventeen married Prime Minister Manuel de Godoy, who was Goya's friend and patron.

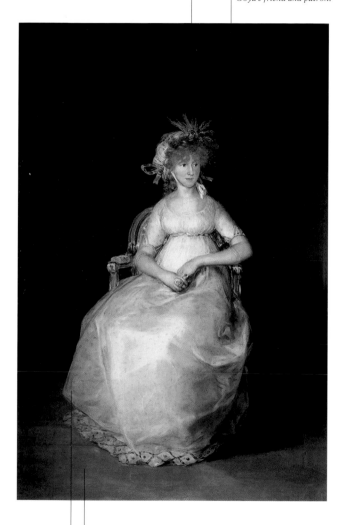

The artist has portrayed the pregnant countess dressed in an elegant, high-waisted gown and seated on a small armchair with gilded profiles.

This defenseless creature seems to project a sense of bashfulness and trusting trepidation for the approaching birth; she immediately arouses our sympathy. The vibrant, delicate application of color emphasizes these qualities.

273

Francisco Goya

This large canvas is an extraordinary example of Goya's skill in composing group portraits worthy of Velázquez and Rembrandt. The painter has portrayed himself working in the shadows, in a totally incongruous position.

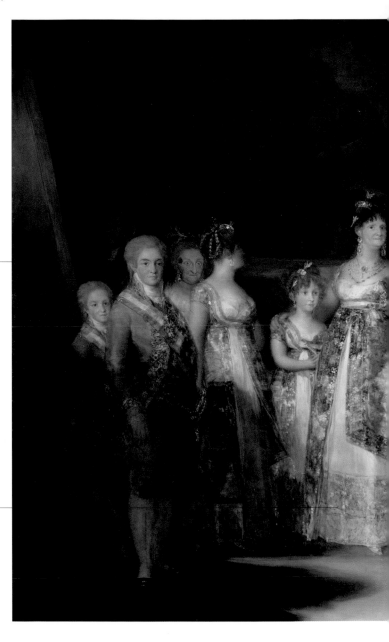

In the center, Queen Maria Luisa of Parma proudly exhibits the somewhat coarse traits of her face and her full, shapely arms, of which she was so proud that she launched the fashion for short sleeves.

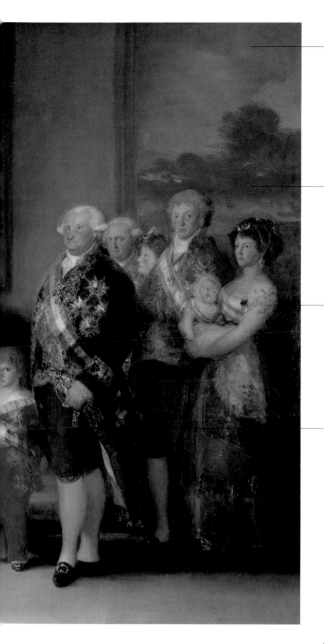

An eloquent, pompous portrait of the royal family, this painting is a parade of almost ghostly masks, a gallery of fourteen haughty, ludicrously self-assured characters. Reality and appearance are in patent disagreement: only the children stand outside the fatuous theater of the adults.

The splendor of the colors that sparkle in the rich, luxurious dresses, the coiffures, and the excessive jewelry clash with this memorable parade of broken-down, stolid, vacuous faces among the family members, at the limits of the grotesque.

Goya depicts the royal family with ruthless realism and irony. Without filters or idealized imagery, he conducts a psychological, almost psychosomatic, analysis of a monarchy in decline.

In the foreground is Charles IV, with ruddy cheeks and nose and eyes of an almost glassy blue. A few years later he abdicated after the Aranjuez Rebellion, facilitating the invasion of Spain by Napoleon's troops (1808).

▲ Francisco Goya, *Charles IV and His Family*, 1800–1801. Madrid, Museo del Prado.

Greuze dedicated his life to a moralizing art, representing feelings of pathos, of young adolescents, midway between false candor and languid sensuality, sentimentalism, and eroticism.

Jean-Baptiste Greuze

Tournus 1725–Paris 1805

**Principal place
of residence**
Paris

Travels
Naples and Rome
(1755–57)

Principal works
The Village Betrothal
(1761, Paris, Musée du
Louvre); *Portrait of Jean-
Georges Wille* (1763,
Paris, Musée Jacquemart-
André); *Girl Weeping for
Her Dead Bird* (1765,
Edinburgh, National
Gallery of Scotland); *The
Ungrateful Son and The
Punished Son* (1777–78,
Paris, Musée du Louvre).

Links with other artists
He was a student of
Natoire and was appreci-
ated by Diderot; his
works were widely imi-
tated and his fame even
reached the court of
Russia. Starting in the
1780s, David's new style
obscured Greuze's art.

Greuze moved to Paris around 1750 after an early training period in
Lyons. His first works, exhibited at the Salon of 1755, received
enthusiastic reviews. They were already marked by what became a
constant in his production: household scenes with edifying tones, in
which the understated seductiveness later became explicit sensuality.
In his Italian sojourn, Greuze absorbed a taste for picturesque genre
scenes with ambiguous allusions, as in *Broken Eggs* (1756, New
York, Metropolitan Museum of Art). He adopted a delicate, pol-
ished, mellow, and brilliant touch that is evident in the few paintings
in which he depicted the aristocracy. The canvas *The Village
Betrothal*, shown at the Salon of 1761, opened the way to genre
painting treated in the manner and with the ambition of historical
painting. The genre scene with attractive young girls in disconsolate
poses was repeated with several variants. From 1767 to 1769,
Greuze attempted subjects from history, the Bible, and mythology,
but negative criticism made
him break with the Acad-
emy. From then on, he no
longer participated in the
Salon but instead used his
own studio as exhibition
space. In his last years, he
introduced into his moraliz-
ing paintings a sense of aus-
terity and references to
antiquity, knowledge
acquired by working on his-
torical and biblical subjects,
such as the well-known pen-
dants *The Ungrateful Son*
and *The Punished Son*.

▶ Jean-Baptiste Greuze,
*Portrait of Claude Henri
Watelet*, 1763. Paris,
Musée du Louvre.

Diderot, one of Greuze's earliest admirers, said of this young woman: "Charming, but . . . a scamp that I wouldn't trust for even a second."

This painting was exhibited at the Salon of 1761 and made Greuze an acclaimed and successful painter.

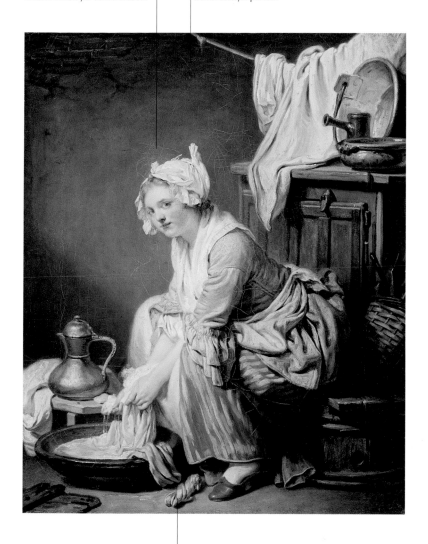

▲ Jean-Baptiste Greuze, *The Laundress (La Blanchisseuse)*, 1761. Los Angeles, J. Paul Getty Museum.

The edifying substratum that in the previous century was embedded in works of this genre has almost totally vanished, replaced by a mischievous representation of the female universe.

277

Venice is the protagonist of his vedute *(views): his technique captures the faded silvery atmosphere of the city and the lagoon, as if they were corroded by an intense, luminous vibration.*

Francesco Guardi

Venice 1712–1793

**Principal place
of residence**
Venice

Principal works
Turkish Scenes (1742–43),
a series based on J. B. Van
Mour's etchings, executed
jointly with his brother
Gianantonio for Marshal
Schulenburg; *View of
Cannaregio Canal* (after
1788, Washington, D.C.,
National Gallery); *Fire at
San Marcuola* (1789–90,
Munich, Alte Pinakothek)

Links with other artists
He collaborated with his
older brother Gianantonio
(1699–1760) in their
family studio in Venice;
their close cooperation
continues to make the
attribution of some
works very difficult.

Although Guardi's early production is still close to his brother Gianantonio's style, it already reveals an independent personality and an unusual sensibility to landscapes and the atmospheric bond between figures and the surrounding environment. He probably began to paint *vedute* around mid-century, as confirmed by *Carnival Thursday Feast in the Square* (1756). His first views were inspired by Canaletto, including his etchings, as evidenced from the many canvases painted in the early 1760s. When his brother died in 1760, Guardi became the head of the family studio. At this time, he turned definitively to landscapes, views, and capriccios, even interpreting the *veduta* theme in a fantastic key that is very far from the rigorous, limpid compositional structures of Canaletto. In the many vistas he painted of Venice, he gave his collectors not a lucid, analytical snapshot, but the sentimental memory of the visitor who is enthralled by the mysterious charm of the unique experience that is Venice. He celebrated the arrival of the "Northern Counts"— Archduke Paul and his wife Maria Feodorovna—stressing fantastic liveliness, rhythmic essentiality, and a flowing rendering of space.

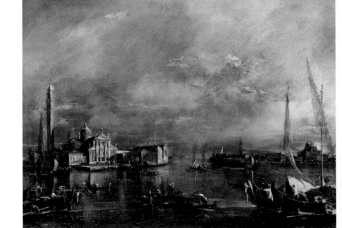

▶ Francesco Guardi,
*Bacino di San Marco with
San Giorgio and the
Giudecca*, 1774. Venice,
Gallerie dell'Accademia.

278

The convent of San Zaccaria received young women from the highest Venetian nobility who were slated to become nuns. Although it was a cloistered convent, the nuns had more freedom than in other such venues, including the freedom to receive visits from their families.

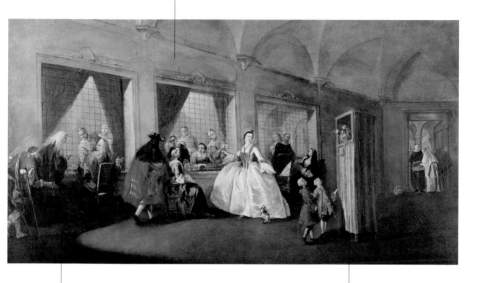

In this interior, a rare subject for Guardi, who mostly painted vedute, *the artist has captured a cross-section of daily life in San Zaccaria, one of the principal convents of 18th-century Venice.*

To amuse the children who came along with the relatives, a puppet theater was set up in the receiving room.

▲ Francesco Guardi, *The Parlor of the Nuns at San Zaccaria,* 1745–50. Venice, Ca' Rezzonico.

He was one of the leading Rococo masters of southern Germany;
his polychrome wood sculpture brought a subtle and refined
worldly elegance to sacred art.

Ignaz Günther

Altmannstein 1725–
Munich 1775

**Principal place
of residence**
Munich

Travels
Munich (1743);
Salzburg (1750);
Mannheim (1751);
Vienna (1753);
Munich (1754)

Principal works
Pietà (1758, Kircheiselfing
near Wasserburg, Saint
Rupert's); central altar of
the abbey churches of
Rott-am-Inn (1760),
Neustift (1765), and
Stamberg (1766–67);
Pietà (1774, Nenningen,
cemetery chapel)

Links with other artists
In Munich, he apprenticed
in the studio of Johann
Baptist Straub (1704–
1784), court sculptor; in
Mannheim in 1751 he
worked with the Palatine
sculptor Paul Egell (1691–
1752), who was in turn a
student of Permoser's.

► Ignaz Günther,
Annunciation, ca. 1764.
Weyarn (Bavaria),
Convent Church.

Günther's sculptural opus is one of the great achievements of
Rococo statuary in the Catholic countries north of the Alps, in par-
ticular, in the churches and castles of Upper Bavaria. After appren-
ticing under his father, a cabinetmaker and sculptor of simple
altarpieces for village churches, Günther moved in 1743 to
Munich, at the time a cosmopolitan artistic center promoted by the
intense patronage of the Wittelsbach family. He chose polychrome
wood sculpture because Germany lacked high-quality marble,
which had to be imported from Italy. The wooden sculptures were
covered with a thin layer of stucco, then gilded or painted by spe-
cialized painters. Günther always used dazzling colors on a golden
or silvery background, to better convey the effects of the luminous

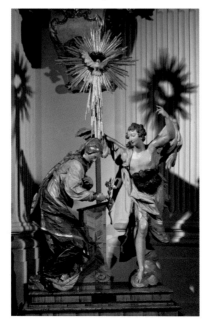

chromaticism. His altar-
pieces are dynamic, full of
motion, and seem to be
floating in midair, and all
the effects are heightened by
the elegant polychromy. The
figures are elongated with
whimsical contours and pro-
ject a refined elegance that
recalls courtly society, such
as *Cardinal San Pier Dami-
ani* sculpted for the Rott-
am-Inn Abbey (1760–62)
and *Saint Helena* sculpted
for Neustift Abbey, both
rendered with elegant con-
temporary dress and aristo-
cratic bearing, like court
dignitaries.

He reproduced landscapes with an eye free of intellectual artifice, as the heir of a solid classical tradition and, like many other foreign artists, seduced by the beauty and variety of Italian nature.

Jakob-Philipp Hackert

His first successes in landscape painting were from his Berlin years, with two views of the *Tiergarten* (1761), purchased by Frederick II of Prussia. In 1768, Hackert reached Rome with his brother Johann-Gottlieb and frequented the Winckelmann and Mengs circle. His landscapes are marked by essential elements that tend toward synthesizing a desire for objectivity with the need to follow classical rules. In this conception of landscape, there is little interest in urban *vedute*; landscape is conceived as a great outdoor theater that focuses compositional attention on geological formations and plant groupings. Paintings made during his trip to Sicily in 1777 exemplify this: temple ruins at Segesta and Agrigento almost disappear into the landscape, and there is no visionary or romantic interpretation of the scene. Hackert worked mostly in Rome and received prestigious commissions, such as the series of canvases painted for Catherine II.

After he moved to Naples, Ferdinand IV appointed him court painter in 1786. Based on the *Ports of France* series that Vernet had painted for Louis XIV, he executed *Ports of the Kingdom of Naples* (1787–92), intended as a celebratory work. Hackert nevertheless visited each port and drew them from life. His metallic, analytical mode reveals a limpid, luminous Italy, where small human figures are inserted for scale.

Prenzlau 1737–San Pietro di Careggi (Florence) 1807

Principal place of residence
Berlin, Rome, and Naples

Travels
Berlin (1753–61); Stockholm (1764); Paris (1765–68); Rome (1768); Naples (1770); Sicily (1777); Northern Italy and Switzerland (1778); Naples (1786–99); Florence (1800–1807)

Principal works
Naval Victory of the Russian Fleet against the Turks at Cesmé (1770–71, Peterhof Castle); *Ports of the Kingdom of Naples* series (1787–92, Caserta, Palazzo Reale; p. 64); *Mount Solaro on the Isle of Capri* (1792, Caserta, Palazzo Reale)

Links with other artists
After Hackert died, Goethe published his diary.

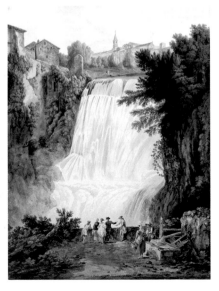

◀ Jakob-Philipp Hackert, *The Tivoli Falls*, 1770. Leeds, Museums and Galleries.

A keen observer of English society, he pilloried the vices and weaknesses of the emerging social classes in a series of satirical canvases and etchings set like theater scenes.

William Hogarth

London 1697–1764

Principal place of residence
London

Travels
Paris in 1743

Principal works
Captain Coram (1740, London, Foundling Hospital); *The Graham Children* (1742, London, Tate Gallery); the series *Marriage à-la-Mode* (1743–45, London, National Gallery); *Self-Portrait with Dog* (1745, London, Tate Gallery); the series *An Election* (1753–55, London, Sir John Soane's Museum); *David Garrick and His Wife* (1757, Windsor, Royal Collections)

Links with other artists
He was a friend of literary figures such as Fielding, Smollet, and Swift, who contributed much to his fame even beyond the borders of England.

▶ William Hogarth, *The Servants of Hogarth House*, 1750–55. London, Tate Gallery.

After training as an engraver, Hogarth, at around the age of twenty, began to work as an illustrator and independently produced satirical drawings of current events. About 1728, he started making portraits and conversation pieces, demonstrating from the beginning remarkable skills in capturing on paper the essence of a person's character. Attracted by the theater and by stagelike settings of historical events, Hogarth executed several series of paintings in which he critically analyzed the mores of the time with a moralizing intent. His best known are *Marriage à-la-Mode* and *A Rake's Progress*. The first illustrates greed and marriages of convenience; the second, vanity and lust. The characters are portrayed in several episodes that trace their inexorable social, financial, but especially moral, downward path. Hogarth possessed exceptional skills in capturing human weaknesses and censuring them with savage irony. His characters gesture eloquently and their expressivity transforms the images into narratives. Each detail of each scene, even apparently minor ones, is studied and chosen for its exact metaphorical function, which hints at the emptiness of the characters and their unavoidable fate. In addition to the private sphere, Hogarth was also interested in public

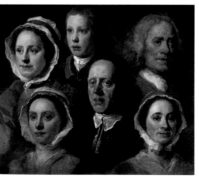

and political life and pilloried certain politicians, as in the celebrated series *An Election* (p. 107). Hogarth's success with both the aristocracy and the bourgeoisie was enormous, for his criticism of English society was widely shared by many of his fellow citizens.

This aristocratic and well-kept domestic interior, decorated with large paintings by Titian, Le Sueur, and Rigaud, typifies aristocratic interiors in the England of this period.

The family architect looks from a window at the Palladian building that remains unfinished, due to overspending on the part of the ambitious Lord Squanderfield.

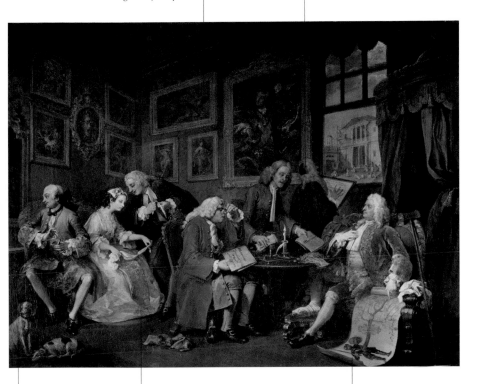

The two chained lap-dogs are indifferent to one another, echoing the human situation.

The spouses-to-be seem indifferent to each other and already destined for separate lives: the future bride is being courted by a secretary, while the groom admires himself in a mirror.

The groom's father, afflicted by gout, proudly exhibits his family's genealogical tree under the interested gaze of the bride's father; with part of the dowry, he paid the mortgage on the house that the usurer, standing in front of him, is delivering.

▲ William Hogarth, *The Marriage Contract*, 1743–44. London, National Gallery.

The scandalized property manager leaves with a folder of unpaid bills. In his pocket he carries the sermon Regeneration *by the Methodist preacher George Whitefield.*

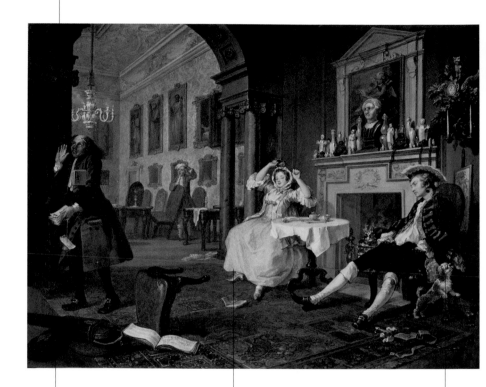

For the six scenes of the series Marriage à-la-Mode, *Hogarth was inspired by the growing trend of marriage alliances between old aristocratic families and rich middle-class businessmen, who so longed for social prestige that they were even willing to buy it.*

The wife lazily stretches after a night of playing cards, which are still scattered on the floor.

In this painting, the second of the series, the characters are caught in poses more suitable to a tavern than an aristocratic home. The husband has just come home from a night of revelry, as we can see from the woman's bonnet protruding from his pocket.

▲ William Hogarth,
The Morning, 1743–44.
London, National Gallery.

This painting has the charm of a picture painted straight off, without preparatory sketches, midway between Frans Hals and Impressionism. It is a unique image of freshness and spontaneity.

The American painter James Whistler said of this canvas, "It is truly the work of a precursor."

The chromatic range is simplified and revolves around two or three colors laid on with easy, wide, and visible brushstrokes.

This "sketch" was probably a model for an engraving to be sold to a large market. The first print on this theme, in fact, was entitled "Shrimp!," presumably the cry this girl seems to be uttering as she sells her wares in the streets of London.

▲ William Hogarth, *The Shrimp Seller*, ca. 1745. London, National Gallery.

285

In a period of profound changes in style, a faithful rendering of the model's personality saved Houdon from extreme Rococo affectation and the crystallization of Neoclassical forms.

Jean-Antoine Houdon

Versailles 1741–Paris 1828

Principal place of residence
Paris

Travels
Rome (1764–68);
United States (1785)

Principal works
The Countess of Cayla (1775, New York, Frick Collection); *Mademoiselle Servat* (1777, Frankfurt, Liebighaus); *Portrait of Voltaire Seated* (1781, Saint Petersburg, Hermitage); *George Washington* (1788, Richmond)

Links with other artists
He was a student of Slodtz and Pigalle.

After several years spent studying at the French Academy in Rome, in 1769 Houdon exhibited at the Salon works that secured his fame, such as *The Flayed, Saint John the Baptist*, and *Saint Bruno* (1766), executed for Santa Maria degli Angeli in Rome. Diderot, whose portrait he sculpted, introduced him to the duke of Saxony-Gotha. For the latter, among other works, Houdon sculpted a bronze *Diana* (Paris, Musée du Louvre); he carved funerary monuments and also received commissions from the Russian court and aristocracy. With typical 18th-century elegance, Houdon's art merged the decorative element with a special attention to the psychology and introspection of the individuals he portrayed. In fact, his strongest expressive works are portrait busts such as those of Gluck (1775), Molière (1776), Turgot (1778), Buffon (1781), and, after the French Revolution, Napoleon and his family—a long gallery of busts and full-size portraits that confirmed him as the unquestionable master of this genre. In some children's portraits, including those of his

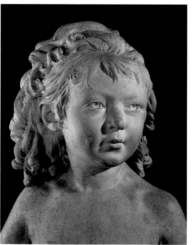

own children, Houdon achieved an exemplary rendering of childhood and grace. Ready to grasp the potential of the American market, Houdon sculpted portraits of several makers of American history who visited Paris. In 1785, with Jefferson's assistance, he was asked to sculpt the full-size statue of George Washington that was erected, and still stands, in Virginia's Capitol building in Richmond.

▶ Jean-Antoine Houdon, *Daughter Sabine*, 1790. Paris, Musée du Louvre.

He painted small oils on paper, without preliminary sketches,
of luminous Italian scenes, such as a wall crumbling in the sun.
He aptly defined himself: "I was born in a time not mine."

Thomas Jones

The oeuvre of Thomas Jones was rediscovered only in 1951. Trained in the tradition of the London school of painting, Jones studied with Henry Pars and Richard Wilson. His first paintings were imaginary and mythical places, such as *Landscape with Aeneas and Dido* (1769, Saint Petersburg, Hermitage). Moving between Rome and Naples, from 1776 to 1783 he lived his most inspired season in the warm golden light of southern Italy. He developed a radical synthetic language that informed his Neapolitan vistas, concentrating them in essentially chromatic, luminous terms. His most amazing pieces are the oil studies on paper, painted without any commercial prospect (only in 1985 did the British Museum purchase two albums of his drawings). He painted extraordinary landscapes that are syntheses of geometric color inlays based on direct, optical experience; he captured the naked beauty of the place, eliminating figures, descriptive episodes, or anecdotes. He sought the patronage of Sir William Hamilton in Naples, but the ambassador ignored him. So he painted the Neapolitan coast, the islands, the city's architecture, its dilapidated walls, sun-baked terraces, linens hanging in the wind, and bright skies.

Trevonen (Radnorshire)
1742–1803

**Principal place
of residence**
London

Travels
In London from 1761;
Rome (1776–80);
Naples (1778–83);
London (1783–89);
Radnorshire (1789–1803)

Principal works
*The Loreto Bridge near
Lake Nemi* (1777, New
York, Thaw Collection);
*Terrace in Naples near
Castel Nuovo* (1782,
Cardiff, National Museum
of Wales); *A Neapolitan
Wall* (1782, London,
National Gallery)

Links with other artists
In Rome he met Cozens,
Fuseli, Hackert, and
Piranesi; in Naples he
knew Lusieri, Towne,
Volaire, Angelica
Kauffmann, and
Michael Wutky.

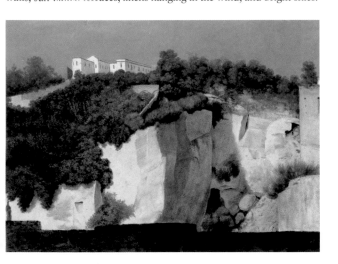

◀Thomas Jones,
Houses on a Cliff, 1782.
London, Tate Gallery.

287

Thomas Jones

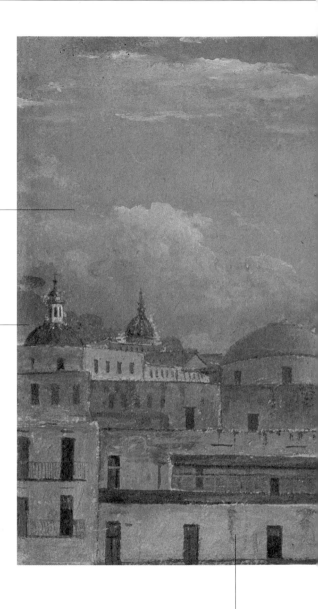

Although there is no trace of human presence, the scene does not look deserted: rather, it looks like siesta time, with the residents barricaded inside the cool rooms to escape the sun.

The painter first reached Naples in September 1778 and lived there until January 1779, and again from May 1780. He was looking for new professional venues, having found no success in Rome.

▲ Thomas Jones, *Neapolitan Houses*, 1782. Cardiff, National Museum of Wales.

This painting plays with the dense geometric weaving marked by the intersections of the large building, the windows, and the buildings in the background, and the receding planes of the solid geometric forms.

These Neapolitan landscapes
went unsold in the painter's
studio because they were not
in accord with the taste of
collectors and merchants.
After three years in Naples,
Jones returned home.

The true protagonist
of this painting is the
crumbling wall with
the falling plaster, on
which water stains
and rain damage are
clearly visible.

Meissen porcelain is one of the highest Rococo expressions from a technical and an artistic point of view. The most able modeler of the 18th century was Johann Joachim Kändler.

Johann Joachim Kändler

Fischbach (Saxony)
ca. 1706–Meissen 1775

**Principal place
of residence**
Meissen

Principal works
Harlequin, Meissen
Manufactory (1738,
Nuremberg, Germanisches
Nationalmuseum); *Lovers
in Spanish Costume*,
Meissen Manufactory
(1740, Dresden, Staatliche
Kunstsammlungen)

Links with other artists
The inspiration for
modeling figurines singly
or in groups was often
found in the more pop-
ular iconographic models
of the time, such as the
paintings of Watteau,
Boucher, or Fragonard.

Until the 18th century, porcelain was imported exclusively from the East, mostly from China, and therefore was prohibitively expensive. The discovery of its formula has novelistic overtones: in 1708, the alchemist Johann Friedrich Böttger succeeded in producing porcelain for the first time in Meissen, but was held prisoner in the castle of Prince Frederick Augustus II of Saxony, who did not want him to reveal the secret. In 1710, the Royal Porcelain Manufactory was established in Meissen, the first in Europe. It was here that Johann Joachim Kändler began his career; the factory lived its golden age under his management, and work was interrupted only in 1759 and 1761 during the Seven Years' War. In fact, although other porcelain factories had opened in Europe, Meissen kept its primacy under Kändler for the quality and selection of the objects produced under the trademark of the two crossed swords. In addition to decorations inspired by the Far East, typical naturalistic flower reliefs were also adopted, and modeling in the round. Kändler, a sculptor and model maker, gave Meissen production its unique character by providing models of figures, animals, and mythological and satirical groups, all in a refined, gay Rococo taste, often inspired by contemporary painting and by Commedia dell'Arte masks. One Meissen master-

► Johann Joachim
Kändler, *Concert*,
1737. Dresden,
Porzellansammlung.

piece was the "swan" table setting made for Count Brühl on a Kändler model, consisting of more than two thousand pieces. Kändler also created altar accessories such as the *Crucifix and the Twelve Apostles* (1737–41, Vienna, Kunsthistorisches Museum) for Amalia of Austria. He also sculpted many portrait busts of saints, popes, and emperors.

A cultured, polyglot painter of international renown, she was at home in the Neoclassical intellectual and artistic world. Hers was a refined, classicizing, eclectic art.

Angelica Kauffmann

A precocious artist who received her first commission at age eleven, Kauffmann perfected her talents by studying and copying originals in Italy, especially works by Raphael, Correggio, and Domenichino. She developed an eclectic personal style close to Neoclassicism, with a soft chromatic range. After fifteen years in London, where she enriched her experience in the world of English painting, learning especially from the portraiture of Joshua Reynolds, she returned to Rome in 1781 and settled there, except for occasional trips to the court of Naples. She was by then married to the Venetian painter Antonio Zucchi, who actively promoted her work. Her success in Italy was as clamorous as in London: her atelier and Via Sistina home were among the most popular destinations of Grand Tour travelers, princes and princesses, intellectuals and painters, including Winckelmann, Mengs, Gavin Hamilton, Wüest, Batoni, Goethe, Tischbein, Herder, and Canova, many of whom asked her to paint his portrait. Her portraits, full of grace and free of rhetoric, influenced many of her contemporaries. She continued to update her style with a vast production of Arcadian, historical, and mythological themes created for her cultivated, cosmopolitan clientele, and followed the emerging Neoclassical trends that were being disseminated by David and Flaxman.

Coira (Grisons, Switzerland) 1741–Rome 1807

**Principal place
of residence**
Rome

Travels
Milan (1754, 1757);
Parma, Bologna, Florence
(1762); Rome (1763,
1764–65); Venice (1766);
London (1766–81);
Rome (1781–1807)

Principal works
Portrait of David Garrick
(1764, Oxford, Ashmolean
Museum); *Portrait of
Winckelmann* (1764,
Zurich, Kunsthaus); *The
Family of Ferdinand IV*
(1783, Naples, Museo di
Capodimonte; p. 203)

Links with other artists
In London she was
friendly with Reynolds;
in 1768, she joined him in
founding the Royal Academy. She also worked for
architect Robert Adam.

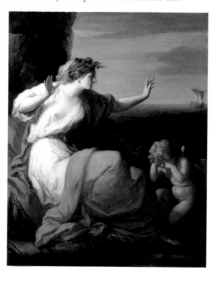

◀Angelica Kauffmann,
*Ariadne Abandoned
by Theseus*, before
1782. Lugano, BSI
Art Collection.

Angelica Kauffmann

Angelica Kauffmann is here portraying two young friends of hers, fellow members of Roman literary and social circles. She executed this double portrait "for her own pleasure," and it was sold only later.

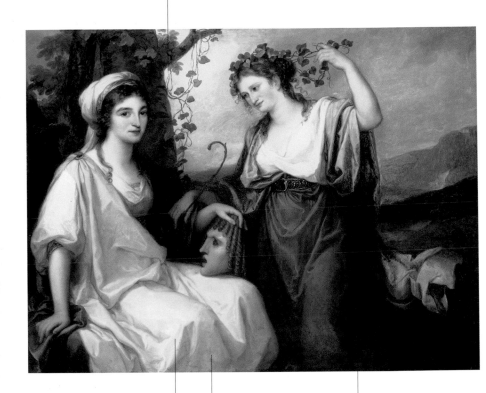

This work may be considered part of a large series of allegorical images that compared opposite or complementary concepts evoked from literature or imagery characteristic of Arcadian poetics.

Dressed as Melpomene with a tragic mask on her knee is Domenica Morghen, daughter of the Venetian engraver Giovanni Volpato and the wife of Raffaello Morghen, also an engraver who worked with his father-in-law.

Maddalena Volpato is dressed as Thalia, the Muse of Comedy; she was the wife of Giuseppe Volpato, son of Giovanni, who had a flourishing porcelain factory in Rome.

▲ Angelica Kauffmann,
The Muses of Comedy and Tragedy, 1791. Warsaw,
National Museum.

His spirited, penetrating portraits were highly successful at court and in intellectual circles. A master of pastel, he documented Parisian life of the period.

Maurice-Quentin de La Tour

La Tour is known for his many pastel portraits documenting a society that cared about appearance, but from which he kept his distance with an ironic, sometimes contemptuous, air. He apprenticed in Paris in the atelier of J. Spoëde, who painted still lifes. He then moved to England for a two-year sojourn. After returning to Paris, he received many portrait commissions; in 1737, he was admitted to the Academy and exhibited regularly at the Salon. He executed portraits of Louis XV and Madame de Pompadour (both at the Louvre), and of high aristocrats and renowned intellectuals such as the encyclopedists Voltaire, Rousseau, and d'Alembert. His medium was the pastel, which had met with success in France after the well-known Venetian pastellist Rosalba Carriera introduced the technique in Paris during her stay there in 1720–21. La Tour's nervous, impulsive character found in the pastel the most appropriate technique for interpreting his subjects. The fast execution translates perfectly to the canvas his quick scrutiny, which succeeds in intuiting the life of an individual and expressing it through vibrant shadings. The refined, sumptuous effects are created through unparalleled technical virtuosity, achieved in the spontaneity and freshness of the pastel.

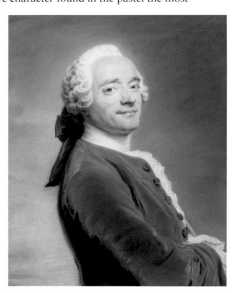

Saint-Quentin 1704–1788

Principal place of residence
Paris

Travels
London (ca. 1723)

Principal works
Volaire (1735, Saint-Quentin, Musée Antoine Lécuyer); *Abbot Huber Reading* (1741, Geneva, Musée d'Art et d'Histoire); *Portrait of Mademoiselle Ferrand* (1753, Munich, Alte Pinakothek); *Portrait of Madame de Pompadour* (1755, Paris, Musée du Louvre); *Portrait of Crébillon* (1761, Saint-Quentin, Musée Antoine Lécuyer)

Links with other artists
His preparatory drawings are fresh, sparkling studies of faces caught in their innermost essence, following the example of Rosalba Carriera.

◀ Maurice-Quentin de La Tour, *Self-Portrait*, 1751. Amiens, Musée de Picardie.

293

Maria Leszczynska (1703–1768) was the daughter of the king of Poland and lived in poverty in France with her deposed father until a political marriage was arranged between her and Louis XV.

Modest and pious, the queen had no political influence on her husband; after 1737 she lived in Versailles, neglected and forgotten by the king.

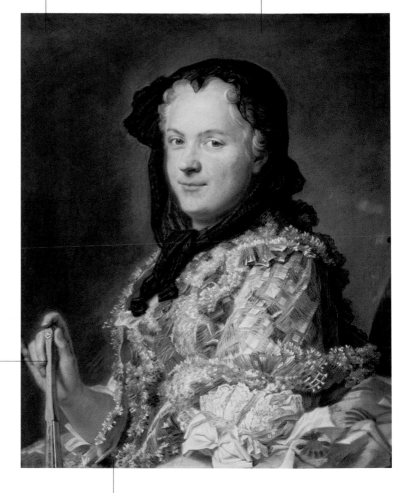

La Tour has skillfully captured the dignified, thoughtful expression of the queen, who seems to have just closed the fan she holds in her right hand.

The symphony of ochers, browns, dark tones, and whites directs the eye to the vaporous dress. The colored pastels move with tiny marks over the light, transparent fabric.

▲ Maurice-Quentin de La Tour, *Portrait of Maria Leszczynska* (1748). Paris, Musée du Louvre.

A unique, isolated artist with no students, Liotard traveled
constantly as an admired portrait painter sought by sovereigns
and the upper classes. He was unsurpassed in the art of the pastel.

Jean-Étienne Liotard

The biography of this unusual artist is studded with long trips and
sojourns all over Europe, culminating in a long stay in Constan-
tinople from 1738 to 1742, for which reason he was nicknamed
"the Turkish painter." His fame as a portraitist followed him
everywhere, and he became friendly with the cultivated, wealthy
aristocrats of cosmopolitan European society. He specialized in
pastel painting on parchment, which gave his portraits a smooth,
velvety finish, transparent and vibrating with light. In the last years
of his life, when his clientele had shrunk considerably, he turned to
the still life with amazingly modern results. Liotard's virtuosity in
painting and reproducing from life is due to his early apprentice-
ship as an engraver, miniaturist, and enamel painter. The many
years spent in the Ottoman Empire gave him a subtle sensitivity
to atmosphere and laid the groundwork for the refined, Eastern
flavor of his later works, such as the poses, the costumes, and the
bare settings of the Orientalizing fashion that favored images of
Europeans in Eastern costume. His unique, unmistakable style
was not learned from past
masters or academic stud-
ies. Almost all his portraits
are busts that stand out on
a monochromatic back-
ground. The painstaking
search for a true likeness
and the humble submis-
sion to optical truth guide
his pastels with precise,
clear marks that are inten-
tionally free of any lyrical
or evocative effect.

Geneva 1702–1789

Travels
Naples, Rome, Florence
(1735–37); Constantinople
(1738–42); Romania
(1742); Vienna (1743–45,
1762); Paris (1746–53);
London (1753–55);
Geneva (1757–61);
Paris (1771–72);
Amsterdam (1771–73);
London (1773–74);
Geneva (1788–89)

Principal works
François Tronchin (1757,
Geneva, Musée d'Art et
d'Histoire); *Maria Theresa
of Austria* (1762, Geneva,
Musée d'Art et d'Histoire);
View from the Studio
(1765–70, Amsterdam,
Rijksmuseum)

Links with other artists
It was Rosalba Carriera
who introduced the pastel
technique in France.
Liotard was admired by
Ingres and Degas.

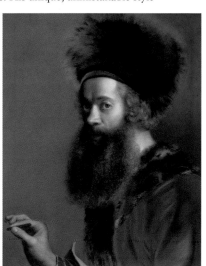

◀ Jean-Étienne Liotard,
Self-Portrait, 1744–45.
Dresden, Gemäldegalerie.

Jean-Étienne Liotard

The artist has drawn a free lady (dama franca)—a European from the Levant—who lived in Pera, the most westernized of Constantinople's districts. Dressed in the Turkish style and escorted by a young servant, she is preparing to bathe.

The young servant's fingers and the toes and heels of her feet are decorated with henna. Her mistress, too, has adopted this custom. Both wear the traditional Turkish costume with bouffant pants (salvar) and a vest (cepken).

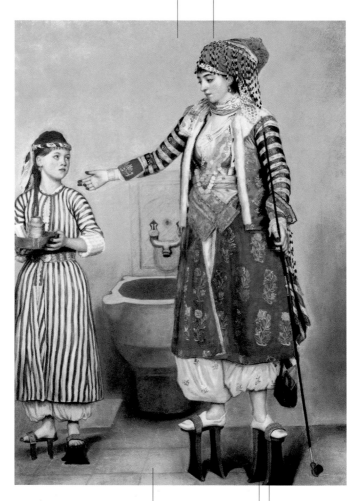

Liotard has succeeded in conveying the moist, warm atmosphere of a Turkish bath, enveloping in the uniform steam of grayish pastels the floor, the fountain, and the wall in the back.

▲ Jean-Étienne Liotard, *Free Lady with Servant*, 1742–43. Geneva, Musée d'Art et d'Histoire.

The two women are about to bathe. They wear high wooden clogs (takunya) to avoid contact with the water and humidity of the hammam.

Liotard's art approaches the quality of the Persian miniatures that he had occasion to see during his long sojourn in the East, for the range of colors, precision in details, and exact rendering of the light.

In 1745, in Venice, Francesco Algarotti bought this pastel for the Dresden Royal Collections; his contemporaries praised the supreme technical perfection of the work.

Liotard's illustrated world is peopled not only by the great Austrian, French, English, and Dutch nobility. He found characters from the humbler classes also worthy of being portrayed.

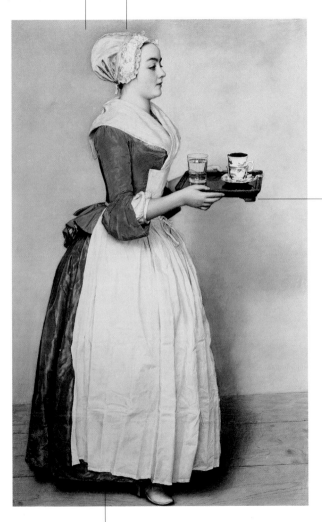

The space and ambiance have been reduced to a minimum; the neat, incisive strokes alone create the character's physiognomy in clearly outlined surfaces devoid of any ornamentation, far from the codes of gallantry.

▲ Jean-Étienne Liotard, The Chocolate Girl, 1744–45. Dresden, Gemäldegalerie.

The chromatic range of the composition is extraordinarily subtle, restricted to gray, ocher, and rose tones and to the great white "color field" of her pinafore; the same tints reappear in the decoration of the porcelain cup.

Jean-Étienne Liotard

Pears, plums, and figs rest on a napkin next to a knife and a roll of bread—humble fruits laid out without any special arrangement, but absolute protagonists of a silent representation of nature.

The essentiality of the pictorial technique and the firm definition of the fruits in this pastel anticipate the compositions of later centuries, from Manet to Cézanne and Morandi.

"When I was thirty years old I would not have made them so well, since now I have more craft than I had then. They found them so beautiful that they asked me to write my name and also my age, eighty years old." Thus Liotard explained the inscription on the table drawer.

Everything revolves around an infinite range of grays, from the wooden table to the knife's metal, from the velvety, silvery skin of the fruit to the folded napkin. Only the blue of the ribbon that peeks from the drawer evokes the ripe skin of the plums.

▲ Jean-Étienne Liotard,
Still Life, 1782. Geneva,
Musée d'Art et d'Histoire.

He was a faithful, unassuming poet of his Venice, painting scenes from domestic bourgeois life and humble peasant life in small-sized canvases alive with subtle, gentle irony.

Pietro Longhi

A student of Antonio Balestra of Verona, Pietro Longhi began his career in 1732 as a painter of altarpieces. In Bologna around 1730, he had become acquainted with Giuseppe Maria Crespi's tradition of painting the lives of common folk. He applied this approach to the genre of historical-mythological paintings, such as the frescoes with *The Fall of the Giants* (1734) that decorate the staircase of the Palazzo Sagredo in Venice, executed after he returned from Bologna. He painted genre scenes of the life of peasants and servants, and later the customs of the Venetian nobility in a sort of updated international style derived from French and English models. Exceptions are the frescoes *Santa Casa di Loreto* in San Pantalon (1745). Contemporary Venetian artists Rosalba Carriera and Jacopo Amigoni were among those who influenced his work in the soft, delicate tones and the precious, luminous chromaticism of works such as *The Sagredo Sisters Visiting the Old Servant* (1739–40, London, National Gallery) and *The Concertino* (1741, Venice, Gallerie dell'Accademia). In his prolific work in the service of patrician Venice, he captured fragments of Venetian life with great powers of observation and biting irony: the settings are aristocratic palaces, bourgeois mansions, and the city's narrow, colorful *campielli*. In his late work, the tonalities became darker and the strokes quicker and somewhat imprecise in his production of almost exact replicas (*Charlatans* and *Women Sellers* series); but late works such as *Caffè* and *Morning Hot Chocolate* still exhibit a keen power of observation (both are at Ca' Rezzonico, Venice). He died in 1785 in his Venetian home in San Pantalon.

Venice 1701–1785

Principal place of residence
Venice

Travels
Educational trip to Bologna, 1732–34

Principal works
Polenta (ca. 1735, Venice, Ca' Rezzonico); *The Tailor* (1741, Venice, Gallerie dell'Accademia); *The Sacraments* and *Valley Hunting* series (1755–57 and ca. 1765, Venice, Pinacoteca Querini Stampalia)

Links with other artists
His son Alessandro (1733–1813) was a capable portraitist who captured with spirit and naturalness the physical and psychological traits of the Venetian aristocracy.

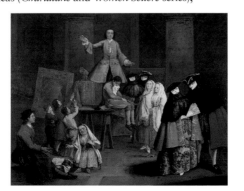

◀ Pietro Longhi, *The Tooth Puller*, 1746–52. Milan, Pinacoteca di Brera.

Pietro Longhi

This painting documents an unusual event in Venice: the exhibition of a rhinoceros. An animal until then unknown in Italy, it created a sensation throughout Europe.

The writing on the scroll reads: "True portrait of a rhinoceros brought to Venice in 1751, by Pietro Longhi on commission by Our Honorable Giovanni Grimani of the Servi Patrizio Veneto."

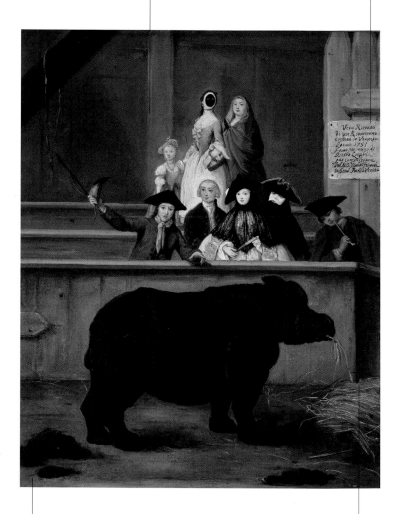

Longhi's descriptive skills, besides giving a glimpse of this sideshow attraction, do not omit realistic details such as the impressive animal's droppings in the foreground.

In this painting the artist also portrayed some members of the aristocratic Grimani family of Venice; they are mixed among the public and all are curious to look at the exotic animal.

▲ Pietro Longhi, *The Rhinoceros*, 1751. Venice, Ca' Rezzonico.

With quick, jagged slashes of the brush he gave life to a world filled with monks, hoboes, mountebanks, gypsies, and convicts, where the real strays into the fantastic.

Alessandro Magnasco

At a very young age, after the death of his father, a painter of the Genoese Baroque school, Alessandro moved to Milan, where he studied the seicento Lombard painters and for a brief period painted religious works and portraits. Important iconographic sources were the Dutch and Flemish *bambocciate* (followers of Pieter van Laer) and Jacques Callot's picaresque prints. From 1703 to 1710, he lived in Florence as a protégé of Prince Ferdinand de' Medici in a stimulating, modern cultural environment, making the acquaintance of Sebastiano and Marco Ricci and Giuseppe Maria Crespi. His best-known works from this period are *The Thebaid* (1705, formerly Della Gherardesca Collection), *The Beggars' Concertino* (Warsaw, National Museum), and *Hunting Scene* (Hartford, Wadsworth Atheneum). His style is marked by darting brushwork and long, enervated, sinewy strokes of mostly dark tones brightened by intense flashes of color. During his

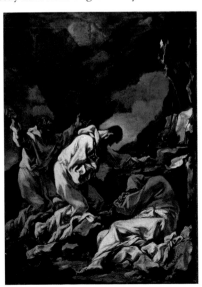

second stay in Milan, he worked for several aristocratic families of collectors, executing sarcastic, irreverent canvases that mirrored the secular, enlightened tendencies of the Lombard aristocracy. Significant, too, for their implications on the continuing debate about justice are his paintings of prisons and interrogations. In 1735, Magnasco retired to Genoa, where he continued working with little success until his death.

Genoa 1667–1749

Principal place of residence
Milan

Travels
He moved to Milan in about 1678; in Florence (1703–10), as a protégé of Grand Prince Ferdinand de' Medici; Genoa (1735–49).

Principal works
Series of four canvases, *Library, Capuchin Refectory, Synagogue,* and *Catechism in the Church* (1719–25, Seitenstetten, Benedictine Abbey); *Sacrilegious Theft* (1731, Milan, Diocesan Museum)

Links with other artists
He apprenticed in the studio of Filippo Abbiati; as a figure painter, he worked closely with landscape painters, set designers, and painters of ruins, such as Antonio Francesco Peruzzini and Clemente Spera, later with Marco Ricci and Carlo Antonio Tavella.

◄ Alessandro Magnasco, *Monks in Prayer,* 1710–20. Amsterdam, Rijksmuseum.

Alessandro Magnasco

Magnasco introduced some "street" scenes into a religious context, such as the "silencer" who tries to hush unruly children or the "fisherman" who collects children from the street to teach them the catechism.

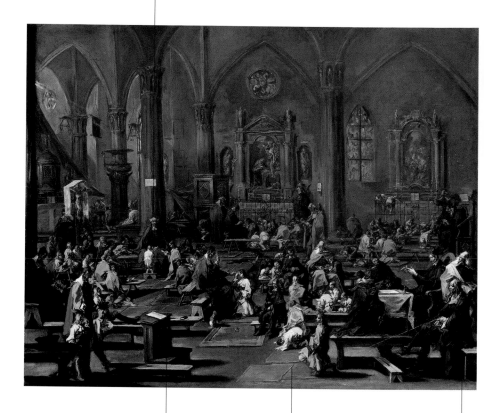

The church's interior is inspired by the Milan Duomo, although the latter did not have a school that taught prayer or the precepts of the Catholic catechism.

Together with the two "monastery scenes" and Synagogue, this painting is part of a group of four conserved in the Seitenstetten Benedictine Abbey, in southern Austria.

Between 1719 and 1725, Count Girolamo Colloredo-Wallsee, then Austrian governor in Milan, commissioned this important group of paintings, the most prestigious commission the artist ever received.

▲ Alessandro Magnasco, *Catechism in the Church*, 1719–25. Seitenstetten, Benedictine Abbey.

A crumbling wall separates the group from the vast landscape one enjoys from the park terraces.

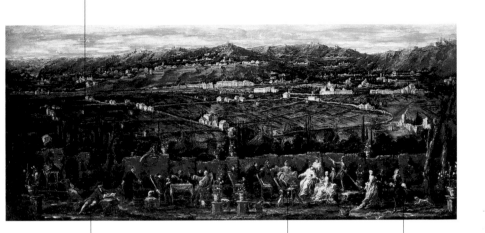

The painter, removed to one side, observes the scene but does not participate in this world of ladies, knights, prelates, and cicisbei.

This image by Magnasco, which became the symbol of the "villa lifestyle," at the same time seems to depict the inexorable unraveling of the ancien régime, *whose members seem unaware that their golden paradise is threatened by the new, rising social classes.*

The members of nobleman Bartolomeo Saluzzo's family and some clerics are spending leisure time in the garden of Villa Bombrini, known as "Paradise," a renowned suburban villa near Genoa on the slopes of Albaro Hill.

▲ Alessandro Magnasco,
Entertainment in an Albaro Garden, ca. 1740. Genoa,
Galleria di Palazzo Bianco.

Called the "Austrian Tiepolo," Maulbertsch was one of the more significant Baroque fresco painters at a time when the dying Rococo was giving way to the growing influence of European classicism.

Franz Anton Maulbertsch

Langenargen 1724–
Vienna 1796

**Principal place
of residence**
Vienna

Travels
In Vienna starting in
1739; Moravia, Bohemia,
Hungary, and Austria to
work in churches, palaces,
and castles

Principal works
Dome of Piarist Church
(1753, Vienna); ceiling
of the Archiepiscopal
Palace (1758–60,
Krems); ceilings of the
Klosterneuburg Library
and the Strachov Library
near Prague; decoration
of the Hungarian Sümy
(1757–58) and Székesfe-
hérvár (1767) churches

Links with other artists
He was influenced by
the quick sketchwork of
Carlo Innocenzo Carlone,
who introduced the oil
sketching technique north
of the Alps.

▶ Franz Anton
Maulbertsch, *Annuncia-
tion*, ca. 1755. Paris,
Musée du Louvre.

Of German origin but Austro-Hungarian in his style and work, Maulbertsch is one of the more interesting interpreters of European Rococo. He trained in Vienna, attending Troger's lessons and admiring Andrea Pozzo's *sprezzato* boldness. His art has an international breadth; it caught the glittering flavor of the southern German courts with the splintered, quick brushwork steeped in light derived from Venetian masters such as Sebastiano Ricci and Piazzetta. In particular, Maulbertsch closely studied the work of Giambattista Tiepolo, whom he met during the latter's stay in Würzburg. Tiepolo was a double source of inspiration to Maulbertsch on account of his unbridled canvas painting and the airy decorations of the large frescoes. Always aristocratic and full of

imagination, Maulbertsch had a brilliant court career and prestigious ecclesiastical commissions in Austria, such as the frescoes he painted in the Vienna Piarist Church (1753) and the Innsbruck Hofburg (1775), and in Bohemia, Slovakia, and Hungary. He did not differentiate between sacred and mythological or allegorical subjects: Maulbertsch's art always projects a high tone of transfiguring imagination. Whenever possible, he painted flying figures swirling overhead in the most athletic and unpredictable poses, all in keeping with the light Rococo touch.

In a fairy-tale landscape, a group of
Turks sits around a well: in the center
is the queen, perhaps, with a standard
bearing the crescent and the star.

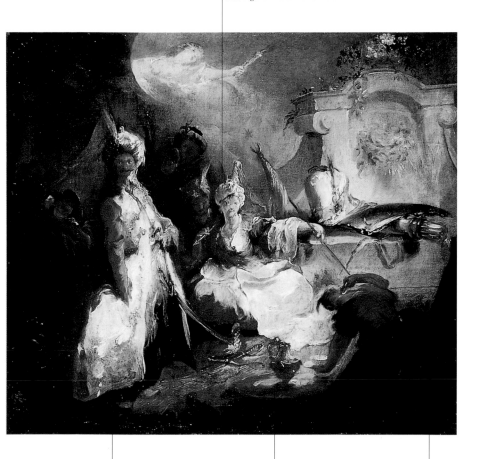

The richly attired man
wearing a saber and
surrounded by servants
is probably the king.

This painting is an example of the
Turkish trend that became fashion-
able in Vienna starting in the 1750s,
one that also influenced music and
was first applied by Mozart in his
Abduction from the Seraglio (1782).

The painter used free-flowing,
loose brushwork with strong
chiaroscuro accents. Partially
in shadow, the server pours
coffee for his queen.

▲ Franz Anton Maulbertsch,
Turkish Scene, ca. 1760.
Private collection.

Chance can play a role in an artist's critical success. The Spanish painter Meléndez still does not enjoy the fame he deserves as one of the preeminent still-life artists of the 18th century.

Luis Eugenio Meléndez

Naples 1716– Madrid 1780

Principal place of residence
Madrid

Travels
Moved from Naples to Madrid

Principal works
Still Life with Glass, Fruit Stand, and Bread (1770, Madrid, Museo del Prado); *Still Life with Melons and Pears* (ca. 1770, Boston, Museum of Fine Arts)

Links with other artists
The Neapolitan seicento still-life tradition with flowers, fruits, fish, and crustaceans, best exemplified by the Recco family, greatly influenced his education.

Meléndez does not belong to Spain's artistic golden age, the seicento; perhaps for this reason, he was discovered only recently by antiquarians and museums, which now vie for his works. His training was steeped in the heritage of the Neapolitan tradition of the Recco family of painters, which was one of the most inspired still-life periods of the late 17th century. Thanks to these influences, he learned to meditate on the compositional relationship of objects, on the possibility of creating suggestive effects in dark kitchens, playing with gleaming dinnerware and textures of meat, salami, fruit, and fish. After moving to Spain, Meléndez passionately studied the work of Sanchéz Cortán and Velázquez, adopting their moral severity and their almost mystical predilection for everyday objects weighed and calibrated in well-proportioned compositions. He thus developed a fascinating, timeless style removed from fashionable trends, although he also worked on prestigious royal commissions, such as decorating the Aranjuez Palace. Comparing the still-life paintings of his late period with

Tiepolo's and Mengs's production—they were active at the Madrid court at the time—is striking, for few artists succeeded in achieving Meléndez's amazing virtuosity in reproducing the most diverse textures and mastering the use of light. Meléndez died in Madrid in 1780 as Goya, the rising star of Spanish painting between the two centuries, was starting to achieve recognition.

▶ Luis Eugenio Meléndez, *Still Life*, 1770. Madrid, Museo del Prado.

The impeccable tactile rendering almost creates a visual trick, while the composition, coupled with the skillful use of suggestive dim lighting effects, projects a monumental feeling.

Meléndez interprets in an updated manner the austere tradition of the Spanish golden-age bodegónes *(still life); he was to be one of the last, an extraordinary interpreter of that genre.*

In a century dominated by light, even in the field of optical research, Meléndez's shadowy still lifes seem incredibly out of time, especially if compared to the work of his contemporaries Tiepolo and Mengs.

The amazing technical virtuosity of this artist makes the viewer touch with his hands the presence, texture, fullness, and almost the flavor of each element—from the fragrant, crunchy bread crust to the wicker braiding of the basket to the soft sensuality of the half-open figs.

▲ Luis Eugenio Meléndez,
Still Life with Figs, ca. 1760s.
Paris, Musée du Louvre.

A painter and art theoretician, he was a founder of Neoclassicism and a protagonist in the transition from the late Baroque to the shift produced in art and culture by the effects of the Enlightenment.

Anton Raphael Mengs

Aussig (Bohemia) 1728–
Rome 1779

**Principal place
of residence**
Rome

Travels
Rome (1741–44,
1746–49); Venice
(1751–52); Rome (1752);
Madrid (1761–69);
Florence (1770–71);
Rome (1771–74);
Madrid (1774–77);
Rome (1777–79)

Principal works
Glory of Saint Eusebius
(1757, Rome, Sant'Euse-
bio); *Pope Clement
XIII Rezzonico* (1758,
Venice, Ca' Rezzonico);
Charles III, King of Spain
(ca. 1765, Florence,
Palazzo Pitti; p. 178)

Links with other artists
In Rome in 1760 he
met Giacomo Casanova;
he was in Madrid in
1762 when Giaquinto
left and Tiepolo and his
children arrived.

▶ Anton Raphael Mengs,
Perseus and Andromeda,
1774–77. Saint Petersburg,
Hermitage.

A student of his father, who was a miniaturist at the court of Saxony, Mengs spent his early years between Dresden and Rome. In Italy, the young artist fell in love with archaeology and Raphael's paintings, as had been the case for Poussin a century earlier. Mengs took a radical, programmatic stand against the dynamic virtuosity and the animated but often excessive gestural expressiveness of Baroque art. In Rome he advocated a calm, intellectual art based on classical notions of decorum, harmony, and composure. He gave these precepts a didactic forum when he became director of the Capitoline Academy. His introduction in Rome to the philosopher and man of letters Winckelmann, in 1755, opened the door to a productive period of study and recovery of ancient art. His fresco *Parnassus*, which decorates the vault of Villa Albani (1761), summarizes the rediscovery of Raphael and classicism. As Enlightenment ideas and aesthetics became broadly accepted, the time was ripe for a radical shift in taste. In 1762, Mengs published the first edition of his *Reflections on Beauty*, a fundamental theoretical work that soon reached all of Europe. Having been called to Madrid on two separate occasions, he exceeded even Tiepolo's creative exuberance by proposing a new model that opened the way for Neoclassicism.

The manifesto of Neoclassical painting was conceived in close contact with Winckelmann and his theories, thanks also to Cardinal Albani's patronage. In the cardinal's villa, destined to house his collections of antiquities, the new style was born.

Having abolished the pomposity of Baroque representation, Mengs staged the Parnassus like an antique bas-relief, in which each character seems frozen in a timeless fixity devoid of emotion or passion.

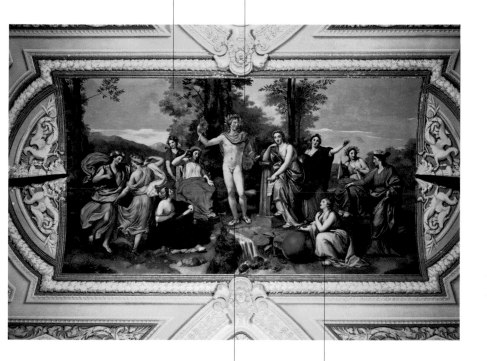

Each character seems to descend from a classical original: Apollo is a derivation of the Apollo Belvedere and the two dancing figures repeat analogous Pompeian subjects, though all the figures seem to partake of the classical composure of Raphael's Parnassus.

The Muses escorting the god, seen through the "classical" filter of Raphael, Guido Reni, and Domenichino, seem to personify a selection of the best "products" of nature, purified of all "accidents."

▲ Anton Raphael Mengs,
Parnassus, 1760–61. Rome,
Villa Torlonia (formerly Albani).

His fame rests on a series of unusual portraits—faces contorted by infinite combinations of grimaces—that make him one of the more fascinating artists of the century.

Franz Xavier Messerschmidt

Wiesensteig 1736–
Presburg 1783

Principal place
of residence
Vienna

Travels
In Munich from 1736,
then Graz

Principal works
The series of sixty-nine
Character Heads, executed
after 1770, today housed
for the most part in the
Vienna Österreichische
Galerie Belvedere

Links with other artists
He apprenticed in
Munich with his uncle,
Johann Baptist Straub
(1704–1784), and in
Graz with Philipp Jacob
Straub (1706–1774); he
was influenced by the
sculptor Georg Raphael
Donner (1693–1741).

A sculptor of portrait busts for the court of Vienna and the wealthy bourgeoisie, Messerschmidt lived the transition between Rococo art and Neoclassicism. In 1755, he studied at the Academy of Vienna, then taught there starting in 1769. When he was not promoted to the director's position in 1774, he retired to Pozsony (today's Bratislava), where until his death he worked at a series known as *Character Heads*, which he had begun in Vienna around 1770. A posthumous inventory counted sixty-nine pieces: they are all men's heads on small busts, with exaggerated, contorted facial expressions, grimaces, and bizarre muscle movements. According to this artist's theory, bodily impulses are in a proportional relationship with the head, and the latter mimics a reaction to the tension of the body. He used to grimace before the mirror, an obsessive self-observation that is linked to the physiognomic and pathognomic theories of Lavater and Lichtenberg, respectively. The ratios follow Masonic doctrines of analogies and are also linked to the theory of magnetism of Franz Anton Mesmer (1734–1815), a physician and healer who was a friend of Messerschmidt's: his magnetic cures would explain the ropes around the necks of several of these portraits, to be understood not as hangman's nooses, but as magnetic therapy tools that connected the neck to the diseased parts.

▶ Franz Xavier Messerschmidt, *Man Yawning*, ca. 1770. Budapest, Szépmüvészeti Múzeum.

Master of the female portrait, whether in a natural pose or a mythological interpretation, he rendered his patronesses with grace and elegance using clear, brilliant color and a fluid brush.

Jean-Marc Nattier

Nattier apprenticed with his father. Starting in the 1720s, he turned to portraits and sought to raise this genre to the level of historical painting by frequently using allegorical devices. *Mademoiselle de Lambesc as Minerva* (1732, Paris, Musée du Louvre) is an early example of the mythological or "history" portrait, a genre in which he was active during his lifelong career. After refusing the opportunity his godfather Jouvenet had offered him of spending some time in Rome at the French Academy, in 1742 Nattier was hired as the official portraitist of the royal family. He painted portraits of Louis XV, Queen Maria Leszczynska, and the king's daughters. There are several portraits of the latter posing as nymphs, shepherdesses, and young goddesses. Nattier perfected a style of posed portraiture; rather than interpreting the subjects' personality and probing into their psychological traits, he created an unreal, carefully edited elegance of settings and poses. His portraits are among the last examples of a still classically composed world that recalls the art of Guido Reni and Domenichino. They

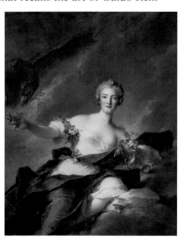

acquire an emblematic value as symbols of a society, a milieu, a style of life marked by a taste for artificial entertainment and affected elegance, a world that would soon disappear forever. As a matter of fact, Nattier's last years were overshadowed by the awareness that the hegemonic aesthetic sense was changing.

Paris 1685–1766

Principal place of residence
Paris

Travels
To Holland in 1717

Principal works
Madame Henriette as Flora and *Madame Adelaide as Diana* (1742 and 1748, Versailles, Musée National du Château); *Portrait of Maria Leszczynska* (1748, Versailles, Musée National du Château); *Portrait of Maria Zeffirina* (1751, Florence, Gallerie degli Uffizi)

Links with other artists
In those years, the celebratory portrait found its best interpreters in court artists such as Nicolas de Largillière (1656–1746) and Hyacinthe Rigaud (1659–1743); Nattier's greatest heir is François-Hubert Drouais (1727–1775).

◀ Jean-Marc Nattier, *Portrait of the Duchess of Chaulnes as Hebe*, 1744. Paris, Musée du Louvre.

The red cape is bordered with dark, fringed fur, rendered with an incredibly naturalistic effect.

The Tessin Collection of architectural drawings and paintings is an important holding of the Stockholm National Museum.

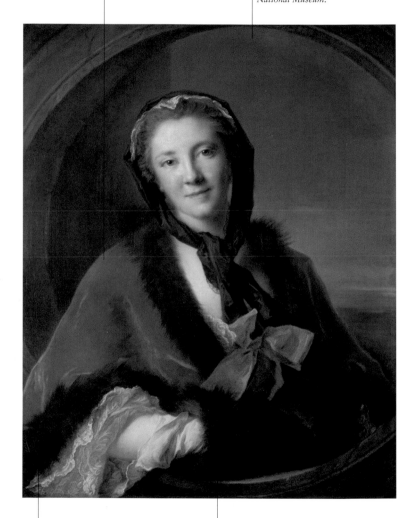

The woman's forearm, wrapped in a generous sleeve, extends outside the frame, invading the viewer's space.

▲ Jean-Marc Nattier, *Portrait of the Countess Tessin*, 1741. Paris, Musée du Louvre.

Louise Ulrike Sparre de Sundby was the wife of Count Carl Gustav Tessin, Swedish ambassador to the king of France and a patron and passionate collector of art objects. He founded the Royal Academy of Design in Stockholm in 1735.

*He gave his canvases a grandiose sense of space and sceno-
graphic, monumental effects, contrasted with the fluid charac-
ter of the small figures sketched with quick, spirited touches.*

Giovanni Paolo Panini

Panini matured artistically in the Bibiena school and that of the
Emilian *quadraturisti* from whom he acquired the taste for scenog-
raphy that informed all his work. He soon became known interna-
tionally for his prodigious versatility that allowed him to experiment
with different genres, from urban *vedute* to portraits, from land-
scapes to architectural capriccios and illustrations of the life and
monuments of Rome, ancient and modern. His paintings are com-
posed around a rigorous perspectival plan, which reveals his skill in
quadraturista, and filled with scenographic architectural inventions
or famous classical ruins and human figures drawn with an elegant,
exact touch, all within an optically correct rendering of the luminis-
tic elements. He painted the frescoes of Villa Patrizi (1718–25, no
longer extant) and of palaces such as the De Carolis (1720), the
Quirinale mezzanines (1722), and the Alberoni (1725–26; part of
these decorations were detached and moved to Palazzo Madama).
The four paintings with episodes from the life of Jesus, executed
between 1736 and 1737 for Philip V of Spain for hanging in Granja
Palace, became popular, and he made several versions of them, with
the help of his atelier. In 1742, Benedict XIV asked him to paint
Piazza Santa Maria Maggiore for the Quirinale Coffee House as a
companion to *Piazza del Quirinale*,
which had been commissioned by
Clement XII in 1733. He col-
laborated with Hubert
Robert, the French painter
who had come to Rome
in 1754 in the French
ambassador's retinue and
who shared Panini's pas-
sion for ancient ruins and
architectural capriccios.

Piacenza 1691–
Rome 1765

**Principal place
of residence**
In Rome from 1711

Principal works
Frescoes in the Villa
Montalto Grazioli
(1720–30, Frascati);
Ruins with Figure (1727,
Leipzig, Museum der
Bildenden Künste); *Prepa-
rations in Piazza Navona
to Celebrate the Dauphin's
Birth* and *The Cardinal
Visits Saint Peter's* (1729
and 1730, Paris, Musée
du Louvre); *Charles III
of Bourbon Visits Saint
Peter's* and *Charles III of
Bourbon Visits Benedict
XIV in the Quirinale Cof-
fee House* (1746, Naples,
Museo di Capodimonte)

Links with other artists
Van Wittel, Van Bloemen
and Locatelli, Ghisolfi,
Codazzi, and Piranesi

◄ Giovanni Paolo Panini,
*Great Feast under a
Portico*, 1720–25.
Paris, Musée du Louvre.

313

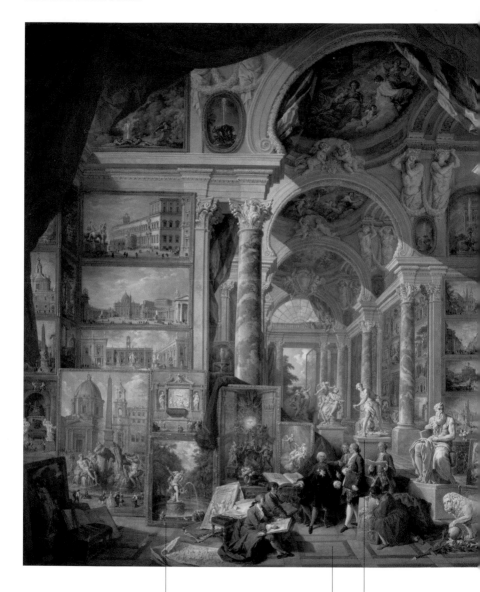

The group of paintings depicts the Quirinale, Saint Peter's Square, the Campidoglio, and various sculptures by Bernini (Saint Theresa in Ecstasy, the Four Rivers Fountain, the Chair of Saint Peter), even Saint Yves's drum at the Sapienza.

The theme of a painting inside a painting, of Flemish inspiration, was much appreciated by collectors and merchants. Zoffany also painted in this genre. Hubert Robert, in contrast, was more interested in the spatial quality of these grandiose dilapidated galleries.

The sculpture gallery includes Michelangelo's Moses *and* Bernini's David, The Rape of Proserpina, *and* Apollo and Daphne.

The series of Views of Modern Rome, *painted after* Views of Ancient Rome, *was commissioned by Monsignor de Canillac.*

Following the tradition of the Emilian quadraturisti, *Panini developed grandiose settings filled to capacity with decorative elements, characters, and objects.*

On the right we recognize the basilica of Santa Maria Maggiore, the Lateran Palace, Piazza Navona, and the Trevi Fountain.

The exceptional documentary value of this genre of painting is clear, as witnessed by the importance given to monuments and paintings throughout history.

The Grand Tour experience created the need to collect a "piece" of Italy. Unable to purchase the originals, the tourists satisfied themselves with collections of idealized views of the most celebrated works of art.

▲ Giovanni Paolo Panini, *Imaginary Gallery with Views of Modern Rome,* 1759. Paris, Musée du Louvre.

Permoser's masterpiece is the decoration of the Zwinger in Dresden. His sculptures fuse sinewy Rococo elements with a Renaissance-like dignity.

Balthasar Permoser

Kammer (Bavaria)
1651–Dresden 1732

Principal place of residence
Dresden

Travels
Vienna (1670); Venice, Rome, and Florence (1675–89); Dresden (from 1689)

Principal works
Sculptural decorations in the Zwinger (1712–18, Dresden); *Saint Ambrose* and *Saint Augustine* (ca. 1720, Bautzen, Stadtmuseum); *The Apotheosis of Prince Eugene of Savoy* (1718–21, Vienna, Österreichische Galerie)

Links with other artists
He was a student of Wolf Weissenkirchner and Giambattista Foggini.

After training in Salzburg and Vienna, Permoser spent fourteen years in Italy moving between Venice, Rome, and Florence and carefully studying Renaissance art and Bernini. He settled in Dresden in 1689 as court sculptor and lived there until his death. A master of technique, he sculpted majestic marble groups, garden statues, and ivory figurines that were reproduced in porcelain at the Meissen Manufactory. His most famous work is the plastic decoration of the Zwinger complex, one of the most successful examples of the wedding of architecture and decoration, created with the architect Pöppelmann. Through this work Permoser brought to Germany the formal novelties of Baroque sculpture, which he had learned in Italy. He worked at the Zwinger starting in 1712: in addition to making lovely wood, stone, and ivory sculptures, he also designed the general plan of their arrangement. He sculpted an allegorical cycle dedicated to the Saxon elector prince in the Wallpavillon; he also sculpted the intensely plastic *Atlases* and *Seasons* groups. One of Permoser's last marble masterpieces is *The Apotheosis of Prince Eugene of Savoy*, shipped to Vienna in 1721. Almost seven feet tall, it celebrates the greatness of the military leader who definitively defeated the Turks in 1697; notwithstanding the rich Baroque decorations and the mythical rendering of the prince, his facial features are true to life.

▶ Balthasar Permoser, *Pilasters with Herms*, 1714–18. Dresden, Zwinger.

He was the leading exponent of the Venetian chiaroscuro school in the transition from Baroque to Rococo, opposed to chiaristi such as Sebastiano Ricci and Giambattista Tiepolo.

Giovanni Battista Piazzetta

Piazzetta's youthful style still reveals his solid *tenebresco* Venetian background with intense chiaroscuro accents. His 1722 canvas of *Saint James Being Led to Martyrdom*, part of a *Twelve Apostles* series that the Church of San Stae had commissioned from several painters, is characterized by brutal naturalism, dramatic chiaroscuro, and marked plasticity. His only decorative project clearly inspired by the Rococo art that was being practiced by Ricci and Tiepolo in Venice is the *Glory of Saint Dominic* (1727) on the ceiling of Santi Giovanni e Paolo. In addition to religious art, in the mid-1730s Piazzetta went back to the genre painting that he had practiced in his early years, in the footsteps of Giuseppe Maria Crespi. He painted either biblical or secular scenes with isolated or half-figures set in pastoral Arcadian landscapes: some of these are *Rebecca and Eleazar at the Well* (1735–40, Milan, Pinacoteca di

Brera), *Pastoral Scene* (ca. 1740, Chicago Art Institute), and *Strolling in the Fields* (ca. 1745, Cologne, Wallraf-Richartz Museum). In addition to painting, Piazzetta was a prolific graphic artist. His large drawings of heads and half-figures known as "character heads" sold very well, as did his illustrations of printed volumes, such as Tasso's *Gerusalemme liberata* (Jerusalem Delivered), engraved by Marco Pitteri.

Venice 1682–1754

Principal place of residence
Venice

Principal works
Assumption of the Virgin (1735, Paris, Louvre); *Madonna and Saints* (1739–44, Cortona, Sant'Andrea); *Saint Dominic* (1743, Venice, Gesuati Church); *Decapitation of the Baptist* (1744, Padua, Basilica of Saint Anthony)

Links with other artists
He perfected his art in Bologna in Giuseppe Maria Crespi's studio, assimilating his intense chiaroscuro and strong chromatic contrasts; he also studied the art of Guercino and Luca Giordano. He served as first president of the Venice Accademia.

◄ Giovanni Battista Piazzetta, *Head of Young Shepherd*. Venice, Gallerie dell'Accademia.

317

Giovanni Battista Piazzetta

This canvas is part of a cycle commissioned from twelve artists to decorate the chancel of San Stae, a true creative laboratory in which all of the best Venetian settecento painters participated.

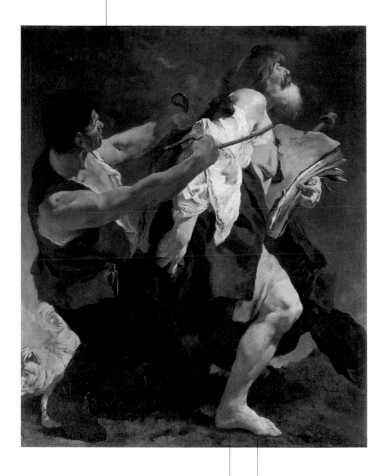

▲ Giovanni Battista Piazzetta, *Saint James Being Led to Martyrdom*, 1722. Venice, San Stae.

Piazzetta reduces the spatial setting to a minimum, concentrating on the monumental figures of the muscular guard and the unruly saint who—surrounded by a supernatural light—still carries a voluminous tome even as he is being captured.

This work was immediately successful with contemporaries, artists, and literati for the synthetic power it projects, the vigorous representation of the common man, and the dramatic intuition that seems to inspire it.

Commonly known as The Fortune Teller,
this work could also depict the initiation
to love of one of the two boys standing
behind the woman, or even a prostitute
as an allegory of city corruption.

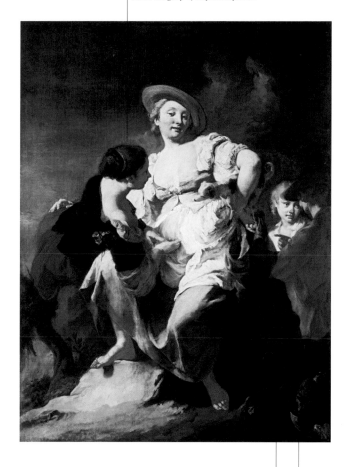

▲ Giovanni Battista Piazzetta,
The Fortune Teller, 1740.
Venice, Gallerie dell'Accademia.

The tenebrismo *that had
characterized Piazzetta's
early work, on the Emil-
ian models of Crespi
and Guercino, seems to
soften in later works
such as this one, which
has clearer colors and is
saturated with light.*

*This delightful genre
scene, free of rhetori-
cal and conventional
artifice, stands out for
its naturalness and
close correspondence
with reality.*

319

He sculpted allegorical and idyllic groups, portraits, scenographic religious compositions, official statues, and grandiose funerary monuments, all marked by realistic vitality and spontaneous elegance.

Jean-Baptiste Pigalle

Paris 1714–1785

Principal place of residence
Paris

Travels
Rome (1736–39)

Principal works
Madame de Pompadour (1748–51, New York, Metropolitan Museum of Art); *Child with Cage* (1749, Paris, Musée du Louvre); *Funerary Monument of Maurice of Saxony* (1753–76, Strasbourg, Church of Saint Thomas); *Love and Friendship* (1758, Paris, Musée du Louvre); *Portrait of Voltaire* (1776, Paris, Institut de France)

Links with other artists
He was a student of Robert Le Lorrain and Jean-Baptiste II Lemoyne (1704–1778).

► Jean-Baptiste Pigalle, *Mercury Putting on His Wings*, 1744. Paris, Musée du Louvre.

Toward the middle of the 18th century, the sculptors who best represented French taste were Bouchardon, Falconet, and Pigalle. Pigalle's work belongs to the transitional phase from frothy, gay Rococo to the calmer, more composed Neoclassicism. His art is marked by the contrast between a strong naturalism, reflected in the careful definition of anatomical details, and the polished form of the emerging Neoclassicism. He went to Rome even without winning the coveted Prix de Rome that allowed the other artists to spend a long period of study in Italy free of charge. *Mercury Putting on His Wings* (1744, Paris, Musée du Louvre), with a *recherché* pose that still echoes the Rocaille taste, was his first success. Next to mythological works, Pigalle also sculpted religious subjects, which he humanized; this is especially evident in his tender, sweet, and composed treatment of the Virgin Mary. Portraiture, however, was the genre in which he excelled and that brought him to the attention of Madame de Pompadour in 1748; he painted her under the veil of allegory in *Love and Friendship* and *Education to Love*. He executed portraits of the most famous intellectuals of his time, such as Voltaire (1776) and Diderot (1777), capturing the most intimate and human aspect of these famous men without any sort of allegorical or mythological idealization. Between Rococo and Neoclassicism, Pigalle's interest was always and primarily focused on studying nature.

The grieving angel holds its torch pointed downward.

The gaunt, bloodless body of the deceased tries to rise from the sarcophagus, but Death, bent and covered by a veil, offers a spent hourglass, signifying that his time is over.

The widow of Count Henri-Claude d'Harcourt, marshal of France, grieves before the pile of weapons, weeping and praying for her husband's soul.

▲ Jean-Baptiste Pigalle, *Funerary Monument of Henri-Claude d'Harcourt*, 1774. Paris, Notre-Dame.

Although this monument evokes the Baroque memento mori, a reminder of man's transience, it also foreshadows a new classicism that is visible, for example, in the composed drapery of the angel and the widow.

With a studied choice of vistas and the skillful use of light and shadow, Piranesi ennobled the art of etching with an infinite series of real and fantastic views, collected by amateurs all over Europe.

Giovanni Battista Piranesi

Maiano di Mestre (Venice)
1720–Rome 1778

**Principal place
of residence**
Rome

Travels
Rome (1740, 1747–78);
Naples, Pompeii, and
Herculaneum (1770);
Paestum (1777)

Principal works
Views of Rome and
*Roman Antiquities from
the Time of the Republic*
(starting in 1747, for the
rest of his life); *Of the
Magnificence and Archi-
tecture of Rome* (1761);
as an architect, he esigned
Santa Maria del Priorato
with the Piazza dei Cava-
lieri di Malta in Rome
(1764–66)

Links with other artists
He never broke his ties
with Venice, even signing
his works "Venetian
Architect"; he was friendly
with English architects
such as Chambers.

The vast production of Piranesi, one of the greatest engravers of all time, encompasses various artistic trends of the 18th century, from the fanciful Rococo of *Capriccios* to the love for the ancient world of *Roman Antiquities*. Arriving in Rome at the age of twenty after an apprenticeship in architecture, etching, and set design, he engaged his passion for the history of antiquity and the perfection and grandeur of Rome's monuments with a series of innovative etchings flavored with the dynamic, theatrical style of the Bibiena brothers. Piranesi's prints of modern and ancient Rome became sought-after mementos of the foreigners touring the Eternal City. He also drew inspiration from and perfected his art on the work of the *vedutisti*, Canaletto's in particular; from them he learned to render topography in precise perspective and, at the same time, to depict the vibrant atmosphere of the skies. Piranesi applied these lessons to the art of etching with new, extraordinary results. His architectural renderings seem almost in relief, thanks to skillful plays on perspective, the trompe l'oeil effect of elaborate stagelike settings, and a careful study of light and shadow. The collection of prints entitled *Imaginary Prisons* (1749–61) was born of his fantastic blending of architectural design with a powerful vision, such that they were often inter-

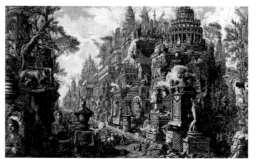

► Giovanni Battista
Piranesi, frontispiece of
Roman Antiquities, vol. 2,
1756. Milan, Civica
Raccolta delle Stampe
Bertarelli.

preted as meta-phorical visions of the unsettling meanders of consciousness. Some critics even consider these prints precursors of Romanticism.

In Rome Piranesi studied Cardinal Corsini's collection of prints. He specialized in etchings, which preserved for posterity the power of his celebrated views.

The immense, unlikely space of this prison, expanded to the point of dizziness, has a fragmented perspective in which the insignificant human figures, as well as the viewer's gaze, become lost.

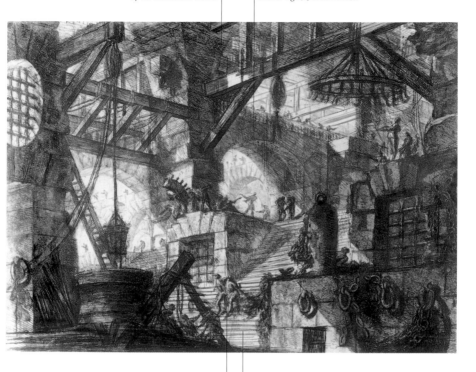

Left to their destiny, the few figures seem crushed by this infernal locale, represented with a perspective from below to exaggerate the impression of unreachable heights, and thus the impossibility of escape.

The multiplication of staircases, suspended beams, grates, chains, and ropes that increase the viewer's sense of anguish is further heightened by a masterly arranged chiaroscuro that generates a grandiose, deeply disturbing effect.

▲ Giovanni Battista Piranesi, *The Well*, from *Imaginary Prisons*, copperplate engraving, 1761. Rome, State Printing Office.

He was a brilliant fashionable portraitist in the London of his time. He also carefully studied the work of Hogarth, anticipating ideas that would be developed in the following century.

Joshua Reynolds

Plympton Earl (Devonshire) 1723–London 1792

Principal place of residence
London

Travels
Rome (1750–52); Flanders and Holland (1781)

Principal works
Lady Cockburn and Her Eldest Sons (1773, London, National Gallery); *Lady Delmé and Her Sons* (ca. 1780, Washington, D.C., National Gallery); *Grenadier Colonel George K. H. Coussmaker* (1782, New York, Metropolitan Museum of Art); *Master Hare* (1788–89, Paris, Musée du Louvre)

Links with other artists
He developed a style influenced by the great Venetian masters from Titian to Paolo Veronese and by 17th-century Flemish and Dutch art, from Rubens and Van Dyck to Rembrandt.

Reynolds's trip to Italy, begun in 1749 with his friend, Commodore Keppel, was decisive for his career. He stayed in Rome from 1750 to 1752, with brief stays in major Italian cities such as Florence, Bologna, and Venice. He was particularly attracted by classical statuary and cinquecento painting, especially the works of Raphael and Michelangelo, even though his fierce parody of Raphael's *School of Athens* (see p. 106) might lead one to suspect that he wanted to distance himself from the solemn decorum characteristic of Renaissance art. Still, while he refused to call himself an academic, Reynolds was a sincere admirer of classical art, both ancient and modern. This is evident in the portrait he painted of his friend Keppel (1753, Greenwich, National Maritime Museum), inspired by the *Apollo Belvedere*. In 1753, Reynolds settled in London, which he rarely left except for a short trip in 1781 to Flanders and Holland. There he acquired a strong interest in the dramatic treatment of color and the impetuous brushwork he admired in Rubens. His *Discourses* are of theoretical interest; he gave them at the annual awards ceremonies held by the Royal Academy of Arts, of which he was president

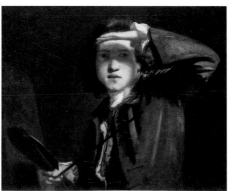

from its foundation in 1768. Around 1774 his unquestioned fame as a portraitist began to be dimmed by Gainsborough's rising star.

▶ Joshua Reynolds, *Self-Portrait*, 1747–48. London, National Gallery.

Captain John Hamilton, a friend of Reynolds, is portrayed wearing a Hussar busby and an ample fur coat. In the background, a stormy sea recalls the courage the captain displayed during a shipwreck in 1736.

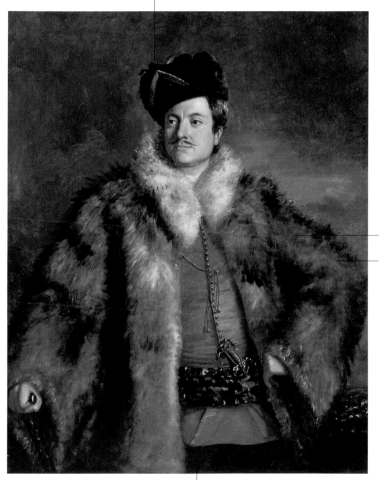

The captain is wearing the Hungarian Hussar uniform, which had become a popular masquerade costume around the middle of the century. The decorated sash into which he has slipped a knife and the fur coat project an exotic air, in keeping with the dangers of seafaring.

The texture of the fur has been rendered with soft, nuanced brushstrokes that echo its softness and its gradual transitions from brown to gray to black.

▲ Joshua Reynolds, *Captain John Hamilton*, ca. 1746. Abercorn Heirloom Settlement.

Reynolds's technical daring and the unconventionality of this portrait drew Londoners' attention and launched his celebrated career.

Joshua Reynolds

This famous portrait of the Walde-grave sisters was commissioned by their great-uncle, Horace Walpole, for his Strawberry Hill residence.

White is the dominant color: in the powdered hair arranged in elaborate coiffures, in the muslin gowns, and in the almost marble-like flesh, all in line with the latest fashion.

The three sisters were single when this painting was made; thus its exhibition at the Royal Academy in 1781 was an advertisement of their availability and their talents as future wives. In fact, all three were married soon thereafter.

Reynolds evokes here the classic image of the Graces, showing the three young women as if they were different aspects of the same person, conscious of being admired not just by their future husbands, but also by the public.

Embroidery, the feminine work par excellence, is here shown as a group pastime: Maria and Lauren twist the white silk threads, while Horatia uses them to embroider a piece of fabric that flows from the tambour onto the shiny dress.

▲ Joshua Reynolds, *The Waldegrave Ladies*, 1780–81. Edinburgh, National Gallery of Scotland.

▶ Joshua Reynolds, *Mrs. Baldwin*, 1782. Compton Verney House Trust, Peter Moores Foundation.

The bicolor turban has small roses painted with quick, sketchy strokes, a signature of the painter's mastery, like the embroidered shawl, the green and gold caftan, and the white ermine overcoat.

This typical Levantine costume was worn by a lady at one of King George III's balls. Perhaps Reynolds was acquainted with Van Dyck's portrait of Lady Theresa Shirley dressed in lavish Eastern dress (1622).

The model was irritable and made the sitting sessions difficult. Finally Reynolds suggested that she read while posing: the book she held was replaced in the painting by an ancient coin from Smyrna.

Jane Baldwin, the model, was only nineteen years old when she posed for this painting. Born in Smyrna of English parents, she was known for her beauty and was appreciated by the Austrian emperor and London society, which referred to her as the "lovely Greek."

The daring cross-legged pose evokes the sensual atmosphere of a house of ill repute.

The leader of the new chiarista trend opposed to the Venetian tenebrismo, he was a protagonist of cosmopolitan and elegant painting in the early part of the settecento.

Sebastiano Ricci

Belluno 1659–Venice 1734

Principal place of residence
Venice

Travels
Bologna (1681–83) in the atelier of Gian Gioseffo Dal Sole or Carlo Cignani; Rome (1691); Milan (1694–95); Florence (1706–8), at the court of Grand Prince Ferdinand with his nephew Marco; England (1712–16), with his nephew Marco; Paris (1716)

Principal works
Glorification of Marcantonio Colonna (1692, Rome, Palazzo Colonna); *Madonna with Child Enthroned and Saints* (1708, Venice, San Giorgio Maggiore)

Links with other artists
He worked on many commissions with his nephew Marco, who was a landscape specialist.

▶ Sebastiano Ricci, *Bacchanal in Honor of Pan*, 1716. Venice, Gallerie dell'Accademia.

Ricci was barely fourteen when he began apprenticing with Federico Cervelli, a follower of Luca Giordano; from him he learned the impulsive brushstroke and the loose, bright palette of his first works. At the end of 1685, Count Scipione Rossi commissioned him, together with the *quadraturista* Ferdinando Galli Bibiena, to decorate San Secondo Castle (Parma). Here he displayed both Bolognese and Parmense traits, echoing especially Correggio, Parmigianino, and Annibale Carracci. His second important work in Emilia, a cycle of paintings celebrating Pope Paul III (1687–88) and commissioned by Ranuccio II, is in the same vein. In Venice he worked for the city and for prestigious private clients, prefiguring the frothy Baroque in his compositional rhythms and chromatic intensity. In 1702, he painted *Allegory of the Princely Virtues* in Schönbrunn Castle, introducing the new style (even before Pellegrini and Amigoni), thanks to which Venice, at the turn of the century, became one of the leading European cultural centers. His collaboration with his nephew Marco intensified from 1712 to 1716 in England, where he worked for Lord Burlington, the count of Portland, and the duke of Shrewsbury, creating elegant mythological and biblical scenes influenced by Van Dyck, whose works were in English collections. After returning to Venice, he continued his frenetic activity with ingenious inventiveness, virtuosity of execution, and a quick, darting brush. Starting in 1724, he worked for the court of Savoy in Turin and for his new Venetian protector, Joseph Smith.

Executed with his nephew Marco during their stay in Florence in the Medici family palace, this fresco is all soft pastel tones spread across a luminous sky.

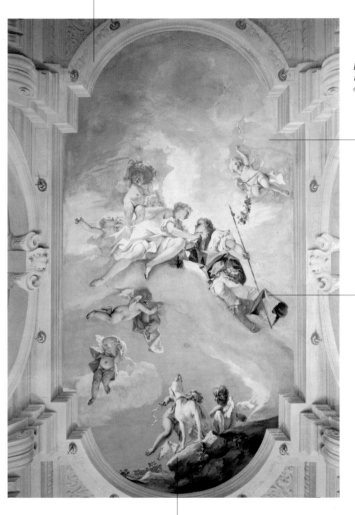

Ricci discarded the taste for the dark, "tenebrist" colors of late seicento Venetian art for the luminous, colored Venetian cinquecento style, in particular the art of Paolo Veronese.

The idyll between Venus and Adonis is recounted in Ovid's Metamorphoses. *Armed with a spear and followed by his dogs, Adonis is eager to go hunting. Venus tries in vain to hold him back, for he was not to return alive from that hunt.*

The chiarista *taste is recognizable in the use of a warm, sunny chromatic range. Lively details round out the composition, such as the dog that watches the scene, its head raised, from the edge of a cliff.*

▲ Sebastiano Ricci,
Venus and Adonis, 1707–8.
Florence, Palazzo Pitti.

Sebastiano Ricci

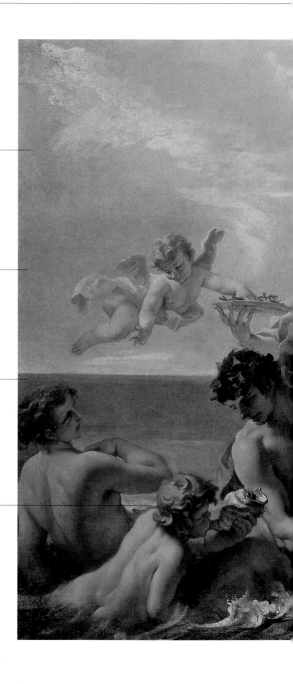

This is one of four mythological paintings executed for the central staircase of Burlington House in Piccadilly, the residence of Lord Burlington, today seat of the Royal Academy.

The memory of Paolo Veronese's work is palpable in this painting, which is luminous and filled with light, as well as subtly erotic, also recalling the mellow, sensuous art of Titian.

The composition is laid out along the intersection of the horizon line with the vertical axis represented by Venus and her handmaiden. Inside this grid, the painter has harmoniously arranged the lively characters.

The sea goddess is escorted triumphantly by the usual train of nereids and tritons sounding the conch.

▲ Sebastiano Ricci, *Triumph of the Marine Venus*, ca. 1713. Los Angeles, J. Paul Getty Museum.

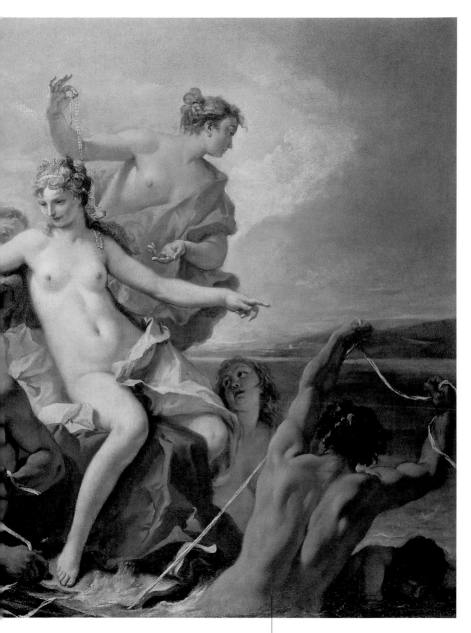

The virile torsos and the soft feminine
flesh reveal a painstaking study of
human anatomy.

With geniality, free strokes, and inventiveness, he painted ruins and architectural capriccios, imaginary places and real monuments, shady gardens and Parisian views.

Hubert Robert

Paris 1733–1808

Principal place of residence
Paris

Travels
Rome (1754–65);
Naples (1760)

Principal works
Ripetta Port (1766, Paris, École Nationale Supérieure des Beaux-Arts); *The Discovery of the Laocoön* (1773, Richmond, Va., Museum of Fine Arts); the series of four *Principal Monuments of Provence* (1787, Paris, Musée du Louvre)

Links with other artists
The drawings made while in Italy are so similar to Fragonard's as to create some attribution problems; both worked for the Abbott of Saint-Non as designers and chroniclers of his travels in southern Italy.

As was true for many foreign artists, an Italian sojourn from 1754 to 1765 forever marked Robert's artistic destiny. In Rome he filled the gaps in his Paris education and discovered his vocation for the *veduta* and landscape. For a long time he felt the influence of Panini, though he differentiated himself by attempting to create an atmosphere rather than describe a recognizable place, and by the spontaneity of his drawings, often just sketches. From Piranesi he took a passion for archaeology, for the chiaroscuro contrast, and for the theatrical setting. Thus, Robert perfected the art of assembling real and imaginary ancient monuments, landscapes, and *vedute*, interspersed with small human figures busy in humble occupations; one example is *Architectural Capriccio with Pantheon* (1758, Saint Petersburg, Hermitage). He always painted with enthusiasm and impulse, laying the color in one thin layer and barely touching the canvas. After returning to Paris, he successfully exhibited at the Salon from 1767 to 1798, and in 1778 he was appointed "designer of the king's gardens" and member of the commission charged with transforming the Louvre Gallery into a national museum (see p. 99). In 1787 he was asked by Louis XVI to create for the castle at

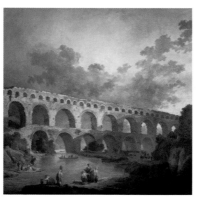

Fontainebleau a series of four views of *Principal Monuments of Provence,* where we again find the greatness of Rome in the ruins of southern France. In his last years he also worked for foreign clients such as Count Stroganov, who introduced his art to Russia.

▶ Hubert Robert, *The Pont du Gard*, 1787.
Paris, Musée du Louvre.

The artist has imagined the Louvre's Grand Gallery destroyed in a distant future, when only the noble traces of an illustrious past remain.

The Grand Gallery was built to connect the Louvre to the Tuileries Palace. Exhibited at the Salon of 1796, this work met with extraordinary success among critics and the public.

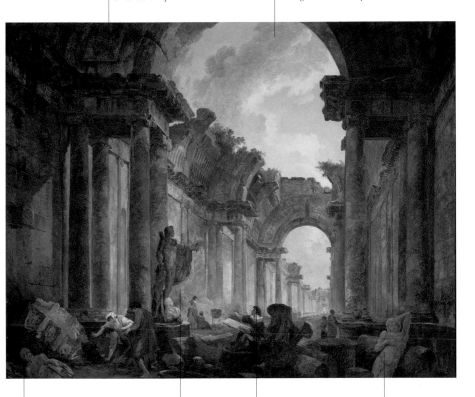

A head of Minerva lies next to a fragment of a statue of Zeno.

The bust of Raphael is here arranged casually at the feet of the Apollo Belvedere, the antique sculpture kept at the Vatican, which the artist had seen during his sojourn in Rome.

The destruction worked by time would spare only a few works of art, sufficient, however, for the young artist (perhaps the same Robert who lived inside the Louvre curating the collections) to find lessons for the present.

Michelangelo's Dying Slave lies abandoned among the ruins.

▲ Hubert Robert, *Imaginary View of the Grand Gallery in Ruins*, 1796. Paris, Musée du Louvre.

He made a name for himself as an acclaimed portraitist of elegant London nobles. His portraits are characterized by refined touches of color arranged in classical, well-proportioned compositions.

George Romney

Romney is one of the more refined portraitists of 18th-century English art, a period when many painters were active in this genre. To understand the history of English art, we should recall that in the early 1700s the scene was still dominated by foreign—mostly Italian and French—painters, and only in the 1720s did a national school begin to emerge. Portraits were the only source of income for English painters; to decorate their country mansions, the aristocracy commissioned family portraits set in landscapes that gave an idea of their landholdings. It was therefore natural for Romney to turn to portraits after he arrived in London in 1762. For more than two years he traveled in France and Italy, where he studied ancient sculpture and the art of Raphael, Michelangelo, Titian, and Correggio, copying hundreds of their drawings. From these examples he developed his classical, poised, and calm style of composing figures that harmonized with the background, bestowing solemnity on episodes from private life. In Rome he associated

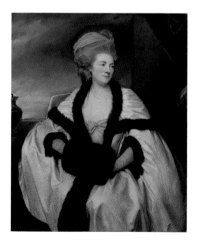

with Fuseli, who had a marked influence on his graphic style, as we can see from Romney's illustrations of the works of Aeschylus, Shakespeare, and Milton, and the Bible. He also painted historical canvases, but his fame continued to be linked to portraiture.

▶ George Romney, *Portrait of Mrs. Wilbraham Bootle*, 1781. Edinburgh, National Gallery of Scotland.

Lady Hamilton is portrayed here
"dressed" as Circe, the famed sorcer-
ess who tried to bewitch Ulysses; the
comparison is due to Lady Hamilton's
fame as a great seductress of men.

The spontaneity of this portrait,
which seems to anticipate certain
19th-century solutions, derives from
the use of widely spaced brushstrokes
that produce the effect of a sketch.

▲ George Romney, Lady
Hamilton as Circe, ca.
1782. London, Tate Gallery.

From humble origins Lady
Hamilton (1765–1815) became
the storied mistress of London
aristocrats. Charles Greville,
son of the count of Warwick,
settled her in a cottage in
Paddington Green and intro-
duced her to Romney, for whom
she began to pose in 1782.

Introduced to the court of Naples
by Sir William Hamilton, who was
Greville's uncle, Lady Hamilton was
known for poses in which she dressed
as Lucretia, Hebe, Juno, and other
figures from antiquity. She posed for
several painters, including Angelica
Kauffmann, Benjamin West, Gavin
Hamilton, and Wilhelm Tischbein.

The heir to Luca Giordano, he led the Neapolitan school in the first half of the century, creating classically composed, well-proportioned paintings filled with intense direct and reflected light effects.

Francesco Solimena

Canale di Serino (Avellino)
1657–Barra (Naples) 1747

**Principal place
of residence**
Naples

Principal works
*Heliodorus Driven from
the Temple* (1725, Naples,
Gesù Nuovo); frescoes in
the Chapel of San Filippo
Neri (1727–30, Naples,
San Gerolamini); *Charles
III of Bourbon Triumphs
at the Battle of Gaeta*
(Caserta, Palazzo Reale);
*Portrait of Marzio Carafa,
Duke of Maddaloni*
(Naples, Museo di
Capodimonte)

Links with other artists
In Naples he founded the
most accredited painting
academy in southern Italy;
it went on to become the
center of Neapolitan artis-
tic life and trained painters
such as De Mura,
Giaquinto, and Bonito.

▶ Francesco Solimena,
Self-Portrait,
1730–31. Florence,
Gallerie degli Uffizi.

Solimena studied the Neapolitan art of Lanfranco and Mattia Preti, the luminous Baroque of Pietro da Cortona and especially of Luca Giordano. In the early 1690s he turned to Mattia Preti's *tenebroso* Baroque style, rich with chiaroscuro and compositional plasticity, in works such as *The Miracle of Saint John* at the Hospital of Peace (1691). During his successful career he showed an increasing interest in Carlo Maratta's classicism, especially in the works he executed around 1700 for prestigious clients, such as the paintings for Cardinal Spada and the completion of the decorations for Santa Maria Donnalbina in Naples. During his brief stay in Rome, he established an intense rapport with the Arcadian literary and poetic circles and with the progressive, rationalist-oriented milieu of Neapolitan cul-ture. In 1709, he frescoed the vault of the sacristy of San Domenico Maggiore in Naples; this became a decorative model for all Neapoli-tan painters for the next half century. Solimena achieved an interna-tional reputation and worked for important Austrian and Bavarian

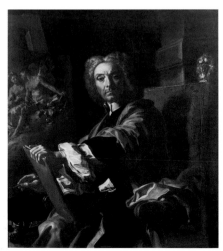

clients, decorating chapels and private resi-dences and painting official portraits. Start-ing in the 1740s, when the new Kingdom of Naples under Charles of Bourbon was formed, he went back to a marked Baroque style with intense chromatic and luministic vibra-tions, renewing his early passion for Mattia Preti and Luca Giordano.

Venus, goddess of beauty and wife to Vulcan, sits on a throne of clouds next to Cupid, who holds a plumed helmet. Scantily dressed, she looks down at her husband.

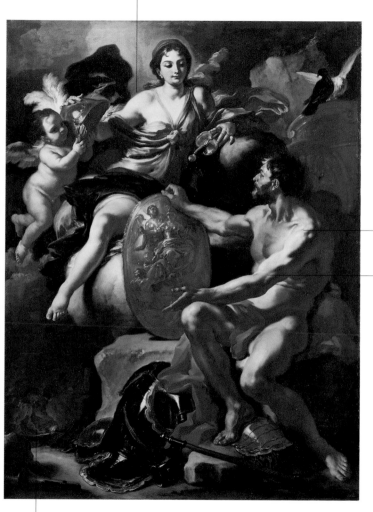

Vulcan is the god of underground fire (volcanoes are named after him) and the blacksmith of the gods. In the Aeneid, *Virgil recounts that Venus asked Vulcan to forge a complete set of armor for her son Aeneas, who was about to go into battle against the Latins.*

The golden shield reflects light from the left, like the armor lying on the floor. Solimena's thick brushstrokes dart and vibrate on the metal surfaces and the statuesque flesh, half marked by shadows.

Below, inside the cavernous forge, Vulcan's laborers—two Cyclopes—bend over the anvil with hammers in their hands.

▲ Francesco Solimena, *Venus inside Vulcan's Forge*, 1704. Los Angeles, J. Paul Getty Museum.

Francesco Solimena

This is the preparatory cartoon for one of three large canvases that decorated the Small Council Room in the ducal palace in Genoa, commissioned by the Giustiniani family; the paintings were destroyed in a fire in 1777.

The theme is the heroic fight of the Giustiniani family during the Turkish rebellion against the Genoese domination of Chios. Sheltered under a baldachin, the Turkish commander watches the massacre and barks out orders.

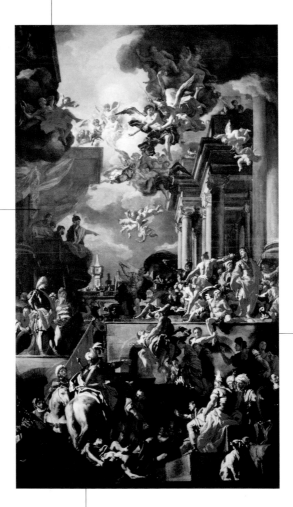

Starting in the 14th century, Chios, an island in the Southern Sporades, was dominated by a Genoese ship-owning company, the Maona, whose members had changed their family name to that of Giustiniani. These ship-owners took part in battles between Genoa and Venice and against the Aegean Turks. In the end, they were forced to pay a yearly tribute to the Turks, who in 1566 wrested power from them.

▲ Francesco Solimena, *The Massacre of the Giustiniani in Chios*, 1710–15. Naples, Museo di Capodimonte.

The skillful distribution of volumes and the alternating of more and less crowded areas are linked to the style of the frescoes Solimena had just completed in 1709 in the sacristy of San Domenico Maggiore in Naples.

In Rome he developed a stately, monumental style. In his altarpieces, just as in his portraits and daring nudes, he favored white, rose, and gray tones combined with refined sensibility.

Pierre Subleyras

Subleyras trained first in Toulouse, then in Paris. In 1728, the year after he received the prestigious Prix de Rome for his *Bronze Serpent* (Nîmes, Musée des Beaux-Arts), he settled in Italy. The development of his pictorial technique can be clearly traced in the succession of his Roman paintings: the self-assured draftsmanship, the subtle chromatic plays of whites and pinks, and especially the perfect mastery of the anatomy. Subleyras decided not to return to France and soon received official recognition for his talent, even being admitted to the Accademia di San Luca in 1740. The Roman clergy became his principal client: evidence of his fame is the prestigious commission he received in 1743 to paint the *Mass of Saint Basil* for Saint Peter's; in 1748 its transposition to mosaic was begun, an honor never before bestowed on a French artist.

He painted small and large canvases. The skillful, precious portraits such as *Benedict XIV* (1740, Chantilly, Musée Condé) and *The Abbess Battistina Vernasca* (Montpellier, Musée Fabre), as well as monumental altarpieces such as *The Crucifixion* (1744, Milan, Pinacoteca di Brera) and *Miracle of Saint Benedict* (1744, Rome, Santa Francesca), display refined and highly advanced colorist skills. His late art has a reduced chromatic range and recalls the work of Philippe de Champaigne.

Saint-Gilles-du-Gard
1699–Rome 1749

**Principal place
of residence**
Rome

Travels
Paris (1726);
Rome (1728–49)

Principal works
*Lady Anne Clifford,
Countess Mahony* (Caen,
Musée des Beaux-Arts);
Mass of Saint Basil
(1743–47, Rome, Santa
Maria degli Angeli)

Links with other artists
He was deeply influenced
by the Roman classicism
of Sacchi and Maratta. In
Rome he married the
miniaturist Maria Felice
Tibaldi (1707–1770),
daughter of the violinist
G. B. Tibaldi.

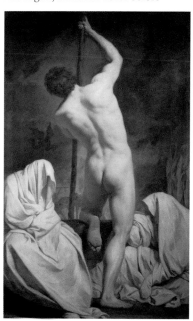

◀ Pierre Subleyras, *Charon Ferries the Souls of the Dead*, 1735–40. Paris, Musée du Louvre.

Pierre Subleyras

This work met with such success that numerous copies in smaller sizes were made by the painter, his atelier, and even his wife, Maria Felice Tibaldi.

The canvas is filled with marvelous still lifes, from the silver and copper ware behind the dining table to the wicker baskets and tableware on the floor, to the arrangement on the table.

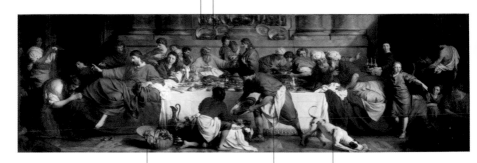

This colossal canvas—over twenty-three feet long—marked the public success of the artist in Rome. Commissioned by the Convent of Santa Maria Nuova in Asti, it was exhibited in Rome before being shipped to its final destination.

This composition demonstrates that Subleyras has developed confident draftsmanship, refined coloring, and tangible naturalistic sensibility, all within a rigorous formal control.

Famous for his whites, Subleyras here shows his talent in the dog's hair, the linen tablecloth, the servants' aprons, and even the turbans of two guests.

▲ Pierre Subleyras, *Dinner in the House of Simon*, 1737. Paris, Musée du Louvre.

▶ Pierre Subleyras, *The Painter's Atelier*, 1747–49. Vienna, Akademie der Bildenden Künste.

With the paintings included in this work, Subleyras
created a veritable visual autobiography, a catalogue
of his own opus. The variety of the themes repre-
sented gives an idea of the universality of his art.

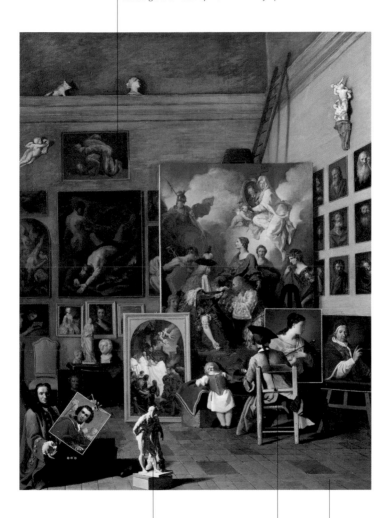

The Farnese Hercules, *the*
Abduction of the Sabines *by*
Giambologna, and other sculp-
tures in the atelier are inter-
pretative keys of the artist's
sources and reference points.

The artist has also
painted himself busy
at work in his atelier,
and he reappears at
bottom left displaying
his self-portrait.

On the reverse
side of the canvas,
the artist has
painted himself
at work, the
mechanical pencil
between his lips.

Tiepolo represents the height of uniquely Italian skills. Only he was able to master and arrange with infinite imagination colors, figures, clouds, and all sorts of animals and objects inside luminous skies.

Giambattista Tiepolo

Venice 1696–Madrid 1770

Principal place of residence
Venice

Travels
Udine (1726–30);
Milan (1731, 1740);
Würzburg (1750–53);
Madrid (1762–70)

Principal works
Histories of Antony and Cleopatra (1746–47, Venice, Palazzo Labia); *Apollo and the Four Continents* (1750–53, vault over the staircase, Würzburg); *The Apotheosis of Spain* (1764, Madrid, Royal Palace, Throne Room)

Links with other artists
He embraced Sebastiano Ricci's luminosity, taking up again Veronese's sunfilled fields and rediscovering the cinquecento technique of painting canvases and frescoes over white primer that allows light to shine through.

His first works, marked by a strong contrast of light and shadow in low tonalities, echo the long Venetian *tenebroso* season. In 1722, he painted *Martyrdom of Saint Bartholomew* for the *Apostles* series for San Stae, in something of a competition with Piazzetta. Later, he transitioned from a captious, elegant Barocchetto similar to Pittoni's to wider, more scenographic compositions. These he perfected in collaboration with the Ferrara *quadraturista* Girolamo Mengozzi Colonna, who was to be his faithful partner in almost all the large decorative works executed in Venice and the Veneto region. In the 1730s, Tiepolo was extremely busy in Venice working on several commissions, including large ones in which he displayed unequaled decorative skills. In Milan, in 1740, he painted the vault of the Palazzo Clerici gallery, a masterpiece of dazzling luminosity. In 1750, he was called to Würzburg, where he reached the summit of Italian settecento pictorial dexterity (pp. 151, 152). In 1762, Charles III of Bourbon

summoned him to Madrid, where he renewed his splendid career with ingenious scenographic pieces containing a wealth of details (p. 180). Tiepolo ended his prolific career by painting seven altarpieces for the church of San Pasquale Baylon in Aranjuez; five years after his death, they were replaced by the works of other artists whose style was more consonant with the new Neoclassical taste.

▶ Giambattista Tiepolo, *Banquet of Antony and Cleopatra* (detail), 1746–47. Venice, Palazzo Labia.

This memorable cycle of frescoes was commissioned by Dionisio Dolfin, patriarch of Aquileia, to decorate the gallery of the Palazzo Arcivescovile in Udine.

The rebel angels are driven from Paradise and cast down into Hell. One of them seems to fall out of the painted surface and enter the real space.

Paolo Veronese's influence is clear in this early masterpiece, in the harmonious complexity of the compositional modules and the intense luminosity of the chromatic arrangements.

▲ Giambattista Tiepolo, *The Expulsion of the Rebel Angels*, 1725. Udine, Palazzo Arcivescovile.

On either side of the
throne are statues of
Apollo and Diana, gods
of art and wisdom.

Blind Homer, escorted by a
young guide carrying the trumpet
of Fame, represents Poetry.

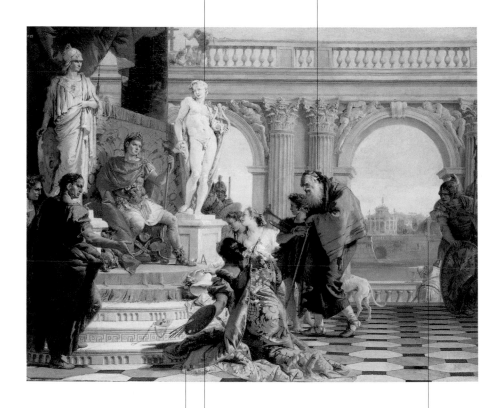

Francesco Algarotti
commissioned this work
in 1743 in honor of
Count Brühl, the power-
ful minister of Frederick
Augustus II, elector of
Saxony and king of
Poland (as Augustus II).

Painting, Sculpture,
and Architecture
kneel before the
emperor.

In the background behind
the splendid Palladian arches
stands the façade of Brühl
Palace in Dresden, which, as
capital of the kingdom of
Saxony, had been planned
as a new Rome.

▲ Giambattista Tiepolo,
*Maecenas Introduces the Liberal
Arts to Augustus*, ca. 1745. Saint
Petersburg, Hermitage.

Forced to enclose the figure in a small space, the artist has focused on her psychological intensity.

This is not a portrait, although Tiepolo sometimes also worked in that genre.

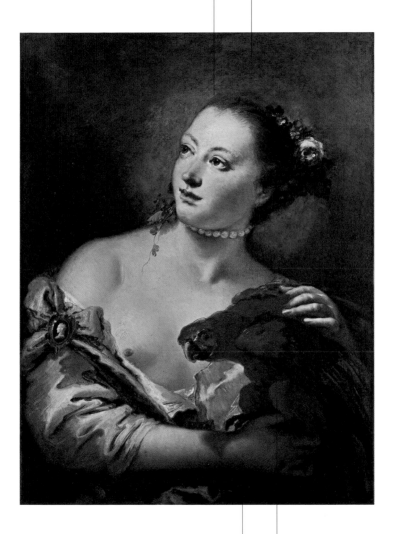

▲ Giambattista Tiepolo, *Young Woman with Parrot*, 1760–61. Oxford, Ashmolean Museum.

The memory of Titian's sensual "half-figures," mediated by Rosalba Carriera's pastels, are the most plausible precedents for this type of picture.

The parrot is a traditional, sometimes insolent, symbol of loquaciousness; perhaps it alludes to this, or simply to the woman's social status.

345

The last exponent of the Venetian settecento tradition, now at the threshold of the Neoclassical wave, he painted the coming of the new century in a melancholy, satirical vein.

Giandomenico Tiepolo

Venice 1727–1804

Principal place of residence
Venice

Travels
Würzburg (1750–53) and Madrid (1762–70) with his father and younger brother Lorenzo

Principal works
Minuet with Pantaloon and Columbine and *A Quack Docto*r (1756, Barcelona, Museo de Arte de Catalunya); *Stroll in the Orchard, Countryside Minuetto, The Mountebanks' Shed*, and *Punchinello Scenes* (1791–97, Venice, Ca' Rezzonico)

Links with other artists
With his younger brother Lorenzo (1736–1776), he faithfully collaborated with his father, even creating attribution problems, as in the case of *Consilium in Arena*, which hangs in the Musei Civici of Udine.

Although Giandomenico followed his father's compositional and coloristic patterns during his apprenticeship, he still succeeded in developing a personal language, already visible in the *Via Crucis* cycle (1747–49), painted for the Oratory of the Crucifix in San Polo, Venice. In Würzburg, where he painted the overdoors with *Justinian the Legislator, Constantine Disseminator of the Faith*, and *Saint Ambrose Refuses Emperor Theodosius*, he established himself as a mature, independent artist. A turning point in his career that reveals his originality is the set of frescoes painted with his father in Villa Valmarana ai Nani in Vicenza (1757; p. 28): an expansive narrative freedom, a witty realism, and a subtle satirical vein mark his representation of daily life executed in luminous pastel tones. He worked with his father also in Udine (1759), at Villa Pisani in Stra (1761–62), and at the Scuola di San Giovanni Evangelista in Venice (1761). He returned to Venice in 1770 after a long period in Madrid. Surprisingly original and ironic is the series of 104 drawings entitled *Entertainment for Children* (today dispersed among several collections), which depict the exploits of Punchinello, the picaresque antihero who ridicules every convention. Starting in 1744, Giandomenico also worked prodigiously as

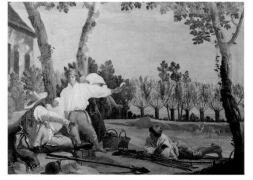

an engraver, reproducing his father's paintings and creating his own series of twenty-five engravings: of these, *The Flight into Egypt* is a masterpiece of settecento Venetian graphic art.

▶ Giandomenico Tiepolo, *The Peasants' Rest*, 1757. Vicenza, Villa Valmarana ai Nani.

This detached fresco originally graced
the walls of the family villa at Zianigo
between Padua and Vicenza; here the
artist decorated some rooms with scenes
expressing his smiling disenchantment.

All identical and all dressed in white,
the Punchinellos move as if on a
stage. The masks with the hooked
nose recall those worn by the actors
of the Commedia dell'Arte.

▲ Giandomenico Tiepolo,
Punchinellos on the Swing, ca.
1791. Venice, Ca' Rezzonico.

Ironic and melancholic at
the same time, the figure
of Punchinello is the most
popular of the Commedia
dell'Arte masks.

Giandomenico Tiepolo

This is the best known of the cycle of frescoes removed in 1907 from the Tiepolo family villa in Zianigo, near Mirano, where Giandomenico had decorated some rooms.

The metaphysical landscape in the background heightens the crowd's expectations.

▲ Giandomenico Tiepolo,
The New World, 1791.
Venice, Ca' Rezzonico.

The mountebank stands on a stool and holds a magic lantern. There is a palpable awareness of the imminent end of a world: only six years later, the Serenissima would lose its independence.

A small crowd waits to look through a magic lantern, a sort of "cosmorama" where one could glimpse figures and scenes of faraway, exotic lands.

No character shows his or her face: all are portrayed from the back, in a highly original composition in which the viewer can identify himself.

The decorations of the Tiepolo villa, like Goya's Quinta del Sordo, are some of the surviving few that painters of the past created in their homes for their own pleasure.

Renowned for his sharp, roguish genre scenes of wretchedness and nobility, he has only recently reached an important position in the panorama of European settecento painting.

Gaspare Traversi

Naples ca. 1722–
Rome 1770

**Principal place
of residence**
Naples and, from 1752,
Rome

Principal works
Old Beggar (ca. 1752,
Narbonne, Musée d'Art
et d'Histoire); *The Brawl*
(1753–54, Naples, Museo
Nazionale di San Mar-
tino); *The Tickle* (ca.
1755, New York, Metro-
politan Museum of Art)

Links with other artists
His witty genre scenes
were once attributed
to Giuseppe Bonito
(1707–1789), who had
worked with Traversi
in Solimena's studio
in Naples.

Traversi apprenticed in Solimena's studio in Naples; from him he learned to use a thick, chromatic paste and contrasting light effects. Already in his earliest works, such as the canvases executed in 1749 for Santa Maria dell'Aiuto in Naples, he was rereading and reinterpreting the naturalistic tradition of Naples and the Carracci. After moving to Rome in 1752, he painted a series of six *Biblical Scenes* for the Carmelites of San Crisogono (now hanging in the basilica of San Paolo fuori le Mura in Rome). In 1753, Father Raffaele of Lugugnano, who was known in Naples and whose portraits Traversi had painted, asked him to decorate Santa Maria di Monte Oliveto in Castellarquato near Parma. The work was completed in 1758 and today is dispersed among the Duomo in Parma, San Rocco in Borgotaro, and the Museo della Collegiata in Castellar-quato. In those same years he also painted many sharp, analytical scenes drawn from peasant and middle-class daily life, such as *The Feeding* (Rome, private collection) and *The Posing Session* (Paris, Musée du Louvre). He analyzed with canny accuracy characters from life such as *Drunk Old Woman* (Milan, Pinacoteca di Brera) and made bitingly ironic portraits of the empty drawing-room society life, such as *The Music Lesson* and *The Drawing Lesson* (Kansas City, Nelson Atkins Museum of Art). His works are precious documents of the life, customs, and characters of Italian painting at mid-century.

► Gaspare Traversi, *The Wounded*, 1755–56. Venice, Gallerie dell'Accademia.

Traversi's works mercilessly dissect scenes from everyday life, between misery and splendor, translating traditional Neapolitan comedy to canvas.

The young, somewhat bewildered draftsman is attracted more to the comely young woman who stares blankly ahead than to his work.

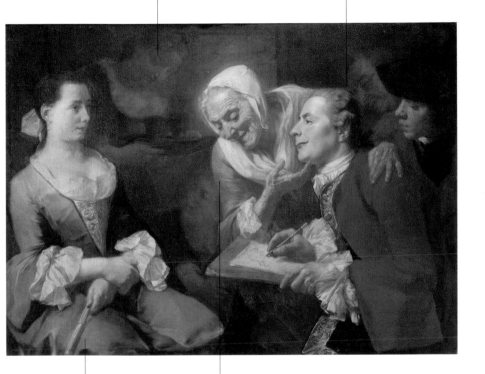

This painting, whose companion is The Brawl *(Paris, Musée du Louvre), does not have an explicit subject, although there is an intended moral message, probably inspired by the contemporary theater.*

The old, wrinkled woman could be a procuress, a recurring figure in 17th-century Neapolitan painting, from Ribera onward.

▲ Gaspare Traversi, *The Posing Session*, 1754.
Paris, Musée du Louvre.

The great Dutch painting tradition of the golden 17th century continued in the 18th in Cornelis Troost, a careful chronicler of the fashions and habits of Amsterdam's bourgeois society.

Cornelis Troost

Amsterdam 1696–1750

Principal place of residence
Amsterdam

Principal works
The Regents of the Chaplain's Orphanage (1729, Amsterdam, Rijksmuseum); *Family Group around the Harpsichord* (1739, Amsterdam, Rijksmuseum); *The Spendthrift Woman* (1741, Amsterdam, Rijksmuseum)

Links with other artists
He apprenticed with Arnold Boonen, a renowned portraitist.

An established painter by 1724, Cornelis Troost soon became an important figure in Amsterdam's art world, and he never left his native city. His work consists mostly of portraits of the prosperous middle class, comic and edifying scenes, conversation pieces, and representations of theater performances. He found an inexhaustible source of inspiration in the theater throughout his career, and for a number of years was also an actor, even marrying a woman from that milieu. Many of his subjects are theater plays, especially the comedies in which he himself performed. None of his theater scenes is set in an actual theater, though, but rather in houses, on the street, or in taverns, such as *The Discovery of Jan Claasz* and *Godefroy and His Servant Drive Out Hopman Ulrich* (1738, The Hague, Mauritshuis). As a portraitist, he drew strong characterizations of both private individuals and officials, such as the regents of various city institutes, also painting group portraits, a genre that came to the fore in the 1600s. He developed a style marked by nimble brushwork and spirited chromaticism, often using a mixed pastel and brush technique that produced lively results and allowed for quick execution.

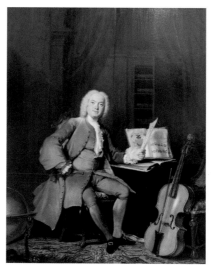

▶ Cornelis Troost, *Portrait of a Musician of the Van der Marsch Family*, 1736. Amsterdam, Rijksmuseum.

The artist has adopted traditional composition with a perfectly central focus and opposing symmetrical structures.

The city's profile, the trees, and the sky seem to belong to a theater set, as if they were painted on a backdrop behind a scene with which the painter was intimately familiar.

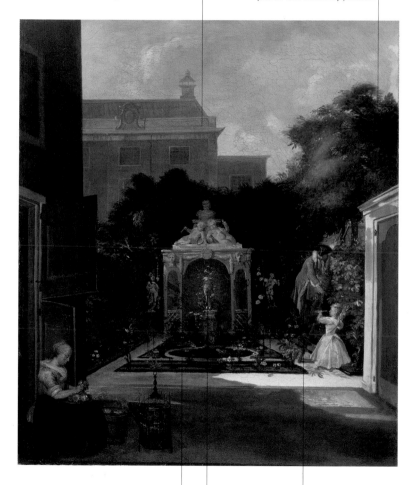

In these city gardens there was usually a sort of gazebo or "game house," in this case decorated with classical-style statues and two putti with brush and pen, symbols of painting and poetry.

The statue in the center is Fortune balanced on top of a globe.

Troost has staged a peaceful day out of doors in a walled garden such as were frequently found in the back of Amsterdam's patrician residences. Father and daughter are the main actors in the composition, together with the more prominent figure of a servant cleaning cabbage.

▲ Cornelis Troost, *The City Garden*, ca. 1743. Amsterdam, Rijksmuseum.

He was a pioneer of modern landscape art; his work painted out of doors reconstructs, in colored fragments, the natural structure of light, with precise perspectival and atmospheric details.

Pierre-Henri de Valenciennes

Toulouse 1750–Paris 1819

Principal place of residence
Paris

Travels
Italy (1769); Paris (1771); Italy (1777); Rome (1778–85); Naples, Sicily, Pompeii, and Paestum (1779)

Principal works
Study of the Sky over the Quirinale (Paris, Musée du Louvre); *Rome, Roofs in the Sun* (Paris, Musée du Louvre); *The Ancient City of Agrigento* (1787, Paris, Musée du Louvre)

Links with other artists
His work is an important precedent for the art of Corot, of French 19th-century landscapists and Impressionists, and of Cézanne.

After apprenticing in Toulouse with history painter Jean-Baptiste Despax, Valenciennes traveled in 1769 to Italy. There he found his vocation as a landscape painter. His experience in Italy was somewhat similar to that of the English painter Thomas Jones: both evoke in their work a feeling for a silent, enchanted nature free of visionary, Romantic, or sublime echoes. His later stays in Rome were punctuated by short exploratory trips documented in his notebooks, especially one from 1779, when he visited Naples, Sicily, Stromboli, Pompeii, and Paestum. Much of his work consists of oils on paper painted from life. Many are of the same locality captured at different times of the day: he was describing as precisely as possible the nuances of light and atmospheric effects. *Rome, Roofs in the Sun* and *Rome, Roofs in the Shade* (Paris, Musée du Louvre) are excellent examples. Once back in Paris, he became a teacher and took it upon himself to transmit to the young artists and the academic milieu the dignity of landscape painting.

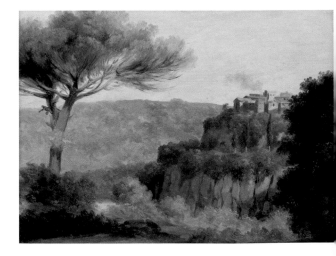

▶ Pierre-Henri de Valenciennes, *View of Nemi*, 1782–84. Paris, Musée du Louvre.

The elongated pyramidal shape of the poplar recalls that of the cypress, tall and slender, and assumes a clear structural function in addition to being evocative.

The sky has an almost metaphysical feel. Valenciennes started to paint from the sky, using it to calibrate the tone of the entire canvas.

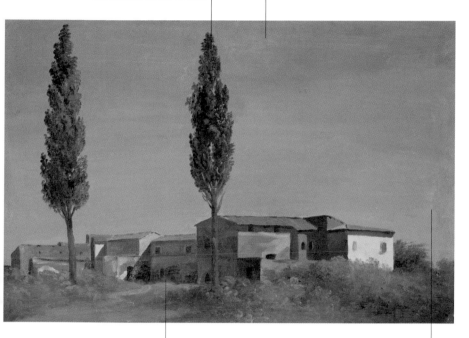

A well-thought-out geometry underlies this apparently spontaneous composition: the vertical lines of the poplars contrast with the horizontal sequence of the houses.

Thanks to Valenciennes's efforts, a special Prix de Rome was instituted in 1817 for historical landscapes. In 1800, he set down his ideas in Elements of Practical Perspective, To Be Used by Artists, *a fundamental text that codifies the rules of the Neoclassical landscape.*

▲ Pierre-Henri de Valenciennes,
Two Poplars at Villa Farnese,
1778–82. Paris, Musée du Louvre.

Portraitist of Parisian aristocracy and the court, she was independent, brilliant, and passionate about her art; she built an international reputation based on her exceptional talent.

Elisabeth Vigée-Lebrun

Paris 1755–1842

Principal place of residence
Paris

Travels
Italy (1789–92); Vienna (1792–95); Saint Petersburg (1795–1801); Paris (1802–5); England, Low Countries, Switzerland

Principal works
Portrait of Marie Antoinette and Her Children (1787, Versailles, Musée National du Château); *Woman Folding a Letter* (1784, Toledo, Museum of Art); *Portrait of Hubert Robert* (1788, Paris, Musée du Louvre); *Self-Portrait with Daughter* (1789, Paris, Musée du Louvre)

Links with other artists
She married Jean-Baptiste Lebrun, one of the leading art merchants of all times; thanks to him, she was able to study the masters of different schools.

► Elisabeth Vigée-Lebrun, *Self-Portrait*, 1800. Saint Petersburg, Hermitage.

At a time when women were not admitted to the Paris Royal Academy, Elisabeth Vigée-Lebrun was perforce a self-taught precocious and gifted artist. Having been introduced into Parisian high society by her husband who was an art merchant, in 1778 she painted a *Portrait of Marie Antoinette* (Vienna, Kunsthistorisches Museum) for Empress Maria Theresa of Austria that brought her immediate success. From that date she became the queen's official portraitist, painting more than thirty portraits of her over a period of ten years. Her association with the court of Versailles allowed her to gain experience and renown, which, in turn, gave her access to the courts of Europe in the long years when she was an exile. She fled France when the Revolution broke out, intending to return when law and order were reestablished; instead she spent twelve years in exile, three of them traveling in Italy (1789–92). Her stay in Italy confirmed her preeminence as a portraitist of royalty and cosmopolitan high society, in Naples in particular. She was just as successful in

Vienna and Saint Petersburg, being the most popular and best paid of all portrait painters. After returning to Paris in 1802, she continued her successful trips abroad: in Switzerland she painted the renowned *Portrait of Madame de Staël as Corinna* (1808, Geneva, Musée d'Art et d'Histoire). In the last years of her life she wrote her *Memoirs* (1835–37).

The feathered hat completes the refined chromatic play of grays, pale blues, and lilacs that reappear in the ribbon and the wide brim of the hat. The stylistic details are always an occasion to display virtuosity and luministic details on the different surfaces.

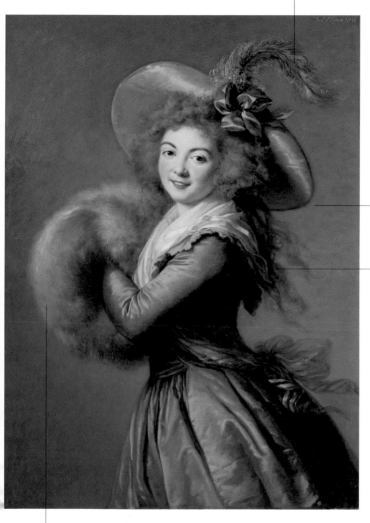

The subject of this portrait was a famous Italian Commedia *actress working in Paris; the painting was executed a few years before the artist went into exile in the wake of the French Revolution.*

The long, loose hair, which echoes the feather on the hat and the bow on the shawl, expresses the woman's movement, captured almost running, as she smiles for a second before exiting the picture to the left.

The fur muff is a soft, fluffy ball. The volume of the fur is rendered by fine dark marks with lighter color patches where the hand disappears, yet one can almost feel the warmth.

▲ Elisabeth Vigée-Lebrun, *Mademoiselle Raymond*, 1786. Paris, Musée du Louvre.

Elisabeth Vigée-Lebrun

The entire composition expresses the exquisite femininity in Vigée-Lebrun's art: a mother's love and a child's tenderness are recurring themes in her work, as in the many portraits she made of her daughter Julie.

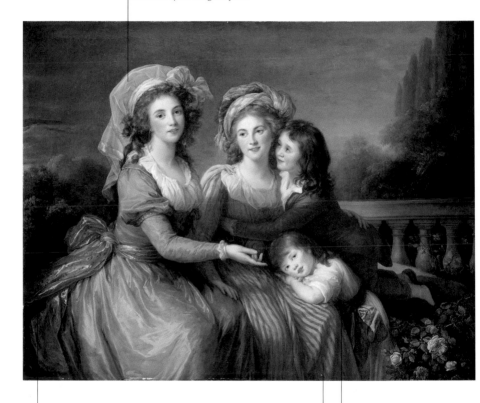

The ladies' dresses are rendered with gentle, liquid brushstrokes that glitter where the light falls on them, as in the amazing rendering of the sash on the left made of thick, full-bodied threads of gold.

The two ladies proudly and lovingly display their children in informal, unconventional poses. The relaxed atmosphere and the gentle expressions and postures project this portrait into the following century, for the modernity of the conception and of the technical skill.

The little girl leans her cheek on her mother's lap, anticipating so much of French Impressionism with the sweetness of the expressions and the free, flowing strokes.

▲ Elisabeth Vigée-Lebrun, *The Marquise de Pezay and the Marquise de Rouge with Their Children*, 1787. Washington, D.C., National Gallery.

"Watteau: bright carnival, where illustrious hearts, / like butterflies, flit about; / fresh and light décors lit up by flares / they pour their madness on this whirling dance." (Baudelaire)

Jean-Antoine Watteau

Watteau moved to Paris in 1702. For the first few years he barely made a living from his work. He spent some time in Claude Gillot's atelier, where he developed a taste for scenographic and theatrical settings, something that would characterize all his later work. While a student at the Royal Academy, he discovered Rubens and the cinquecento Venetian painters, all of whom proved important for his artistic education. He perfected his technique and style by constantly practicing drawing and frequently attending the theater, which was an inexhaustible source of ideas for settings and characters. By 1715, he had acquired a reputation among art lovers and collectors such as the wealthy banker Pierre Crozat, who, in addition to housing him and giving him work, introduced him to the rarefied Parisian intellectual milieu. Still, even with this recognition he was not in the good graces of the establishment, which never took an interest in his paintings. In 1717, the Academy registered him as a *"fête galante* painter,"* the genre that made him famous: the representation of aristocratic pastimes set outdoors in blooming gardens, with musicians and actors joining couples in idyllic, dreamy atmospheres (p. 15). Watteau's reputation in official academic circles was limited to his role in introducing an unusual new genre. Although he was appreciated by Boucher, it was only in the latter part of the 19th century that Watteau's talent was officially acknowledged. He was finally recognized as the poet of that charmed, idle world that was wiped out by the French Revolution.

Valenciennes 1684–
Nogent-sur-Marne 1721

**Principal place
of residence**
Paris

Travels
London (1719)

Principal works
The Embarrassing Proposal (ca. 1715, Saint Petersburg, Hermitage); *The Pretender* and *The Indifferent* (ca. 1717, Paris, Musée du Louvre); *Mezzetin* (1717–19, New York, Metropolitan Museum of Art); *Shop-Sign of Gersaint* (1720, Berlin, Charlottenburg; p. 44)

Links with other artists
He went to work in the atelier of Claude III Audran, curator of the Royal Collections of Luxembourg Palace, where he studied the Rubens cycle *Life of Maria de' Medici*; Rosalba Carriera painted his portrait in Paris.

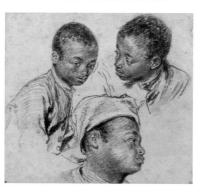

◄ Jean-Antoine Watteau, *Studies of Heads*. Paris, Musée du Louvre.

Jean-Antoine Watteau

Notwithstanding the apparent gallantry of the scene, the atmosphere seems filled with melancholy and a sense of the ephemeral.

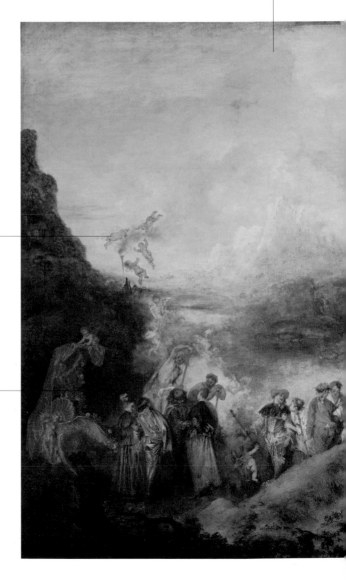

The swirling Cupids and the boat transformed into a splendid golden gondola seem to encourage the company to embark for the island of love.

This work has been interpreted to signify the inevitable decay of myth, of the great historical ideals, even of tragedy.

▶ Jean-Antoine Watteau, *Pilgrimage to the Isle of Cythera*, 1717. Paris, Musée du Louvre.

The pairs of lovers are about to step onto a boat that will lead them to Cythera, where, according to the legend, the goddess of love was born.

Even nature, here rendered with an airy, delicate touch, participates in this evanescent, sensual atmosphere.

The bust of Venus, garlanded with roses, is the point of departure for this sort of "theatrical" path that leads to happiness.

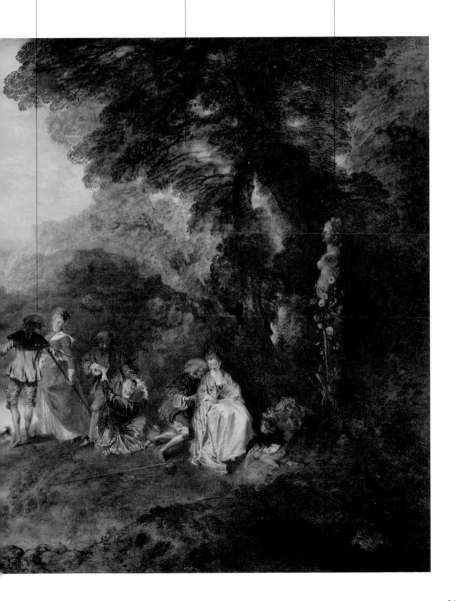

Jean-Antoine Watteau

Here Watteau seems to mock those artists who "aped" nature, taking the real as model, just as monkeys are known to imitate man.

This bust of a woman, with her melancholy, disinterested expression, seems to suffer under the monkey's chisel; the "artist" in turn seems satisfied with the work.

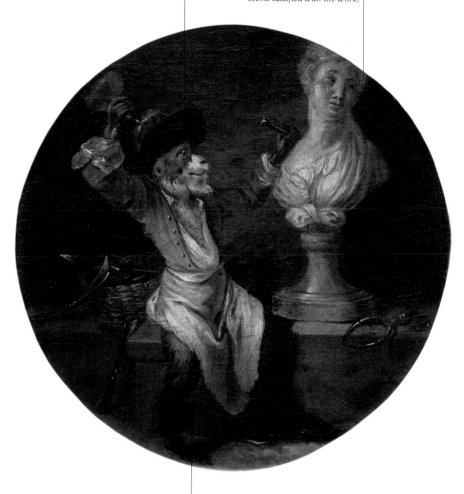

The imitation of nature was a hotly debated issue in the aesthetic theories of the early 18th century.

▲ Jean-Antoine Watteau, *Monkey Sculptor*, 1709–12. Orléans, Musée des Beaux-Arts.

The clumsy gestures and the rather blank stare of Gilles, a droll, pathetic burlesque character, make him a symbol of naiveté and stupidity that also provokes deep tenderness.

A keen connoisseur of the theater, Watteau used Commedia dell'Arte masks to bring to the canvas characters, anxieties, and pretense. This subject is drawn from Éducation de Gilles, a vaudeville act staged by the Opéra Comique, the Italian comic actors' theater.

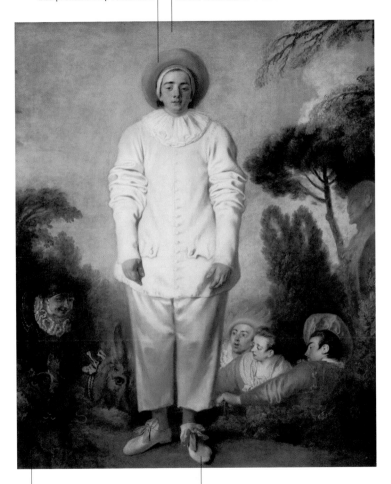

Below is Gilles's father Pantalon atop a donkey, and on the right, the pair of lovers Leander and Isabella, and the fop who oppresses poor Gilles.

▲ Jean-Antoine Watteau, *Pierrot*, 1718–19. Paris, Musée du Louvre.

The monumental size, the daring perspective from below, the care in finishing the surfaces, the original and effective chromatic ensemble, led some to theorize that Gilles was meant to be a projection of the artist's state of mind, just two years before his death.

He achieved success by painting contemporary historical themes ennobled by a stately, Neoclassical style that reflected Anglo-Saxon civic and moral virtues.

Benjamin West

Springfield (Penn.) 1738–
London 1820

**Principal place
of residence**
London

Travels
Philadelphia (1756);
Italy (1760–63);
London (1763–1820)

Principal works
Agrippina Lands in Brundisium with the Ashes of Germanicus (1768, New Haven, Yale University Gallery); *William Penn's Treaty with the Indians* (1771–72, Philadelphia, Academy of Fine Arts); *Death of Lord Nelson* (1806, Liverpool, Walker Art Gallery)

Links with other artists
His London atelier was a meeting point for young American painters who traveled to Europe to learn the craft, such as Peale and Stuart.

An American who settled in London in 1763, West inaugurated a new genre, the painting of contemporary historical events. He spent three years in Italy from 1760 to 1763, when he met Winckelmann's circle and took painting lessons from Mengs, then settled in London, where he worked first as a portraitist and later as a painter of ancient history scenes. The court found his canvases pleasing, and George III commissioned him to paint several religious canvases of Old and New Testament episodes, suitably modified for the Protestant religion, for Windsor Castle's royal chapel, but they were never completed. West then turned to contemporary themes and customs, which he treated in a neo-seicento, Baroque style. The *Death of General Wolf* and *William Penn's Treaty with the Indians* are typical of this new genre, where the academic-style epic is adapted to the needs of narrating current events, representing them in a strongly realistic manner. As evidence of his fame, he was appointed, after Reynolds's death in 1792, the second president of the London Royal Academy, which had been founded in 1768. His late works reveal personal touches, which are interesting also because they are suggestive of Edmund Burke's Romantic theories and his meditations on the concept of the "Sublime."

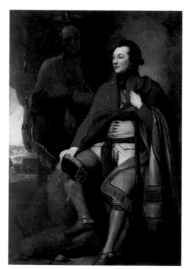

► Benjamin West, *Portrait of Colonel Guy Johnson*, 1776. Washington, D.C., National Gallery.

This is an episode from the English conquest of Quebec in 1759, a significant event that marked the permanent defeat of the French in North America.

All the bystanders, including two praying soldiers, are arranged in a semicircle as if on a stage.

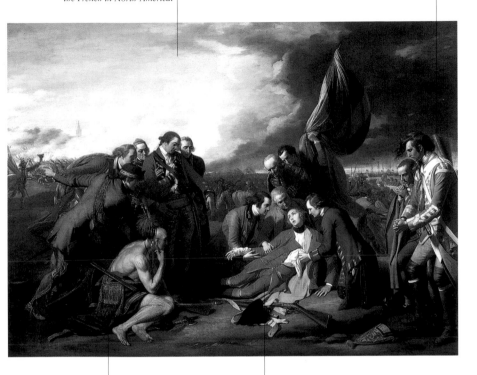

The kneeling Indian in the foreground geographically situates the event as being in the New World.

The dying general is the focus of the composition; around him the characters are arranged as if in a revisited Deposition.

▲ Benjamin West, *Death of General Wolfe*, 1770. Ottawa, National Gallery of Canada.

Admiration for Caravaggio's style and curiosity about scientific and technological discoveries are part of Wright of Derby's pictorial language in the panorama of English 18th-century art.

Joseph Wright of Derby

Derby 1734–1797

**Principal place
of residence**
Derby

Travels
Liverpool (1768–71);
Italy (1773–75)

Principal works
Lesson with the Mechanical Planetarium (1766, Derby, Museum and Art Gallery); *The Indian Widow* (1785, Derby, Museum and Art Gallery); *Landscape with Rainbow* (ca. 1795, Derby, Museum and Art Gallery)

Links with other artists
He was in contact with eminent figures such as Josiah Wedgwood, founder of the renowned English ceramic and porcelain manufactory.

Although he trained in London in the atelier of Thomas Hudson, a portrait painter, from the beginning Wright was attracted especially to compositions with artificial light, in the manner of the Dutch Caravaggesque artists such as Honthorst and Terbrugghen. For this specialty, his trip to Italy in 1773 was decisive, for it allowed him to complete research that he had begun in 1750, as evidenced by his canvases with candlelit scenes illustrating scientific experiments and industrial themes. These canvases reveal this painter's scientific mindset and acuteness, as he was the first to express the spirit of the Industrial Revolution: for Wright, as for the intellectuals of his time, science and industry were closely linked in the ideas of the Enlightenment and the belief in human progress. In homage to science, he painted industry as the direct application of research and human understanding, with man himself the ubiquitous and determinant presence in his paintings. His clientele included manufacturers and scientists who supported these first important efforts of

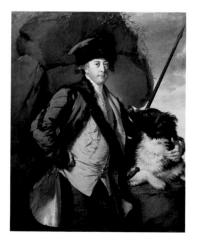

industrialization. Wright's frequent visits to factories and foundries came from a need to draw from life scenes lit by artificial light. In the last twenty years of his activity, he painted compositions with classical and Shakespearean subjects as well as themes from contemporary literature and landscapes of his native Derby.

▶ Joseph Wright of Derby, *John Whetham of Kirlington*, 1779–80. Los Angeles, J. Paul Getty Museum.

In candlelight, three men study a copy of the famous Borghese Gladiator, *which Wright of Derby had admired in his Italian travels.*

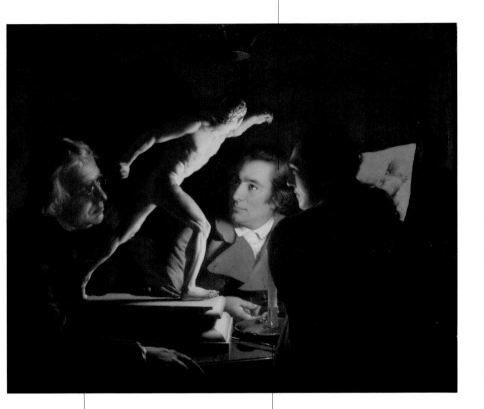

The Borghese Gladiator *was the most celebrated sculpture by Agesias of Ephesus. Found in fragments in 1609 in Anzio, near Rome, it was restored by Nicolas Cordier and later looted by Napoleon's troops; it subsequently became the property of the Musée du Louvre.*

The luminist tradition begun with Caravaggio was still alive after more than a century and a half: Wright of Derby favored compositions dominated by natural or artificial light.

▲ Joseph Wright of Derby, *Three Gentlemen Observing the "Gladiator,"* ca. 1765. Private collection.

Joseph Wright of Derby

The highly realistic reproduction of the characters' physiognomy leads one to suspect that the artist used complex optical instruments.

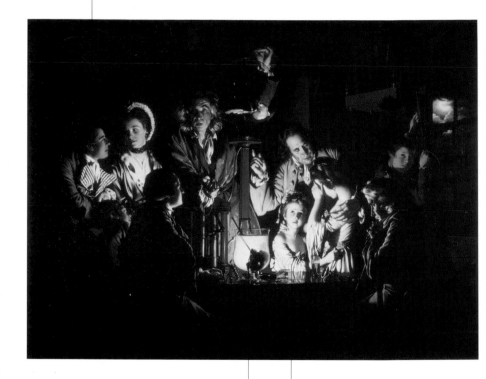

Thanks to Wright of Derby, even contemporary science, its popularizing language, and its values became a subject for art.

The girl on the right is crying for the little bird who is about to die in the air pump, while the younger sister seems to be more courageous and watches the experiment.

▲ Joseph Wright of Derby, *Experiment on a Bird in the Air Pump*, 1768. London, National Gallery.

Born and educated in Germany, he chose England as his adopted country. His accurate portrayals of people and places reflect the image of contemporary cosmopolitan society.

Johann Zoffany

Zoffany was educated in Regensburg in the atelier of Marteen Speer, a protagonist of the Bavarian Rococo. From 1750 to 1753 he worked in Rome, where he met Anton Raphael Mengs. Around 1760, he moved to London, where he changed his name from Zauffely to Zoffany. Here he was introduced to an art world where portraits and conversation pieces were the major types of commissions. His meeting with the famous actor David Garrick led to his receiving a commission for a portrait and a number of theater scenes that continued a tradition begun by Hogarth and brought him immediate success. Faithful reproduction of the subjects and the careful description of details are typical of Zoffany's pictorial language. He subsequently made several portraits for the royal family. In 1770, he exhibited his work at the Royal Academy that he helped establish; in the same year, he went to Florence, where he stayed until 1778, painting *The Uffizi Tribune* (1772–78, Windsor, Royal Collections), commissioned by Queen Charlotte. Then he moved to the Bourbon court in Parma. Returning to London in 1779, he found a changed, somewhat hostile environment, partly because Reynolds and Gainsborough were gradually taking his place. In 1783, he went to India, where he made portraits of the English families who lived there and a *Last Supper* for Saint John's Church in Calcutta.

Johann Zauffely
Frankfurt-am-Main 1733–
London 1810

**Principal place
of residence**
London

Travels
Rome (1750–57);
ca. 1760 he moved to
London; Florence and
Parma (1772–79);
India (1783–89)

Principal works
David Garrick in "Lethe"
(1766, Birmingham
Museum and Art Gallery);
The Uffizi Tribune
(1772–78, Windsor, Royal
Collections); *Ferdinand
of Bourbon and Maria
Amalia of Bourbon*
(1778, Parma, Galleria
Nazionale); *Charles
Townley in His Sculpture
Gallery* (1782, Burnley,
Townley Hall, Art
Gallery and Museum;
p. 55)

Links with other artists
In Rome he studied
with Agostino Masucci
and was a friend of
Piranesi and Mengs.

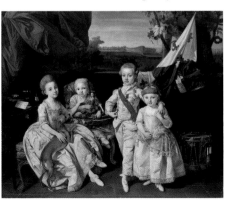

◀ Johann Zoffany,
*The Grandchildren of
Maria Theresa in Parma*,
1778. Vienna, Kunsthistorisches Museum.

Johann Zoffany

Tea is taken in a sumptuous
room in Compton House, one
of the most illustrious 18th-
century English residences,
redesigned by Robert Adam.

The palace gardens were designed by
the landscape architect Lancelot Brown
(known as "Capability"), the famous
planner of English-style gardens.

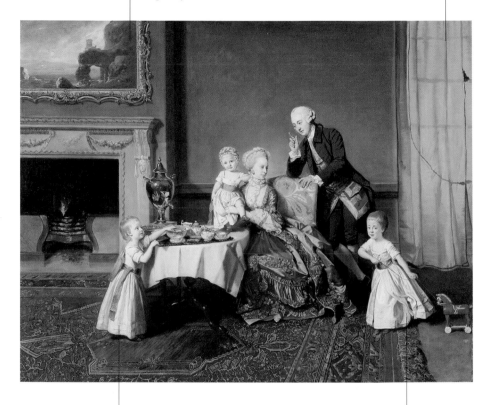

A little child is trying to steal some
cookies from the table, but is scolded
by the admonishing finger of the
father, Lord Willoughby de Broke.

The other child enters
the scene pulling a
wooden horse.

▲ Johann Zoffany, *John, Fourteenth
Lord Willoughby de Broke and
His Family*, ca. 1766. Los Angeles,
J. Paul Getty Museum

The profile of Petitot, the court architect, is recognizable; the scene is probably the villa where the shucking dances usually took place.

The well-dressed figure with a list in his hands is probably the estate administrator.

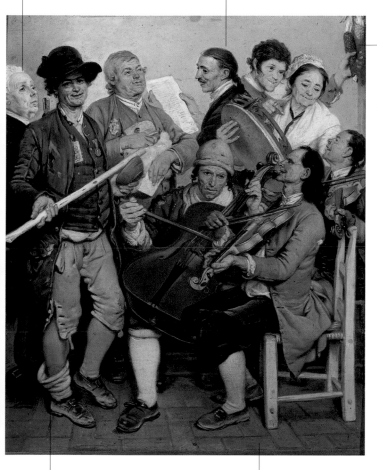

The ears of corn already shucked hang from the wall. The husking is over, and, after a dinner hosted by the owner, it is time to have some fun on the threshing floor with music and song.

This slice of peasant life is captured with a lucid naturalism: the painter has carefully reproduced the shoes with their holes and the baggy socks on the farmer.

▲ Johann Zoffany, Corn-Husking Feast, 1778. Parma, Galleria Nazionale.

Zoffany executed this painting during his brief stay in Parma in 1778. A strong representation of farm life, the subject of this painting is the shucking feast (scartocciata), in which the peasants and the owner's friends took part after the corn harvest.

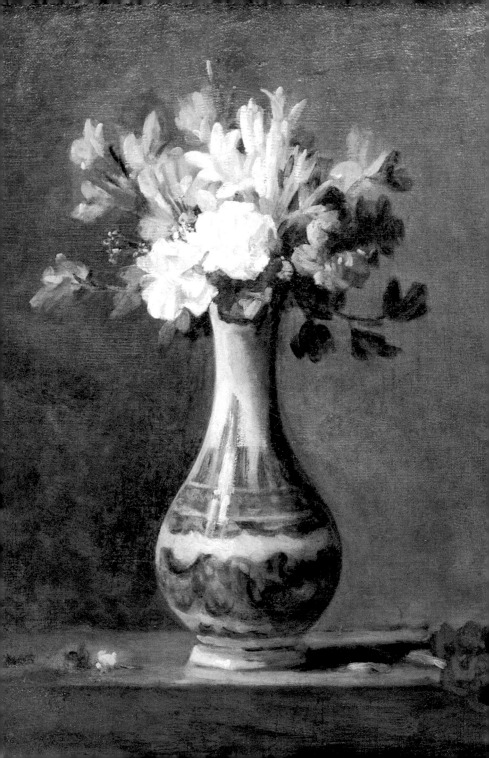

APPENDIXES

Chronology
Index of Artists

Chronology

1700

Charles II of Spain dies without leaving a direct heir; the leading European powers compete for his kingdom. Pope Clement XI (Gianfrancesco Albani) is elected pope; he will serve for more than twenty years. In Berlin the Prussian Science Academy is founded, headed by Leibnitz. John Locke writes *An Essay Concerning Human Understanding.*

1701

The Spanish War of Succession breaks out; it will last fourteen years. In England, the Act of Settlement frustrates the Catholic Stuarts' hopes to gain the throne. Hyacinthe Rigaud paints *Portrait of Louis XIV* (Paris, Musée du Louvre). Pope Clement XI issues an edict banning the export of ancient art from Rome.

1702

Anne Stuart becomes queen of England. The first newspaper, the "Daily Courant," is published in London. Andrea Pozzo leaves for Vienna, summoned by the Prince of Liechtenstein. Antonio Stradivari builds his first violins in Cremona.

1703

Czar Peter I founds Saint Petersburg. Carlevarijs publishes a collection of 104 etchings, *Buildings and Views of Venice.*

1704

The French prepare to invade Piedmont. Newton publishes his treatise on light particles. In Naples, Luca Giordano paints the frescoes in the Tesoro della Certosa in the church of San Martino, Naples.

1705

Leopold of Hapsburg dies, further complicating the Spanish succession. The French sweep through Piedmont. In Rome, the sculptor Pierre Legros begins work on the statues for San Giovanni Laterano; he would complete them in 1712.

1706

The patriot Pietro Micca sacrifices his life in an explosion during the French siege of Turin. Prince Eugène comes to the aid of his cousin Amadeus with the imperial army. Giuseppe Maria Crespi paints *Slaughter of the Innocents* (Florence, Gallerie degli Uffizi) for Prince Ferdinand de' Medici.

1707

The Hapsburg imperial troops occupy Naples and conquer Lombardy. With the Act of Union between England and Scotland, Great Britain is born. Playwright Carlo Goldoni is born. Sebastiano Ricci completes the frescoes of Palazzo Marucelli in Florence.

1708

Great Swedish offensive against Russia, but they blunder in penetrating too deeply into the immense eastern expanses.

1709

Charles XII of Sweden is defeated by Russia at the Battle of Poltava. The German alchemist Böttger discovers the formula for making porcelain.

1710

France reintroduces the clergy's tithe to try to remedy its economic crisis. The Royal Saxon Porcelain Manufactory is founded in Dresden. St. Paul's Cathedral, begun by Wren in 1668, is completed in London.

1711

Charles VI of Hapsburg becomes king of Austria. In Florence, Bartolomeo Cristofori invents the pianoforte. Ferdinando Maria Galli Bibiena publishes in Parma his "maniera per angolo" theory, which becomes the foundation of European theater architecture.

1712

A generalized economic crisis begins to attenuate the War of the Spanish Succession. Rousseau is born. Vivaldi composes *L'Estro Armonico.* Sebastiano Ricci moves to England.

1713
The Treaty of Utrecht ends the War of the Spanish Succession. Charles VI of Hapsburg issues the Pragmatic Sanction, ensuring that his daughter Maria Theresa will inherit the Austrian throne.

1714
In England, George I of the House of Hanover becomes king. In Palermo, Serpotta begins the stucco decorations of the Oratorio del Rosario.

1715
After a 72-year reign, Louis XIV, the "Sun King," dies. Philip of Orléans becomes regent on behalf of Louis XV. Fischer von Erlach begins to build the Karlskirche in Vienna.

1716
Death of Gottfried Wilhelm Leibniz, German philosopher and mathematician. First slaves arrive in Louisiana.

1717
Philip V of Spain, not resigned to the Peace of Utrecht, tries unsuccessfully to retake the Kingdom of the Two Sicilies, which the treaty had handed to the rulers of Austria-Piedmont. Watteau paints *Pilgrimage to Cythera* (Paris, Musée du Louvre).

1718
Philip V, king of Spain, declares war on Emperor Charles VI, hoping to recover the lost Italian territories. The Peace of Passarowitz ends the conflict between Austria, Venice, and the Ottoman Empire. Juvarra builds Palazzo Madama's façade in Turin.

1719
New Spanish attack in Sicily. Defoe publishes *Robinson Crusoe*. The Du Paquier Porcelain Manufactory opens in Vienna, inspired by Meissen's factory.

1720
The Peace of The Hague consigns the Two Sicilies to Austria, leaving Sardinia to Savoy, to Victor Amadeus's great regret. Watteau paints *L'Enseigne de Gersaint* (Berlin, Charlottenburg).

1721
The Peace of Nystadt puts an end to the war between Sweden and Russia. Montesquieu publishes *The Persian Letters*. Watteau dies.

1722
First English trade embargo against the American colonies. In Vienna, Hildebrandt builds the Belvedere Palace as the summer residence of Eugene of Savoy.

1723
Louis XV becomes king of France. With Prime Minister Fleury, he inaugurates a period of relative peace and growth. De Sanctis designs the scenographic Piazza di Spagna staircase in Rome.

1724
Pope Innocent XIII dies; he is succeeded by Benedict XIII. The Stock Exchange opens in Paris.

1725
Czar Peter the Great dies. Giambattista Vico publishes *The New Science*. Vivaldi finishes *The Four Seasons*. Solimena paints the fresco *Heliodorus Driven from the Temple* in the Gesù Nuovo in Naples.

1726
The Treaty of Hanover is signed between Spain, England, Prussia, and Austria. Swift publishes *Gulliver's Travels*. Tiepolo begins to decorate the gallery of the Palazzo Arcivescovile in Udine.

1727
George II is king of England. Isaac Newton dies. In Hamburg, Neickel writes *Museographia*, the first treatise on systematic criteria for organizing and displaying an art collection.

1728
The Peace of Berlin between the Hapsburg Empire and Russia. Boucher leaves for Italy, where he will stay for three years as a guest of the French Academy in

Rome. In Naples, Sanfelice begins to build Palazzo Sanfelice.

1729
The Treaty of Seville cuts the last ties between Spain and the Hapsburgs. Jean Meslier's *My Last Testament* lays the philosophical foundations of atheism. Juvarra begins construction of the royal hunting lodge at Stupinigi, near Turin.

1730
Charles Emmanuel III becomes king of Savoy. Lorenzo Corsini is elected pope and takes the name of Clement XII. Vaccarini designs the reconstruction of the city of Catania, wiped out by the 1693 earthquake.

1731
Antonio Farnese, duke of Parma, dies, the last of his dynasty. In France, the clergy become subject to the Crown. Crosato paints the fresco *Sacrifice of Iphigenia* in the hunting lodge at Stupinigi.

1732
Nicola Salvi is commissioned to build the Trevi Fountain. Hogarth begins the series of paintings and engravings entitled *A Harlot's Progress* and *A Rake's Progress.*

1733
The War of the Polish Succession breaks out. Charles Emmanuel III conquers Milan. Panini paints *View of the Piazza del Quirinale* for the Coffee House of the Palazzo del Quirinale.

1734
Voltaire publishes *The Philosophical Letters*. Rome's first public museum, the Museo Capitolino founded by Clement XII, opens. De Cuvilliés builds the Amalienburg Pavillion in the royal residence park of Nymphenburg, near Munich.

1735
The Peace of Vienna reestablishes a tentative balance between the various Italian powers. Linnaeus publishes his *Systema Naturae*, causing a sensation in Rome. Lemoyne paints the ceiling of the Hercules Room in Versailles, the last such work inspired by the *grand goût* of the era of Louis XIV.

1736
Maria Theresa of Hapsburg, daughter of Emperor Charles VI, marries Francis Stephen, duke of Lorraine. Rastrelli is appointed court architect in Saint Petersburg.

1737
Gian Gastone de' Medici dies, ending the historic Florentine dynasty. The Grand Duchy of Tuscany passes to the dukes of Lorraine. In Turin, Guarino Guarini's treatise on civilian architecture is published posthumously by Bernardo Vittone. Chardin inaugurates a long career of showing works at the Paris Salon, where he draws the notice of Diderot. Algarotti publishes *Newtonism for Ladies.*

1738
The Peace of Vienna is signed. Excavation work begins at Herculaneum, the city buried with Pompeii by the eruption of Vesuvius in A.D. 79.

1739
Charles III of Bourbon becomes king of Naples and Sicily.

1740
Upon the death of Emperor Charles VI, the War of the Austrian Succession breaks out. Frederick II ascends the throne in Prussia, and Maria Theresa in Austria. Frederick II introduces freedom of religion and of the press; by the end of his reign,

ninety percent of Prussians have learned how to read and write. Piazzetta paints *The Soothsayer* (Milan, Pinacoteca di Brera).

1741
France breaks the peace and forms an alliance with Frederick II of Prussia against Austria. Elizabeth, daughter of Peter I the Great, becomes empress of Russia. In Rome, Ferdinando Fuga builds the façade of Santa Maria Maggiore in Rome.

1742
Pietro Bracci completes *Funeral Monument of Maria Sobieska* in Saint Peter's in Rome.

1743
The House of Savoy and the Austrians defeat the Spaniards but gain no new territories. Following the death of Cardinal de Fleury, Louis XV relies increasingly on Madame de Pompadour for his political choices. Handel composes *Messiah*. Anna Maria Luisa de' Medici gives to the city of Florence the Grand Duchy's collections, which are now housed at the Gallerie degli Uffizi.

1744
The French and the Spaniards lay siege to Cuneo and unite in a war against Maria Theresa of Austria. Joseph Smith, one of Canaletto's major clients, is appointed English consul to Venice. Tiepolo completes *Apollo and Daphne.*

1745
Nattier completes *Maria Adelaide of France as Diana*. Hogarth paints the series *Marriage à-la-Mode*. Knobelsdorff designs the palace of Sanssouci in Potsdam for King Frederick II of Prussia.

1746
The Peace of Dresden between

Austria and Prussia allows Maria Theresa to deploy all her troops to fight the Spaniards in Italy. In Spain, Philip V dies and his son Ferdinand VI takes the throne. Canaletto moves to London.

1747
Savoy defeats the French. Andreas Margraf discovers that sugar can be extracted from beets. Bellotto moves to Dresden when Frederick Augustus II of Saxony appoints him court painter.

1748
The Peace of Aachen legitimizes Maria Theresa as empress of Austria and settles the endless European quarrels. Montesquieu publishes *The Spirit of Laws*. Excavation work at Pompeii begins.

1749
Commissioned by Raimondo di Sangro, decoration begins on the Sansevero Chapel in Naples, one of the highest achievements of European settecento sculpture.

1750
England, Russia, and Austria form an alliance against France. The world population stands at about 643 million; Italy has about 17 million people. Johann Sebastian Bach dies. Tiepolo begins the frescoes of the prince-bishop's Residenz at Würzburg, designed by architect Balthasar Neumann.

1751
The first volume of the *Encyclopédie*, edited by d'Alembert and Diderot, is published in Paris. David Hume and Adam Smith lay the foundations of *laissez-faire* economic theory. The Accademia delle Belle Arti is established in Parma; it would stimulate active contacts with France, in line with the reforms of the Bourbon minister Du Tillot.

1752
Vanvitelli, called to Naples by Charles III of Bourbon, begins construction of the royal palace in Caserta.

1753
Royal Navy surgeon James Lind discovers that scurvy can be treated with citrus fruits, allowing more extensive exploration of the oceans, including the Arctic. In London, Hogarth publishes *The Analysis of Beauty*, in which he advocates a realistic art that is socially committed.

1754
Rousseau publishes *Discourse on the Origin and Basis of Inequality among Men*; Denis Diderot publishes *Les Pensées de la Nature*. Hubert Robert associates with Piranesi, Panini, and Fragonard in Rome.

1755
Winckelmann's *Reflections on the Imitation of Greek Art* breaks with the existing antiquarian tradition. In Naples, the Royal Academy of Fine Arts is established. Tiepolo is elected president of the newly founded Venetian Academy of Painting and Sculpture.

1756
England prepares for war and allies with Prussia, while the skillful Austrian minister Von Kaunitz approaches Louis XV. Mozart is born in Salzburg. The National Porcelain Manufactory, formerly at Vincennes, opens in Sèvres. Fragonard stays at the French Academy at Villa Medici, Rome.

1757
England and Prussia fight Austria, France, and Russia in the Seven Years' War. Prussia is defeated in the early battles. *Antiquities of Herculaneum* is published, the

first of an eight-volume series that sparks a new enthusiasm for antiquities worldwide.

1758
Prussia drives the Russians from her territory. Carlo Rezzonico becomes pope taking the name of Clement XIII and begins his battle against the Enlightenment and the Jesuits.

1759
Charles III, king of Naples, acquires the Spanish throne. Frederick II of Prussia is defeated at Bergen. Harrison patents his fourth chronometer and receives a rich reward from the English Navy for discovering a formula for calculating longitude. Voltaire publishes *Candide*. In London, the British Museum opens to the public. In Burslem (Great Britain), Josiah Wedgwood opens his ceramic manufactory.

1760
The Russians set fire to Berlin, but Frederick II drives them back at Turgau. George III becomes king of England. Tiepolo paints *Apotheosis of the Pisani Family* in Stra (Venice).

1761
Death of English novelist Samuel Richardson.

1762
Rousseau writes *The Social Contract* on the foundations of democracy. In Zurich, Mengs publishes *Reflections on Beauty* about the principles of Neoclassicism. George III of England purchases a large collection of drawings of antique statuary from the Albani collections and the collection of Consul Smith. Tiepolo moves to Madrid to paint *Apotheosis of Spain* on the ceiling of the throne room at the royal palace.

1763
The Peace of Paris ends the Seven Years' War with the victory of England and Prussia. Clement XIII appoints Winckelmann prefect of antiquities in Rome.

1764
Cesare Beccaria publishes *Of Crimes and Punishments*, the first treatise to argue against torture and the death penalty. In Rome, Salvi completes the Trevi Fountain. William Hamilton, an avid collector, is appointed English ambassador to Naples. Winckelmann publishes *History of Ancient Art*, a theoretical treatise on the Neoclassical style.

1765
Francis I of Austria dies; Maria Theresa becomes co-regent with her son Joseph of Hapsburg. Boucher is appointed the king's first painter and director of the Royal Academy and the Beauvais tapestry works.

1766
Death of Giaquinto and Nattier.

1767
England begins to tax tea. The Jesuits are expelled from the European courts. Antonio Bibiena designs the Accademia Theater, also known as the Scientifico, in Mantua.

1768
Milizia, an advocate of Neoclassicism, publishes *The Lives of Celebrated Architects*, in which he offers a critique of Baroque and Rococo styles. The Royal Academy of Arts is established in London. Death of Canaletto. Winckelmann is murdered in Trieste.

1769
Napoleon Bonaparte is born in Ajaccio, Corsica. Giovanni

Manganelli becomes pope with the name of Clement XIV. In Florence, Peter Leopold of Lorraine opens the Uffizi Gallery to the public and oversees the reconstruction of the museum according to educational principles of the Enlightenment.

1770
The French Dauphin Louis XVI marries Marie Antoinette, daughter of Maria Theresa of Austria. Greuze leaves the Salon after one of his historical paintings is criticized. Tiepolo dies in Madrid.

1771
Work begins on the archducal palace (later the royal palace) in Milan. Piermarini is the architect. Mengs is appointed director of the Accademia di San Luca, Rome.

1772
In England, Judge William Murray (Lord Mansfield) rules that slavery is illegitimate, providing a great boost to the abolitionist movement. With the mediation of Diderot, Catherine II buys Crozat's art collection, which becomes the core of the Hermitage Museum collection in Saint Petersburg.

1773
In Boston, the American colonists throw a shipment of tea overboard (Boston Tea Party). This marks the outbreak of the American War of Independence. A public bid is called for the renovation of Piazza del Popolo in Rome.

1774
Louis XVI appoints Turgot finance minister. Gluck presents his opera *Iphigenia in Aulis*. Volpato executes a series of engravings of the Raphael Stanze in the Vatican.

1775
Pius VI begins his long, difficult pontificate. Goethe writes *The Sorrows of Young Werther*. The sculptor and designer Flaxman begins his association with the Wedgwood Ceramic Manufactory.

1776
The American colonies declare their independence from England. Adam Smith publishes *The Wealth of Nations*. Under Maria Theresa of Austria, the Accademia di Belli Arti is founded in Milan, housed in Palazzo Brera (formerly the Palazzo dei Gesuiti).

1777
Francesco Guardi is painting his capriccios with ruins and ancient architecture. The Royal Bourbon Museum is founded in Naples: it houses the finds of the Pompeii and Herculaneum excavations.

1778
Beethoven gives his first public concert. Rousseau and Voltaire die within a month of each other. The Belvedere Picture Gallery is organized in Vienna, arranged by schools and chronologically, in keeping with the new art-historical criteria.

1779
In London, the Shakespeare Gallery opens with the collaboration of the leading artists of the time, including Fuseli. Mengs dies in Rome and his bust is placed in the Pantheon, where Raphael's ashes also rest.

1780
Death of Empress Maria Theresa of Austria. Death of Bellotto in Warsaw.

1781
Kant publishes *Critique of Pure Reason*. Like his predecessor,

Necker fails to revive the French economy. Canova begins *Theseus and the Minotaur*, his first work clearly inspired by Neoclassical ideals.

1782
Watts manufactures the first steam machine. Chordelos de Laclos writes *Dangerous Liaisons*. Metastasio dies in Vienna.

1783
Two reckless aristocrats fly over Versailles in a hot-air balloon made by the Montgolfier brothers. Giandomenico Tiepolo is appointed Academy president.

1784
The American War of Independence ends with the Treaty of Versailles and the birth of the United States of America. The East India Company becomes state-owned. Boullée designs *Cenotaph for Newton*.

1785
Villanueva, a major interpreter of Spanish Neoclassicism, designs the Museo del Prado in Madrid. In Rome, David exhibits *The Oath of the Horati*, which meets with great success.

1786
Mozart composes *Le Nozze di Figaro*. Mont Blanc is scaled for the first time by Balmat and Paccard.

1787
The American Constitution is adopted. Edward Gibbon completes the last volume of *The Decline and Fall of the Roman Empire*. Canova's *Funerary Monument of Clement XIV*, a manifesto of Neoclassicism, is unveiled at Santi Apostoli in Rome.

1788
Flaxman, director of a Wedgwood Ceramic Factory branch, begins to illustrate *The Iliad*, *The Odyssey*, *The Divine Comedy*, and the tragedies of Aeschylus. Joshua Reynolds paints *Master Hare* (Paris, Musée du Louvre).

1789
The people of Paris take the Bastille and the French Revolution begins. Soon after, the Constituent Assembly ratifies the Declaration of the Rights of Man. The Neoclassical architect Langhans begins construction of Berlin's Brandenburg Gate, designed like ancient propylaea.

1790
Kant publishes *Critique of Aesthetic Judgment*, in which he differentiates the judgment of taste from a rational judgment. Fuseli paints *The Awakening of Titania*.

1791
Major slave rebellion in Santo Domingo. Mozart completes his *Requiem* and dies soon afterward.

1792
France declares war on Austria. The French Convention declares the Republic. Turner holds his first exhibition in London. The Musée du Louvre opens in Paris.

1793
The Reign of Terror begins in Paris. Louis XVI and Marie Antoinette are sent to the guillotine. Canova sculpts *Eros and Psyche*; David paints *The Death of Marat*.

1794
Robespierre is sent to the guillotine. Canova sculpts *Venus and Adonis*.

1795
Peace of Basel between Prussia and France. Goethe publishes *Roman Elegies*.

1796
Napoleon begins the Italian campaign, separately defeating Savoy and the Austrians. Francisco Goya paints *The Capriccios*.

1797
The Treaty of Campoformio marks the end of Venice's independence: the city falls under Austrian rule. The Danish sculptor Thorvaldsen begins to work in Rome. Gerard paints *Eros Kissing Psyche*.

1798
Napoleon lands in Egypt and wins at the Pyramids. Hölderlin and the Schlegel brothers usher in German Romanticism. Malthus publishes *Essay on the Principle of Population*. Vincenzo Camuccini, in *Death of Julius Caesar*, creates for the first time in Italian painting a work directly inspired by David's civic virtues.

1799
Napoleon returns to France with a small number of followers and in a coup d'état replaces the Directory with a Triumvirate, with himself as first consul. England adopts laws against labor unions. Beethoven premiers his *Symphony No. 1 in C Major*. Schlegel writes *Lucinde*. Friedrich completes *A Sailing Ship in the Polar Sea*. David finishes *The Sabine Women*.

1800
Napoleon crosses the Alps into Italy, defeating the Austrians at the Battle of Marengo. Novalis writes *Hymns to the Night*. The architect Chalgrin is asked to rebuild Luxembourg Palace in Paris in the Neoclassical style. In the European courts, the Empire style becomes popular, inspired directly by French models.

Index of Artists

*Page numbers in italics refer to the entries
in the "Leading Artists" section*

Photo Credits

AKG Images, Berlin: pp. 13, 14, 16–17, 18, 26, 39, 44–45, 48, 78, 79, 87, 89, 109, 110–11, 118, 121, 122, 125, 129, 137, 139, 148, 158–59, 162, 163, 164, 167, 169, 222, 238, 241, 246, 250, 255, 257, 263, 264, 267, 270–75, 282, 295, 310, 313, 316, 321, 340, 352, 354, 362, 368, 372

Amsterdam, Rijksmuseum: pp. 301, 353

© Archivio Mondadori Electa, Milan: pp. 22, 28, 32, 33, 71, 152–53, 179, 185, 186, 190–91, 211, 227, 234, 242, 243, 244–45, 252, 258, 260, 269, 290, 291, 302, 309, 318, 322, 341, 342, 343, 346 / By permission of the Ministero per i Beni e le Attività Culturali pp. 23, 24, 34, 47, 64, 82–83, 96–97 (Foto Schiavinotto), 112, 182, 183, 184, 192, 193, 198, 203, 236, 240, 247, 254, 259, 278, 279, 299, 300, 303, 317, 319, 323, 328, 336, 338, 347, 350, 371

Boston, Museum of Fine Arts: p. 60

Brest, Musée des Beaux-Arts: p. 58

Vatican City, Biblioteca Apostolica Vaticana: p. 104

Daniela Teggi, Milan: p. 142
Dresden, Gemäldegalerie: pp. 136, 297

Dublin, National Gallery of Ireland: p. 106

© Erich Lessing/Contrasto, Milan: pp. 10, 21, 27, 38, 43, 61, 73, 90, 91, 98, 99, 100, 103, 105, 107, 113, 130, 133, 134, 138, 140, 141, 143, 144, 146, 147, 149, 150, 151, 155, 156, 157, 160, 161, 166, 170, 172–73, 178, 180, 206–7, 223, 224, 230, 235, 256, 276, 280, 283, 284, 285, 286, 293, 294, 304, 307, 311, 312, 314–15, 320, 332, 333, 335, 339, 348–49, 351, 355, 357, 360–61, 363, 367

© Foto Scala, Florence: pp. 20, 200, 201, 202

Frankfurt, Städelsches Kunstinstitut: p. 56

Geneva, Musée d'Art e d'Histoire: p. 298

Hillerød, Nationalhistoriske Museum: p. 189

Leipzig, Museum der Bildenden Künster: p. 75

London, National Portrait Gallery: pp. 53, 324

London, Sir John Soane's Museum: p. 74

London, Tate Gallery: p. 251

Los Angeles, The J. Paul Getty Museum: pp. 54, 62–63, 101, 174, 232, 266, 277, 330–31, 337, 366, 370

Madrid, Museo Thyssen-Bornemisza: p. 231

Munich, Alte Pinakothek: pp. 171, 233, 248, 261

Moscow, Tretyakov Gallery: p. 127

Moscow, Pushkin Museum: p. 195

New York, Metropolitan Museum of Art: p. 2

Ottawa, National Gallery of Canada: p. 365

Oxford, Ashmolean Museum: p. 345

Paris, Bibliothèque Nationale: p. 8

Paris, Musée Carnavalet: pp. 52, 116

© Photo RMN, Paris: pp. 11 (88-000154 – Daniel Ar-

naudet), 102 (84-000346 –
Gérard Blot), 359 (90-003165
– Michèle Bellot)

Potsdam, Sanssouci Palace: p.
132

Providence, R.I., RISD Muse-
um of Art: p. 77

Saint Petersburg, Hermitage:
pp. 67, 68, 126, 135, 225, 226,
237, 249, 262, 308, 344, 356

Sarasota, The John and Mable
Ringling Museum of Art: p. 35

Sion, Musée Cantonale des
Beaux-Arts: p. 86

Stockholm, Nationalmuseum:
p. 12

© The Bridgeman Art Library,
London: pp. 15, 40, 41, 46, 57,
65, 69, 70, 72, 80, 81, 85, 88,
92, 108, 115, 117, 119, 120,
145, 165, 177, 197, 205, 209,
210, 213, 214, 215, 216, 219,
253, 268, 281, 287, 288–89,
296, 306, 326, 329, 334

Tulsa, Gilcrease Museum: p. 218

Warsaw, National Museum:
pp. 131, 292

Washington, D.C., National
Gallery: pp. 66, 228, 358, 364

Zurich, Kunsthaus: pp. 76, 265

The Publisher has made all rea-
sonable efforts to identify the
owners of photographic rights
and is at their disposal to fulfill
all rightful obligations.